The Late Middle Ages

Art and architecture from 1350
to the advent of the Renaissance

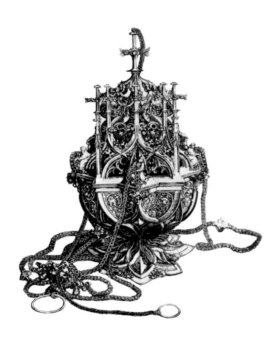

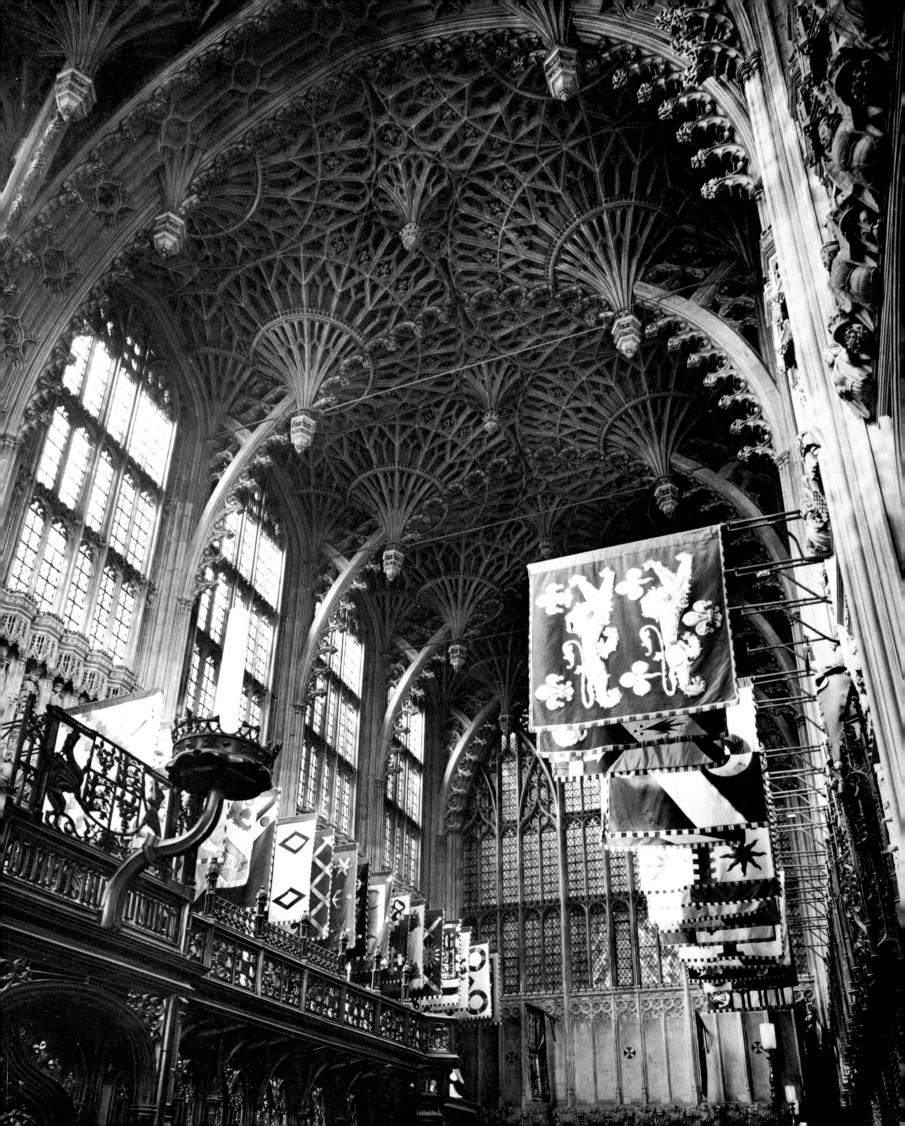

Wim Swaan

The Late Middle Ages

Art and architecture from 1350
to the advent of the Renaissance

with photographs by the author

Paul Elek London

To the memory of my mother
who first awakened my interest
in the Middle Ages

ISBN 0 236 30911 0

Designed by Harold Bartram and produced
by Paul Elek Ltd

© 1977 Paul Elek Ltd

First published in Great Britain 1977 by
Paul Elek Ltd
54-58 Caledonian Road
London N1 9RN

Filmset in England by Photocomp Limited, Birmingham
I.G.D.A., Officine Grafiche, Novara 1977 Printed in Italy

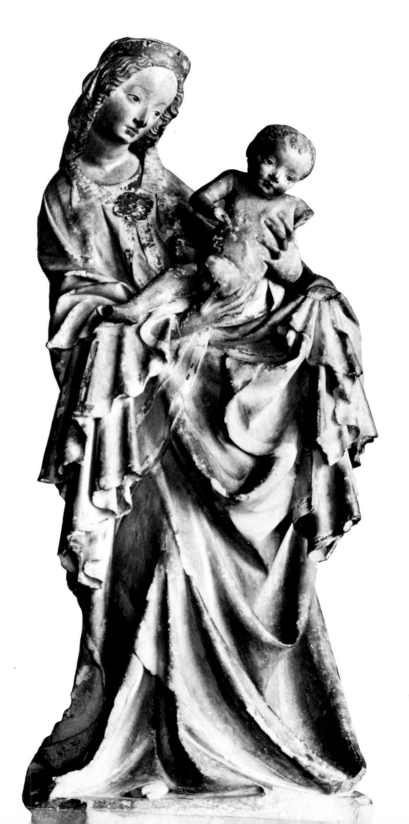

1 *Half title* Engraving of a censer by Martin Schongauer, *c.* 1480–91.

2 *Frontispiece* Built in 1503–19 by Henry VII as a chantry chapel and as a
shrine to commemorate the murdered Lancastrian Henry VI, this interior
represents Gothic at its most chivalric. *Henry VII's Chapel, Westminster
Abbey*

3 *Right* The *Krumau Madonna, c.* 1390, epitomises the courtly elegance of
the International Gothic style as it manifested itself in Central Europe.
Kunsthistorisches Museum, Vienna

4 *Opposite* Tiny figures of the Damned, enveloped in flame, are propelled
headlong into the gaping maws of a fish-headed Satan whose distended
belly sports a monstrous face. Detail from the Last Judgement Window, *c.*
1500. *Fairford Parish Church, Gloucestershire.*

Contents

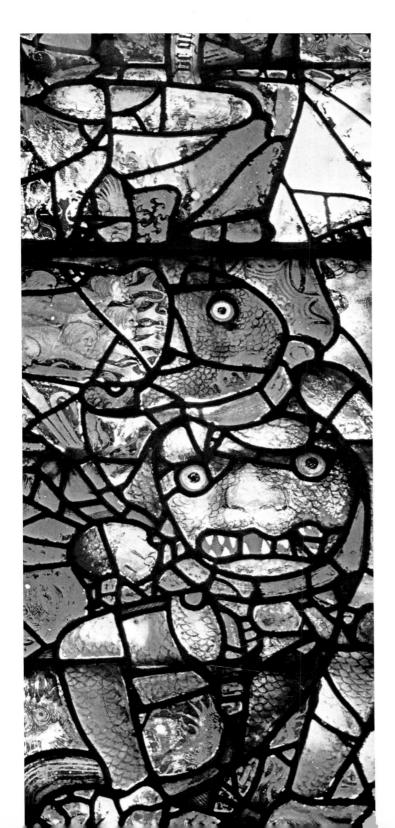

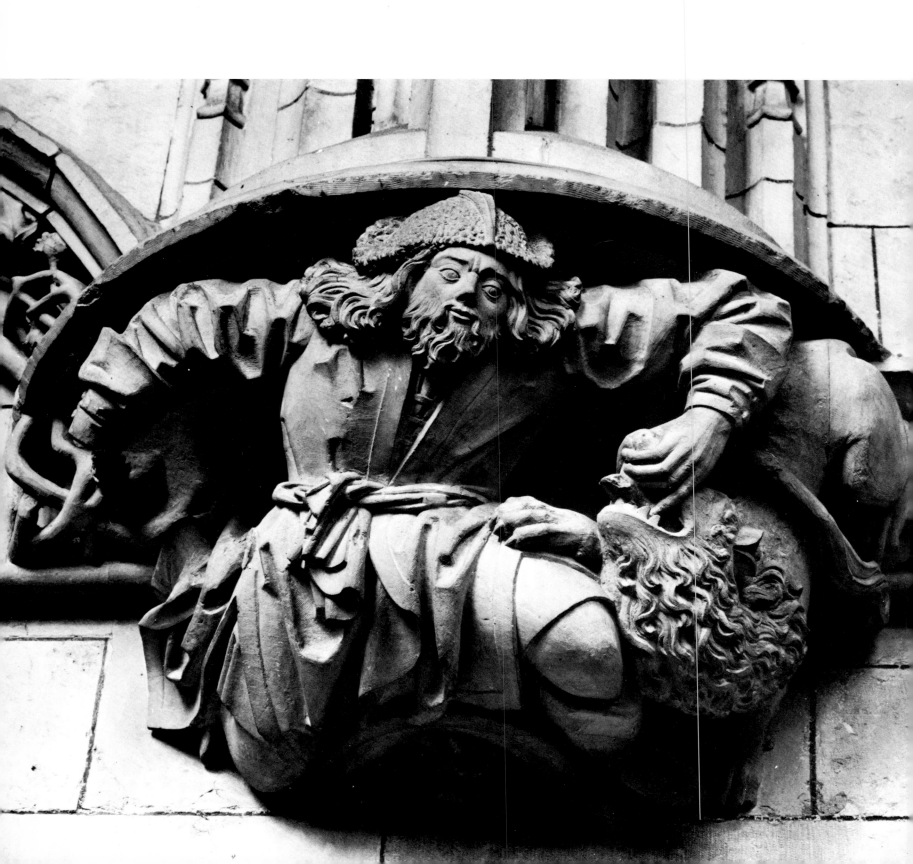

Preface

Our subject is the final harvest of the Gothic style, from 1350 to the advent of the Renaissance, in the countries of Northern Europe and the Iberian Peninsula. It is the period which Johan Huizinga described so evocatively as 'The Waning of the Middle Ages', but the phrase is somewhat misleading in terms of architecture and the visual arts, since it implies an attenuation of creative vigour. Nothing could be further from the truth. The Middle Ages 'waned' in a pyrotechnic blaze of glory, leaving as legacy some of the most spectacularly beautiful buildings and sculpture in the world and, in the paintings of the Flemish School, one of the supreme artistic achievements of mankind.

In architecture the maturing of national consciousness found expression in highly individual styles that epitomised the national genius: in England the Perpendicular, sober but capable of flights of sheer poetry; in France, Burgundy and the Netherlands the exultant, flickering forms of the aptly-named *style flamboyant*; in Germany the mystic spatial ambiguity and prodigious feats of virtuosity of the *Spätgotik*; in Spain the twin heritages of mercantile Catalonia and aristocratic Castile, compounded with a heady admixture of Moorish influence; and in Portugal the extraordinary aberrations of the Manueline style with its unique repertoire of nautical and marine motifs celebrating the triumphs of the Age of Discovery.

Of particular interest is the great variety of building types; not only splendid additions to the great cathedrals – for completely new cathedrals were rare, except in Spain – but mortuary chapels and parish churches, town-halls and commercial exchanges, colleges and hospitals, and mansions for the rising class of merchant princes.

If the number of architectural monuments is vast, the legacy of sculpture, metalwork, painting, illumination and the minor arts constitutes a veritable store of treasures. To avoid a mere recitation of facts and figures, I have had to be severely selective, concentrating on a few outstanding examples in each genre, chosen not only for their intrinsic excellence, but for the manner in which they exploited the inherent potentialities of the Gothic style and mirrored the national genius; yet at the same time I have tried to cover all the major fields of endeavour, including stained-glass and tapestry.

For practical reasons I have, at the direction of the publishers, reluctantly confined my survey to the arbitrary boundaries created by the Iron Curtain, thereby omitting present-day Czechoslovakia, East Germany and Poland. In areas like the Vistula, Silesia and Cracow many monuments were created which are characteristic of their region and important for an understanding of Gothic Germany; while in Bohemia a splendid school of court painting flourished under the Emperor Charles IV. However, it can at least be argued that developments in Eastern Europe did not greatly influence the rest of Europe, and can be paralleled to a large extent in Germany.

It is seldom realised how long the Gothic style – so congenial to the Northern temperament – survived and flourished. Italy during our period witnessed the last phase of its curiously ambivalent version of Gothic and not only the genesis but the full flowering of the High Renaissance. Fra Angelico and Jan van Eyck were contemporaries and Botticelli's *Primavera* and the *Portinari Altarpiece* by Hugo van der Goes both date from *c.* 1475. More surprising – indeed almost incredible – is the fact that Veit Stoss carved his *Salve Regina* for St Lorenz in Nuremberg in 1517-18, shortly after Michelangelo had completed his *Moses*, and half a century after the death of Donatello; or that Brunelleschi's Pazzi Chapel of 1446, a model of perfection in its Renaissance detail, had been completed some seventy years before the construction of the pendent fan vaults of Henry VII's Chapel at Westminster Abbey, or the conception even of the design of the Eglise de Brou.

It is hoped that this book will contribute to a better understanding of the art and architecture of the Late Middle Ages, products of wealth, skill and imagination which represent the aspirations of the broad mass of the people of the time far more accurately than those of the Renaissance.

Wim Swaan
New York, March 1977

5 *Opposite* Samson rends the lion asunder. Corbel bracket dating from the opening decade of the sixteenth century. *Santiago Chapel, León Cathedral*

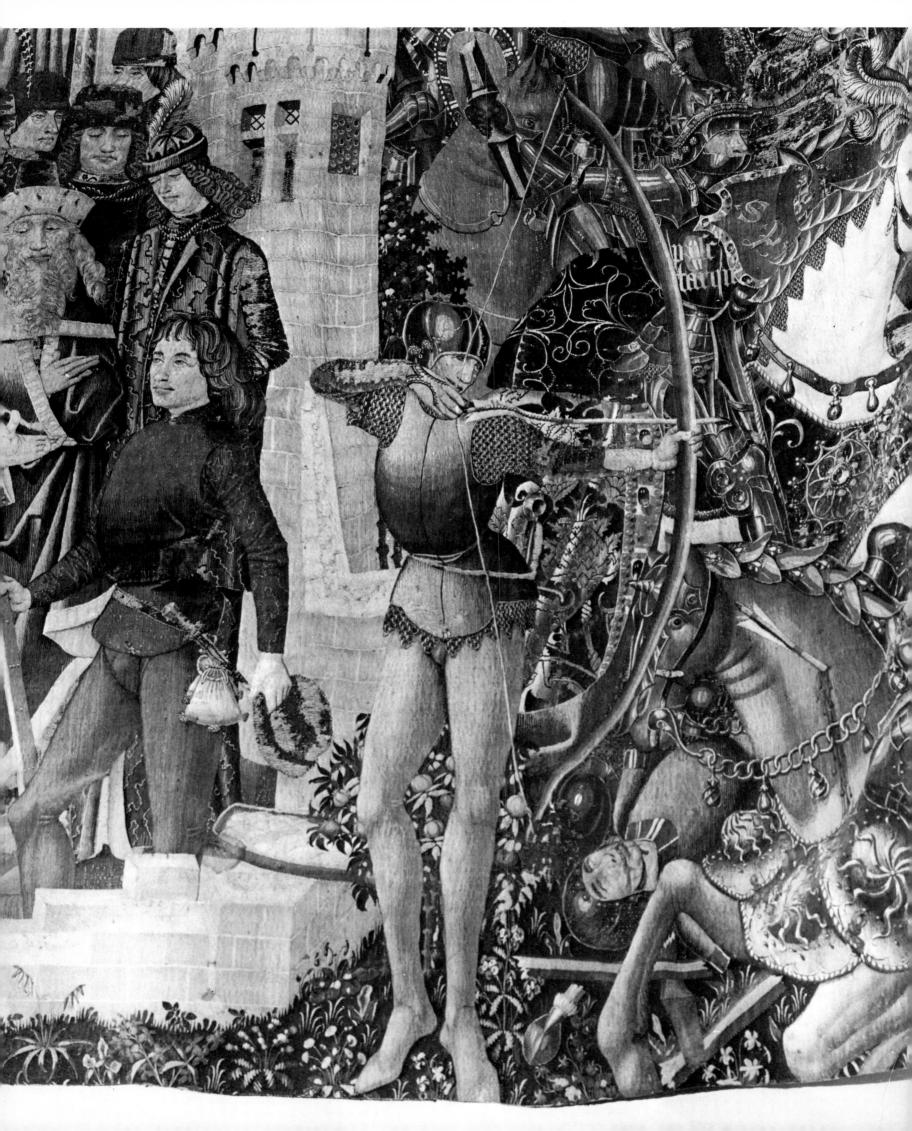

1 The Tenor of the Age

The twelfth and thirteenth centuries–when High Gothic culture reached its apogee–had been eras of spectacular economic prosperity and growth in Europe. A vigorous process of wresting land from forest and fen, comparable to the expansive pioneering days of America, almost managed to keep pace with the increasing population, the surplus being absorbed by the thriving urban communities. Already during the second half of the thirteenth century there were insidious symptoms of over-population, but this only became really serious when, around the turn of the fourteenth century, no more virgin land suitable for cultivation was available. The area of land under cultivation in Europe at this time was, indeed, remarkably large–larger, in fact, than it would be at any time until the nineteenth century. However, a considerable amount of the land proved of marginal quality, and the penalty exacted by a failure to rotate crops and soil-erosion resulted in progressively lower productivity while the hungry mouths multiplied.

Nature now entered the picture to compound the problem. The first half of the fourteenth century witnessed a major cyclical change for the worse in the European climate. It grew significantly colder and wetter. There were massive crop failures, and grain cultivation in many upland and northern areas had to be abandoned, as was vine growing in England, until this time quite extensive. Hunger became commonplace and in the Great Famine of 1315-17 multitudes starved to death–in Ypres, for example, no less than ten per cent of the population. Further major famines in 1332 and between 1345 and 1348 merely highlighted a chronic state of malnutrition which debilitated the population and rendered it singularly susceptible to disease.

Around 1338 there occurred in Central Asia an outbreak of bubonic plague in a particularly virulent form.[1] The caravans of the silk road provided a fatal means of transport, bearing the pestilence east to China, south to India and on its slow but inexorable path westwards. By 1346 the travellers' tales of a plague of unimaginable proportions decimating the East had assumed a new reality: the Black Death had reached the Tartar territories of the Crimea,[2] and the dubious honour of introducing the plague to Europe probably belongs to a fleet of Genoese galleys returning from the Crimea in October 1347 and disembarking at Messina. By the spring of 1348 the plague was firmly entrenched in Sicily and several mainland ports. In 1348 it ravaged Italy, France and Spain, in 1349 England and Germany, reached the Baltic and Scandinavia in 1350, and in these three years wiped out a third of the entire population of Europe. What is more, it returned every decade or so, though

with diminished strength, breeding a chronic sense of insecurity.

It is almost impossible to exaggerate the panic which the Black Death must have inspired, for to the physical horror of suppurating boils or 'buboes', discoloured flesh and the unbearable stench that exuded from the breath, the excrement, even the sweat of the afflicted was added the terror of the unknown: of a scourge apparently without cause or remedy. As to the plague's true significance, there was no doubt in anyone's mind that it was an expression of God's wrath at a sinful age. The reaction was towards extremes of behaviour: to prayer and repentance, or riotous living for the hour.

The 'Brethren of the Cross' or 'Brotherhood of the Flagellants' provided the most spectacular, if sinister, expression of the conviction that mortification might appease the Almighty. Members undertook to scourge themselves thrice daily for thirty-three days–symbolic of the thirty-three years of the Saviour's life–pledged absolute obedience to their leader, and vowed not to shave, wash, change their clothing, sleep in a bed, or even talk to members of the opposite sex for the duration of the pilgrimage. Contrasting incongruously with these austerities are such eminently practical stipulations as that married members obtain the permission of their spouses and that each member contribute 4d a day towards the cost of food! Headed by the Master and his two lieutenants bearing banners, each group of Brethren, usually a couple of hundred strong, wended its way in double-file from town to town, the silence broken only by an occasional doleful hymn or prayer, in marked contrast to the hysterical clamour with which they would be welcomed as they approached the town. The Brethren would first chant their litany in church, then move to a central open space for the ritual flagellations. Stripped to the waist they would march in a circle, scourging themselves on breast and back with knotted leather thongs embedded with needle-sharp spikes, in an orgy of virtuous masochism. Initially well-disciplined, the movement gradually degenerated, assumed Messianic pretensions and incited anti-clerical vandalism and a savage persecution of the Jews.

Haunted by the spectre of death as never before, the waning Middle Ages displayed an obsession with the morbid details of bodily corruption unparalleled in any era–an attitude summed up by the word 'macabre', which first appears at this time.[3] In

6 *Opposite* Detail from *The History of Tarquin*, a fifteenth-century Flemish tapestry called 'The Black Tapestry of Zamora'. *Cathedral Treasury, Zamora*

art and literature 'The Dance of Death' or *'Danse Macabre'* becomes a favoured theme; in sculpture the finest talent is lavished on the tomb. To earlier, and again to later ages, such an epitaph as, 'Here lies dust, ashes–nothing!' sufficiently evokes the transience of human existence. After the Black Death this seemed hopelessly inadequate. Not even the skeleton, scoured clean by time, embodied the contemporary vision of death. Only the putrefying corpse sufficed, preferably rendered all the more ghastly by contrast with the healthy body. The 'cadaver-tomb' gave expression to this morbid philosophy: above, the deceased ruler or ecclesiastic, splendidly attired in his robes of state, lies as if merely asleep; below, as if in a tomb, lies a rigid and emaciated corpse, naked or clad only in a winding sheet, with open mouth and hollow eye sockets, often

depleted labour force was in a strong bargaining position and wages virtually doubled within a few years. A mower who received 5d an acre in 1348 was being paid 9d in 1350, and there were proportionate increases for ploughmen and threshers.[5] At the same time reduced demand caused a sharp decline in the prices of produce and livestock, but prices of manufactured goods and implements rose sharply due to the shortage of skilled labour and the additional cost of transport. All three factors operated against the landlord, who was obliged to spend more on labour and equipment for a reduced return. Furthermore, with labour scarce and land plentiful, the villein was only too likely to abscond and seek another master who would offer him more favourable terms. The tendency was, therefore, for the lord to parcel out the demesne to tenants on a rental basis,

in a state of advanced decomposition, the decaying flesh crawling with worms and vermin.[4] This was the basic theme, capable of many variations. In French royal tombs, for example, the corpse is not emaciated, and only the bellies slit open and stitched together again by the embalmers, depicted with extreme realism, betray the ghastly truth. In the case of the most gruesome figures the sombre moral is often further reinforced by an inscription, the corpse addressing the spectator with such admonitions as, 'Wretch, why are you proud? You are nothing but ashes, and will, like me, be food for worms', or, 'In me behold the mirror of life. Such you will be, for I was what you are'. Another side to this coin was shown in the building of chantry chapels where prayers and masses were said for the souls of the departed, representing a more mystical response to the fact of death, and a fervent belief that the soul in its expiatory journey from Purgatory to Paradise could benefit from the prayers of the living.

The second half of the fourteenth century could hardly have begun less auspiciously against this sombre background of famine, economic recession, and moral and spiritual decline. Only towards the end of the century would there be gradual recovery, gaining momentum during the course of the fifteenth century; and only by the beginning of the sixteenth century would the population of Europe–now with a far larger proportion living in towns and cities–once again equal that of two centuries earlier.

The change from the over-populated Europe of the early fourteenth century to a Europe critically short of labour as a result of famine and plague in the second half of the century, had far-reaching social and economic repercussions. The

7 *Above left* Tombstone of the architect Guillaume Letellier in his mid-fifteenth-century Church of Notre Dame. He is depicted as a decomposing cadaver, holding his master-mason's pair of compasses; on the right of the inscription is the plan of the church with builder's mallet, trowel and level. *Caudebec-en-Caux, Normandy*

8 *Above* Mourner overcome by the stench of the corpse, a telling example of the contemporary taste for the macabre; from the procession of mourners on the tomb of Philip the Bold of Burgundy (photographed *ex situ*). *Musée des Beaux Arts, Dijon*

9 *Above right* Death rides a white charger. Detail from the *Apocalypse Tapestry*, 1375–81. *Musée des Tapisseries, Angers*

and to accelerate the process–already far advanced in France, for example–of commuting labour service for cash rent payment. By the end of the fifteenth century there would hardly be a serf left in Western Europe.

This emancipation was not, however, achieved without determined resistance from the landowners. With the Black Death still raging in England, Parliament enacted the Statute of Labourers of 1349, aimed at keeping the *status quo* by fixing wages and preventing the mobility of labour. Many landlords insisted on retaining their feudal rights if only on a portion of their land. In this period of transition it was the coexistence of serfdom and liberty, coupled with increased taxation by stronger central governments to pay for extended and ever more costly wars, that so embittered relations between landlord and tenant, and periodically erupted into brief uprisings such as the *Jacquerie* in northern France in 1358, the Peasants' Revolt in England in 1381 and that in Catalonia in 1409-13. It is interesting to observe that the peasants in the *Jacquerie* and

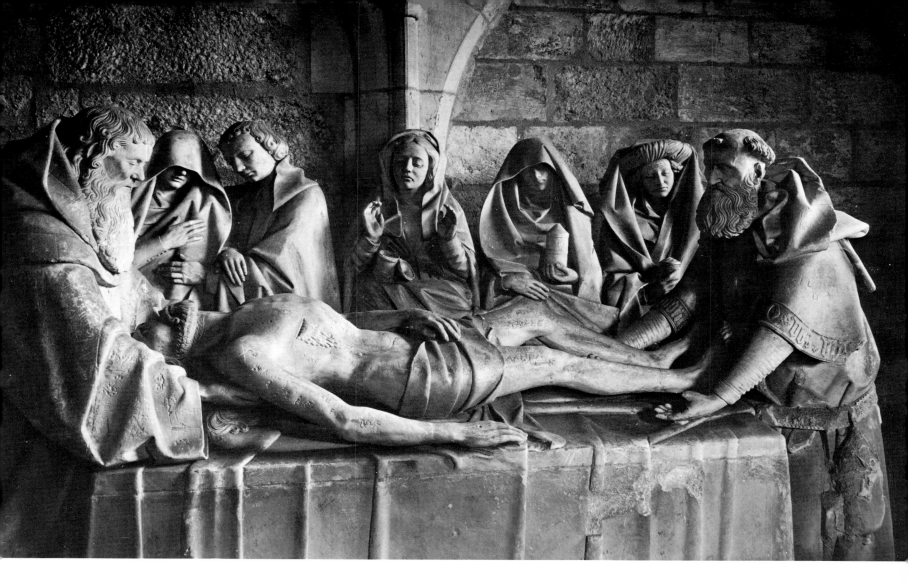

10 *Entombment* (1451–54) by Jean Michel and Georges de la Sonnette, sculpted for a charitable hospital. Its theatrical character may have been inspired by Mystery Plays. *Ancient Hospital of Tonnerre, Burgundy*

Peasants' Revolt gained considerable support from the townsfolk of Paris and London and that 'the leaders were the prosperous rather than the poorer elements in rural society . . . with whom questions of status, the dislike of the juridical nature of villeinage, and envy of the privileged quality of the gentleman and the priest, were likely to weigh most heavily'.[6]

Although the landed aristocracy maintained their power, the old rigidity of class structure was breaking down, and we find a new fluidity of movement from one class to another. In the great industrial cities of Flanders and northern Italy, and the semi-autonomous towns and cities of Germany, the merchants were beginning to constitute a new affluent class. In England, the sumptuary law of 1363 permitted merchants with goods worth £500 to eat and dress like landed gentry with up to £100 of rents[7]—something unthinkable a century earlier. The next step would be for the wealthiest to marry or buy their way into the ranks of the nobility, provoking Piers Ploughman's caustic comment that 'soap sellers and their sons for silver are made knights'.[8] Permitted to live like a gentleman, the rich merchant also yearned to be commemorated with fitting dignity in death, and in many an English parish church we find engraved funerary brasses in which the woolmerchant lies with his feet resting not upon the heraldic lion or dog of the knight, but upon a sheep and a woolpack, and sporting his merchants' mark in default of a family crest.

Chivalry, the accepted code of conduct of the noble knight in both war and peace, with its emphasis on personal honour, service and courtesy, and its strong religious overtones, had originated in the feudal era. Its truly great days – exemplified by the spirit of the early Crusaders, with St Louis (Louis IX, 1226-70) as the paragon – were by now long past, but, paradoxically, it was only in the Late Middle Ages, when it constituted something of a picturesque anachronism, that chivalry achieved its most splendid visual expression, perhaps again as a reaction to the Black Death. Although the goal of liberating the Holy Land was never abandoned, the various later attempts to launch a new Crusade were abortive, for national interests now exerted a greater lure than the service of Christendom. Something of the true crusading spirit survived in the fight against the Moors in Spain, but neither the aims nor the conduct of the bloody national struggles elsewhere were really compatible with the chivalric ideal. The nature of warfare had also changed. Infantry played the decisive role in the great pitched battles of the Late Middle Ages, with the loser precisely the side which fought the battle according to the rules of chivalry with its reliance on the mounted knight – the French at Crécy and Agincourt, for example, or Charles the Rash of Burgundy against Swiss pikemen at Grandson. The introduction of gunpowder also made the once impregnable castle vulnerable to artillery.

Small wonder that chivalrous conduct found its most congenial setting not on the battlefield but in the tournament – 'in the imaginary world of (King) Arthur, where the fancy of a fairy-tale was enhanced by the sentimentality of courtly love'.[9] Here in an atmosphere far removed from the *mêlée* of the mock battle of troops of knights on open ground,

typical of the tournaments of the early Middle Ages, knights could contend within the lists, in an exhibition of personal valour and prowess, conducted under conditions as minutely regulated as those of the bullfight today. The most lavish tournaments were held on such festive occasions as a royal marriage or the signing of a treaty. Befitting the social prestige at stake, the pageantry and ceremony, and the armour and trappings of knight and steed grew ever more elaborate and costly, exploiting with brilliant imagination the splendid visual potential of the art of heraldry.

Heraldry had originated in the twelfth-century custom of decorating the shield of a royal warrior with an individual 'charge' or distinguishing device. The next century saw the practice popularised and extended to the nobility at large and, most significantly, the adoption of the concept of descendants perpetuating the use of the 'family' emblem. The permitted arrangement and verbal description, or blazon, of the coat-of-arms were regulated, and standardised methods adopted of imparting additional information, such as connections with other noble families by marriage, or even an illustrious but

11 *Below* Haloed eagles, heads turned dutifully towards the altar, dominate the transeptal wall of the church intended as the burial place of Ferdinand and Isabella. They are the symbols of St John the Evangelist, to whom the queen paid particular devotion. *San Juan de los Reyes, Toledo*

12 *Above right* Rubbing of the funerary brass of the wool-merchant, John Fortey (†1458), his feet resting on a sheep and a woolpack, and his merchant's mark represented in the surrounding medallions. *Northleach Parish Church, Gloucestershire*

13 *Below right* The royal arms of England carved above a door. *King's College Chapel, Cambridge*

14 *Opposite* Typical timber-framed buildings in a prosperous English wool town. In the centre a ground-floor shop of a merchant or craftsman with living quarters above. The three openings were originally fitted with a hinged board that folded down into the lane and was supported on two legs, forming a shelf for the display of wares, a so-called 'stall board'. *Lavenham, Suffolk*

illegitimate origin. Heraldry, in short, became a method of identification which has proved an inestimable boon to historians in establishing the donors of works of art and buildings and the occupants of mutilated tombs. The late Gothic period was the Golden Age of armorial art, whether on the small scale of the incised brasses attached to the stalls of the Knights of the Garter at Windsor, where the earliest examples of the continuous series down to the present day are incontestably the finest, or in the monumental carved crests of the great Spanish mortuary chapels, or the manuscripts of French nobles.

A similar fantastic and improbable fairy-tale quality informs the costume of the aristocracy, each item seemingly calculated to outdo the other in extravagance: the huge swathed turbans with jagged edges resembling cockscombs for men; the elaborate wimples and later the towering cone-shaped *hennin* or steeple headdress as much as three feet in height for women; the so-called *mi-parti* or parti-coloured garments divided into two dissimilar halves by vertical, horizontal or diagonal stripes, with occasionally not only the colour and pattern, but even the cut different on the two sides, one sleeve wide, the other narrow, for example; and perhaps the most

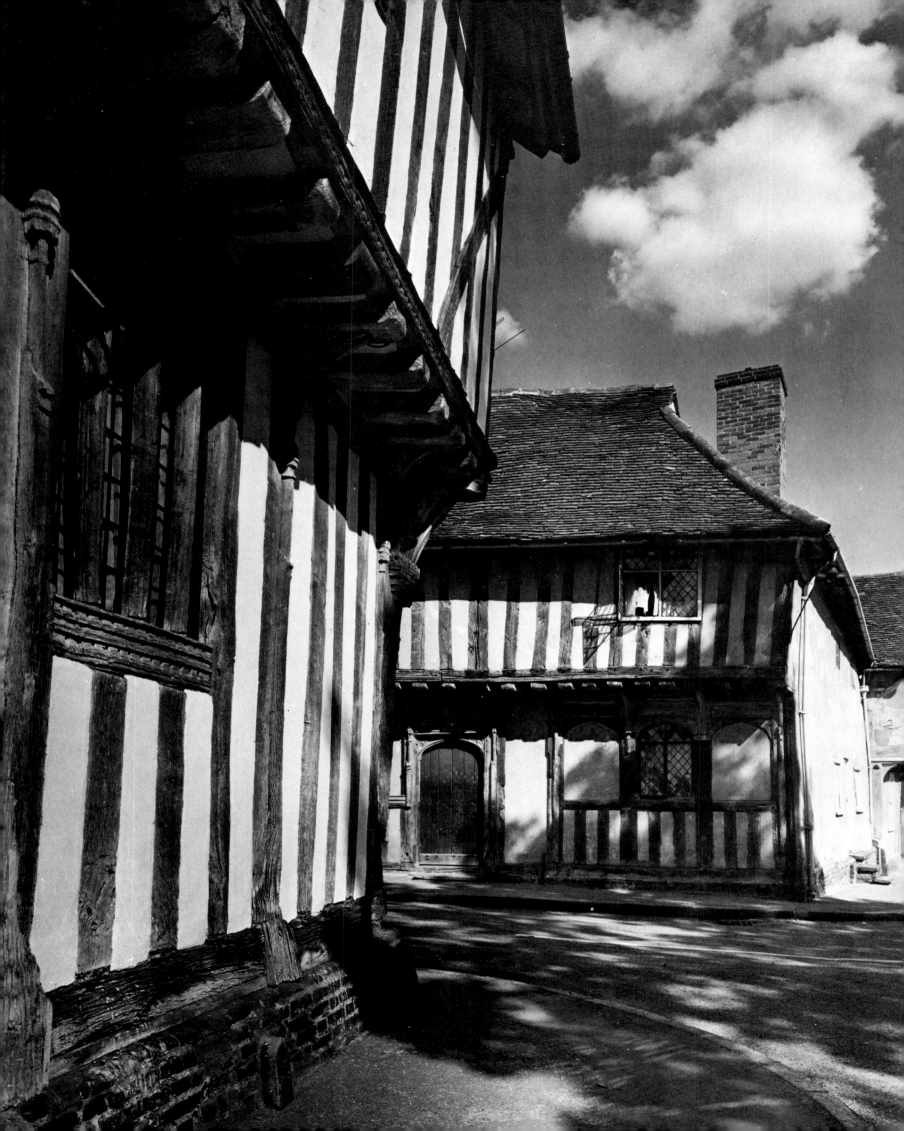

15 *Below* Page from the *Très Belles Heures de Notre Dame* from the library of the Duc de Berry, showing a typical interior of *c.* 1420. Attributed to the Van Eycks. *Museo Civico, Turin*

16 *Below right* Courtly sophistication in the International Gothic style: from the April Calendar of the *Très Riches Heures du Duc de Berry*, illuminated by the Limbourg Brothers, 1416. *Musée Condé, Chantilly*

points measuring two and a half times the length of the foot, the higher aristocracy twice the length, the lower nobility a length and a half, the rich bourgeoisie a foot, and the common people only half a foot. An illumination from the *Chroniques de Hainault*, depicting Philip the Good of Burgundy and his entourage, shows the Duke, whose court was the acme of taste 177

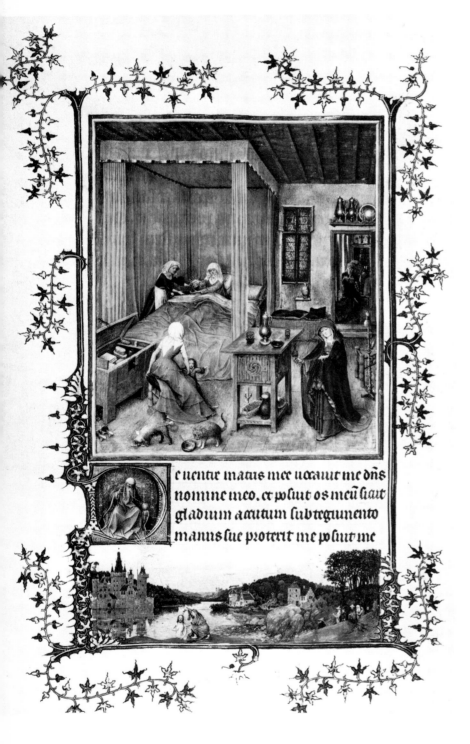

and arbiter of fashion for all Europe, wearing *poulaines* of comparatively moderate length. In his huge turban-like *chaperon* tied with a kerchief under the chin, the short doublet and tight hose, he cuts an almost incongruously jaunty figure, saved from vulgarity by the sober black favoured by leaders of fashion as a reaction to the general riot of colour.

The similar life-style followed by all European nobility, and their interaction in battle, without doubt was influential in creating that strong sense of unity in court life and art that culminated *c.* 1400 in the refined and elegant 'International Gothic' court style. This found its most characteristic expression in painting, in a style so truly international that one of the finest examples has, as we shall see, been credited by different authorities on strictly stylistic grounds to half a dozen countries, from Italy and Bohemia to England. This uniquely cosmopolitan expression was shortlived and succumbed in the first decades of the fifteenth century to the general trend towards divergent and distinctive national expression.

The period also saw the expansion and diversification of international trade which was reflected in the growth of towns and the increasing strength of merchants and industrial producers. The logical step was for the merchants to form

incredible feature of all, the footwear for men with pointed toes so long that they had to be reinforced and attached with wire to the instep, so cumbersome that after their rout by the Turks at Nicopolis, the knights had to cut them off in order to escape! Rank and status determined the permitted length of these *poulaines*. Kings, dukes and princes could wear shoes with

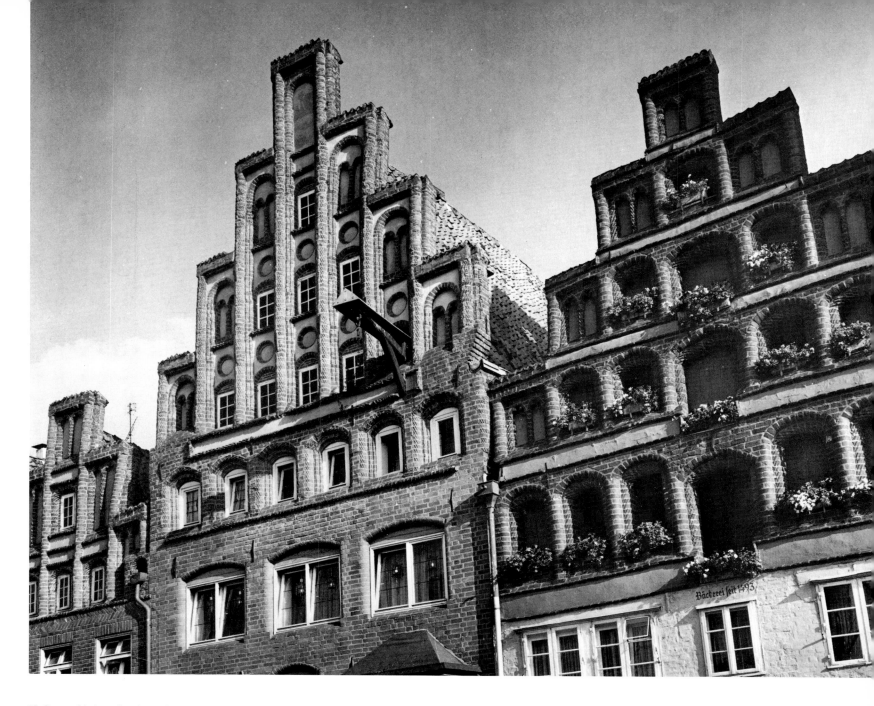

17 Step-gabled medieval warehouses (now much restored) in Lüneburg, the major source of salt in the Baltic, thanks to its brine springs.

associations for their mutual benefit and protection. Such was the origin of the spectacularly successful Hanseatic League (from the German, *Hanse*: a company, association or guild), which played a paramount role in the commercial life of Northern Europe from the second half of the thirteenth century to the end of the fifteenth. The League had its origin in two groups of merchants. The first, in the German cities of the north, engaged in the Baltic trade, exchanging raw materials, furs and food, particularly fish from the Scandinavian countries, for the great variety of manufactured goods available in the *entrepôts* of Flanders. The second group, centred in the Rhineland, and more particularly in Cologne, specialised in carriage between Flanders and England, where they were granted a charter of privileges as early as 1157 by Henry II. In the second half of the thirteenth century the northern group, already enjoying a monopoly of long-distance carriage in the Baltic, began to intrude upon the preserves of the Rhinelanders, and by the beginning of our period the two groups had amalgamated as the 'German Hanse', and broadened their base

of operations from an association of the leading merchant families constituting a patrician oligarchy in the various cities, to an association of the cities themselves, under the leadership of Lübeck.

Around the middle of the fourteenth century the League assumed its definitive form. Curiously enough it had no permanent officials or central treasury which levied regular contributions. Major policy decisions were taken at assemblies or diets (*Hansetage*), held periodically at Lübeck, by a majority vote of the towns in the League. This number fluctuated, from a maximum of over a hundred to an average of around seventy during the greater part of the life of the League. In practice, many of the smaller towns entrusted their interests and vote to one of the main cities. The *Hansa* acting *en bloc* wielded formidable power, but throughout its existence remained an economic rather than a political entity. Although it occasionally resorted to war and with greater frequency to blockade, its chief weapons were boycott and sanction and, for member towns, the threat of expulsion and the consequent loss of the privileges of membership. Outside Germany the affairs of the League were channelled through four main *Kontore* (counters) at Bergen, Novgorod, Bruges and London. These privileged

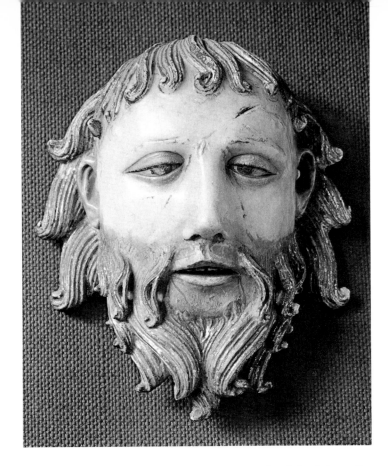

fix the dyes, alum from Asia Minor and potash from the forests of the Baltic, and the exotic dyes themselves: kermes for a brilliant red, obtained from insects in the Iberian Peninsula and North Africa, orchil for purple from the lichen of Norway, woad for blue for general use, with indigo from distant India reserved for only stuffs of the very finest quality. The main suppliers of raw wool for the looms of Flanders and Northern Italy, the other great centre of cloth production, were Spain and particularly, England, which also enjoyed the reputation for the very finest quality–a reputation so ingrained that even today, four hundred and fifty years after Henry VIII's break with Rome, the Pope's woollen garments are still made from English wool. However, during the fourteenth and fifteenth centuries exports of finished cloth rose steadily while that of raw wool declined proportionately. The weaving industry brought great prosperity to England. There is more than a grain 14 of truth in the saying that wool paid for the Hundred Years' War; and it is certainly no coincidence that some of the finest Perpendicular-style parish churches–the so-called 'wool churches'–should be found in the regions where the industry 46 flourished.

In the warehouses and in the homes of the wealthiest Flemish merchants could be found ivory carvings and illuminated books from Paris, enamels from Limoges, embroideries, pewterware and alabaster carvings from England, glassware and especially mirrors from Murano, lustreware ceramics, tooled leather and pile carpets from Spain, silks from Byzantium and the Near East and from Italy, and arms from Augsburg and Milan. Flanders itself was particularly renowned for its wool hangings or tapestries, the chief centres of 6 production being Tournai and later Brussels,[10] and also, from 130 the time of the brothers Van Eyck, for the paintings of the Flemish School, collected by connoisseurs all over Europe.

A classic example of the tendency to standardisation and the virtual mass-production of works of art towards the end of the Middle Ages is furnished by the small-scale alabaster figures and reliefs with religious subjects produced during the fourteenth and fifteenth centuries in and around Nottingham,

establishments enjoyed special extraterritorial rights, the resident merchants being subject to German law and the jurisdiction of the Hanseatic Diet, rather than that of the host country. In addition there were numerous subsidiary depots. In England, for example, the London 'Steelyard' (a corruption of *stälhof*, a court for the display of samples or patterns) was supplemented by the depots at York, Boston, Lynn and Norwich. The middle of the fourteenth century marked the apogee of the League's power. Thereafter, its hitherto expansive and progressive policy became increasingly restrictive and monopolistic in an effort to maintain its power, threatened in the north and east by a politically strong Denmark, a Poland and Lithuania recently united, and the rise to power of Muscovy in Russia.

Cities in the Low Countries and North Germany flourished as the intermediaries between Northern and Southern Europe. Bruges, for example: on its crowded quays and in its step-gabled, brick warehouses was handled varied and exotic merchandise: furs from Russia, timber, pitch and amber, and a huge trade in salt herrings from the Baltic, metallic ores from Germany, tin, lead and coal from England, salt from Portugal and the Bay of Bourgneuf near the mouth of the Loire, dried fruits, sugar and almonds from the Iberian Peninsula and spices from the East via the Levant. Most important of all, there were the bales of woollen cloth for export for which Flanders had been famous since Roman times and which constituted the chief source of its prosperity, and the materials required for its manufacture, not only the raw wool, but the mordants required to

18 *Above* Fifteenth-century alabaster head of St John the Baptist in high relief preserving its original colour and gilt. *Victoria and Albert Museum, London*

19 *Right* Self-portrait of the architect-sculptor, Anton Pilgram, peering from a *trompe-l'oeil* opening in the base of the monumental pulpit he designed, 1510–15. *Stephansdom, Vienna*

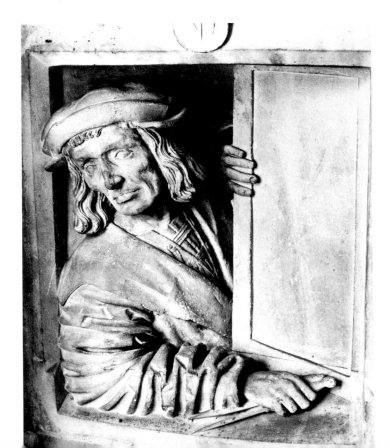

and exported all over Europe—fortunately so, since those that remained in England were almost all destroyed. Virtually the only alabasters to survive *in situ* in English churches are those on tombs protected from the iconoclasts, among the finest being the reliefs of The Annunciation and The Trinity on the tomb-chest of Dean Hussey, *c.* 1440, in Wells Cathedral. The mystic fervour of the age, and the taste for the macabre, found an ideal vehicle in heads of the decapitated St John the Baptist for use in home and oratory. These were produced in large numbers, distributed by travelling salesmen, and usually sold at no more than 1s 6d. In a lawsuit of 1491, Nicholas Hill, a Nottingham manufacturer, sued his salesman for the value of fifty-eight such heads.[11] These we may assume to have been of indifferent quality. Fine individual pieces were, however, also produced for discriminating patrons. In a class by itself is the head of the Baptist, for many years in Spain and now in the Victoria and Albert Museum. The plaque has preserved its original, most effective polychromy, the gilded hair and beard providing the needed touch of hieratic dignity to complement the naturalism of the distraught features. The gory gash on the forehead, painted with such obvious relish, records the legend that Herodias, presented with the grisly trophy by Salome, could not resist stabbing the head of the prophet who had dared to denounce her.[12] Only the sincerity and superb skill of the artist have prevented a lapse into mawkish sentimentality.

Just as the merchants had their corporations or guilds, so did each of the building trades, the craftsmen and the manufacturers—even the prostitutes. Indeed, so ubiquitous a feature of medieval urban life was the guild, so closely linked its rise and its fortunes with those of the medieval city, as to prompt one authority to equate the guilds with the city in its economic aspect, the city with the guilds in their social and political aspect.[13]

In the Middle Ages the crafts and even such a major industry as wool-processing in the large cities of Flanders—where it provided a livelihood for no less than half the population—were, to a very large extent, produced individually in small shops, comprising the master, with one or two senior assistants ('journeymen' who had already completed their apprenticeship), a couple of apprentices and a boy to help with the menial tasks. Mostly of modest means, it was all the more essential that such shop owners band together to obtain the advantages of collective bargaining to ensure a just price and fair competition by establishing and enforcing standards of material and workmanship. So successful was this collective action that by the end of the medieval period the leaders of the major guilds commonly were represented on the town-council and thus shared in the administration together with the nobility and merchants. Both craftsman and town prospered, and the guilds and the municipality joined the ruler and the Church as important independent patrons of monumental architecture and the arts.[14]

Although the craft guild—like the trade union—did everything in its power to exclude non-members from practice, guild organisation was initially basically democratic, affording the opportunity for virtually any townsman to progress from apprentice to journeyman and eventually attain full membership of the guild as a master, when he might well set up his own shop. However, towards the end of the Middle Ages, the craft guilds tended to be controlled increasingly by a few well-entrenched families, constituting a virtual oligarchy, with membership made increasingly difficult for any but their sons

and relatives, and only too often the progressive social goals that had earlier characterised the guild tended to be subordinated to narrow financial considerations and preserving the *status quo*. All told, however, the medieval guild represented one of the happiest solutions to the problems of production, both for the craftsman, and in promoting and maintaining consistently high standards of workmanship.

Among the guilds of building workers, that of the stonemasons presented some particularly fascinating features. It must be remembered that the vast bulk of buildings, even in the towns of Northern Europe, were of wood-framed construction, with an infilling of wattle-and-daub or brick, usually whitewashed for protection to give the characteristic black-and-white, half-timbered effect. Stone was reserved for fortifications and a few monumental structures, though even here wood, so prone to destruction by fire, must have played a far larger role than the small proportion of surviving examples would indicate. Whereas such craftsmen as carpenters, plasterers and tilers could hope to find steady employment in the town, the mason was often obliged to move from one major project to another in search of work. This mobility, in such marked contrast to the sedentary existence of most workers, led to certain unique features of his corporate existence—some perpetuated to this day in the institution of honorary freemasonry. Often away from home, it was natural that the mason should turn to his colleagues for companionship and for the masons' lodge, originally just a shed to protect him from the weather and store his tools, to become also a place for discussion in the nature of a club. Secret signs and passwords were used to distinguish fellow freemasons.[15] It is interesting to note that the secret handshake was first felt necessary in a part of Scotland where numerous builders of the traditional 'dry-walling' posed as freemasons, and the quality of the local stone made a quick assessment of a stranger's ability impossible. In Germany, in particular, a clear distinction was drawn between masons attached to the lodges, working for the Church or the Crown, and members of the local masons' guild, employed on relatively minor projects in the town.

The organisation of the stonemasons is of added interest since it was from their ranks that arose the designer, in other words, the architect, or to use his customary medieval title, the national equivalent of the Latin *magister*: the master, *maistre*, *maestro* or, more specifically, the *baumeister* or master-builder. The lodge system was also instrumental in preserving working drawings, or pattern-books, which enabled designs or modifications of them to be applied to another building without the labour of working out its structure again mathematically.

In 1387 the new Pope, an Italian, Urban VI, had set about thoroughgoing reforms, tactlessly commencing with the predominantly French cardinals, who retaliated by averring that they had been tyrannised by the Roman mob into voting for Urban, declared the election void and chose one of their number Pope. 'The Great Schism of the West' had begun. Initially, Urban VI enjoyed greater support in Italy, so his rival set sail for France and Avignon. All now rallied behind one or the other contender, their support dictated less by regard for the legal claim of either candidate, than by observance of traditional political alignments. France and her allies, Scotland and Castile, supported Clement VII; England and Germany, Urban VI. Portugal initially championed Clement VII, then switched her allegiance to Urban VI in deference to her treaty with England.

For the next thirty years Christianity would face the ludicrous and degrading spectacle of two, and even three, purported Vicars of Christ, each routinely excommunicating the other, and alternately wooing and threatening his rival's supporters; each making appointments to the same sees and offices, the successful incumbent depending on which Papal candidate the secular ruler in question championed. From such a situation the Church could only lose, the secular powers gain. Even after the 'Great Schism' was healed in 1417, there could never be a return to the *status quo*. The concept of the unity of Christendom under the Pope had been dealt a blow from which it would never recover.

In the years between the healing of the Schism and the Reformation, abuses within the Church increased rather than diminished, particularly within the monastic communities, where both discipline and zeal were at a low ebb. Despite the fact that their preachers were chiefly responsible for the periodic resurgence of religious fervour, the begging orders of friars were singled out for abuse, perhaps, as Huizinga suggested, because the conception of poverty advocated by St Francis of Assisi was no longer consistent with the spirit of the age, with 'people beginning to regard poverty as a social evil instead of an apostolic virtue', and comparing the begging friars unfavourably with the 'true poor'.[16] Molinet was no doubt voicing a widely held popular sentiment in his facetious New Year's rhyme:

Prions Dieu que les Jacobins
Puissent manger les Augustins,
Et les Carmes soient pendus
Des cordes des Frères Menus.

(Pray God that the Jacobins devour the Augustinians, and that the Carmelites be hanged with the cords of the Minorites.)

However, if anti-clericalism was rife, the sanctity of the sacerdotal office was unquestioned, and religion and life were still integrated in an indissoluble unity. Sacred and mundane, supernatural and natural, still overlapped or merged imperceptibly. The saints were still credited with active intervention in the affairs of the living, and the most commonplace acts imbued with religious symbolism. Thus Heinrich Suso, the great mystic, regularly ate three-quarters of his apple in the name of the Trinity and the fourth in remembrance of the apple given to her infant Son by the Madonna – this quarter unpeeled since children do not peel their fruit! If this example verges on the ridiculous, it nevertheless effectively highlights the omnipresent character of medieval religion, the very antithesis of 'Sunday-Worship'.

Simultaneously there were intellectual developments that potentially at least might have threatened the primacy of Pope and Church. Scholastic philosophy of the twelfth and thirteenth centuries had found a compelling unity pervading every aspect of life, sacred and profane – all but reflections of the Divine 'Idea' emanating from the mind of God, and achieving true significance only in relation to the Christian Revelation. This abstract 'Realism' achieved its supreme expression in the *Summa Theologica* of St Thomas Aquinas († 1274), an inexorably logical exposition of the unity of truth and the compatibility of Faith and Reason. However, already before the end of the thirteenth century this delicate

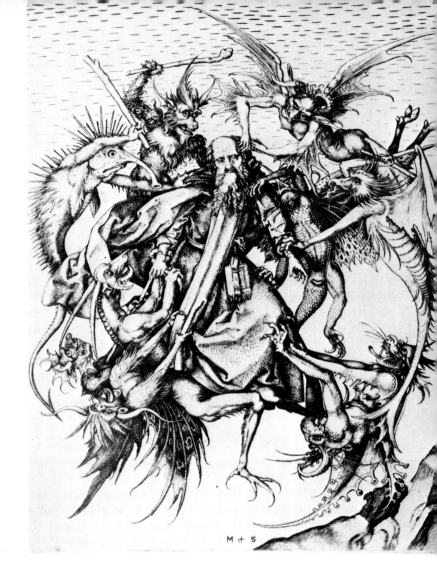

20 *Above The Temptation of St Anthony*, engraving (*c.* 1470-75) by Martin Schongauer. *British Museum, London*

21 *Opposite* Sculptured screen, surmounted by an imposing Flamboyant Gothic canopy, donated by the canon Jean Wytz (†1522 or 1523). The scenes depicting rites in the Temple of Jerusalem are strongly influenced by the illustrations in the 1493 edition of the *Nuremberg Chronicle*, providing an important early example of the dissemination of models through the recent invention of printing. *Amiens Cathedral*

equilibrium was undermined and soon succumbed to two diametrically opposed concepts: an anti-rationalist, ecstatic mysticism, epitomised by Master Eckhart and his followers, and the 'Nominalism' of the school of William of Ockham, whose emphasis on the evidence of the senses, experiment and logical thought justifies his reputation as the first 'modern' philosopher.[17]

Mysticism, with its emphasis on an intensely personal relationship with God, would be the dominant creative force in the sacred art of the Late Middle Ages. Nominalism, with its implicit recognition that the individual and specific were worthy of note, would encourage the development of a secular, objective, realistic art and, in particular, a new genre, the portrait. In its dispassionate attitude Nominalism also laid the ground for the birth of a scientific attitude. The theories of the Arab philosopher, Averroës, were even more important in this regard. In no way could his interpretation of Aristotle be reconciled with Christian dogma, but the scholar of the Late Middle Ages could expound such theories and even uphold their philosophical truth, so long as he did not infer that he believed them.[18] This dichotomy of religious and philosophical

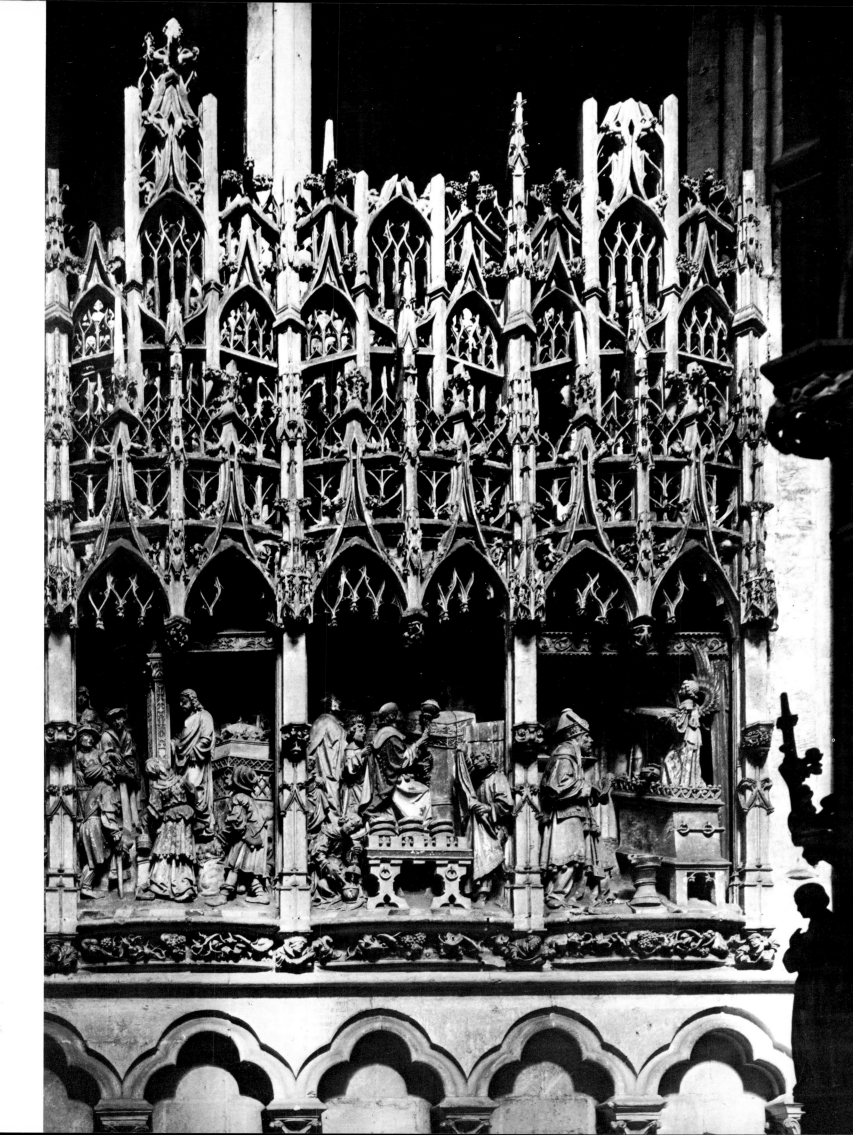

truth—each tidily compartmentalised—permitted the coexistence of the most profound scepticism and the most credulous piety in one and the same person. When scholars no longer played the game according to these rules it would lead inevitably to the Reformation.

These developments in religious and philosophical thought were all the more significant in that they could be made accessible to a much wider lay public, as a result of the expansion of educational institutions and the growth of literacy. The marked increase of national awareness in the Late Middle Ages found expression in a proliferation of national universities which had started as guilds of masters: from twenty-three in all Europe prior to 1300, to no less than seventy-nine at the end of the fifteenth century. The motivation for founding many of the new universities was, in many cases, primarily political rather than educational. Increasingly, rulers adopted measures to discourage students from studying abroad and, at the same time, attempted to exercise greater control at home.[19]

If the increase in the number of university students was not necessarily directly proportional to the number of new universities, there was, nevertheless, a considerable growth of the student population in the Late Middle Ages, and the same growth is also evident in secondary education, now provided not only by the traditional Grammar School, but also in flourishing mercantile cities such as Florence and Lübeck by what might almost be termed commercial schools, with an emphasis on such practical subjects as arithmetic. It has been estimated that by the mid-fifteenth century at least forty percent of the London merchants could read and write a little Latin. If so, one may presume that a considerably higher percentage could read and write English. There is also clear evidence that an increasing number of people in both town and countryside, who had had no more than the elementary education such as was provided by chantry priests, could read and write.

The vernacular languages were accorded an ever more important role in literary expression. This was the age of Petrarch and Boccaccio, of the chroniclers Froissart and Chastellain and that wayward genius François Villon, of Iñigo López de Mendoza, and of Chaucer. Latin was still very much alive, the language of the Bible and the ritual of the Church, written and spoken by all educated persons, but national sentiment and devotion to a mother tongue were gaining ground. In England the shortage of French-speaking teachers after the Black Death gave a great boost to the study of English, now first introduced as the medium of instruction in grammar schools, and into the Courts of Law in 1362. Business dealings were best expressed in the native tongue, and it is most significant that Italian superseded Latin even in the Vatican Curia after 1480.

At the beginning of the fifteenth century this marked increase in literacy and the growing craving for knowledge were, however, still stifled by the scarcity of books. A major intellectual centre such as Cambridge still had a mere 122 volumes in the university library in 1424, although colleges and private individuals would own their own volumes.

The raw materials for the mass-production of books were already at hand. Paper made from rag pulp had been known in China as far back as the second century. The technique had arrived in Europe via the Muslim world and paper had already been produced in Spain since c. 1150. Production soon spread to France and later to Italy, where the paper mills of Fabriano became the largest and most celebrated in Europe. By the

22 *Below* View of the court of New College; detail from a miniature in the Chaundler Manuscript, c. 1460 (Ms 288, fol. 3v). *New College, Oxford*

23 *Opposite* Detail of the upper part of the west front of the church, showing the tondo of the *côro alto* and one of the angle buttresses, girt with a realistic buckled garter—an allusion to King Manuel's investiture with the Order of the Garter. *Monastery of the Order of Christ, Tomar*

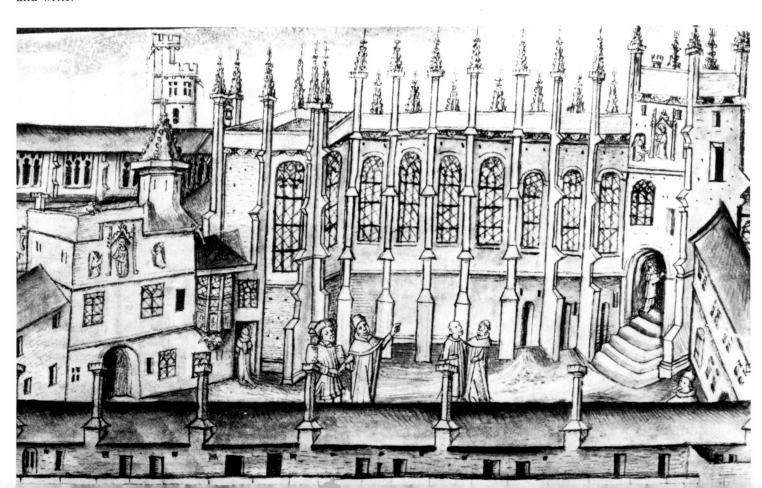

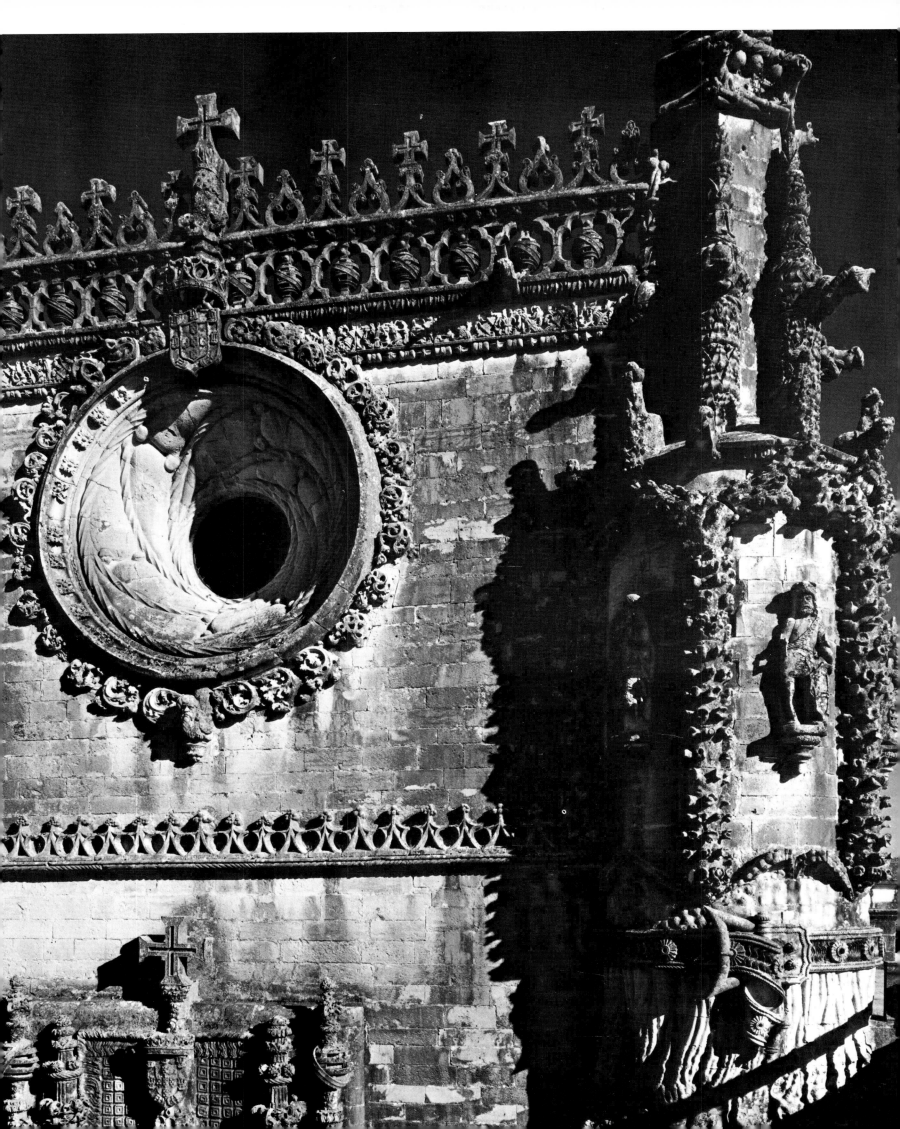

fifteenth century paper was widely used as a substitute for vellum in cheaper manuscripts. Oil-based pigment suitable for printer's ink was available, as was the screw-press, used by bookbinders and in the long-practised techniques of printing designs on textiles by means of wood-blocks. As we shall see, wood-block prints would provide the earliest means of reproducing illustrations, which sometimes incorporated a few lines of text.

China had also led the way in evolving movable type of wood and bronze, but the Chinese method was not known, and printing had to be invented independently in the West. Goldsmiths commonly used moulds to cast letters for such decorative purposes as bookbinding, and this may well have suggested the production of the large numbers of identically formed letters required for type-setting, by casting the letters first in lead and later in more durable metals.

There is documentary evidence that already in the 1430s Johann Gutenberg (c. 1398-1468), born at Mainz but living at Strasbourg at the time, was heavily involved financially in the printing experiments that he would bring to a triumphant conclusion two decades later. To Gutenberg belongs the honour of producing the first book using movable type, a monumental Bible completed in 1454 or 1455 at Mainz. Comprising 643 pages of print, arranged in double columns of forty-two lines each, and with a type-face of great distinction, based upon the best contemporary written hand, the two-volume 'Gutenberg Bible' or 'Forty-two Line Bible' remains to this day one of the finest examples of typography. The edition appears to have consisted of some two hundred copies, some on vellum, some on paper, forty-eight of which have survived.

Fulfilling as it did such a pressing need, printing spread rapidly throughout Germany, to Italy in 1464, Paris in 1470, the Netherlands in 1471, Spain in 1474 and England in 1476. The year 1462 saw the production of the first profusely illustrated book, the *Edelstein* or 'Gem', a collection of fables, with eighty-five woodcuts, while the earliest printed music dates from 1473.

Initially, the printing press served primarily to disseminate existing rather than new ideas, particularly since the considerable financial outlay made the ready market for a 'bestseller' a necessity. Consequently, the first printed books were Bibles, such popular devotional works as the *Imitatio Christi* of Thomas à Kempis—of which no fewer than ninety-nine editions appeared before 1500—and text and school books such as Donatus' celebrated *Grammar*. However, the increasing availability of books nurtured the growing literacy and intellectual curiosity that had precipitated the development of printing in the first place and there was an ever increasing demand for books on an ever broader range of subjects. With the printing press the rapid transmission of new ideas to a large public at last becomes feasible.

Finally, the changing patterns of trade in the waning Middle Ages were closely linked to developments in the epic struggle between Christianity and Islam. In the East the fall of the tolerant Mongol Empire and the rise of the Ottoman Turks witnessed the disruption of the traditional trade routes and progressively weakened the Byzantine Empire, culminating in the fall of Constantinople in 1453. Henceforth, European trade with the Far East would be channelled chiefly through Alexandria, with Venice serving as the middle-man. In Western Europe the outcome of the struggle was very different. Here it was Islam whose power was eclipsed with the successful Christian reconquest of Spain, completed with the fall of Granada, the last Moorish stronghold, in 1492.

The very same year saw the discovery of America by Christopher Columbus, sailing under the flag of Castile, and in 1497 Vasco da Gama crowned almost a century of Portuguese pioneering in the science of navigation with his voyage to India via the Cape of Good Hope. The Age of Discovery would furnish not only the wealth, but also the inspiration for Portugal's magnificent contribution to the final chapter of Gothic art: the Manueline Style with its nautical motifs and exotic overtones. Although it would not have been apparent to contemporaries, the focus of European trade was moving from the Mediterranean to the Atlantic. In the sixteenth century Lisbon would surplant Venice as the chief *entrepôt* for the riches of the Orient, and the Iberian Peninsula, hitherto on the very edge of the known world, would become the central terminus of trade routes converging from the far corners of the earth.

As Huizinga has observed, the Late Middle Ages was a period of violent contrasts, when 'life bore the mixed smell of blood and roses'.[20] A study of the chronicles and the histories would have emphasised the blood; the evidence of the visual arts that are the subject of our book, on the other hand, would alone have created too rosy an impression, for it is a characteristic of great art to sublimate even death and suffering into beauty. That it was an age of proud endeavour and superb achievement in the visual arts will emerge without gainsay from the following pages.

But first let us take a look at one of the most opulent and extravagant examples of the goldsmith's art created in the Late Middle Ages, when the wealthy élite gave each other glorious trifles which were also devotional objects. It is the so-called *'Goldenes Rössel'* or 'Little Gold Horse'. Commenced in 1393, this miracle was a New Year's present from Queen Isabeau to her husband Charles VI of France in 1404. It was given in pledge for a loan to the depleted French exchequer by Isabeau's brother, Duke Louis the Bearded of Bavaria, who removed it in 1413 to his capital, Ingolstadt, whence it subsequently found its way as a pious royal donation to the treasury of the pilgrimage church of Altötting.

216

Within a jewel-encrusted, golden bower sit the Virgin and Child with the three patron saints of the royal children at their feet: St Catherine reaches out for the ring preferred as token of their Mystic Marriage by the Christ Child; St John the Baptist plays with his gambolling lamb, and St John the Evangelist holds a chalice in one hand and a bouquet in the other. Kneeling before this celestial scene in adoration are Charles VI on the left and his marshal on the right, bearing the royal tournament helm, symbolic of the king's dedication of his person and his kingdom to the Virgin. This scene is set in a chapel at an upper level, approached by flanking stairs. Below, a page wearing parti-coloured stockings—one white, one red—tends the king's champing steed. The figures, including the little horse, are of twenty-one carat gold beneath the brilliant enamels, varying from opaque matt white to richly translucent crimson, examples of a technique mastered only a few years previously by the goldsmiths of Paris and Limoges. Technical perfection and an acute artistic sensitivity—notice, for example, how effectively the white field of the child saints' robes increases the apparent scale and regal dignity of the figure of the Virgin—are combined with an infectious spontaneity of expression.

2 England

The first half of the fourteenth century saw the triumph of 'Decorated' (or 'Curvilinear') features in English Gothic architecture, characterised, as the names imply, by exuberant, often excessive, ornamentation of a markedly plastic quality, by free-flowing forms, notably the sinuous, reverse-curved ogee arch, and by an almost Baroque infatuation with three-dimensional movement in space.

The inevitable reaction was not long in coming. By the 1340s we find the first examples of the 'Perpendicular' style, diametrically opposed to its predecessor in its severe and rigid linearism, and so congenial to the English temperament that it became the national style *par excellence*, unchallenged from its general acceptance in the 1370s until the advent of the Renaissance some hundred and fifty years later. Significantly, it never spread to the Continent, although it had originally found some inspiration there, as we shall see later.

One feature that distinguishes the new style from all others is the habit of continuing the vertical line of tracery straight up through the head of the window to meet the curve of the arch.[1] This change in aesthetics is clear when we compare two

24 *Below left* Detail of the curvilinear tracery of the great west window at York, dating from 1338, sometimes known as 'The Heart of Yorkshire'. *York Minster*

25 *Below* The oldest surviving example of the Perpendicular style: the tracery of the south window of the transept, dating from *c.* 1335. *Gloucester Abbey, now the Cathedral*

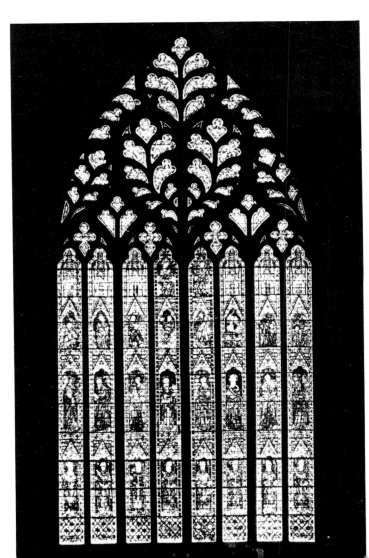

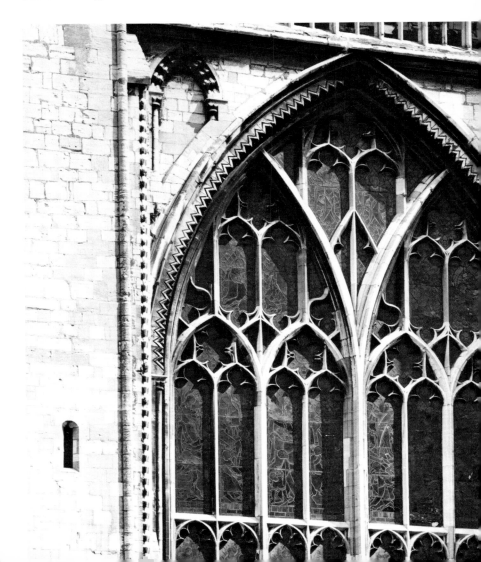

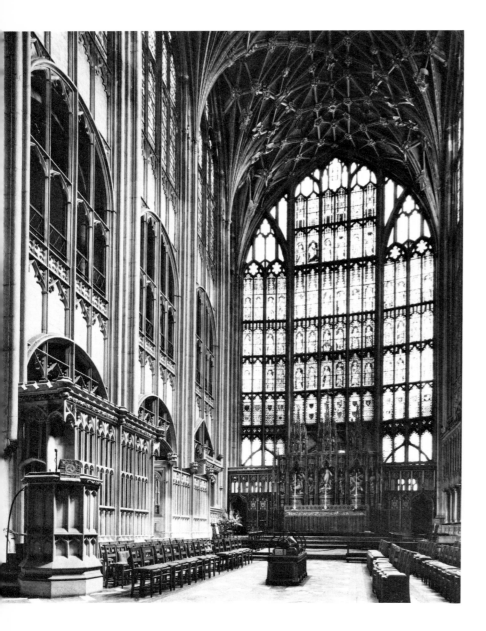

Typical, too, are the rows of tall, narrow panels inscribed with cusped-arch heads, repeated tier upon tier both in the window tracery and over blank wall surfaces, both internally and externally, to give a powerfully unified rectilinear effect. Although the vertical line is dominant, the horizontal has also achieved a new importance, particularly in the window tracery, with the introduction of horizontal stone members or transomes which gave greater rigidity to the huge window-walls now customary than did the far less conspicuous horizontal iron stiffeners used previously.[2]

The prosperity of Gloucester Abbey at this period, which permitted the lavish building programme of which these two examples formed part, was due to a particularly lurid episode in English history. In 1327 Edward II was murdered in a dungeon at Berkeley Castle. For fear of his adversary Queen Isabella and her accomplice Roger Mortimer, the abbots of nearby Bristol and Malmesbury refused to bury the king. The Chronicle of Gloucester Abbey relates how Abbot Thokey, moved by charity, fetched the putrefying corpse and bore it to Gloucester, where it was received with fitting pomp and ceremony and buried in the choir. The abbot's courageous act proved an unexpected godsend to the abbey. The course of events turned against the conspirators; the dead king's son achieved his independence and ruled as the great Edward III. His royal favour, bestowed on Gloucester as part of an effort to redeem his father's reputation, notorious for impropriety, placed ample funds at the disposal of the abbey, and after the remodelling of the south transept, attention was turned to the choir. Here, apart from the complete rebuilding of the east end and the construction of a high new clerestory, raising the height of the vault some twenty feet above that of the nave, the Norman structure was retained and its massive forms simply pared down and sheathed with Perpendicular panelling of extreme lightness and elegance, likened by one commentator to 'an amazing work of carpentry in stone'.[3] Most significantly, by effectively screening the aisles and tribune gallery, the panelling confines the eye within the choir, and gives the illusion of an aisleless chapel, achieving the spatial unity so sought after in Late Gothic.

Two of the hallmarks of the Gothic style, both as constructional device and symbol, are the pointed arch and the ribbed vault. The structurally-perfect vaulting system of transverse ribs and a groin vault, with two diagonal cross ribs under the groins dividing the surface into four triangular compartments, was developed early in the period. With their passion for logic and *clarté*, the French were content to remain faithful to this classically pure solution. Other nations, of a less rational turn of mind, proved less committed to a scrupulous expression of structure, for their interests lay elsewhere. The English had always shown a fondness for repetitive surface ornament and were quick to realise and exploit the decorative potentialities of additional rib members: for example, ridge-ribs which followed the longitudinal and transverse ridge lines; tiercerons or intermediate diagonals, which like the main ribs rose from the springer, but terminated at the ridge-rib; and short ties or liernes, used to create net- and star-shaped patterns of extraordinary intricacy. (See Glossary for explanatory diagram of vaulting terms.)

The vault over the remodelled choir at Gloucester, completed by 1367, illustrates to perfection both the English indifference to structural clarity and their accompanying decorative bent. Major structural elements such as the cross-ribs and even the

26 Interior of the choir (1337–67), looking towards the great east window. The second chantry screen on the left encloses the tomb of the murdered Edward II. *Gloucester Abbey, now the Cathedral*

windows, one at York Minster and one at Gloucester Cathedral. In the head of the great west window of the first, the rhythmic curvilinear tracery evokes the forms of foliage and a central heart; the mullions are all deflected from their vertical paths as they rise towards the arch. In the second, the oldest surviving example of the new style, the window inserted into the Norman fabric of the south transept of Gloucester Cathedral, *c.* 1335, several of the verticals are extended upward to meet the curve of the arch even though this creates a very awkward junction. There is a new rigidity of line, and a partiality for crystalline polygonal shapes. In this prototype the bifurcation of the central mullion distracts attention from the, as yet, tentative verticality, but in the great east window of the choir, constructed only a few years later and taking up an entire wall, the two major mullions defining the central bay continue to the head of the window with uncompromising directness. Refinements were to follow, but the essentials of the new style had been established.

transverse arches expressing the bay division are lost among the welter of tiercerons and liernes, which create an overall pattern resembling a close-meshed net knotted at the intersections. The bosses, a decorative feature often employed by English masons to mask the intersecting ribs, are of exceptional interest and beauty, particularly over the altar, where they take the form of a choir of angels bearing the Signs of the Passion or playing musical instruments.

Gloucester has a further major claim to architectural distinction in its honey-hued cloister, which boasts the oldest surviving example of fan vaulting. This quintessentially English form of vaulting developed in a uniquely English building-type – the polygonal chapter-house with a central pier from which the vaulting springs upward and outward, resembling the flaring trumpet of the arum lily or, more prosaically, a concave-sided filter funnel.[4] How this vaulting might be applied to a continuous corridor is demonstrated in the Gloucester cloister, *c.* 1370, where each abutting fan might be seen as half the conical section rising from the central pier of a chapter-house. The fan vaults, regular both in plan and section, with the ribs formed at equal angles, describe circles which touch tangentially, leaving concave, lozenge-shaped gaps which are filled with tracery pattern. That such a high degree of fluency and harmony is obtained by this somewhat awkward and unlikely scheme is due to an important innovation. An examination of the vault will show not a system of lines, of angular intersections, as found in the Gloucester choir, but a system of cells arranged in a self-perpetuating pattern, where each cell swells in the upper section to encompass the springing of two further cells above. The impression is of curving flexible forms, based on a concept of organic growth rather than a measured grid, a scheme that necessarily could only be developed in the relative freedom of window areas, where pattern rather than function pertained. This in fact was the logical conclusion to developments in the Perpendicular style, that window tracery, already applied to the walls, was now applied to the vaults, the interior finally acquiring perfect homogeneity. At the same time, curvilinear elements are reasserted in a new and exciting application.

Fan vaulting represents an ordered simplification of the bewildering variety of the lierne vault. Repetitive by nature, it permitted a considerable degree of standardisation and mass-production of identical elements, and hence efficient and economical construction, while giving an impression of great richness.

The Gloucester cloister achieves added interest through its power to evoke the religious life of the period. In the monastery, no less than in other walks of life, we witness an increasing concern with comfort and convenience. Earlier, the tracery of the cloister had been left open; here the openings are glazed, and in the scriptorium, which at Gloucester is situated in the southern walk, each bay was subdivided to create two cubicles or carrels, each with its own tiny, two-light window. In the northern walk, conveniently near the now vanished refectory, the communal *lavatorium* extends into the cloister garth. On the continuous wall-shelf a lead cistern originally discharged water into the stone channel, and the wall recess opposite was probably used for towels.

In effect, all the intrinsic features of Perpendicular architecture are to be found at Gloucester. Previously the component parts of an elevation, piers, shafts, capitals and ribs had retained their structural roles in visual terms, and were essentially plastic in their expression. From Gloucester

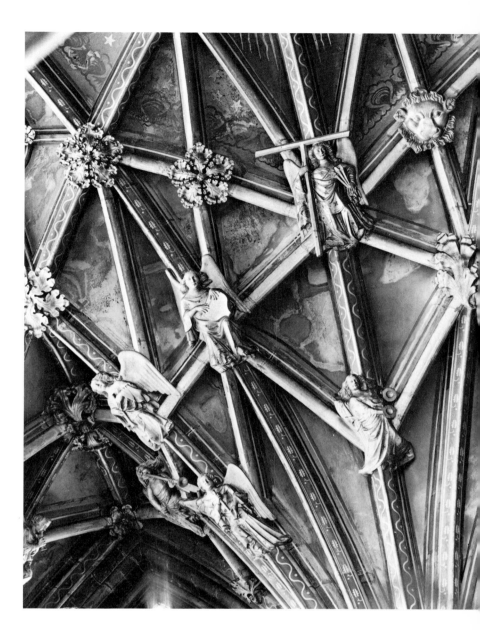

27 Detail of the intricate lierne vaulting over the altar, with its elaborate angel bosses. *Gloucester Abbey, now the Cathedral*

onwards, under the impulse of a new aesthetic, these were superseded by the two-dimensional patterns of tracery. In the type of window tracery introduced there we find the features pushing out of the constraining window frame and spreading over the surrounding mural surfaces in the form of blind tracery panels. Even more distinctive is the role of the mullions which knit together the various levels in the elevation, running on below the window sill to include the wall beneath, much as they rise in the east window as though to pierce the enclosing arch. The overriding impression with this development is one of unification; the entire wall is expressed as a screen of tracery, which significantly endows whatever it adorns with a new spatial unity.

The 'west-country' masons, justly celebrated for their skill and originality in vault construction, undoubtedly played a decisive role in the evolution of the splendid lierne and fan vaults of Gloucester. In the absence of surviving examples elsewhere, they were also credited by nineteenth-century historians with no less than the invention of the Perpendicular

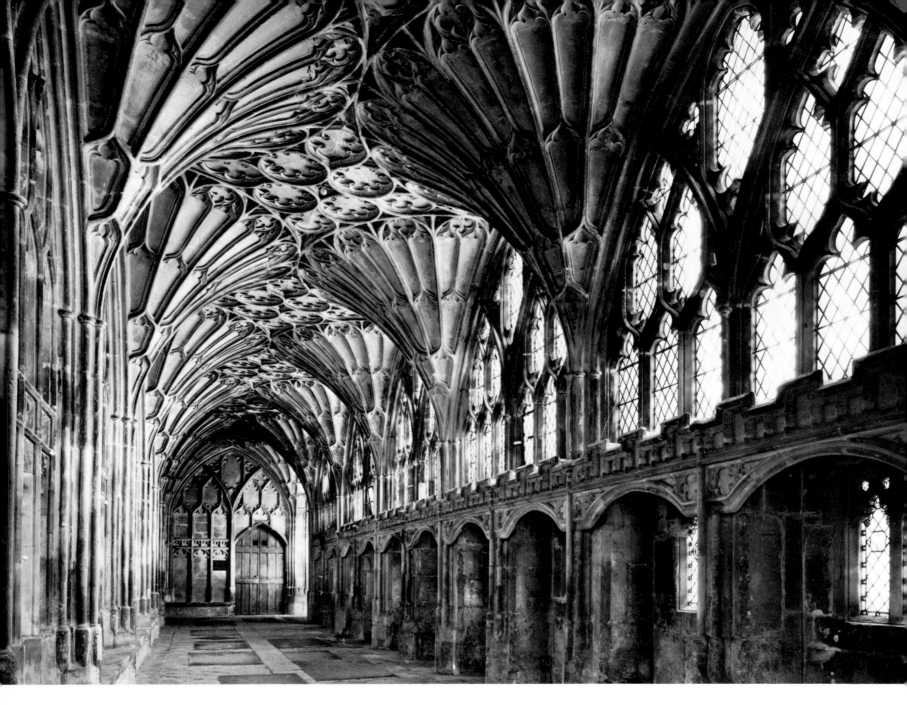

28 *Above* South walk of the cloister, commenced *c.* 1370, showing the carrels of the scriptorium. *Gloucester Abbey, now the Cathedral*

29 *Right* Detail of the *lavatorium* where the monks washed their hands before entering the adjoining refectory. *Gloucester Abbey, now the Cathedral*

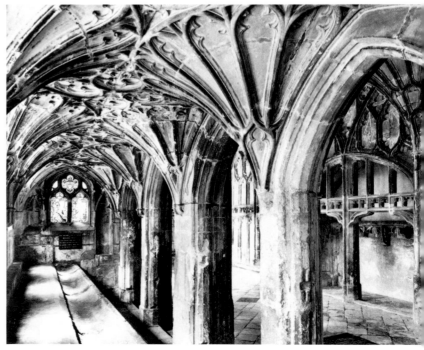

style. However, subsequent research has revealed the genesis of the style in slightly earlier work in London where, by one of the vagaries of fortune, hardly any major building survives from the hundred years before Richard II's reign. Two important monuments are, however, known through drawings and surviving fragments, the Royal Chapel of St Stephen in the Palace of Westminster and the chapter-house and double-storied cloister at Old St Paul's, both associated with a London mason who hailed from Norwich, one William Ramsey.

Ramsey's work at St Paul's can be accurately dated. In June 1332 the Dean and Chapter formally deeded the land for the new cloister, while the Bishop granted an indulgence of forty days to all persons assisting in the worthy project. Work must have started almost immediately, for only a month later 'William de Ramseye' is recorded as being granted exemption from jury-service on the grounds that his duties as master in

charge of the new works at St Paul's demanded his undivided attention. By 1335 this was apparently no longer necessary, for we find Ramsey serving on a commission surveying the Tower of London, and in 1336 he was appointed the King's mason and chief surveyor. As such, Ramsey was also in charge of the final stage of construction of St Stephen's Chapel at Westminster Palace between 1341 and 1348.[5]

It would seem that the key monument in the development of the Perpendicular style was Ramsey's work at St Paul's, the appearance of which is known from an excellent engraving published in 1658, only a few years before the Great Fire of London. Although the predominant character is still 'Decorated', several features herald the new style, notably the tracery of the upper cloister and of the great chapter-house windows with their crystalline polygonal forms, and also the mullions continued down as panelling over the wall surface below. Significant, too, is the treatment of the spandrel over the doorway below. This framing of an arched head within a rectangle, with the spandrels decorated with tall, narrow traceried panels, also occurred at St Stephen's with the insistence of a *leitmotif*. Used in conjunction with the four-centred arch, this would constitute one of the most characteristic features of the mature Perpendicular and Tudor styles. This rectangular framing of arches can, curiously enough, be shown to derive from French practice[6] – as paradoxical as that the origin of the French *style flamboyant* can, as we shall see, be traced back to the English 'Decorated' style! Of greater importance than the evidence of familiarity with advanced contemporary French practice in William Ramsey's work is the highly original interpretation he gave to the borrowed elements that justify his being considered, from the evidence of St Paul's, an important figure in the genesis of the Perpendicular style. The first application of the new style on a truly monumental scale appears to have been at Gloucester. In the second half of the fourteenth century the Perpendicular style came of age in the work of the two greatest masters of the day: Henry Yevele and William Wynford.

In the case of Henry Yevele, born shortly after 1320, references in contemporary records reveal a man of many parts: artist, contractor, *entrepreneur*, civil servant and real-estate speculator. His brother, Robert, was also a mason, and a family association with the mason's craft seems likely. So does an association with the Midlands, since London was full of masons with northern names after the Black Death, which had taken a less heavy toll there than in the capital.[7] Yevele was admitted to the freedom of the City of London in 1353, where he must have made a very favourable impression, for barely two years later he was one of six masons on the commission appointed 'to inform the mayor and aldermen concerning the Acts and Articles of the craft'. By 1357 he was in the employ of the Black Prince, at the manor of Kennington, for which the prince's receiver-general made the final payment to 'Henry de Yevele, the prince's mason' in 1359. By the following year

Yevele was working for the Crown and is described in an account for the Royal Works dated 20 August 1360 as '*Devisour de la maceonerie de noz oeveraignes*' (deviser of masonry, i.e. architect, of our works). He would retain the title for the rest of his life, and was still engaged on work on the Great Hall at the Palace of Westminster in 1399–1400, at an age probably not far short of eighty. In February 1400 he and his second wife were granted licence to hear divine service in their private chapel; in May he made his will, and died on 21 August that year. He left all his property, which included two manors and a considerable number of tenements, loading quays, mills and a brewery in London, to his second wife, with the stipulation that she maintain two chaplains in Yevele's parish church of St Magnus near London Bridge, where he had built a tomb for himself, to pray *inter alia* for the souls of his deceased first wife, his parents, brothers and sisters, and King Edward III.

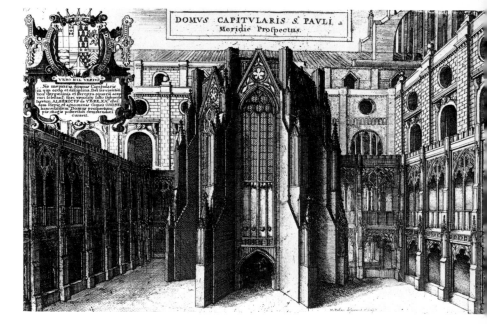

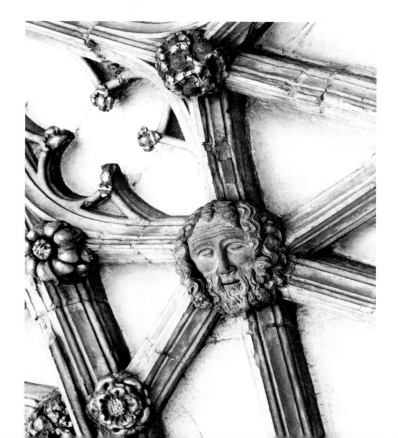

30 *Above right* Engraving by Wenceslaus Hollar of the chapter-house of Old St Paul's which clearly shows Perpendicular tracery and panelling begun as early as 1332 under the direction of William Ramsey. From Dugdale's *History of St Paul's Cathedral in London*, published in 1658 shortly before the Great Fire.

31 *Right* Head of a man, possibly Master Henry Yevele in old age, from a boss decorating the vault of the new cloister (1397–1414), completed by Yevele's partner, Stephen Lote. *Canterbury Cathedral*

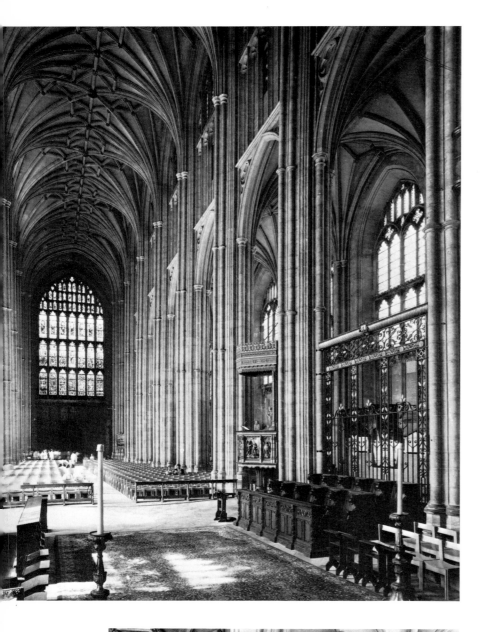

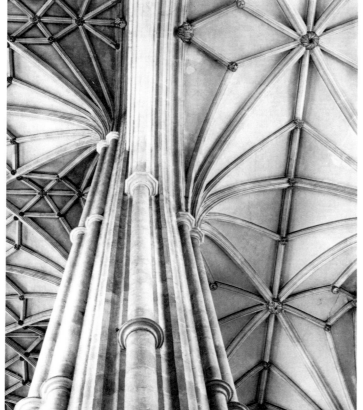

This is clearly the will of a wealthy man. That the office of king's mason in England towards the end of the Middle Ages had become that of a civil servant, with the status of a gentleman, is attested by a document in connection with the arrangements for the royal funeral of Queen Philippa in 1368, always an occasion for strict observance of precedence, in which Yevele is classified as an 'esquire of minor degree'. But far more indicative of his social acceptability is the large number of times he is recorded as having dined amid distinguished company at the 'high-table' of such notables as the worldly chancellor-prelate, William of Wykeham. Yevele had a shrewd business sense. He was constantly engaged in buying, selling and renting property, and had no sooner established contacts at Court than he applied for a special licence to furnish victuals at Calais. The official building accounts also often reveal him in the role of contractor, supplying large quantities of material, often imported, as in the case of Caen stone for Rochester Castle, or the 7000 Flanders tiles used to pave the courtyards at Westminster Palace or the 2000 painted tiles provided by his second wife, shortly before their marriage, for the king's bathroom at Shene Palace. In addition, Yevele and his partner, Stephen Lote, ran a thriving business as monumental masons, designing and executing tombs for the great before the event of their death. The tomb of Richard II and his queen, Anne of Bohemia, in Westminster Abbey, was contracted for £250, with an additional £20 bonus 'if the tomb pleases the king'–an enormous sum, particularly since it did not include the metal effigies, 'weepers' (mourning figures) or angels, ordered from two London coppersmiths.[8] Although there is no documentary evidence, the tomb of Edward III, Richard II's grandfather, is also presumed, on stylistic grounds, to be by Yevele, who is known to have designed the elaborate monument for John of Gaunt and his duchess in Old St Paul's, destroyed in the Great Fire of London, but known from drawings. The contract[9] in this case was for £486, which probably included the effigies.

The scope of Yevele's architecture was vast and varied: ecclesiastical, from cathedral to city chapel; civic, including several bridges; domestic, from palace and castle to manor and charter-house; and military, including city walls, towers and gateways. Apart from his duties as king's mason, Yevele also worked for members of the royal family, the nobility and the Church. His work at Old St Paul's is lost, but his new naves at Westminster Abbey and Canterbury Cathedral survive.

The four bays west of the crossing at Westminster Abbey had already been erected in the thirteenth century, and Yevele, continued the design which had already been established for the balance of the nave. Such is its compelling unity that only details, notably of the piers and mouldings, betray the passage of more than a century between old and new.

In contrast to this adaptability to the designs of others is

32 *Above left* View of the nave, rebuilt between 1379 and 1405 by Henry Yevele, one of the supreme triumphs of English Gothic. *Canterbury Cathedral*

33 *Left* Detail of a pier, looking up at the vaulting of the nave (left) and aisle (right). The rounded vaulting shafts, punctuated by ring mouldings and capitals, are complemented by the adjoining crisp-edged, vertical mouldings, running uninterruptedly from the pier base to the crown of the vault. *Canterbury Cathedral*

34 *Opposite* The finest west front in the Perpendicular style. *Beverley Minster*

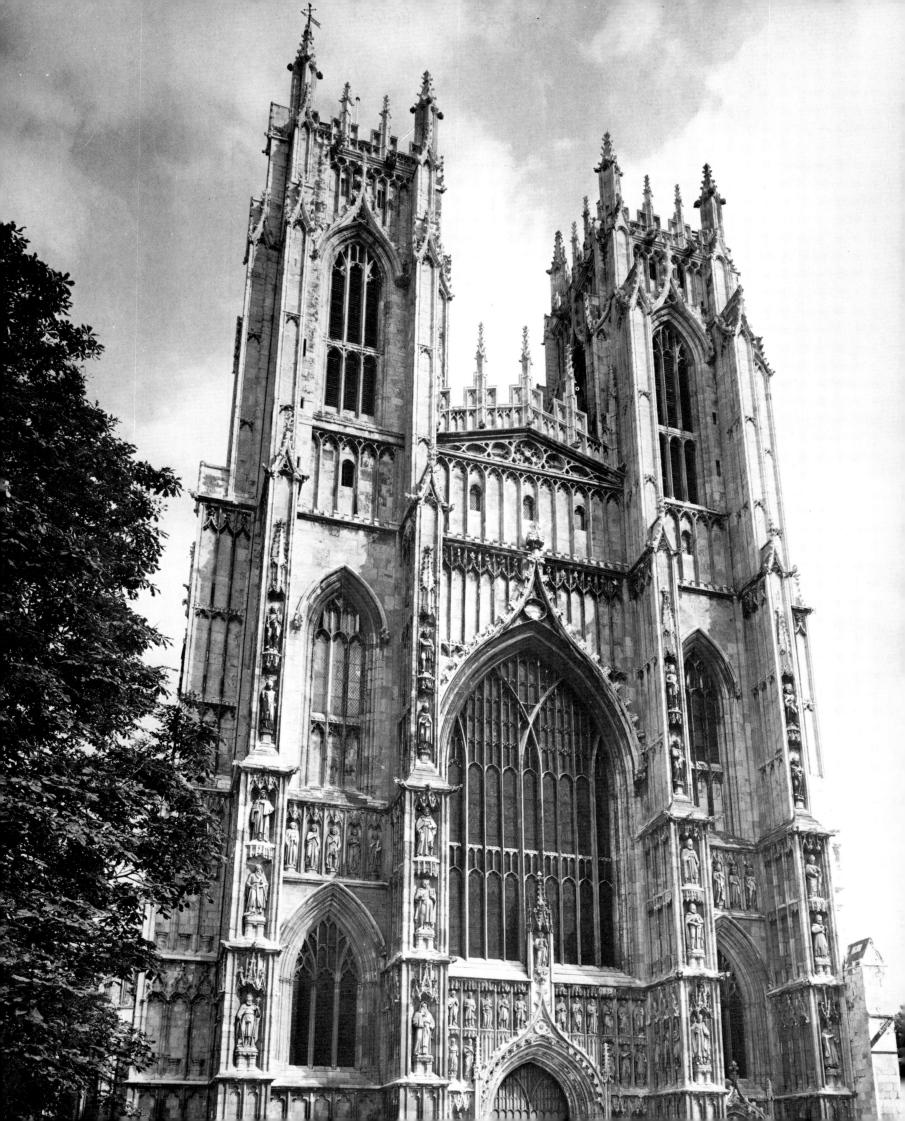

Yevele's brilliant and original conception at Canterbury. The building history of Canterbury Cathedral provides a classic example of English reluctance to break with the past completely. Although the choir had been rebuilt two centuries earlier, the venerable Norman nave built by Lanfranc, the aged Abbot of Caen, appointed to the archbishopric by William the Conqueror, was still unchanged; this despite the wealth that poured into the Cathedral coffers from all over Europe to honour the martyred Thomas à Becket, so that there could hardly have been a shortage of funds. By the beginning of our period the decrepit structure was in danger of collapse and a complete rebuilding of the nave was undertaken between 1379 and 1405.

Yevele's noble design is a work of supreme assurance, combining a courtly sophistication and elegance with the dignity befitting a metropolitan cathedral. At Gloucester the architect introduced spatial unity by screening off the aisles from the nave; at Canterbury Yevele achieved it by doing exactly the opposite: raising the nave arcade to a great height to provide the largest possible opening between nave and aisles and hence effect the maximum integration of their volumes. Such high arcades meant that the clerestory above no longer provided the main source of light to the nave. This function is now delegated to the huge aisle windows, which suffuse the entire interior with light, subtly reinforcing the symphonic unity and grandeur achieved by subordinating every detail to the whole. For example, the simple polygonal capitals and ring mouldings, which alternate with unbroken shafts in the piers, have no intrinsic interest and merely help the eye to explore the modulations of space.

Contemporary with the Canterbury nave but different in character is that at Winchester Cathedral. Here we have an extraordinary remodelling of a Romanesque nave into a Late-Gothic one. In some cases the masons actually carved into the robust Norman columns, seeming to reduce their bulk by transforming the component piers into a diagonally-placed square, with a succession of predominantly hollow, mass-negating mouldings contrasting with the heavy, almost crude, half-round shafts from which the lierne vaults seem to sprout like the branches of some enchanted bower. Throughout, the detailing has a pronounced plasticity and robustness, in striking contrast to the brittle elegance of both Gloucester and Canterbury. Although the clerestory window is proportionately far higher than at Canterbury, it is recessed far back from the plane of the nave arcade, and flanked by a panel of solid wall – a disguised vestige of the original structure. The result is that the window is inconspicuous, if not hidden, in the breathtaking view down the nave, the length of which is further stressed by the positive, longitudinal ridge-rib.

The designer of the Winchester nave was William Wynford. A slightly younger contemporary of Henry Yevele, he, like Yevele, worked for the Crown; more significantly, he was the favourite architect of one of the greatest patrons and most remarkable personalities of the period: William of Wykeham.

William of Wykeham was born at Wickham in Hampshire in 1324, the son of a villein according to some sources, at best the son of a poor yeoman. He must early have displayed exceptional talent, for he received an education in Winchester and was then appointed secretary to the Constable of Winchester Castle. Once his administrative gifts became apparent, his rise was meteoric: in 1356 he was one of the surveyors at Windsor Castle; in 1359 chief surveyor and

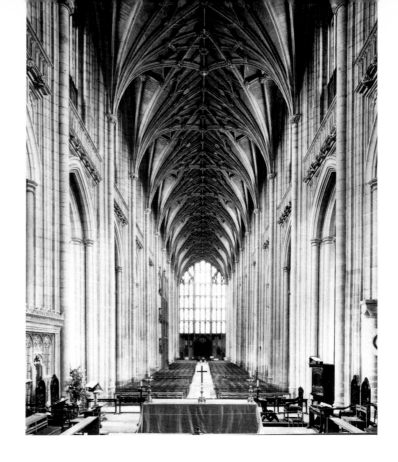

35 The nave of the longest extant medieval church in Europe, remodelled from Norman-Romanesque to Perpendicular-Gothic by William Wynford between 1394 and *c.* 1450. *Winchester Cathedral*

warder; in 1363 Keeper of the Privy Seal, and four years later Chancellor of England. By this time he had become Edward III's most trusted advisor, of whom the chronicler Froissart would comment, 'all things were done by him, and without him nothing was done'. In mid-career he entered the Church. Only ordained a priest by 1362, he was consecrated Bishop of Winchester in 1367. In the early seventies his career suffered a setback, in a clash with the faction led by John of Gaunt, son of Edward III. Found guilty of irregularities during his Chancellorship, he was deprived of his temporalities and ecclesiastic revenues in 1376, but pardoned by Edward III before the king's death the following year. As a member of the council appointed to advise the youthful Richard II, he served the new king's interests so well that when Richard became of age he appointed Wykeham Chancellor for the second time. Wykeham died, an honoured elder statesman, in 1404. A most able administrator, he is today best remembered for his initiative in education as the founder of Winchester College, England's oldest public school, and of New College, Oxford.

William Wynford's career is so closely intermeshed with that of Wykeham that the latter has often erroneously been quoted as the architect of the great projects with which he was associated. William Wynford is first heard of at Windsor Castle when Wykeham was superintendent of the works there, and from 1364 was also master-mason at Wells Cathedral where, by no coincidence, Wykeham had been appointed provost at the end of 1363. At Wells Wynford was paid an annual fee of £2, with a house at a nominal rent and 6d a day while in residence. He was responsible for the design of the upper stages of the two western towers, remarkably sympathetic and sensitive additions, that terminate the façade so effectively. His contribution – together with his patron – towards the planning of the public school and university college, is an achievement which will be discussed later.

40 William of Wykeham died at the advanced age of eighty, but his effigy represents him in the prime of life. The alabaster effigy which alone in the cathedral escaped mutilation in the Civil Wars, has retained much of its original polychromy. The full features, common to many contemporary images of the higher clergy, represent a striking change from the ascetic ideal of earlier periods, and provide a revealing, if unintentional, comment on the worldly tenor of the age. At the foot of the effigy sit three amusing little figures, probably of the great prelate's clerks or secretaries. Vividly characterised, they give the impression of portraits.

37 The tomb-chest with the effigy is enclosed within a cage-like structure of stone, equipped with an altar. Known as a chantry (from the French, *chanter*: to sing or chant), such chapels provided an ideal setting, intimate and secluded, for prayers and masses intoned on behalf of the soul of the founder. Such prayers were considered efficacious in shortening the expiatory period in Purgatory, a concept that acquired added weight in the Late Middle Ages. The rich could pay for the construction of a chantry chapel and provide, by means of an endowment, for the services of a chantry priest in perpetuity; those less well-to-do could secure virtually the same privileges on a group basis

36 *Below* Chantry chapel of William of Wykeham (†1404). The pedestals corbelled from the side panel over the door originally supported images that must have further emphasised the elegant verticality. *Winchester Cathedral*

37 *Below right* Tomb-chest and effigy of Bishop William of Wykeham within his chantry chapel. *Winchester Cathedral*

by joining a religious confraternity or guild which endowed a chapel or altar for its members. Although the practice of saying prayers for the souls of the deceased had been common throughout Europe for centuries, the building of chantries for this purpose, like that of William of Wykeham, was an English phenomenon; elsewhere, as we shall see, chapels might be built along the aisle walls. The universal Late-Gothic preoccupation with greater privacy and comfort, whether for the lord in his castle or the canons in the cathedral, manifested itself in the continual subdivisions of spaces. In England there was a notable proliferation of screens and chantry chapels. At the time of the Reformation there were more than two thousand chantries in England, with more than seventy in Old St Paul's alone[10].

William Wykeham's chantry is located in the nave, traditionally at the spot where, as a boy, he habitually stood to listen to the services. William Wynford's design is subtly integrated with the architecture; the plan is bow-shaped on both sides, so as to create sufficient space inside the chantry, yet not project beyond the nave piers, while the narrow, canted side panels echo the solid ones flanking the clerestory window above. The chantry, which has a closely-spaced screen below, affording protection and privacy, rises to the full height of the nave, where decorative ogee gables are superimposed on solid tracery panels. The intervening space, defined by two attenuated piers, is part of the whole concept. 36

Winchester Cathedral contains the finest surviving series of chantry chapels in England, including that of William of Wykeham's successor, Cardinal Beaufort (†1447). The Cardinal, an illegitimate son of John of Gaunt and Katharine

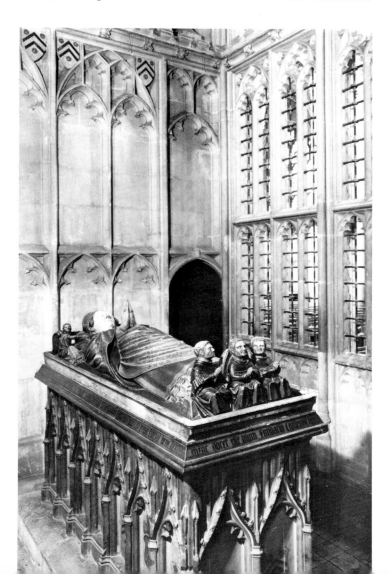

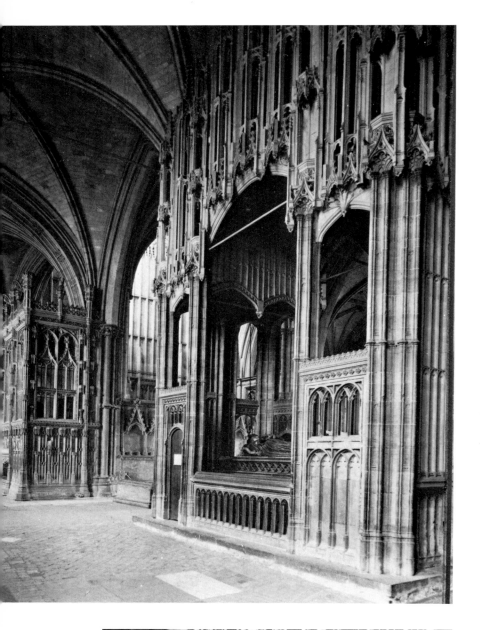

Swynford, a model of the worldly, courtier-statesman-prelate of the time, lies within an elaborate chantry in the retrochoir, beneath an ostentatious fan-vaulted canopy fairly bristling with pinnacles. The polychrome effigy in cardinal's robes provides a brilliant colour accent, but is a restoration of the mutilated original and does not bear close scrutiny. A bay distant is the chantry of Bishop Fox († 1528), designed by Thomas Bartu (or Berty), whose original scale drawing survives.[11] Of exquisite delicacy, the detail also displays the tendency of the period to a rather mechanical precision of execution. These chantries are fine examples of the most common type: a modestly-scaled, stone enclosure falling under the category of church furniture rather than architecture. The opposite extreme was to expand the chantry into a mortuary chapel, the two most representative examples being the Beauchamp Chapel at Warwick and Henry VII's Chapel at Westminster Abbey.

Richard Beauchamp, Earl of Warwick, Lieutenant and Governor-General of France and Normandy from 1437, died in the castle at Rouen in 1439. His body was conveyed to Warwick in accordance with his testament: 'I will that when it liketh to God, that my Soule depart out of this world, my body be enterred within the Church Collegiate of Our Lady in Warrwick, where I will that in such place as I have devised . . . there be made a Chappell of Our Lady, well, faire and goodly built, within the middle of which Chappell I will that my Tombe be made. . . . Alsoe I will that there be said every day, dureing the Worlde, in the aforesaid Chappell, three masses . . .' Directions for the performance of the masses then follow, with provision for an annual sum of £40 to cover their cost.

The foundation stone of the new chapel was laid in 1443 and building, tomb and furnishings were completed twenty-one years later, at a total cost of £2481 4s 7½d. The chapel, later enriched with other tombs and with the single discordant note of a Victorian reredos, has survived virtually complete. Spared excessive restoration, the Beauchamp Chapel evokes the spirit of the Late Middle Ages as few other places can.

The focal point, architecturally, is the east window with its fine tracery and unusually elaborate treatment of the mullions and jambs with figures of saints and the 'Nine Orders of the Hierarchy of Angels'. In the middle of the chapel, following the donor's directive, stands the tomb-chest of Purbeck marble with copper-gilt mourners – distinguished relatives of the deceased, identified by their coats-of-arms below – alternating with dumpy scroll-bearing angels. The robes falling in heavy folds, the downcast eyes and the grieving attitudes reflect the precedent set by the tombs of the Dukes of Burgundy, although these figures are not part of a funeral procession but constrained within their niches. The tomb-chest is covered with a heavy moulded plate of 'laten' (a copper alloy) on which lies the effigy of Warwick wearing a suit of Milanese armour of the finest quality and latest pattern, its every detail rendered with

38 *Above left* View of the retrochoir with the chantry of Cardinal Beaufort († 1447) and, in the distance, that of Bishop Fox († 1528). *Winchester Cathedral*

39 *Left* Demi-figure of an angel, a ubiquitous motif in late-medieval England, here bearing a heraldic shield decorated with the Wounds of Christ. Detail from the chantry chapel of Hugh Sugar († 1489). *Wells Cathedral*

40 *Opposite* Detail of the polychromed alabaster effigy (1399–1403) of William of Wykeham, with (*below*) a detail of the clerks or secretaries praying at his feet. *Winchester Cathedral*

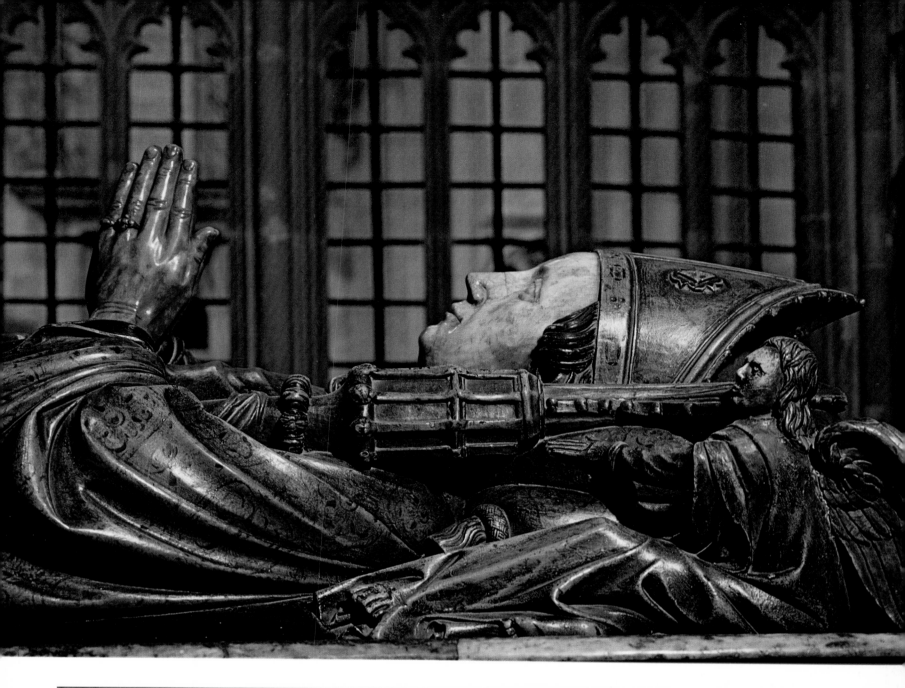

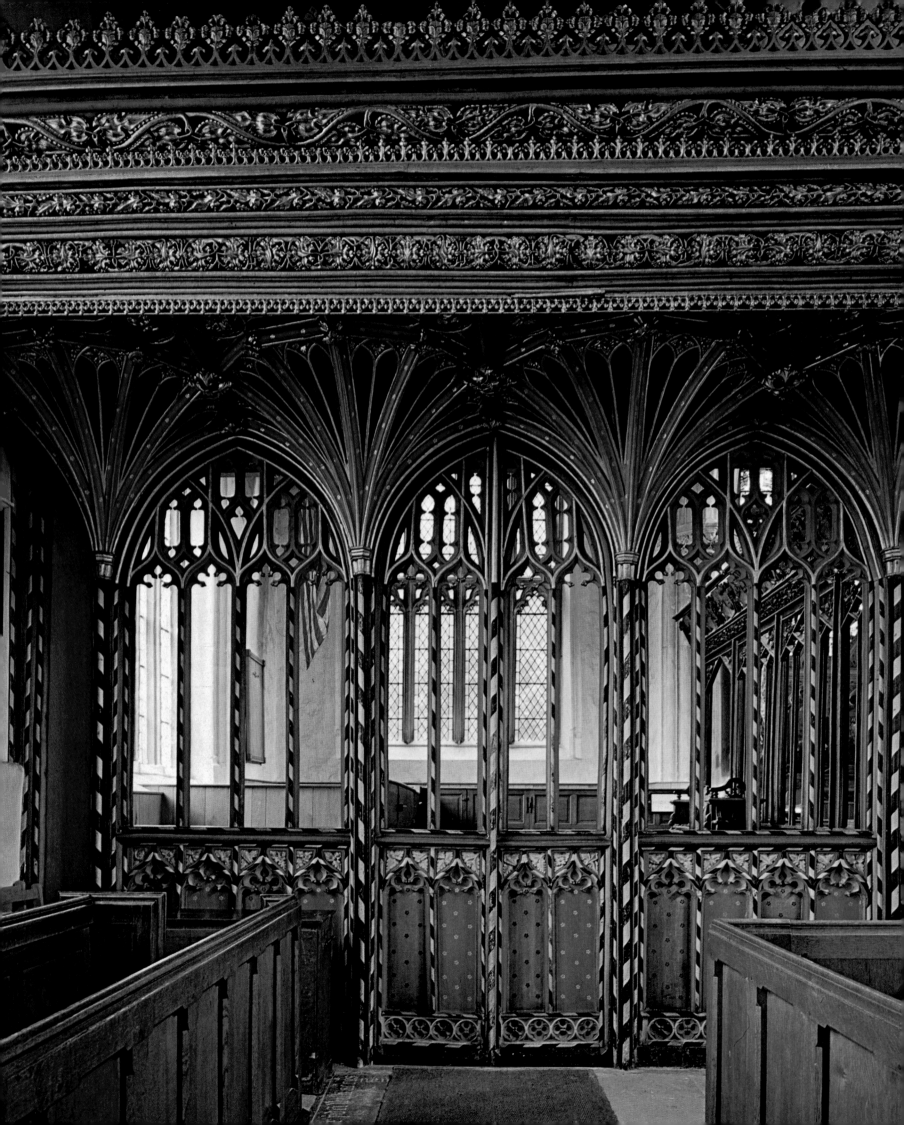

meticulous accuracy. The sensitively delineated head and hands show the same extreme concern for realism. A cylindrical herse (a metal framework to support a velvet pall on ceremonial occasions) encloses the effigy protectively.[12]

The Beauchamp tomb is a classic example of the ability of medieval craftsmen to collaborate on a work which presents no evidence of conflicting personalities, yet has none of the anonymity one associates with design by a committee. The actual design of the tomb would appear to be due to John Essex, a London 'marbler' who, however, contracted with John Bourde of Corfe to supply and carve the Purbeck marble tomb-chest. The 'weepers' or mourners were cast by William Austen of London according to 'patterns made of timber' – presumably by another artist – and completed by a goldsmith, 'Bartholomew Lambespringe, Dutchman', charged with polishing and gilding, and with making 'the visages and hands and all other bares of the said images, in most quick [i.e. lifelike] and fair wise'. Lambespringe was paid £40, excluding the cost of the gold, whereas Austen only received £21 6s 8d, from which we

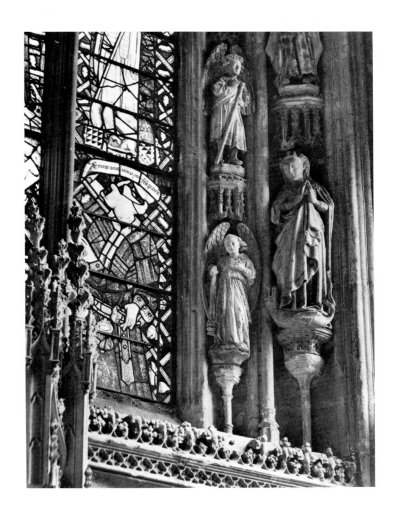

41 *Opposite* Part of chancel screen, *c.* 1450, with polychrome decoration, last renewed in 1849, following the original pattern. *Cullompton Parish Church, Devon*

42 *Right* Detail of the sculptured jamb of the east window of the Beauchamp Chapel, with figures of angels and St Margaret treading the dragon underfoot. *Collegiate Church of St Mary, Warwick*

43 *Below* Detail of the copper-gilt effigy on the tomb of Richard Beauchamp, Earl of Warwick, worked on in 1449–1450 by John Massingham and others. The over-arching metal framework or herse was intended to support a pall. *Collegiate Church of St Mary, Warwick*

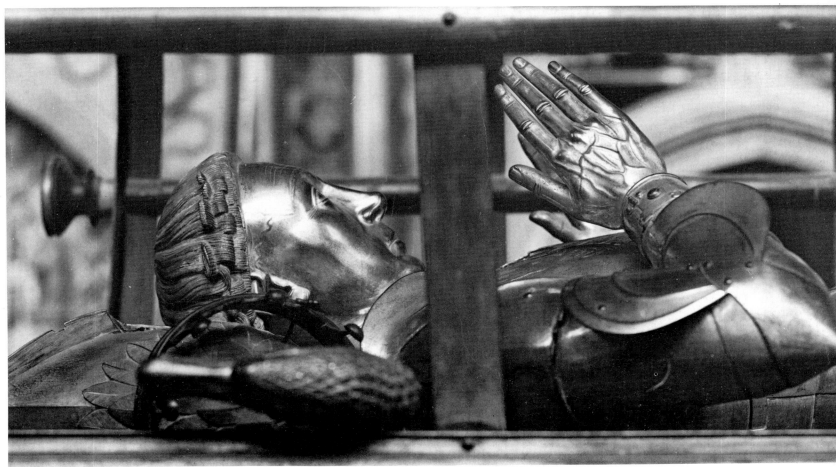

may conclude that Lambespringe was responsible for much of the fine detail, chased and engraved in the soft alloy. Austen, together with Thomas Stevyns, coppersmith, contracted to supply the laten support for the effigy and also the herse. And no less than four persons, and probably five, were responsible for the design and execution of the effigy. John Massingham, 'kerver', the leading sculptor of the day, was entrusted with making the wooden model, or 'pattern'; Roger Webbe, barber-surgeon, and possibly the physician of the deceased, already dead ten years by this time, was engaged, one presumes, to advise on the appearance of the Earl, or perhaps merely assist in achieving anatomical accuracy – certainly the distended veins on the temple and hands are accurate enough for an anatomical diagram; Austen was again responsible for the casting and Lambespringe for finishing, polishing and gilding. And just to complicate matters further, there is a cryptic entry of a payment of £8 to *'Clare pictori pro effigie picture'*, which seems to imply that a painter named Clare produced the original design.[13]

Impressive as the Beauchamp Chapel is, the most significant architectural legacy of our period is not any individual monument but the thousands of predominantly Perpendicular parish churches still in use today. Although there are a few notable exceptions, it would be true to say that until the fourteenth century the parish church tended to be relatively small and insignificant. From this time onward, and with added momentum in the fifteenth century, several factors coincided to transform its scale and character. Changed social conditions were placing more wealth in the hands of an evolving rural middle class, the yeomen, or freeholders, of modest but respectable standing, ranking between the country squires and the peasantry. This process was most marked in the areas devoted to raising sheep for the flourishing cloth trade, where the prosperous wool-stapler or merchant now made his appearance as a patron.

With the decline in the power and prestige of the monastic houses, the village church became ever more the focal point of rural life. It is symptomatic of this change of allegiance that the great Earl of Warwick should have chosen to add his splendid chantry chapel to his parish church, instead of erecting it in a cathedral or monastic church, as one presumes he had the means to do, had he so desired. For the less exalted, the parish church was the obvious choice for the family chantry, or for the altar or chantry endowed for its members by the religious confraternity or guild. The endowment of these chantries channelled wealth into the coffers of the parish church and helped to make possible ambitious schemes of renovation and rebuilding. Prosperous parishes could contribute most generously, and the geographic distribution of the splendid 'wool-churches' accurately reflects the districts that profited most from the cloth-trade. The required chantries were provided either within the existing structure or by adding new chapels, sometimes to a coordinated plan, more often piecemeal, in a typically English way.

Another major programmatic requirement was the provision of an ample space for the audiences of the sermons which were becoming an increasingly popular feature of late-medieval religious life. The movement stemmed originally from the order of Dominican friars, and it is consequently hardly surprising that the prototype for the late-medieval parish church should have been the friars' 'large and wyde chirchis' where a 'multitude of persoones mowe be recevyed togidere, for to here theryn prechingis to be mad in reyne daies'.[14] Specifically, it was the simple, rectangular, aisled hall with slender, widely-spaced piers and ample clerestory which accommodated the laity in the friars' churches that served as a model when rebuilding the nave of the parish church on a more ambitious scale. When a complete rebuilding was not possible, an acceptable compromise consisted in raising the roof to provide a more generous clerestory, to suffuse the interior with ample light even on 'reyne daies'. Many wills record bequests for this purpose.

The existing chancel was generally left untouched. In most cases it was already adequate for its function, but there was an additional reason for this anomaly. The care and maintenance of the chancel was traditionally the responsibility of the incumbent, and hence of the Church; that of the nave the responsibility of the parishioners. Over long periods the chancel generally enjoyed more constant care, while maintenance of the nave tended to be erratic: in bad times, or with indifferent parishioners, it might be neglected for so long as to require extensive repair or even rebuilding. This was particularly true of earlier periods. In the Late Middle Ages, by contrast, when the body of parishioners was increasingly prosperous and conscious of its duties and prerogatives, attention was directed to the nave. Many are the churches in which every part save the chancel was rebuilt on a more imposing scale.

The great parish church at Lavenham, wealthy centre of the wool trade in East Anglia, provides a good example. The modest height of the fourteenth-century chancel, partly compensated for by its steeply-pitched roof, consorts strangely, but rather effectively, with the crenellated parapets concealing the virtually flat roofs of the additions – tower, porch, nave and

46

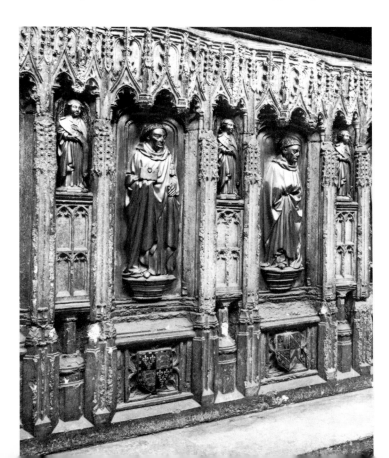

44 *Left* View of the Beauchamp Chapel, looking east, with the tomb of Richard Beauchamp, Earl of Warwick, at left centre. *Collegiate Church of St Mary, Warwick*

45 *Right* Detail of the Purbeck marble tomb-chest of Richard Beauchamp, Earl of Warwick, with copper-gilt figures of relatives of the deceased as 'weepers'. *Collegiate Church of St Mary, Warwick*

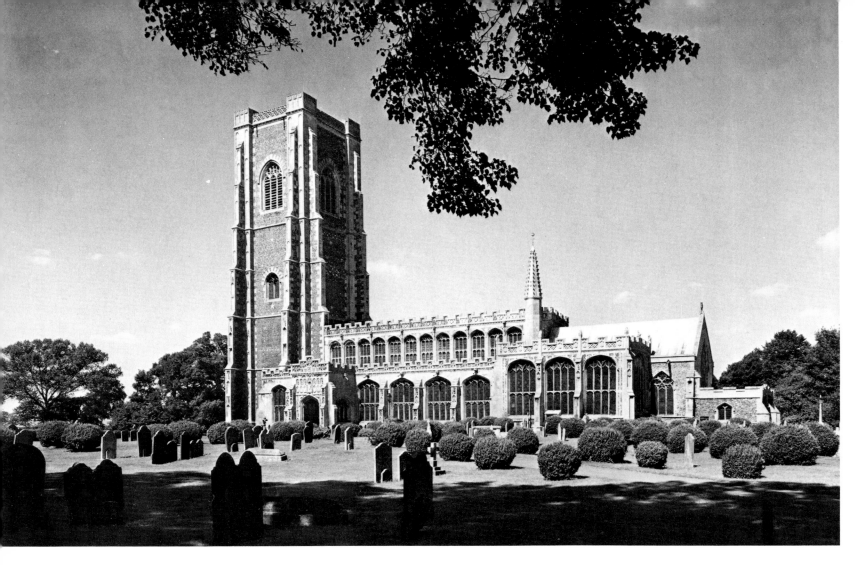
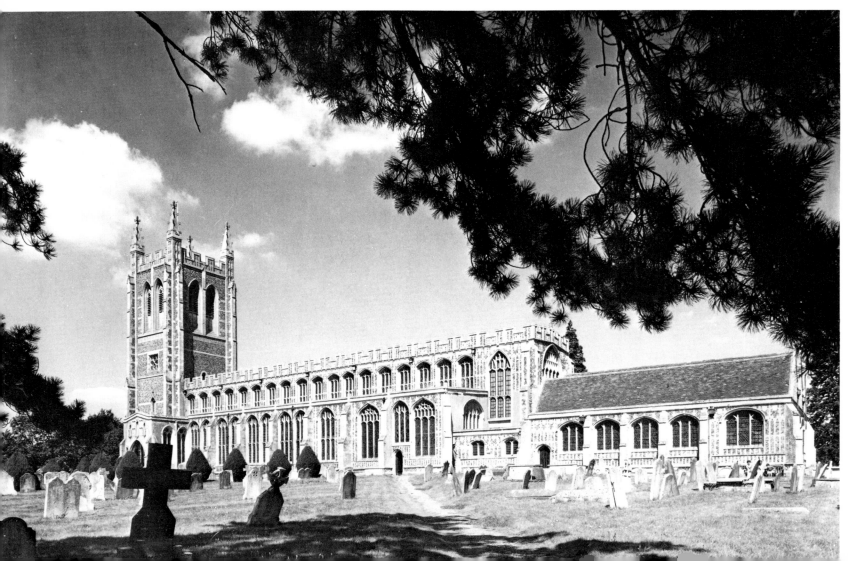

aisles, and lofty, early sixteenth-century chantry chapels which open into the chancel.

Lavenham church is not only exceptionally beautiful – Pugin went so far as to describe it as the finest example of Late Perpendicular – but its well-documented history provides a vivid picture of the changing patterns of patronage, and the corresponding results in architecture and decoration. The ambitious rebuilding programme was initiated in 1485 to celebrate the end of the Wars of the Roses by the lord of the manor, John de Vere, thirteenth Earl of Oxford, in conjunction with the rich clothiers of the town, notably the Spring family. Characteristic of the age, both major benefactors saw to it that their generosity was fittingly commemorated. The arms of the de Veres and their heraldic beast, a boar (a pun on the Latin: *verres*) feature prominently in the sculptured decoration of the exterior, while documents record no fewer than 102 heraldic crests associated with the family in the original stained-glass of the clerestory. Lacking a coat-of-arms, Thomas Spring II who

also contributed most generously, had to be content with his merchant's mark. His son Thomas Spring III, 'The Rich Clothier', owned property in no fewer than 130 places and bequeathed the very considerable sum of £200 to Lavenham to build a chantry chapel for himself and his wife and for 'the fynishing of the stepul'. Knighted shortly before his death, the newly-acquired crest is flaunted no fewer than thirty-two times on the parapet of the tower. Thus the secular interest and promotion of the works is ostentatiously established in the fabric of the church.

One of the most fascinating features of the English parish church is the wide variety of regional types, reflecting local conditions and available materials. In East Anglia, where good building stone was rare, much bulk construction was executed in flint-rubble often faced with split or knapped flint, which contrasted most effectively with the stone reserved for quoins and angles. Known as 'flushwork', this medium, like mosaic, permits extraordinarily rich effects without compromising the integrity of the wall surface. The medieval mason soon realised the decorative possibilities and developed a wide repertoire of designs, ranging from such architectural motifs as panelling and blank arcading to an extremely imaginative use of monograms, initials, and even quite lengthy inscriptions.

The tower of Lavenham, which for some reason never received its pinnacles, affords a splendid if sober example of flushwork. To see the heights of fantasy possible in this uniquely English medium, we need but journey the few miles to nearby Long Melford. The parish church here is roughly contemporary with and as beautiful as Lavenham. If the tower – a laudable reconstruction dating from the turn of this

46 *Opposite above* Man and nature in perfect harmony: the parish church on its spacious green. *Lavenham, Suffolk*

47 *Opposite below* Quintessentially English in its sprawling length and the way it hugs the ground, Long Melford parish church also shows what rich decorative effects were possible in the humble medium of 'flushwork'. *Long Melford, Suffolk*

48 *Below* Interior of the parish church (c. 1460–c. 1495), seen from the south aisle. The entire wall surface over the nave arcade has been unified by continuing the mullions and transoms of the clerestory windows down over the spandrel wall. *Long Melford, Suffolk*

47

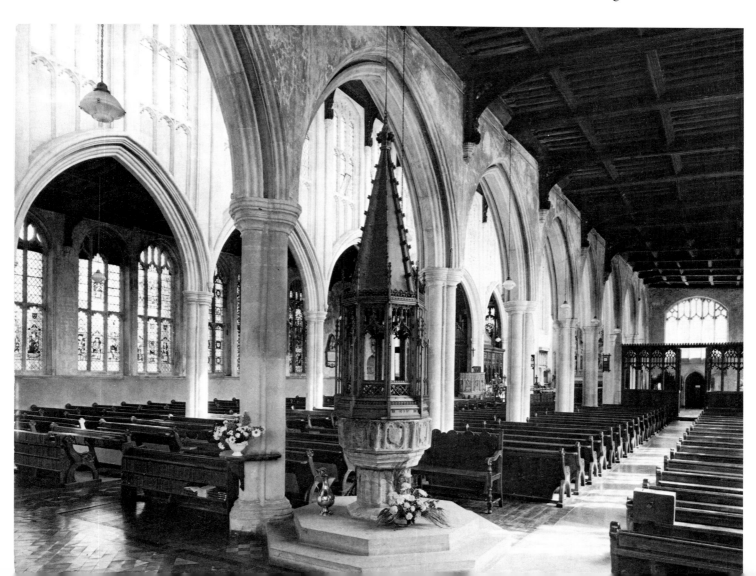

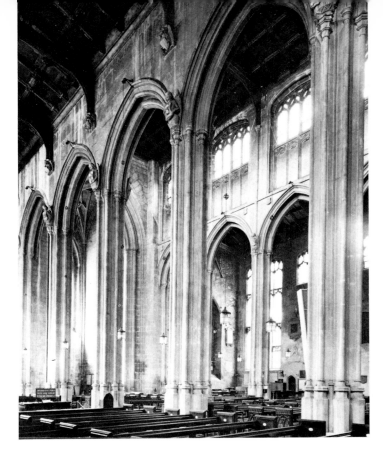

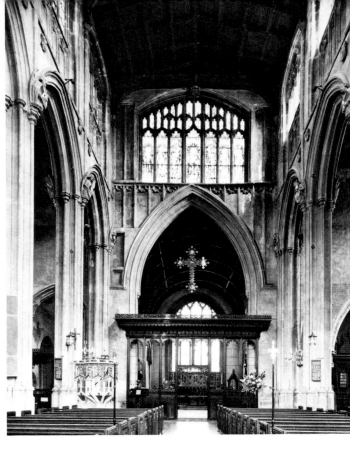

49 *Above* View of the early sixteenth-century nave, a classic example of Late-Gothic spatial unity. *Parish Church of St John the Baptist, Cirencester*

50 *Above right* The modern cross suspended over the chancel screen gives some indication of how effective must have been the Crucifixion groups that surmounted every rood-screen before the Civil War. The stone pulpit is a rare fifteenth-century example. *Parish Church of St John the Baptist, Cirencester*

century – cannot compare with that of Lavenham, the proportions and detailing of the longer nave are even more impressive, and the Lady Chapel unique. This eastern extension, loosely linked to the chancel by a low vestry, brings the total length of the building to no less than 250 feet.

In contrast to East Anglia, the Cotswold country, another very prosperous centre of the wool-trade, enjoyed a plentiful supply of excellent building stone and was renowned from the Romanesque period for the quality of its masonry. Of particular interest is Cirencester, the Roman *Corinium*. The Norman chancel of the parish church – incorporating a Roman column as if to underscore the continuity of history – although subsequently extended and many times remodelled, remains to this day. In the mid-thirteenth century the Norman nave was replaced by one in Early English style and a century later still the chancel arch was raised to its present height. Finally, between 1515 and 1530, the nave was rebuilt in its present form. The extremely high nave arcades with their sensitive mouldings and demi-figures of angels holding badges emblazoned with the arms or merchant's marks of the donors create an interior compelling in its spatial unity. Especially successful is the manner in which the disparity of scale between the lofty new nave and the low chancel has been turned from a liability to an asset and exploited to great effect with the insertion of a large east window over the chancel arch.[15]

The great western portals of French Gothic had never been popular in England. Even in cathedrals the most commonly used entrance was on the side. With the increasing concern for comfort in the Late Middle Ages a porch to shelter the entrance

of the parish church came to be viewed as a necessity rather than a luxury. In connection with this it should be borne in mind that many business dealings and contracts were commonly transacted by the church door. This included the marriage ceremony which, as we shall see, was considered a contract between the two parties rather than a sacrament in the Middle Ages.[16] The provision of a suitable porch also became a matter of civic pride. Porches were even added to humble churches, and existing porches, where deemed inadequate, or out-of-scale with alterations in the nave, were replaced by larger ones. A common solution was to make the porch a two-storeyed structure and provide a room above for the use of the priest or sacristan, or a place where a chantry priest could teach the choir boys – often stipulated as part of his duties. The use of the upper room as a schoolroom persisted even after the chantry priests vanished with the Reformation, and many a schoolmaster left a will requesting that he be buried in the porch 'at the foot of the stair that goeth up to my schole'. A spiral stair generally afforded access to the porch-room, which was often equipped with a fireplace and, in a few rare instances, even with a latrine.

The elaborate porch at Cirencester, with accommodation on three storeys, was apparently built to house the chief craft guild of the town, and included a hall for meetings and celebrations, a kitchen and cellar, and a room for the chantry priest who officiated in the chapel dedicated to the patron saint of the guild.[17] The architectural expression is certainly secular rather than religious in character, the dominant feature being not the entrance, but the ample oriel windows above, which call to mind the great mansions of the Tudor period. Just how completely secular is apparent when one compares the Cirencester porch with that at Northleach not far distant. Here the symbolic importance of the entrance to the House of God is paramount, and all else subordinated to the doorway, further dignified by an elegant ogee hood-mould that sweeps upward to form the pedestal for a canopied statue of the Virgin and Child, and above this a statue of the Trinity – both originals that somehow escaped the attention of the iconoclasts. Crowning

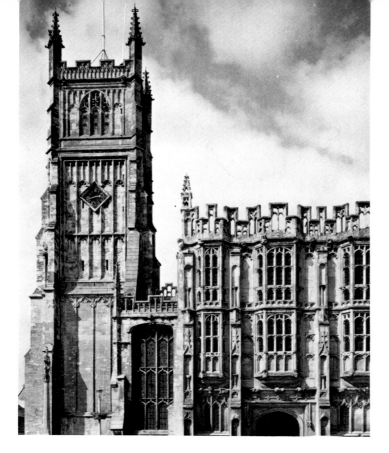

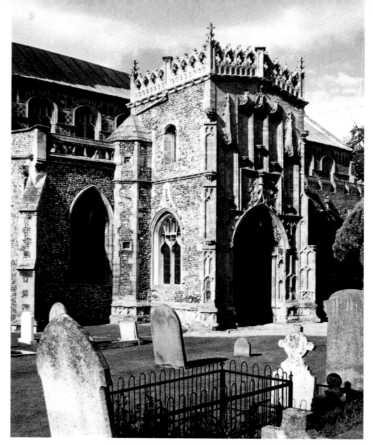

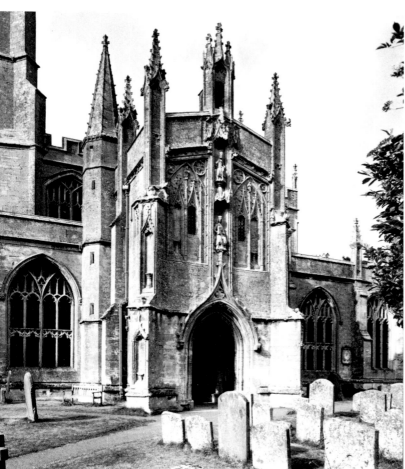

51 *Above left* The tower (1400–20) and the three-storeyed south porch, built *c.* 1480 as a guildhall, and later used as a town hall. The tower was financed by money given by a grateful Henry IV to the citizens, and may have been intended to have a spire. *Parish Church of St John the Baptist, Cirencester*

52 *Above* The porch of another East Anglian parish church. *Woolpit, Suffolk*

53 *Left* The small but highly symbolic porch (*c.* 1410) of a Cotswold 'wool-church'. *Northleach, Gloucestershire*

misplaced effort at conformity – served as the chimney for the fireplace.

With the destruction by bombing of the 300 foot spire of St Michael's at Coventry, St James at Louth reigns unchallenged among the most notable Perpendicular-style parish church towers. The three-stage tower was constructed during the second half of the fourteenth century by an unknown master. Particularly noteworthy is the treatment of the sloping sills and the deep-set windows, imparting a powerful sense of solidity and yet drawing the eye upward – a directional movement encouraged also by the progressive attenuation of the window openings. The spire rising to 295 feet was added between 1501 and 1515 at a cost of £305 7s 5d. Although the tower and spire are of approximately equal height, a top-heavy effect has been avoided by continuing the outline of the tower upward in the octagonal angle turrets which are linked to the spire by elegant flying buttresses, providing an extremely smooth and subtle transition from tower to spire.

Boston, a contraction of 'Bartolph's Town', was the second port of the kingdom at the beginning of the thirteenth century, and a prosperous associate of the Hanseatic League in the fourteenth century. Whether approached by sea or across the Fens, Boston's presence is proclaimed for a distance of thirty miles by its celebrated church tower, the so-called 'Boston Stump'. Commenced in 1309, the body of the parish church is in Decorated Gothic; the tower Perpendicular. The two lower stages as they stand date from the first half of the fifteenth century, terminate in a parapet, and were presumably intended

the composition is a bell-cote, flanked by corner pinnacles. The only indication of the porch-room above is a pair of narrow latticed openings discreetly incorporated within the blank arcading. An octagonal turret houses the stair, while the adjoining pinnacle – of stumpy appearance in old photographs, but recently extended to match the other pinnacles in a

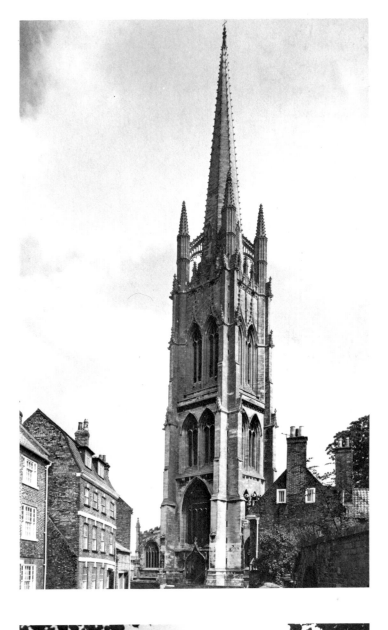

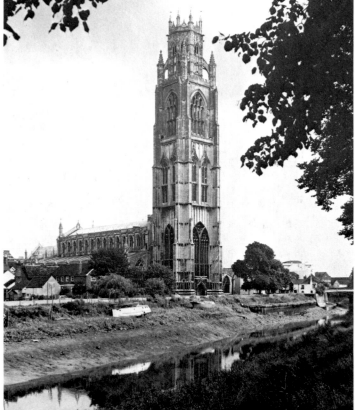

to take a spire as at Louth. However, the spire was not built and later there was a change of plan and a third stage was added. Here the detailing is coarse and the buttress design weak. Worse still, the excessive width of the single large opening on each face breaks the vertical *élan* established by the second stage. No doubt it was the unfortunate appearance of the three-stage composition – together with a touch of the megalomania that had seized tower-builders, particularly in those parts of Northern Europe with which Boston had such close mercantile ties—that prompted the erection in the first quarter of the sixteenth century of yet another stage. This is in the form of a recessed octagonal lantern, with the transition from the rectangular tower effected, as at nearby Louth, by high angle turrets and lacy flying buttresses. A brilliant *tour de force*, combining strength and elegance, the lantern not only distracts attention from, and minimizes, the defects of the weak third stage, but imparts a regal yet festive air to the entire composition with its ogee-capped openings and crowning tiara of jaunty pinnacles and pierced, stepped parapet.

Cornwall remained a Celtic enclave long after the rest of England had succumbed to Saxon and Norman influence and, as in Brittany, the suppressed Celtic heritage periodically manifests itself in the most surprising and vivid fashion. A classic instance is the fascinating little church of St Mary Magdalen at Launceston, the chief town in Cornwall during the Middle Ages, which was built entirely of the tough local granite between 1511 and 1524. The donor Sir Henry Trecarrel had commenced the construction of a splendid mansion three miles from Launceston, but after the death of his infant son in 1511 he abandoned the yet unfinished house and lavished his wealth on the rebuilding of the parish church. The south porch, bearing the arms of Sir Henry and his wife, follows the standard double-storey treatment with a small room over the portal. The central canopied niche contains a statue of the Magdalen, flanked by very primitive but expressive reliefs of St George and the Dragon and St Martin and the Beggar, reduced to two major planes. The balance of the wall surface, here and on the adjoining nave bays, is panelled with such popular decorative motifs as the Tudor rose, thistle and pomegranate, interpreted in rhythmic overall pattern. We have here a remarkable reinterpretation of the naive figurative reliefs and sophisticated abstract interlace ornament that coexist so improbably on the celebrated Irish 'High Crosses'.[18] The exotic, rippling surface ornament covering every square inch of the exterior wall surface at Launceston has been combined with architectural elements which, apart from the curious buttresses with their

54 *Above left* The most beautiful of the Perpendicular spired towers. The delicate crockets on the spire enliven its outline, without compromising the purity of its form, while the angle buttresses provide a smooth transition with the tower below. *Church of St James, Louth*

55 *Left* The 'Boston Stump' with its fine octagonal lantern serving as a beacon to guide seamen to a once bustling port. *Church of St Botolph, Boston, Lincolnshire*

56 *Opposite* Crucifixion with Saints and the mourning Virgin and St John at the foot of the Cross. Flemish embroidery from about 1390, mounted on seventeenth-century brocade and used as a reredos in the crypt. *York Minster*

57 *Overleaf* The interior seen from the antechapel—a perfect union of structural logic and imagination. *King's College Chapel, Cambridge*

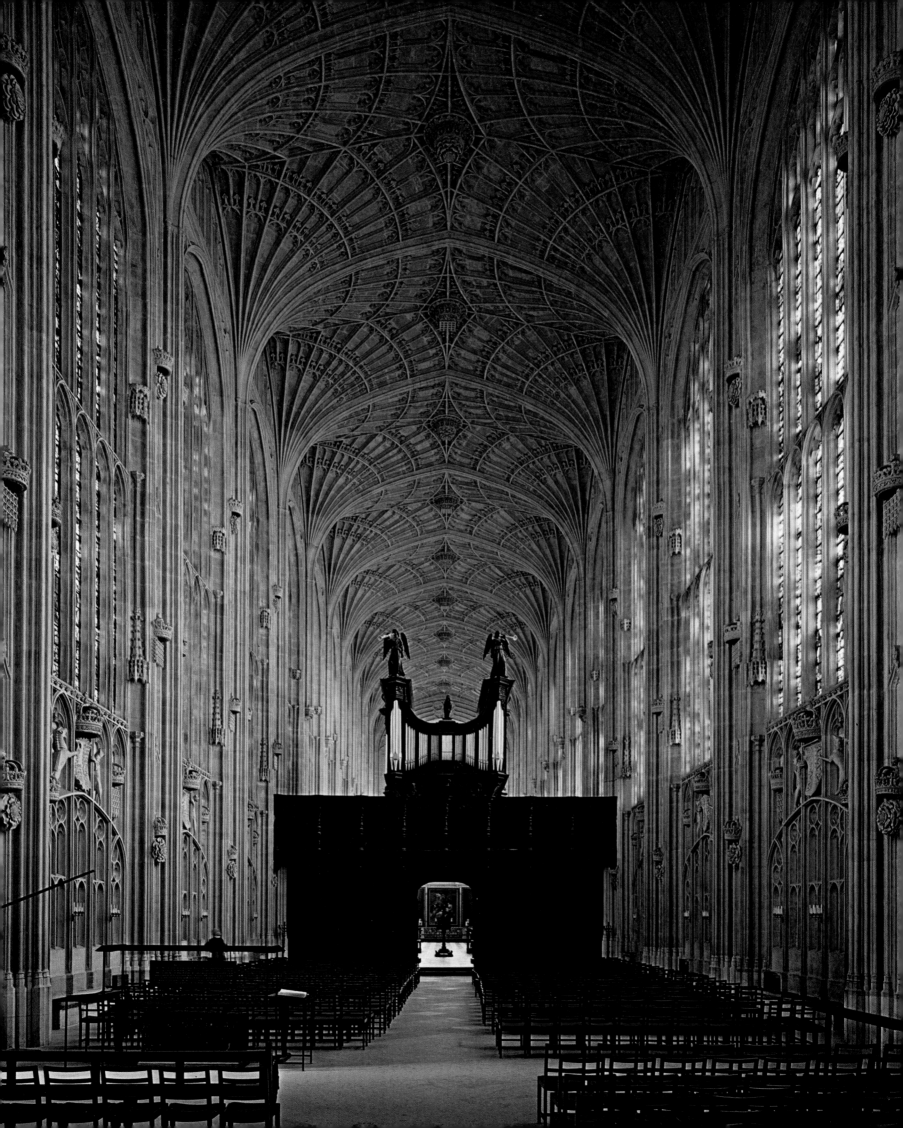

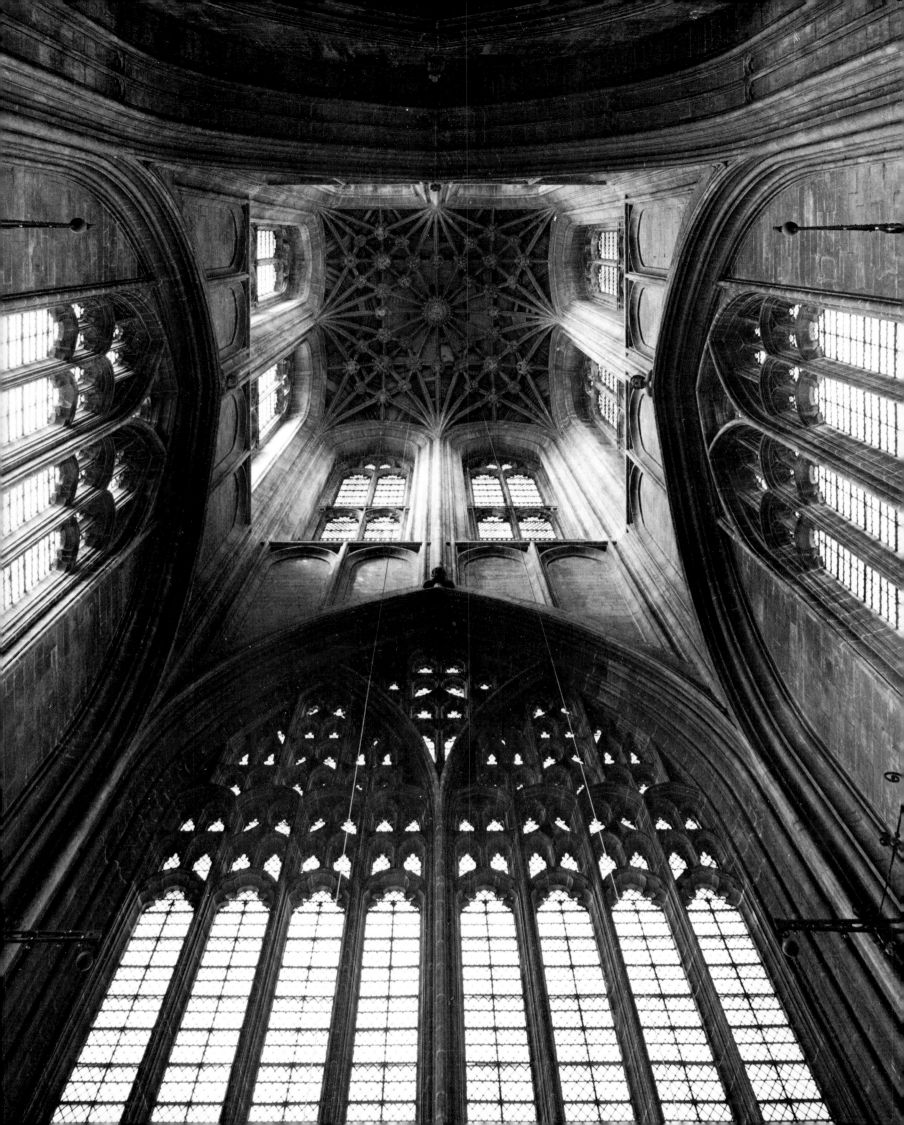

flaring pinnacles, conform closely to the Late-Perpendicular norm.

Devon derived great benefit from the wool boom, with a considerable quantity of woollen cloth exported through Exeter by the Merchant Venturer's Company, a modest fifteenth-century English equivalent of the German *Hansa*. At Tiverton John Greenway, the richest of the local wool-merchants, added a south porch and chantry chapel to the collegiate church, lavishly decorated with exceptionally lively and original reliefs, including depictions of contemporary 'galliasses', the heavy, armed merchantmen propelled by both sail and oar.

One important feature of the parish churches of Devon is their magnificent carved chancel screen. Hardly a church seems to have lacked one at the time of the Reformation. Most of the documented examples, of exquisite quality, were made by 'kyrvers' working in the villages. Decoration was concentrated on the coving supporting the boldly projecting cornice with its narrow bands of richly-carved, small-scale, repetitive plant motifs, the most striking being undulating trails of vine, treated in a wide variety of styles. The screen at Cullompton, dating from *c*. 1450, extends the full width of the church in eleven bays. Resplendent in gilt and glowing colour, the screen makes one realise how perpetually festive the medieval church interior must have looked.

Such chancel screens are but one example of the artistry of the medieval carpenter and wood-carver, whose work developed a new independence from masonry prototypes during the final phase of the Gothic era. Elaborate choir stalls for the clergy catered to their concern for increased comfort, privacy and

58 *Previous page* The dramatic interior treatment of the two lower stages of the tower, suffused with light and vaulted over at a height of 137 feet with an interlocking star pattern. *Church of St Botolph, Boston, Lincolnshire*

59 *Below* Cornwall's Celtic heritage is clearly evident in the exuberant ornamentation of the south porch, dated 1511. *Church of St Mary Magdalen, Launceston*

60 *Opposite top left* South porch and one bay of the chantry chapel built by the merchant John Greenway in 1517. The recently restored stepped parapets follow the design of the weathered originals. *Church of St Peter, Tiverton, Devon*

61 *Opposite top right* Detail of the chancel screen showing the treatment of the vault and the projecting cornice with its running-vine scroll ornament. *Plymtree Parish Church, Devon*

62 *Opposite bottom left* Detail of the choir stalls dating from *c*. 1370. The divider is decorated with 'babewyns', grotesque and often lewd carvings of baboon-like creatures. The central scene of the misericord on the left depicts the decapitation of St John the Baptist, while one of the supporters or 'ears' shows Salome presenting the head to her mother, Herodias. *Lincoln Cathedral*

63 *Opposite bottom right* Detail of the choir stalls with soaring canopies dating from *c*. 1380. *Chester Cathedral*

status. The oldest surviving series in England is at Winchester Cathedral, dating from *c*. 1305; the most splendid are those of Lincoln *c*. 1370 and of Chester some ten years later. Compared to Lincoln, the individual carvings at Chester are of rather uneven quality, but the overall effect of the choir-stall canopy with its markedly linear, architectural character is very striking.[19]

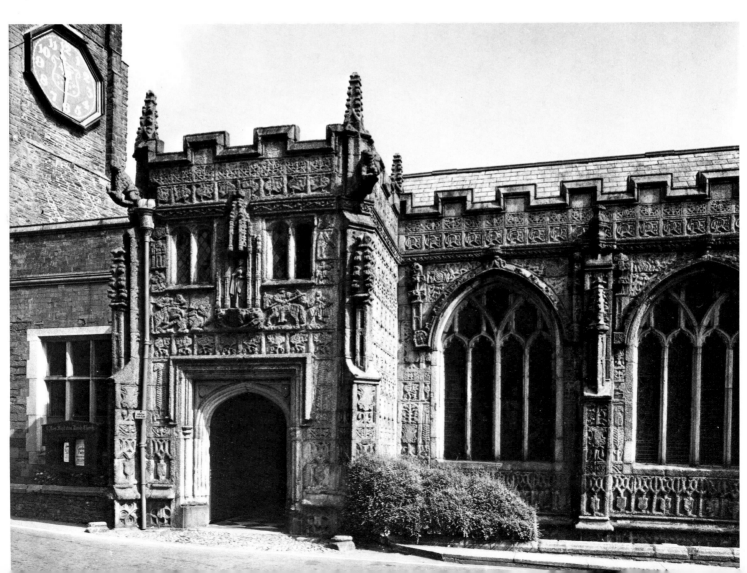

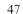

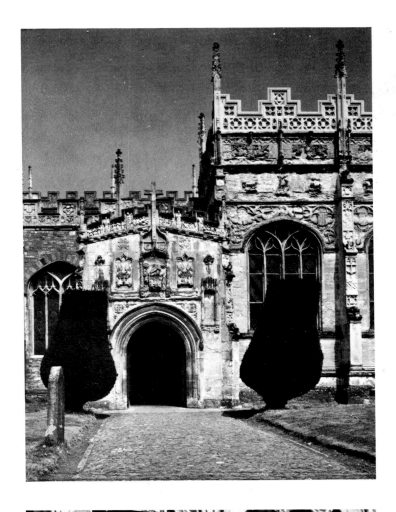

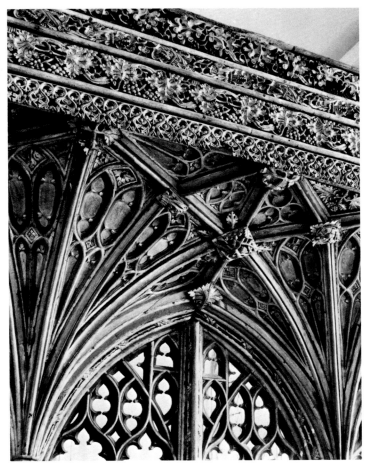

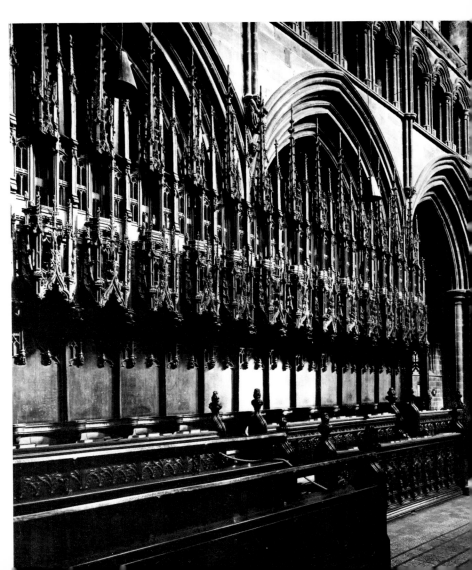

65 *Right* Illustration of the tale of the knight (drawn from the Bestiaries), who deludes a pursuing tigress with mirrors, making her think that her own reflection is the cub he has stolen. The intended moral is that the Devil distracts us from the truth with worldly vanities. Misericord dating from *c.* 1380. *Chester Cathedral*

66 *Below right* Bench-end depicting a fighting elephant, or 'elephant and castle'. *Chester Cathedral*

An extraordinary amount of time and talent was lavished on the decoration of the *misericord* (from the Latin for 'pity'), the projection under the hinged tip-up seat of the choir-stall, on which officiating clergy could prop themselves, while apparently standing, during the long services. Relatively free from the constraints imposed by iconographic programmes that

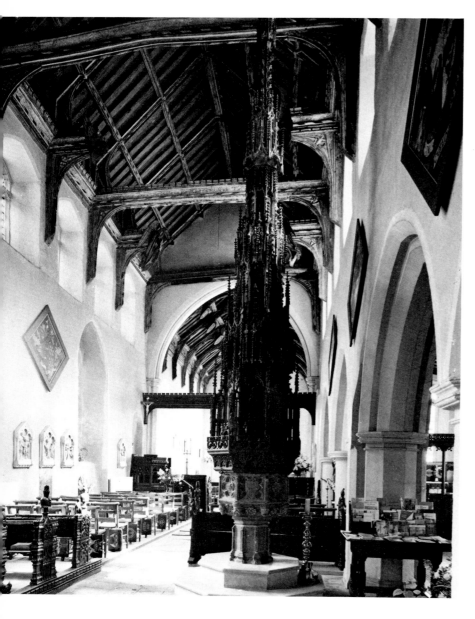

64 *Above* The finest suspended font-cover in England, ingeniously constructed so that the lower portion can be telescoped over the upper portion. The open roof has alternating tie-beams and false hammer-beams. *Ufford Parish Church, Suffolk*

determined both subject matter and treatment in important locations, the medieval carver could here give free rein to his imagination, provide social comment and indulge his keen and often ribald sense of humour. There is a wide range of subject matter based on classical myth and legend, and popular romances such as Tristan and Isolde; genre scenes such as the shrew beating her husband – no doubt a source of consolation to the celibate clergy; and figures and foliage carving of a purely decorative character. Religious subjects are surprisingly rare:[20] out of forty-eight misericords in Chester Cathedral, only five have religious themes, and one of these is a Victorian replacement of a medieval carving deemed 'most unseemly'. There are, however, many quasi-religious subjects drawn from bestiaries, those ever-popular compilations of animal lore, 65

66

fable and pseudo-science dating back to classical times, overlaid with Christian symbolism and frequently quoted in Christological writings which managed to find an image of the Saviour's life and death in the habits, real or imagined, of the animal kingdom. For example, the eagle which flew nearest to Heaven and was considered of all creatures the only one who dared to gaze straight into the sun, was the symbol of the Ascension and of St John the Evangelist who, in his vision of the Apocalypse, had looked upon the blinding light of the Throne of Heaven that eclipsed the very sun; while the owl was likened to the Jews who shut their eyes to the light of truth. The significance of many scenes would be lost on us were it not for the literary record.

Carved wooden baptismal-font covers of monumental scale were a speciality of East Anglia, the most splendid example being that in the parish church at Ufford in Suffolk. Rising to the rafters in tier upon tier of niches and pinnacled canopies of diminishing scale, its beauty apparently even impressed the Commonwealth iconoclast, William Dowsing, on his round of destruction in 1643. In his journal he writes of Ufford, 'there is a glorious cover over the font, like a Pope's triple crown, a pelican on the top picking its breast, all gilt over with gold'. Apparently this mystic symbol of the Passion and the Resurrection did not offend Dowsing's Puritan sensibilities[21] and he contented himself with the destruction of the figures of saints in the niches. The design is as practical as it is beautiful. When the font is needed, the lower portion of the suspended cover can be raised, sliding upward, telescope-fashion, over the upper section.

The greatest achievement of the English medieval carpenter was the construction of the spectacular open-timber roofs which have no counterpart on the Continent. In France even small churches were customarily vaulted in stone; in England they were almost invariably roofed in timber—vaults being reserved for the porch—and the parish churches, especially in East Anglia, present a rich assemblage of open-timber designs.[22]

The evolution of the open-timber roof culminated in the fourteenth century in the development of the 'hammer-beam' roof. The concept was probably suggested to the English designer by the customary framing of the awkward little triangle at the base of the trussed-rafter roof (figure II). If the horizontal member were extended into the space and its cantilevered end given additional support by an arched brace connected to the wall-piece resting on a corbel below, the so-called 'hammer-beam' thus formed could be used to support a stout vertical strut and stiffen the principal rafter above (figure III). The distance between these vertical struts became the effective span of the arched braces above, so that the total clear span, i.e. the distance between the inner faces of the wall below, could be increased considerably.[23]

The hammer-beam roof works aesthetically too. The trusses articulate and enliven, rather than obstruct the space, tempting the eye to explore the play of forms among the shadowy recesses—the oak now age-blackened and retaining little of the original colour and gilt—and rewarding the quest with fascinating architectural detail and figure-sculpture, notably the carved angels that commonly terminate the hammer-beams. Particularly satisfying is the rhythmic alternation of taut curve and straight line.

Numerous imaginative variations were devised, for example, trusses in which curved braces replace the vertical struts, those with an arched rib running in one proud sweep from wall-piece

English open-timber church roofs:
I Tie-beam roof in Trinity Chapel, Cirencester Parish Church
II Evolution of hammer-beam from triangle at base of trussed-rafter roof
III Hammer-beam roof in Trunch Parish Church, Norfolk

to collar above, and roofs with a combination of different types of truss, say hammer-beam and tie-beam alternating. Some enthusiastic designer, convinced that only more than enough was a feast, devised the 'double hammer-beam' in which a second tier of hammer-beams is superimposed upon the first. Lacking the cantilever action afforded by the wall thickness, the upper tier does not function efficiently and actually weakens rather than strengthens the structural system. Such criticism tends, however, to be stifled by the gorgeous spectacle, especially where the angelic population also has been allowed to proliferate. At St Wendreda at March, in the Isle of Ely, no less than one hundred and twenty angels fill every perch with wings outstretched as if poised for instant flight.

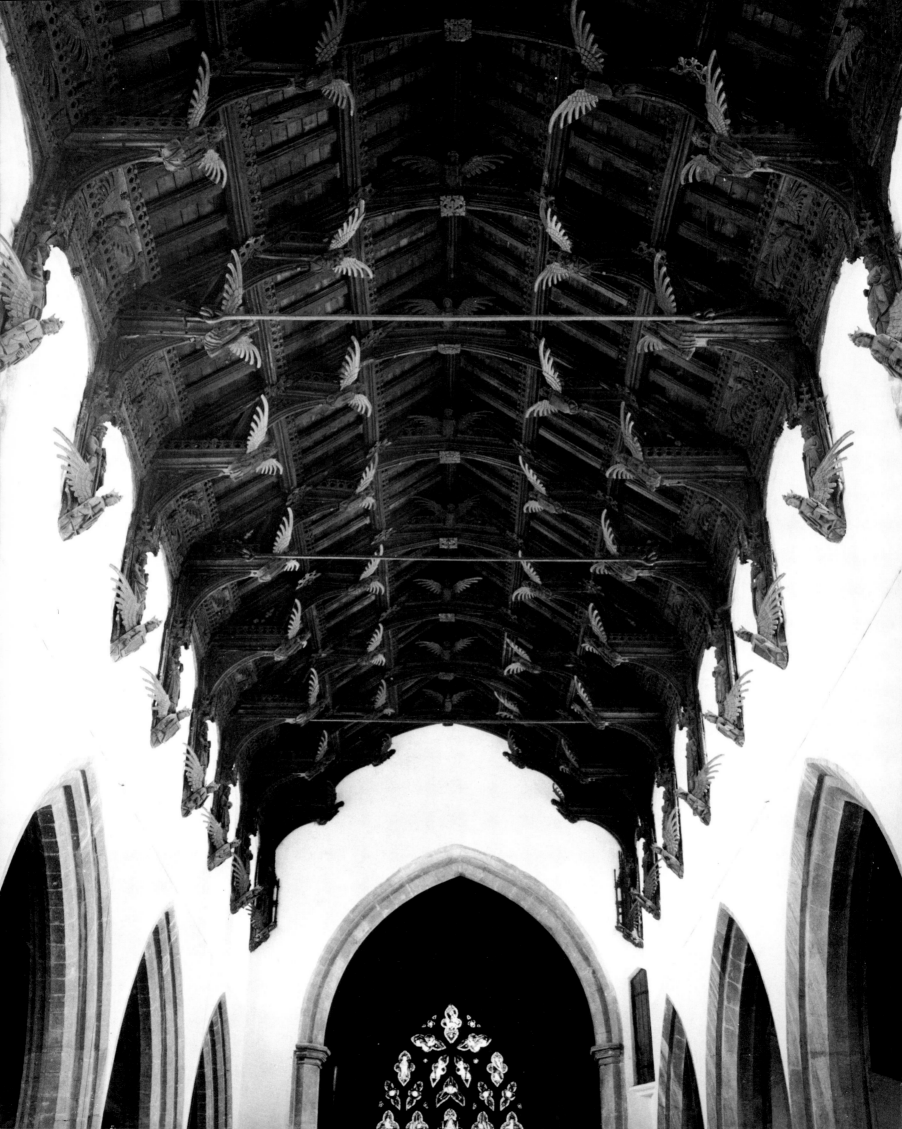

Even in the great cathedrals the English designer periodically
reverted to the wood construction for which he had such a
natural affinity, classic examples being the nave and chapter-
house of York Minster and the octagon at Ely. Neither of these
ecclesiastic examples can be said to reveal a distinctive timber
aesthetic, for wood was being used as a substitute for stone.[24]
For a true expression of the artistic potential of timber
construction on a monumental scale we must turn to secular
building, specifically to the solution of the problem of spanning
the considerable area of the great hall.

The largest and incomparably the finest specimen is Richard
II's Great Hall at the Palace of Westminster. Paradoxically,
with the single exception of the small and undistinguished
Pilgrim's Hall at Winchester, the Westminster Hall has the
oldest surviving hammer-beam roof, although the perfection of
form and technique clearly presupposes major lost antecedents.
The open-timber roof over the vast space, 238 feet by 68 feet –
almost half an acre – rises to a height of 90 feet and is
supported on hammer-beam trusses spaced, a little less than
20 feet apart on centre. With the span of 68 feet, no such
liberties could be taken with the structure as in the case of the
small span of the parish church. The dominant feature at
Westminster is the powerful arched rib springing from corbel to
collar, like the inverted hull of a ship – a fitting and probably not
entirely fortuitous resemblance for a nation of shipbuilders.
One of the basic principles of efficient hammer-beam con-
struction is to lower the point at which the weight and very
considerable thrust of the roof are transmitted to the side walls
and buttresses. At Westminster the curved struts supporting the
hammer-beams and the great arched ribs both spring from a

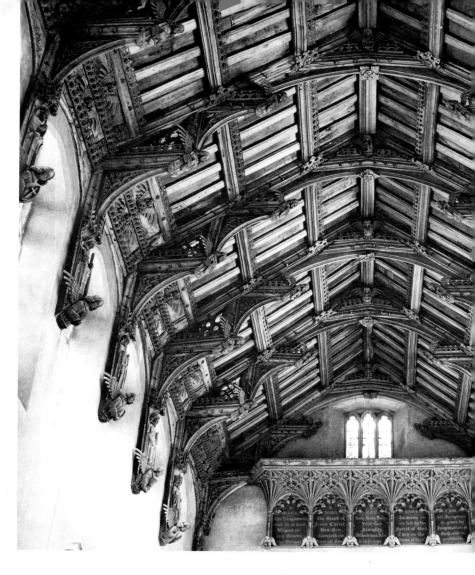

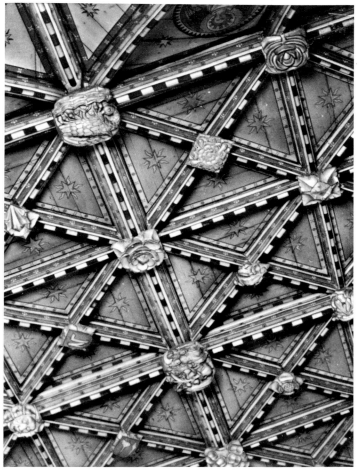

67 *Opposite* Double hammer-beam roof *c.* 1500, alive with the flutter of
angels' wings. *March Parish Church, Isle of Ely*

68 *Above* Detail of engraving of Westminster Hall showing the hammer-
beam roof; from Edward Brayley and John Britton, *The History of the
Ancient Palace and Late Houses of Parliament at Westminster*, 1836.

69 *Above right* A parish church with a double hammer-beam roof. The five
bays of exquisite lierne vaulting, supporting coving and mounted high over
the chancel arch, were probably salvaged from the destroyed rood-screen.
Woolpit, Suffolk

70 *Right* Detail of the boarded ceiling over the presbytery *c.* 1400, enriched
with bosses, no two alike, and preserving the original painted decoration.
Peterborough Cathedral

point no less than half-way down the wall, so that the window openings are integrated within the roof construction, as it were, a device as visually satisfying as it is structurally sound. The decoration, too, is appropriately architectonic for the monumental scale. The repetitive tracery infilling is discreetly subordinated to the strong structural forms, while the angel figures with their horizontal thrust seem not to be applied to the ends of the hammer-beams, but to grow organically from them, the mouldings transmuting to drapery and wing in a subtle metamorphosis.

Not only the name of the designer – one Hugh Herland,[25] member of a dynasty of master-carpenters – but many details of his life and career are known. He is first heard of in 1360 when he and William Herland, the 'King's Carpenter' and probably his father, were instructed to 'impress' carpenters for the royal works at Westminster Palace and the Tower of London.[26] Hugh had undoubtedly entered the king's service considerably earlier, for in 1366 he was given an annual allowance of 10 marks (£6 13s 4d) for life, and the use of a small house in the outer ward of the palace to store his tools and moulds. On the death of William Herland in 1375, Hugh succeeded to the position of 'disposer of the king's works touching the art or mistery of carpentry', with 12d a day and a fur-trimmed robe as worn by 'Esquires of the Household'. Eight years later, already 'verging on old age', he relinquished the appointment and received a generous pension.

The greatest triumphs of his career were, however, yet to come. When exactly Hugh Herland first met the great William of Wykeham is not known, but he was probably responsible for the design of the timber roofs at New College, Oxford, around 1384, and an amusing entry records payment for a professional visit to Wykeham's manor house at Highclere: 6d a day for the four days spent there and 10d for 6 lbs of oats for the horse of 'Master Hugh Harlond coming for divers turns'. During 1388 and 1389 Herland visited New College several times, and on 25 March 1389 the bursar's account notes that Herland, William of Wynford and Henry Yevele dined at the high table. What would we not give for a record by some Northern Vasari of the conversation and views on architecture of the three most celebrated English architects of this most creative period! Around this time all three were consulted and gave a joint recommendation for repairs to Winchester Castle, while Herland and Yevele collaborated at Canterbury Castle. In 1393 Richard II and his queen twice visited William of Wykeham at Winchester, and it has been suggested that the king was probably so impressed by the work he saw that he decided to rebuild, rather than, as had first been his intention, merely to repair the Great Hall of Westminster Palace. Construction of the hall lasted from 1394 to 1400 and cost approximately £12,000, an immense sum, more than half that of Salisbury Cathedral.[27] At Westminster Herland again collaborated with Henry Yevele, but the leading role, by the very nature of the concept, was that of Herland, who functioned not only as the master carpenter, but also as the comptroller. The hall was not yet completed at the time of Richard II's deposition, but Henry IV confirmed Herland and the other royal craftsmen in their appointments. Herland finally resigned his office, though retaining his pensions, in 1404, at what must presumably have been a very considerable age, since he had already been 'verging on old age' twenty years previously. He died c. 1405, a year after Wykeham. Indicative of the favours enjoyed by such a master constructor is the fact that his son William was one of the seventy foundation scholars at Winchester College and continued on to New College, Oxford; while his other son, Thomas, retained his father's lease of Bishop's Hall, a mansion at Kingston, belonging to the see and leased from William of Wykeham, and entertained Henry V there in 1413/14.

We have noted earlier that the effigy of William of Wykeham in his chantry chapel at Winchester alone escaped the mutilation inflicted on the other effigies by the Commonwealth soldiery. The undoubted reason was that Wykeham was already by then best remembered as an educator, rather than as a Churchman or Chancellor of England.

The college that he founded at Oxford in 1379 for the purpose of training clergy for an active life in Church and State, was already occupied by 1387. Officially dedicated to the Virgin as 'Saint Mary's College of Winchester in Oxford', it was dubbed 'New College' from the start, and has retained the name ever since. For its time it was certainly new and revolutionary. To begin with, the scale of the endowment was unprecedented. Previous colleges had seldom housed more than a score of scholars; Wykeham's foundation was designed for seventy, and here for the first time at either of the sister universities, we find a unified design incorporating the various functions of a college, grouped around a closed court or quadrangle – a definitive solution that would influence collegiate design in the Anglo-Saxon world for five centuries.

A charming mid-fifteenth century manuscript admirably conveys the cloistered intimacy of New College quad before the visually disastrous addition of an extra storey around three sides in the seventeenth century, and the replacement of the original windows by sash windows in the eighteenth century. On the left is the main entrance gateway, with the porter's lodge and accommodation for the warden, located with a shrewd eye for effective supervision. Facing us is the range containing the two major architectural elements: the chapel on the left, the hall on the right, their differing functions expressed by the size of their windows. However, this variety is provided within an overall unity, imposed by the regularly spaced, pinnacle-capped buttresses and the uniform, continuous roofline. Raised on its undercroft, the hall maintains the same roofline as the much loftier chapel and the necessary access is provided by stairs with a tower, which balances the projecting transeptal arm of the ante-chapel.

At Merton, oldest of the Oxford colleges, the chancel of an enormous chapel, conceived to serve both college and parish, had been erected at the end of the thirteenth century. Progress was slow and never proceeded beyond the transepts, though the rough masonry infilling provides clear evidence that a nave was originally intended. The suitability for college use of the truncated 'T' plan must have struck William of Wynford: the chancel could serve as the college chapel proper, while the transepts of approximately equal size could provide a place of assembly for processions on ceremonial occasions and a venue for theological debate at a respectful distance from the High Altar. At New College, therefore, the accidentally truncated 'T' plan of Merton College was conceived from the start as the final form. When William of Wynford combined chapel and hall into a single composition, the fact that the hall abutted the east end of the chapel precluded the customary great east window of a chapel. Instead, the vast blank wall behind the High Altar was treated as a monumental sculptured reredos with tiers of figures in canopied niches reaching up to the roof.[28]

Let us return to the fifteenth-century quad as depicted in the

22

Chaundler Manuscript. The tower on the right not only sheltered the stairs, giving access to the hall, but also provided a safe repository for the college deeds and valuables (hence the name: Muniment Tower). The east side of the quad on the extreme right accommodated the bursar or treasurer and the library, while the student body was housed in the south range in the foreground.

The medieval college in its general layout, and particularly the arrangement of the hall with its dais and open timber roof, gives us a good idea of the original appearance of the contemporary manor house, generally much altered in surviving examples. It also reflects the obvious precedent of the monastic establishment. Certainly the university college quad was inspired by the cloister. The college hall, for example,

combined the functions of both refectory and chapter-house. The communal dormitory of the typical monastic order was, however, hardly conducive to individual study. Far more suitable was the accommodation provided for eremetical orders, such as the Carthusians, with separate cells grouped around a cloister. At New College donor and/or architect hit upon an interesting compromise: a bedroom for four students facing the quad and four small rooms for individual study. Such at least was their intention. The students seem soon to have reversed the arrangement, appropriating the four small rooms as bedrooms and using the large room as a common study and living area. By the more commodious standards of the seventeenth century even the sharing of living space seemed intolerable, and it was to provide the additional accom-

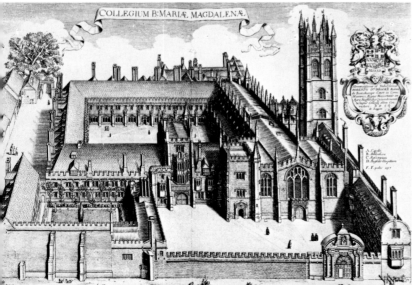

71 *Above left* View of the 'Great Quad'. The upper stage of the tower can be seen behind the chapel, and on the right is the four-storeyed gatehouse. *Magdalen College, Oxford*

72 *Left* View of Magdalen College in 1675 from *Oxonia Illustrata* by David Loggan. Note, in particular, the fine gatehouse affording access to the main quadrangle, and the unified treatment of chapel and hall on the right. The classical gateway in the foreground, perhaps by Inigo Jones, was demolished by the Gothic Revivalists in Victorian times.

73 *Above* View of Magdalen tower, from 'the High'. The building in the foreground incorporates fragments of the thirteenth-century Hospital of St John, formerly occupying the site. *Magdalen College, Oxford*

modation for the same number of students that an extra floor was added at this period.

One of the earliest celebrities produced by William of Wykeham's educational system was William Waynflete. Born in 1395, he was in turn headmaster of Winchester and Henry VI's foundation at Eton and, following directly in Wykeham's footsteps, Bishop of Winchester and Lord Chancellor. In 1458 he founded his own college at Oxford, that of St Mary Magdalen, 'commonly called Maudeleyne', as the royal charter relates; a pronunciation that has persisted to this day.

The buildings of Magdalen, only commenced in 1474, followed the precedent set by New College a century earlier. Hall and T-shaped chapel have again been unified beneath a continuous roofline, here, too, compromised by the nineteenth-century restoration. At Magdalen a cloister walk was provided around all four sides of the great quad, while the gatehouse has developed into an impressive four-storey structure. The 145 feet high belfry of Magdalen was only built between 1492 and 1509. Virtually all the interest has been concentrated on the upper stage with its generously scaled twin openings separated by a median buttress which is carried up through the tall pierced parapet to terminate in a turret pinnacle. The design is a model of sturdy simplicity, with the danger of too workaday a mood avoided by the hint of frivolity in the treatment of parapet and pinnacle. The design, traditionally attributed to Cardinal Wolsey, bursar of Magdalen at the time, must be credited to Master William Orchard, freemason and citizen of Oxford. Many fascinating details of Orchard's dealings with the college survive. Already designated as master of the works in 1468, he functioned as both architect and contractor. Since the property lay outside the city walls, the first necessity was to build a defensive boundary wall. The foundation stone of the actual college buildings was laid in 1474 and in 1475 Master Orchard signed a contract to furnish, among other items, the great west window of the chapel according to his own design ('portrait-ure'), for the sum of 20 marks (£13 6s 8d); and 22 cloister windows, 'as good as those of All Souls College or better', at 48s 4d for each window and buttress.[29] Orchard's 'good and praiseworthy service and counsel' were rewarded by revenues from property in the city of Oxford belonging to the college, and the lifetime lease of land in the parish of Headington at the nominal annual rent of a red rose payable on the Feast of St John the Baptist!

William Orchard worked on several of the Oxford colleges and was apparently also in charge of Waynflete's ambitious building operations at Eton College, for which he contracted to furnish stone from Headington quarry which he leased from the king. As a designer his masterpiece is the vault that he constructed between 1480 and 1483 over the Divinity School.[30] This boasts the earliest surviving use on a large scale of the pendent vault, which had such an illustrious development ahead. The decoration of Orchard's vault is also of great interest and originality, and it has been surmised that the curious treatment of the bosses, featuring the interlaced initials in high relief of Oxford dignitaries, was the designer's ingenious response to a challenge: few of the worthies to be com-memorated possessed a coat of arms.[31]

Two great educational foundations owe their inception to Henry VI: Eton College and King's College, Cambridge. The foundation stone of King's College Chapel was laid in 1446, but the work was only completed in 1515. Reginald Ely (*fl.* 1438-71) is the master mason usually credited with the major role during

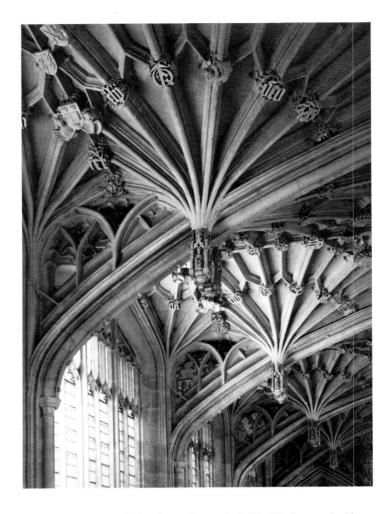

74 Detail of William Orchard's pendent vault (1480–83), decorated with the interlaced initials of university dignitaries. *Divinity School, Oxford*

the first building phase (1446-62), which ended with Henry VI's overthrow. The second phase – marked by a detectible change in colour of the stone for the convenience of architectural historians[32] – lasted from *c.* 1477 to *c.* 1484, and generally continued along the lines established earlier. The third phase (1508-15), due to the munificence of Henry VIII, was marked by brilliant innovations and is fortunately well documented, the master in charge being John Wastell. The plan (figure IV) is extremely simple and coherent: a long, high, narrow central vessel divided into an ante-chapel and the chapel proper, and flanked by a series of low chantry chapels inserted between the buttresses. Externally, the lateral elevations have the most character with their strong repetitive rhythm of window and buttress. The decoration is concentrated on the elaborately pierced parapets, and at the base in the random combination of two different tracery patterns in the windows of the chapels. The west front, though interesting chiefly for the manner in which the projecting octagonal corner turrets mask the side chapels commencing one bay back, is indelibly impressed upon the memory of millions as the focal point of one of the most celebrated views in Europe: that of King's College seen from across the river and over the lawns of the Backs.

The interior, suffused by the glowing hues of the original Flemish-Renaissance stained-glass windows, is breathtaking in its beauty, and affords 'the best evidence that we possess of the total effect intended by a great monumental interior of the early sixteenth century . . .'[33] The spatial effect is confined entirely to

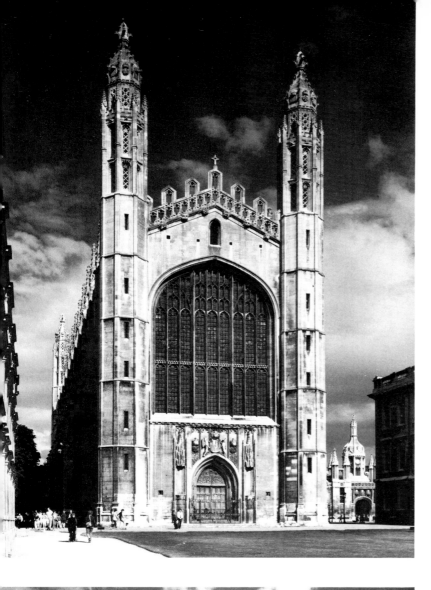

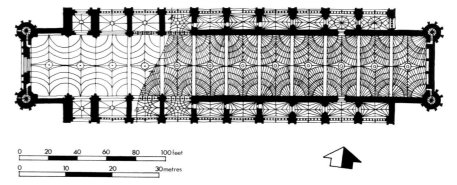

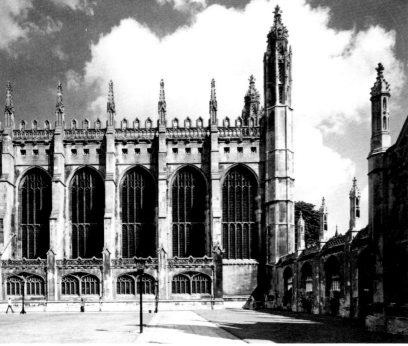

75 *Left* West front. *King's College Chapel, Cambridge*

76 *Below left* Detail of the south façade showing five of the twelve bays with their strong repetitive rhythm. *King's College Chapel, Cambridge*

IV *Below* Plan of King's College Chapel, Cambridge

77 *Bottom* Detail of the screens closing off the chantry chapels, showing the magnificent heraldic sculpture by Thomas Stockton, 'the King's joiner'. *King's College Chapel, Cambridge*

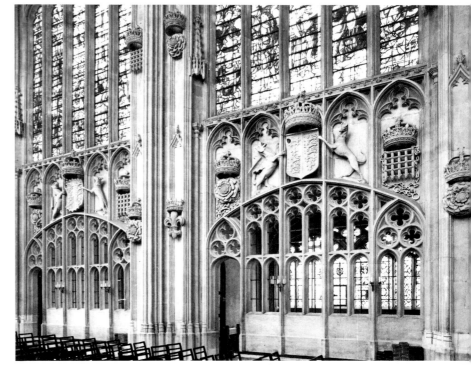

77 the nave, for the openings into the side chapels are obstructed by the choir stalls in the chapel proper and screened by Perpendicular tracery in the tradition initiated at Gloucester in the ante-chapel. The reason for the meagre height of the side chapels, which creates such a disproportionate effect on the exterior, is now apparent. Internally, the chapels are low enough to be treated as a mere sculptured dado, entirely subordinate to the wall of glass and tracery above. The harmony of the interior is finally assured by the rippling series of fan-vaults which appropriate features from the elevation and extend them to enclose the space above.

There is clear evidence that a lierne vault was originally intended,[34] and that only much later, when sufficient technical expertise in the use of fan-vaults over large spans had been acquired, was a fan-vault substituted. The author of the fan-vaults at King's College Chapel was John Wastell, who, on the grounds of stylistic analogy, is also credited with the earlier undocumented fan-vaults at Peterborough Cathedral.[35] The vaults at King's follow those at Peterborough very closely, with two important exceptions. The far greater proportionate height

of the conoids, determined by the far greater span, necessitated the introduction of three intermediate encircling bands of ornament to permit the unobtrusive introduction of intermediate ribs above and to avoid a disproportionately large area of plain vaulting, which would have impaired the overall textural quality. The second change was far more radical: the bold expression of the four-centred, transverse arches which divide each conoid into two segments, emphasize the bay structure and increase the apparent width of the nave—a mere 40 feet compared to a length of nearly 300 feet. The miracle is that the continuity of the vaults is preserved, thanks largely to the concentric rings of decoration, which accentuate the rotundity of the conoids and set up ripples of movement expanding irresistibly over the entire surface of the vault.

The sculptural decoration of the interior is worthy of the architecture. Seen at its sumptuous best in the later ante-chapel,

78 *Below* Detail of the iron grille executed *c.* 1482 by the master smith John Tresilian to protect the original tomb of Edward IV. *St George's Chapel, Windsor Castle*

79 *Right* View of the nave, looking towards the west window. *St George's Chapel, Windsor Castle*

80 *Below right* View of William Vertue's vault over the choir (1506–11). Twenty of the bosses bear the arms of those Knights of the Garter who contributed towards the cost of the vault. *St George's Chapel, Windsor Castle*

81 *Opposite* Detail of Noah and his family on the Ark, depicted as a contemporary merchantman in the great east window, 1405–08. *York Minster*

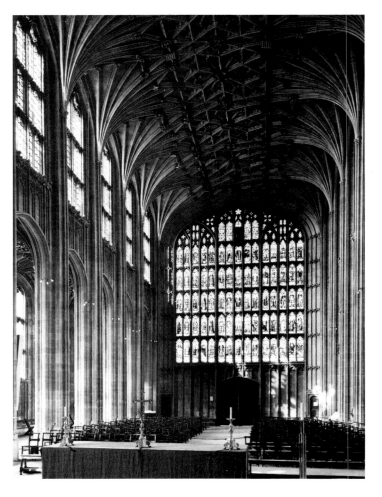

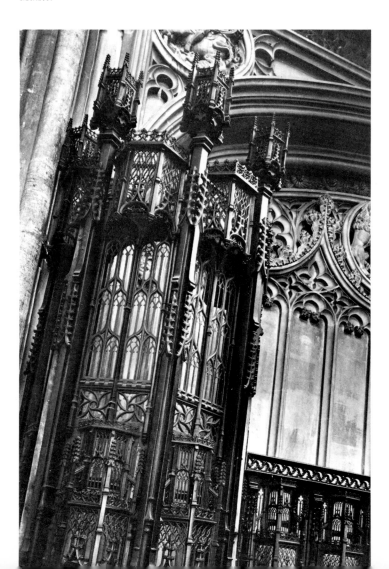

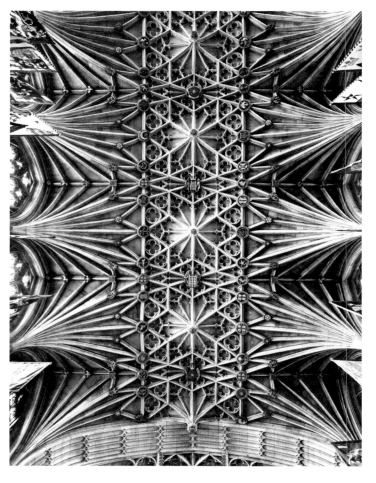

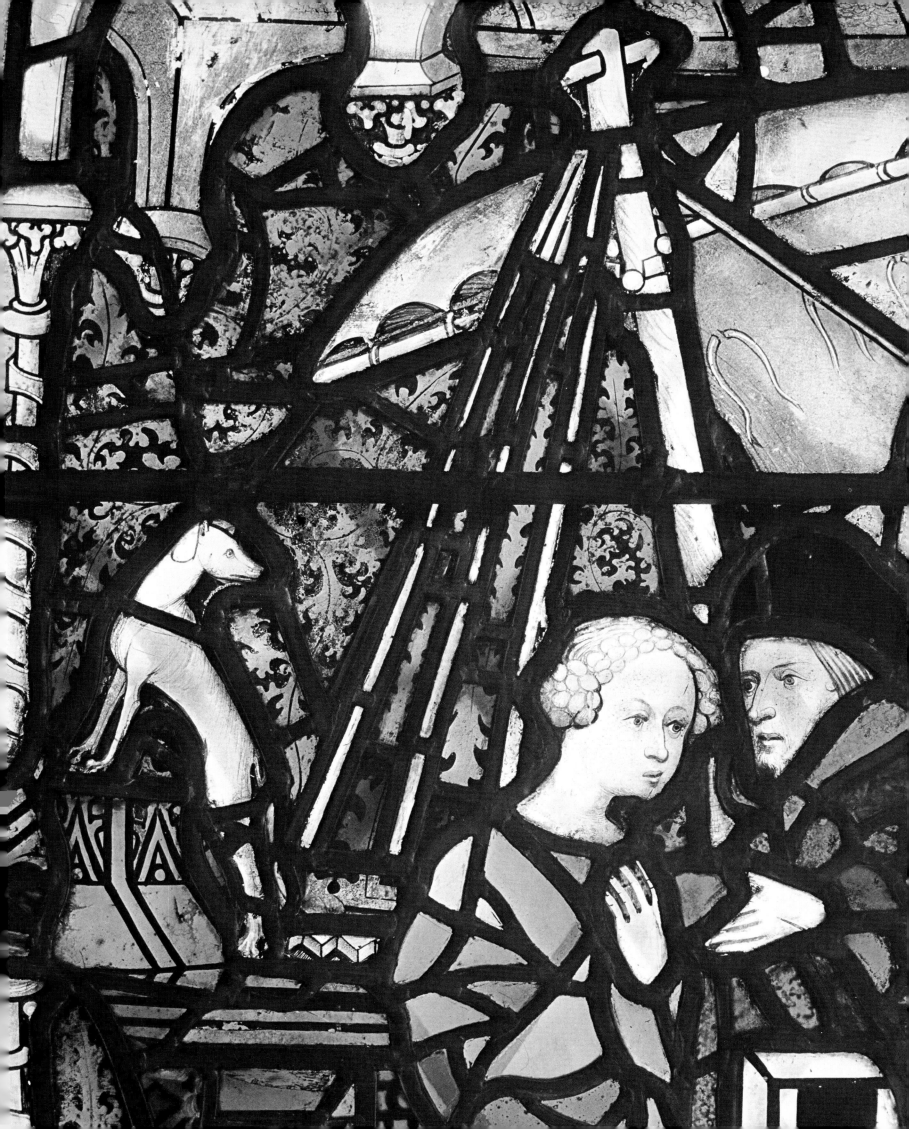

the sculpture, dating from 1512-13, is exclusively heraldic in subject matter, extolling the Tudor family and its illustrious connections through Margaret Beaufort: a six-foot high rampant dragon and greyhound supporting the royal arms, the Tudor rose, the portcullis, and the *fleur-de-lys*, surmounted by regal crowns or coronets. Indeed, apart from the sixteenth-century Renaissance glass, there is today in the ante-chapel not a single motif of religious significance, although the now-empty pedestals in the window jambs probably held small-scale figures of saints.[36]

Where is the precedent for this flaunting display of Tudor dynastic pomp in a religious setting? Irresistibly, one's mind turns to Spain. In the Capilla del Condestable (1482-94) of Burgos Cathedral, wild men – heraldic bearers probably of pagan origin – support gigantic escutcheons of the founder and his wife, and in the Collegiate Church of San Juan de los Reyes in Toledo, designed *c.* 1479, huge hieratic eagles, grasping the royal arms in their talons, provide an even closer parallel to the heraldic beasts of King's College Chapel – closer, visually, but not in their symbolism, for the haloed eagles are symbols of St John the Evangelist, to whom Queen Isabella was particularly devoted, whereas the heraldic symbols at King's College, like the escutcheon bearers at Burgos, have no religious significance whatever. The Spanish analogies apparently are not fortuitous. Elaborate temporary decorations with heraldic devices were devised for the marriage of Prince Arthur, eldest son and heir of Henry VII and Catherine of Aragon, daughter of the Catholic Kings, in 1501, and there is good reason to believe 'that the decisive factor in creating the popularity of the new motifs was these 1501 wedding preparations to celebrate the sealing of a union that was the culmination of the prestige policy of the Tudor dynasty'.[37]

With the apparently permanent triumph of the House of York in 1471, Edward IV had decided to rebuild the Chapel of St George in the royal castle of Windsor, to house his tomb and provide a more worthy setting for the ceremonies connected with the chivalric Order of the Knights of the Garter, founded by his illustrious namesake, Edward III. The actual construction of the new chapel began in 1475, but although the surviving documents only record Henry Janyns as master of the works from 1478 onwards,[38] it seems probable that he was in charge from the start and should be considered the designer. To Henry Janyns would then be credited the serene and noble arcades with their exceptionally subtle pier mouldings. As might have been expected, precedence was given to the construction of the choir, which was carried to its full height and roofed over for protection – but not vaulted – during Edward's lifetime. From this period, too, dates the grille executed by the Cornish master smith, John Tresilian, around the original chest-tomb and effigy of the king.[39] Of exquisitely delicate workmanship, this is the finest surviving example of English medieval ironwork.

Between Edward IV's death in 1483 and 1503 little major work seems to have been accomplished. However, in the latter year a generous bequest by Sir Reginald Bray, minister of Henry VII, enabled work to proceed on the neglected construction of the nave, and by 1509 its vaulting was complete. Meanwhile, a contract between King Henry VIII and the Knights of the Garter, on the one hand, and William Vertue and John Aylmer, a London mason, on the other, had been signed on 5 June 1506. The contract, which included 'finding all stone and timber, with carriage and other necessaries', stipulated that the seven bays of the choir be vaulted to match the design of the nave. The work was to be completed by Christmas 1508, that is, within thirty months, for the sum of £800, which included such ancillary elements as the flying buttresses, parapets and the pinnacles crowned by carved heraldic figures of the King's Beasts.[40]

William Vertue's lierne vaults over the nave and choir are of striking beauty.[41] Viewed directly upward, the central portion presents a brilliant pattern of interlocking stars and lozenges, challenging comparison with the greatest triumphs of Islamic abstract, geometric ornament. However, in the normal oblique view it is precisely the treatment of this central portion that creates a strangely disquieting effect of structural instability, for the vaulting pitch has been reduced so drastically as to approach the effect of a flat – if gorgeously decorated – ceiling rather than a vault. Historically this tendency of the age to ever flatter vaulting is highly significant, for it served as a transition to the Renaissance style with its horizontal aesthetic. By contrast with the over-flattened vault, the profile of the four-centred arch over the great west window at Windsor is strong and satisfying. The window retains nearly all its original glass, the stark grid of mullions and transomes containing serried tier upon tier of kings, popes and saints and, of particular interest, the figure of a master-mason, chisel in hand, presumed to be Master William Vertue.

Henry VII's chantry chapel at Westminster Abbey, was erected between 1503 and 1519 on the site of the early thirteenth century Lady Chapel. Exceeding even King's College Chapel in splendour, the interior is a veritable *embarras de richesse*, climaxed by the lacy web of the vault. We noted in passing that the pendent vaults of the Divinity School at Oxford were the earliest surviving, large-scale example of this extraordinary form, which achieved its ultimate development at Henry VII's Chapel. How was this triumph of *legerdemain*, this seeming defiance of the law of gravity, achieved? Figure V, a cutaway section of the vault, reveals the surprisingly simple solution. Heavy transverse arches provide the structural backbone as it were, upon which the pendent fan is formed by extending one of the wedge-shaped and, therefore, firmly gripped voussoirs downward, and constructing the conoid around this rigid member – rather like a half-open umbrella suspended upside down from its handle, and prevented from opening completely by the abutting spokes of the adjacent umbrellas.

V Cutaway section showing the partially concealed transverse arches supporting the pendent vaults in Henry VII's Chapel, Westminster Abbey

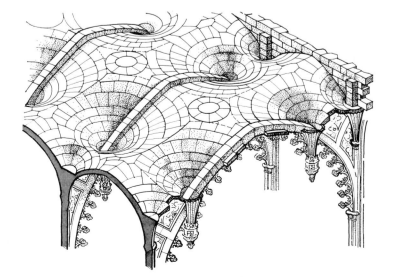

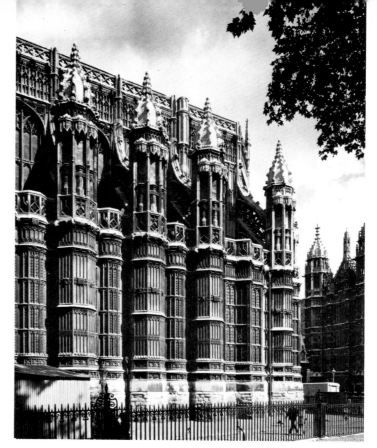

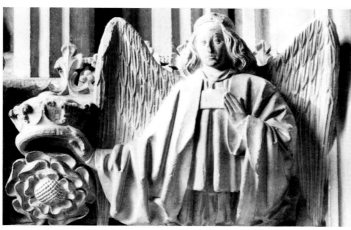

82 *Above left* Detail of the lavish wall treatment of an apsidal chapel, with the insistent use of heraldic motifs, complete with 'King's Beasts' surveying the scene from the canopies over the saints. *Henry VII's Chapel, Westminster Abbey*

83 *Left* One of the angels holding a crown over the royal insignia—in this case, the Tudor rose—in an attitude of deference formerly reserved for such sacred objects as the Instruments of the Passion. *Henry VII's Chapel, Westminster Abbey*

84 *Above* Exterior of Henry VII's Chapel. The cupolas crowning the octagonal buttress-piers were originally topped by heraldic beasts bearing gilded weather vanes. *Westminster Abbey, London*

However, if the principle is simple, the execution must have taxed the skill even of the medieval mason to the utmost. From a purely technical point of view this is, undoubtedly, one of the supreme triumphs of masonry construction. A particularly subtle feature of the design is that the central portion of the transverse arches is concealed *above* the vaulting while the ends are boldly expressed *below* the main vault as flying arches, connected with an infilling of ornamental tracery to small subsidiary fans attached to the clerestory wall. Who but the most rigid purist could fail to be captivated by this potent mixture of structural ingenuity and decorative fancy?

Henry VII had directed that the chapel be 'painted, garnished and adorned in as goodly and rich a manner as such work requireth, and as to a king's work apperteyneth.' Certainly, a more royal vault could hardly be imagined. Small wonder that William Vertue's aid should also have been enlisted for that ultimate exercise in chivalrous make-believe, the décor for the meeting in 1520 between Francis I of France and Henry VIII at the 'Field of the Cloth of Gold'. The wall surfaces of Henry VII's Chapel have a profusion of sculptured ornament,[42] including almost a hundred large-scale figures which reveal a sophisticated understanding of three-dimensional form and,

82
83

hardly surprisingly, are credited by most authorities to foreign artists.

Consistent with the desire for the richest possible effects, the windows of the aisles and apsidal chapels were canted at different angles to create a multi-faceted treatment. If a trifle fussy, this certainly imparts a domestic scale and intimacy appropriate to a chantry chapel. Externally, the building achieves a compelling unity of solid and void, buttress and window almost indistinguishable behind the overall textural pattern.

84

The fine bronze grille enclosing the tombs of Henry VII and Elizabeth of York, the work of one Thomas Ducheman, employs the wide repertoire of Late Gothic forms and heraldic devices with consummate assurance and artistry, to such details as the pricket candesticks in the form of a Tudor rose. Particularly fine are the free-standing statuettes in the niches, six of the original sixteen still surviving. The most beautiful figure is undoubtedly the youthful St John the Evangelist, but perhaps even more expressive is the St Bartholemew with his flayed skin casually draped over his arm.[43] Henry VII's Chapel, both in its architecture and furnishings, is the most impressive record we have of the romance and pageantry of the Late Middle Ages.

2

There is one contrasting note. The commission for the effigies of Henry VII and Elizabeth of York was fiercely contested by

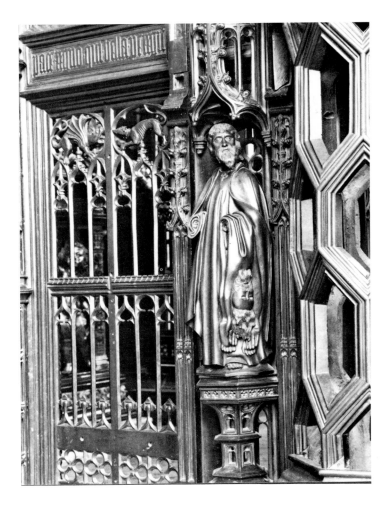

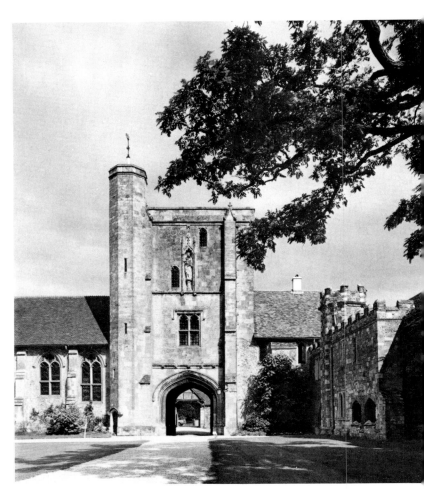

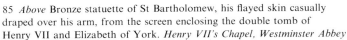

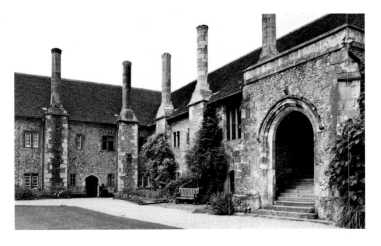

85 *Above* Bronze statuette of St Bartholomew, his flayed skin casually draped over his arm, from the screen enclosing the double tomb of Henry VII and Elizabeth of York. *Henry VII's Chapel, Westminster Abbey*

86 *Above right* The Beaufort Tower seen from the main court. *Hospital of St Cross, near Winchester*

87 *Right* The covered stair giving access to the refectory, the tall chimneys of the master's house (centre) and a couple of the brethren's apartments (left), all date from the mid-fifteenth-century rebuilding. *Hospital of St Cross, near Winchester*

the principal English tomb masons. Thomas Drawswerd of York, for example, in association with the founder, Humphrey Walker, undercut Lawrence Ymber's price by forty-three per cent,[44] but all in vain, for in the end the contract was given to Pietro Torrigiani – the same Torrigiani who, as a fellow student in the sculpture garden of Lorenzo the Magnificent, broke Michelangelo's nose in a quarrel. The magnificent double-tomb in Italian-Renaissance style marks a complete break with Northern tradition and must have filled the craftsmen who came to view it with stupefaction and dismay, prophesying the end of the Gothic sculptor's patronage by the court.

The most complete example of the charitable hospital institutions which played an important role in late medieval society is the Hospital of St Cross near Winchester, founded between 1133 and 1136 by Henry de Blois, Bishop of Winchester and grandson of William the Conqueror. The foundation was to house thirteen indigent and aged men, unable to care for themselves, and also to provide a daily meal for a hundred of the poor. The tranquillity of the rural setting

and the fine buildings mellowed by time belie the turbulent history of the institution, control of whose direction, and its rich benefices and endowments, was constantly being contested by rival religious orders, or its assets squandered by an unscrupulous, often absentee, warden or 'Master'. After William of Wykeham had put the institution's affairs in order, his successor, the worldly Cardinal Beaufort, decided to enlarge it with a second foundation: an 'Almshouse of Noble Poverty', to house thirty-five impoverished noblemen, three noble-women and their two priests – an incongruous combination with the poor brethren of the first foundation. In return for a payment of 13,350 marks[45] to the treasury, the cardinal's nephew, Henry VI, granted the institution an annuity of £500 in perpetuity. Forty years afterwards there was a mere token force

of three brethren of the new foundation – today grown to eight. Then, as now, they were distinguished by their dress, a red gown bearing a cardinal's hat, from the members of the original foundation, who wear a black gown emblazoned with the Jerusalem Cross of the Knights Hospitallers, the original administrators appointed by Bishop de Blois.

Except for the fine Late-Norman church, the Hospital as it stands today dates almost entirely from Beaufort's fifteenth-century rebuilding. The complex is grouped informally around two courts. The outer court is devoted to service elements such as the kitchen, stores and stables, and to the 'Hall of the Hundred Poor'. The inner court is entered by the Beaufort Tower, a fine example of a monumental gatehouse of the period, where the traditional dole of bread and ale was dispensed to wayfarers. Adjoining the tower is the 'Common Hall' or refectory, which still preserves its original timber roof with an opening for the smoke to escape from the open hearth in the centre of the room. The master's spacious quarters and the infirmary complete the north side of the court. On the west is the long range of dwellings housing the brothers, dating from *c*. 1445, with its cosy rooms and tall chimneys that proclaim a genuine regard for the dignity, privacy and comfort of the inmates that many a modern pensioner might envy. Small wonder that even Thomas Cromwell, Henry VIII's notorious 'visitor-general', who could seldom resist confiscating the assets of religious foundations on behalf of his master, contented himself, after his inspection, with strictures against giving alms to lazy young beggars and against the exhibition of relics.

Among the numerous deeds and charters preserved by the Hospital of St Cross, is one excommunicating the villagers of Twyford for not paying their tithes of hay! Particularly appealing to modern taste are the great medieval barns in which such tithes were stored, with their unassuming strength and the honesty of expression of their huge open-timber roofs. Among the finest is that at Bradford-on-Avon, no less than 170 feet in length, which served to house tithes of corn and hay, and also the produce of the grange on which it stood, ceded to the Church in 1001 by King Ethelred, as penance for the murder of his half-brother.

Stained-glass remained the 'painted' art form *par excellence* of Northern Gothic architecture. However, in response to the development of tracery, early in the fourteenth century its character began to change, moving away from the mosaic-like quality and sonorous ruby and sapphire colour schemes associated with Chartres, towards a lighter tonality and, in particular, the extensive use of large sheets of colourless glass enlivened by elaborate painted detail, executed not only in the standard 'enamel-brown' (black), but also in a rather acrid, semi-transparent yellow – conceived as a substitute for gilt – produced by the so-called 'silver-stain' technique.[46] Concurrently, the medallion-type window with its numerous small scenes gave way to large figures isolated within pinnacled aedicules, a device which permitted the human figure, while preserving its natural proportions, to be accommodated within a tall, narrow opening. Needless to say, the simple rectangular subdivisions of Perpendicular-style tracery provided the perfect setting for these ranks of saints ranged tier upon tier with almost monotonous regularity. Undoubtedly we have here a case of mutual interaction, the form of the tracery evolving, at least partly, in response to the dictates of stained-glass composition, and *vice versa*.

Among the leading glass-makers of the late fourteenth

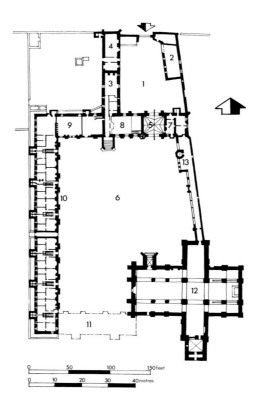

VI General plan of the Hospital of St Cross, near Winchester: 1 Entrance or Service Court; 2 Former 'Hall of the Hundred Poor', later the Brewhouse; 3 Kitchen; 4 Former stables; 5 'Beaufort Tower': Gatehouse with Muniment Room above; 6 Quadrangle; 7 Porter's Lodge; 8 Common Hall and Refectory; 9 North Wing: formerly Master's House; 10 West Wing: Brothers' Dwellings; 11 Site of South Wing: Brothers' Dwellings, demolished 1788; 12 Norman church; 13 Ambulatory.

century was Master Thomas of Oxford, whose shop was responsible for the glass in the chapels at both William of Wykeham's educational foundations, New College, Oxford, and Winchester College. The glass for the latter is documented as being manufactured in Oxford and despatched to its destination by cart. Three of the large-scale figures for the side windows are now in the Victoria and Albert Museum. Of quite exceptional quality is the draughtsmanship of the figure of the Prophet Zephaniah.

Master Thomas of Oxford appears to have exercised a considerable influence on John Thornton at Coventry, not far distant, under whose direction the great east window of York Minster was executed between 1405 and 1408. Seventy-two feet high by thirty-one feet wide, and still retaining almost all its original glass, the East Window contains the largest area of medieval stained glass in all Europe.[47] Thornton's surviving contract with the Dean and Chapter stipulated that he finish the work within three years, 'painting the histories, figures and other things with his own hand'. He was to be paid a wage of 4s. a week, an extra £5 each year and a bonus of £10 on completion of the work: a total renumeration of £56. The cost of the materials and the wages of his assistants were to be borne by the Chapter. Despite the enormous size of the window, its composition was conceived in terms of a multitude of small-scale scenes and figures that, without the aid of binoculars, resolve at normal viewing distance into an abstract kaleidoscope of colour. This in no way deterred the artist in his labour of love from embellishing the scenes with a wealth of anecdotal

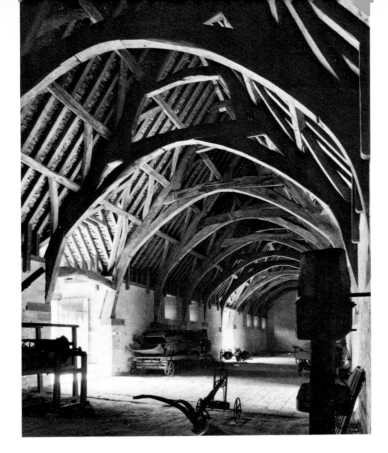

88 Fourteenth-century tithe barn. *Bradford-on-Avon*

Henceforth, the best work is strongly derivative when not actually executed by foreigners.[49]

By good fortune two panel pictures of outstanding quality survive to testify to the apogee of English taste and culture during the reign of Richard II. The first is the hieratic, over-life-size portrait of the enthroned king which now hangs in Westminster Abbey. An example of the courtly 'International Style' of the period, the painting has been heavily restored, compounding the problem of its attribution.[50] Perhaps the most appealing feature is the poignant contrast between the splendour of the robes and symbols of royalty, and the wistful introspective expression of 'a man young in years and in the lineaments of his face but old in experience, though bitter and sad rather than wise in the acquiring of it'.[51]

The second example, incomparably the finest medieval painting associated with England, is the enigmatic Wilton Diptych, so-called from Wilton House, seat of its former owners, the Earls of Pembroke. The phrase 'associated with England' was deliberate, for although there is no doubt whatever of the English subject matter, both the date and the nationality of the artist are the subject of continuing debate. Most plausible on stylistic grounds would seem to be either an English artist trained in France or a French artist long domiciled in England. Probably intended as the altarpiece of a small chapel, the tempera painting (overall 21×14 inches) comprises two panels joined by hinges and painted in a manner suggestive of a double-page illumination forming a single

detail. If the theologian still dictated the hierarchical arrangement of traditional subject matter, from God the Father, holding open a book inscribed with the words, 'I am the Alpha and the Omega', in the uppermost panel, presiding over a convocation of angels and saints that fill the traceried head of the window, to 117 panels each a yard square below, depicting scenes from the Old Testament and the Apocalypse, their interpretation clearly betrays a new bourgeois, secular spirit. Noah's family on the Ark, for example, are fashionably-dressed townsfolk promenading with their dog on the deck of a contemporary merchantman.

Among parish churches, Fairford in the Cotswolds and, on a smaller scale, St Neot's, in Cornwall, almost alone preserve their medieval glass virtually intact, so methodical were the iconoclasts. The glass at Fairford is of extremely late date (1495-1505) and shows the currently dominant Flemish influence, already with some Renaissance touches. With appropriate symbolism the last rays of the setting sun illumine the Last Judgement of the west window, in which the torments of Hell are, as usual, depicted with far more relish than the delights of Heaven. Blue demons trundle the Damned in wheelbarrows through the flames towards a fish-headed Satan, seated sceptre in hand; his distended belly sports a monstrous face, a standard feature of demon anatomy, probably intended[48] to indicate that the fallen angels, descended to the level of the brute, had displaced the seat of their intelligence and put their souls at the service of their lower appetites.

The illuminated manuscripts of the East-Anglian School, celebrated throughout Europe in the first half of the fourteenth century, had lost their vigour and much of their beauty by the middle of the century. Whether this was due to the natural demise of the style, or the death of the major exponents in the Black Death, or the decline of monastic establishments, has been much debated. Certainly, by the second half of the century, the great days of English illumination were over.

89 Stained-glass window, *c.* 1400, by the glazier Master Thomas of Oxford, from Winchester College Chapel. *Victoria and Albert Museum, London*

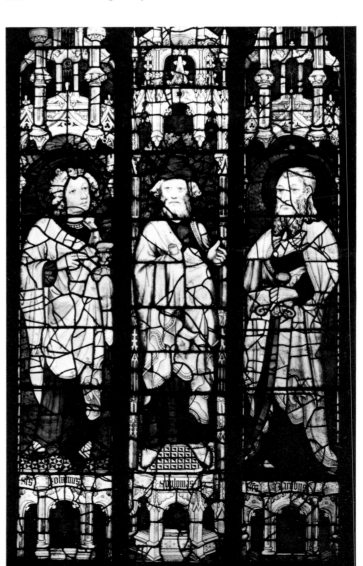

composition in a book. Against a delicately stippled gold background Richard II is commended by his three patron saints, St John the Baptist, St Edward the Confessor and King Edmund, to the Virgin and Child surrounded by angels in a flower-strewn meadow. Both the linear character of the composition and also the physiognomy of the angels, 'remote and charming harbingers of the chaste damsels dear to the Pre-Raphaelites'[52] are quintessentially English.

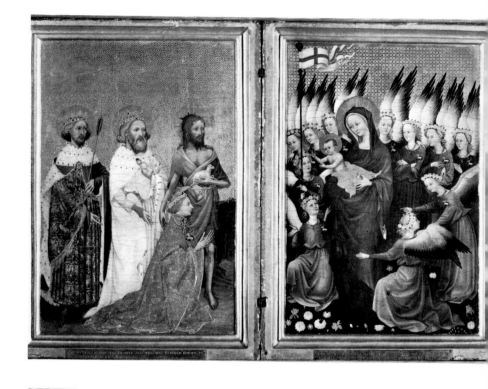

The identity of the kneeling king is established beyond doubt by his heraldic emblems, the broom-pod collar and the lodged white hart. However, these very aids to identification have created an enigma, since they were only adopted late in his reign by the then bearded Richard, whereas the Wilton Diptych depicts a beardless youth or boy. Various ingenious solutions have been proposed to expain this anomaly. The most widely held view is that the painting was commissioned late in Richard's reign, when he was trying to build up a cult of royalty, and to recall his great coronation at the age of eleven – a figure echoed by the number of angels. In this case, the panel would date from the period 1389 to 1399. An increasing number of authorities have, however, endorsed a second theory, namely that the painting commemorates the translation of the deposed king's body from King's Langley to Westminster Abbey by King Henry V shortly after the latter's accession to the throne in 1413.[53] The subject in this case would be King Richard's entry into Paradise where he is welcomed by the Christ Child and angels wearing his insignia. Yet a third proposal is that the painting was commissioned at the time of King Richard's coronation in 1377 and that the anachronistic, heraldic devices were added later. The awkward placing of the white hart badges of the angels, which strike such a discordant note, would seem to lend credence to this theory.[54] However, this would also imply a later date for the reverse side of the diptych, featuring Richard's emblem, the lodged white hart, on one panel, and on the other a coat of arms – that of Edward the Confessor impaled with the quartered royal arms of France and England – only used between 1394 and 1399, when Richard had married Isabella of France. So each solution in turn presents new problems. That eminent authorities should champion dates as early as 1377 and as late as 1415, and, incidentally, no fewer than four countries for the provenance of the artist, including Bohemia, the birthplace of Richard's first queen, is a measure not only of the uniqueness of the Wilton Diptych, precluding dating on the grounds of stylistic analogy, but also of the widespread diffusion of the significantly named 'International Gothic' style in painting.

90 *Top The Wilton Diptych* shows Richard II presented by his patron saints, St John the Baptist, St Edward the Confessor and St Edmund, to the Virgin and Child surrounded by angels. *National Gallery, London*

91 *Right* Detail of the portrait of Richard II enthroned. *Westminster Abbey, London*

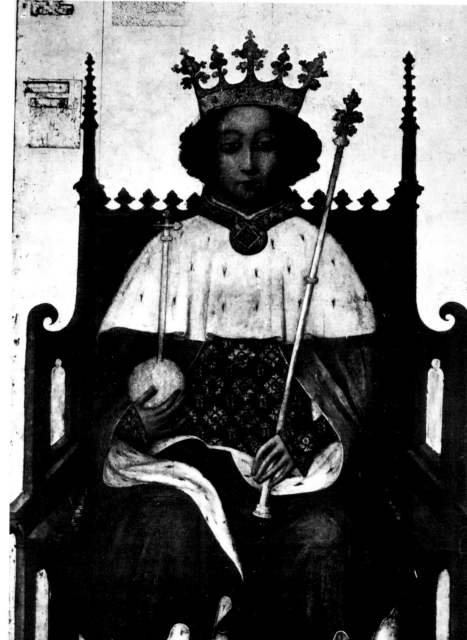

3 France

The Hundred Years' War began in 1337, and reached its nadir for the French when Henry V of England and Philip of Burgundy were appointed co-regents under the provisions of the Treaty of Troyes in 1420, and the youthful Henry VI was crowned King of France at Notre Dame in Paris in 1431, while Charles VII held court at Bourges. The tide finally turned in their favour, however, and the conflict ended in 1453 with the complete expulsion of the English from France.

Despite the disruption of this period there were surprising examples of building activity being continued, notably the large abbey church of St Ouen, in Rouen (choir built 1319-39), which testifies to the continuing pride of the Norman capital. However, it is true to say that France lost her position of architectural dominance at this time, and that when a revival did occur with the Flamboyant Gothic architecture of the last decades of the fifteenth century, this should be seen in the context of the wave of renewed energy and achievement which manifested itself in splendid buildings everywhere throughout Europe.

The *'style flamboyant'* is so called from its flickering, flame-like forms, the basis for which is the undulating reverse-curve whose origin can, ironically, be traced back to the English Decorated or Curvilinear Style of the first half of the fourteenth century, abandoned by the English in favour of Perpendicular. Applied to the head of an opening, the reverse-curve results in the ogee arch, with its outline alternately convex and concave, while in tracery we find such sinuous shapes as the *mouchette* and *soufflet*.[1] Just how irresistible an impression of upward movement these dynamic forms can create can be seen in the pierced gable over the central portal and the tracery of the west window of the Church of the Trinité at Vendôme – a veritable conflagration in stone.

The basic structure and design of the west façades of most of the great French cathedrals testify to the fervour of the great age of cathedral building in the thirteenth century. Our period, in the main, witnessed such secondary additions as the upper stages of west towers, transeptal fronts and rose windows.

The master *par excellence* of the transept façade in the *style flamboyant* was Martin Chambiges, whose work on the south transeptal front of the cathedral at Sens dates from 1490. The focal point of the lucid and harmonious design is the superb rose window, with its delicate kernel resembling the centre of a flower. The inner range of petals, six in number, is inscribed with *mouchettes*, and the twelve gigantic outer petals have metamorphosed into the same asymmetrical, dagger-shaped form, each pair balanced within a rigidly-defined, sixth-part segment of the rose which preserves the architectonic strength of the

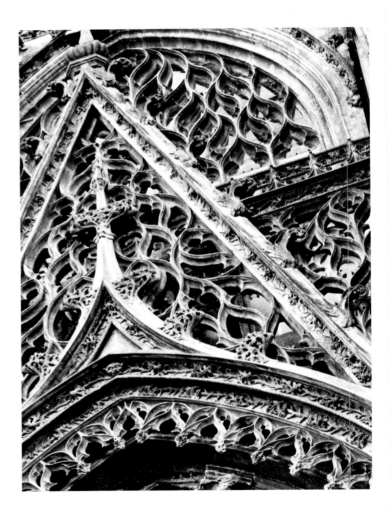

92 *Above* The undulating, flame-like forms of *style flamboyant* are seen in this detail of the pierced gable over the central portal and the west window. *Church of the Trinité, Vendôme*

93 *Opposite* Detail of the south transept façade showing the great rose window and the concave mouldings which reduce the apparent bulk of the buttresses. *Sens Cathedral*

composition. Note how tracery infilling bridges the gap between the top of the rose and the pointed containing arch and, below, how the heights of the five twin-light windows have been adjusted to touch the circumference of the rose. The clear distinction between such structural elements as oculus and triforium in the classic phase of Gothic has dissolved into an

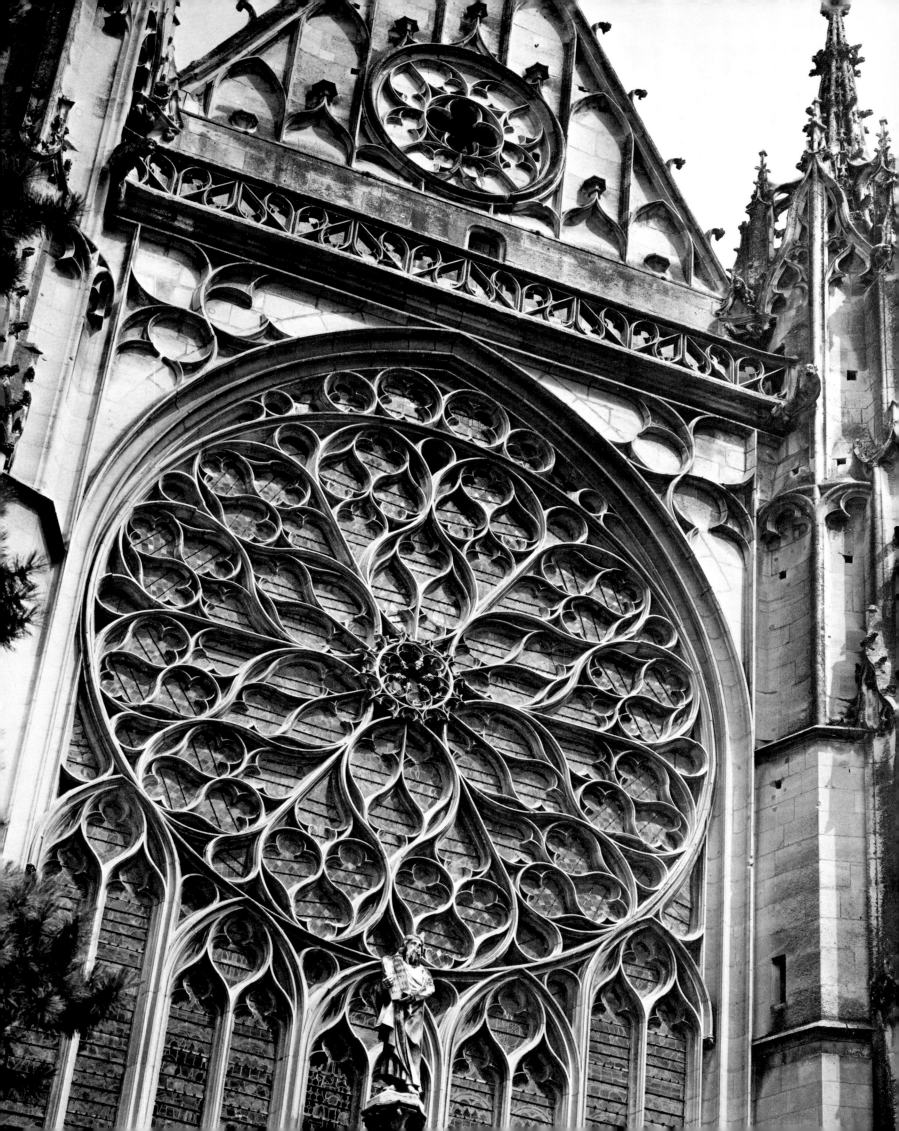

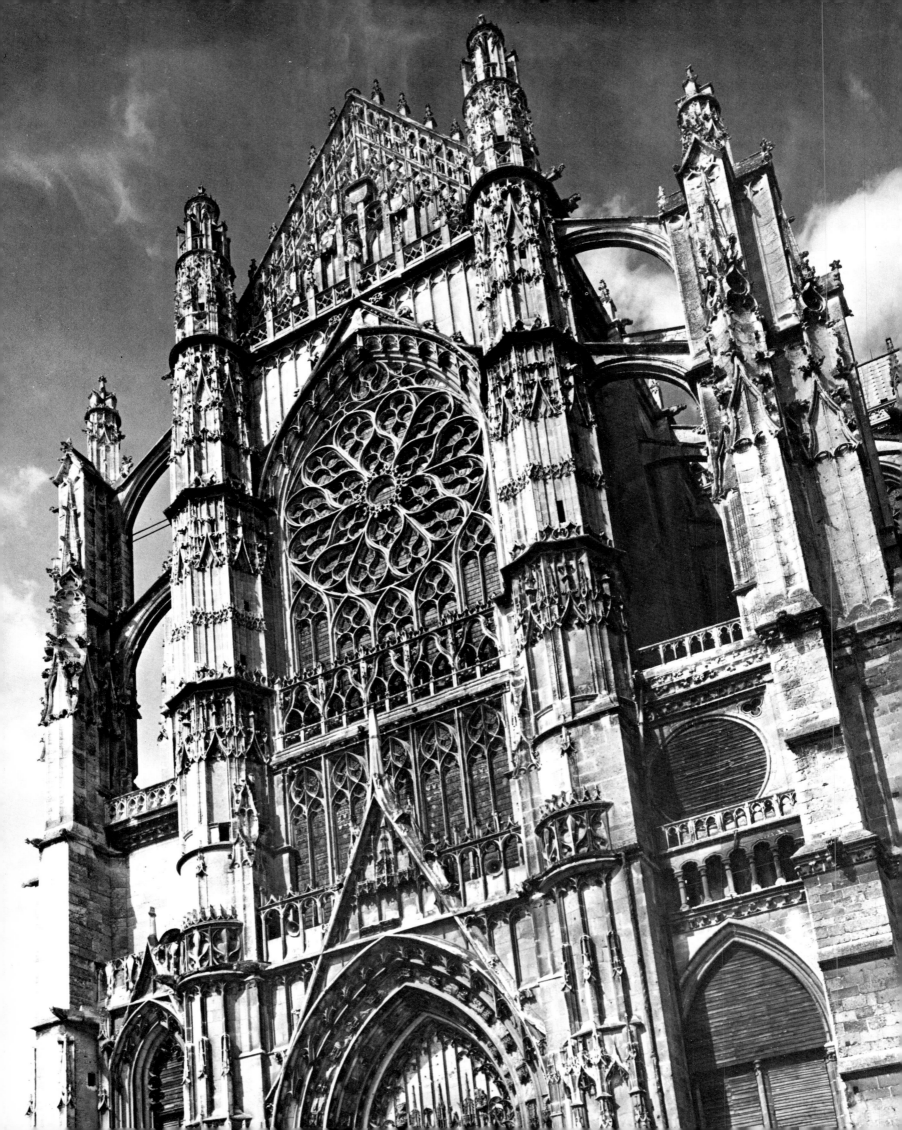

overall textural pattern of tracery. Of particular interest is the treatment of the buttresses whose considerable bulk has been minimised by the use of concave mouldings, which predominate as the buttresses ascend. Typical, too, of this late phase is the capricious, serpentine line of the extraordinary pinnacle gables: concave, convex and yet again concave.

Ten years later Chambiges was entrusted with a prestigious commission: the design of a transeptal front for the cathedral at Beauvais. Details of the contract survive. The Chapter insisted that Chambiges reside in Beauvais and provided him with free accommodation. His annual salary was fixed at 20 *livres*, with an additional 4 *sous* and a loaf of bread per day, while actually engaged on the work. The residence clause and the financial incentive to devote time to the work, both common stipulations in contemporary contracts, tacitly acknowledge the fact that successful masters could not be prevented from accepting other work. Chambiges' chief assistant, Jean Vast, was to receive 5 *sous* daily, but no annual salary, while the other masons had to be content with 2 *sous* a day.

The choir of Beauvais, the loftiest and most ambitious of all French cathedrals, had been completed in 1272. The crowns of the vaults were raised to the dizzy height of 157 feet above the pavement, and supported on piers both more widely spaced and more slender than those of Amiens, with vaults 139 feet high. Twelve years afterwards the Beauvais vaults collapsed, for reasons that are still being debated. The effort which would, undoubtedly, have been expended on building the nave was dissipated on the long and arduous task of the reconstruction of the choir. Still lacking a nave, and consequently a west front, the transept façades at Beauvais assumed additional importance.

94 Chambiges repeated the superb rose window of Sens here almost line for line.[2] At Beauvais it is, however, only one of a large number of elements which combine in a composition of lavish ornamentation; and in the process the beauty which Sens possesses is lost. The design of the buttresses, in particular, is markedly inferior, constricting the rose and loaded with ornament arranged in over-insistent, horizontal bands which interrupt the dramatic skyward thrust.

Martin Chambiges died in 1532 and was buried in the choir of Beauvais. His chief assistant, Jean Vast, had died in 1524 and been succeeded by his son, also Jean by name. It was apparently this Jean Vast the younger who conceived the supreme folly of Beauvais: a stone tower over the crossing, no less than 400 feet in height, capped by a wood spire adding a further hundred feet. This was completed in 1569 but collapsed four years later. Extensive repairs to the damaged structure were effected, but the desire to build so tall had finally been extinguished. But though seeming to stand as an admonition against overweening ambition, the truncated hulk of Beauvais is also a witness to the medieval mason's skill, for the structure, unbraced by the additional support which the nave would have given, survived the holocaust of bombing in World War II.[3]

We noted that most cathedral west fronts were built before our period. Little known but most successful is that of Toul in Lorraine, constructed between 1460 and 1496 to the design of

95 Tristan d'Hâttonchâtel. The disposition of the major elements of the composition—triple, deeply-recessed, gabled portals, rose window, galleries and twin towers—closely follows the classic pattern set at Laon and Paris 250 years earlier. What creates so different an impression at Toul is not only the repertoire of Late-Gothic decorative forms but, even more significantly, the manner in which the self-contained forms in the earlier examples

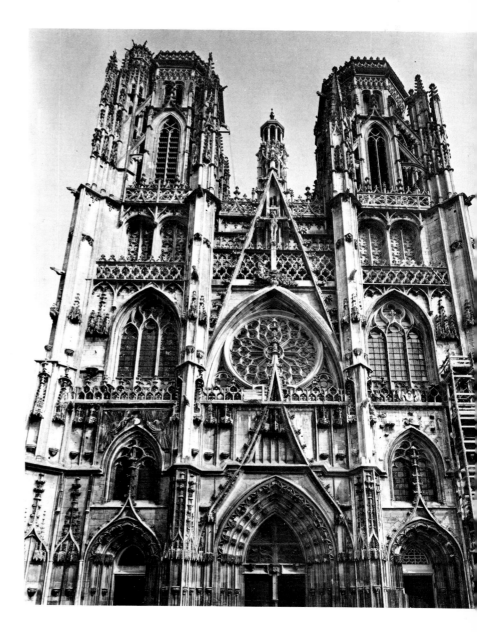

94 *Opposite* South transept façade, 1500–48. *Beauvais Cathedral*

95 *Above* West front, 1460–96. *Toul Cathedral*

now interpenetrate each other and overlap as they ascend, subtly coaxing the eye skyward. The interplay of form and line in the central bay is particularly imaginative. In ascending order we have the convex form of the portal, crowned by an ogee gable with an emphatically concave outline, in turn negated by the powerful convexity of the equilateral arch housing the rose window and, rising from the same base line, in an imperious gesture that finally resolves the rivalry of concave and convex forms, the brutally powerful statement of the triangular crowning gable. This provides the setting for a monumental Crucifix with the figure of St Mary Magdalen kneeling at the foot of the Cross.[4] Equally innovative is the forward splay of the outermost buttresses, which is carried up to the top of the towers, and provides a frame to direct the eye back to the façade.

Between the last quarter of the fourteenth century and the first quarter of the sixteenth century, the west front of Rouen Cathedral, parts of which date back to the mid-twelfth century,

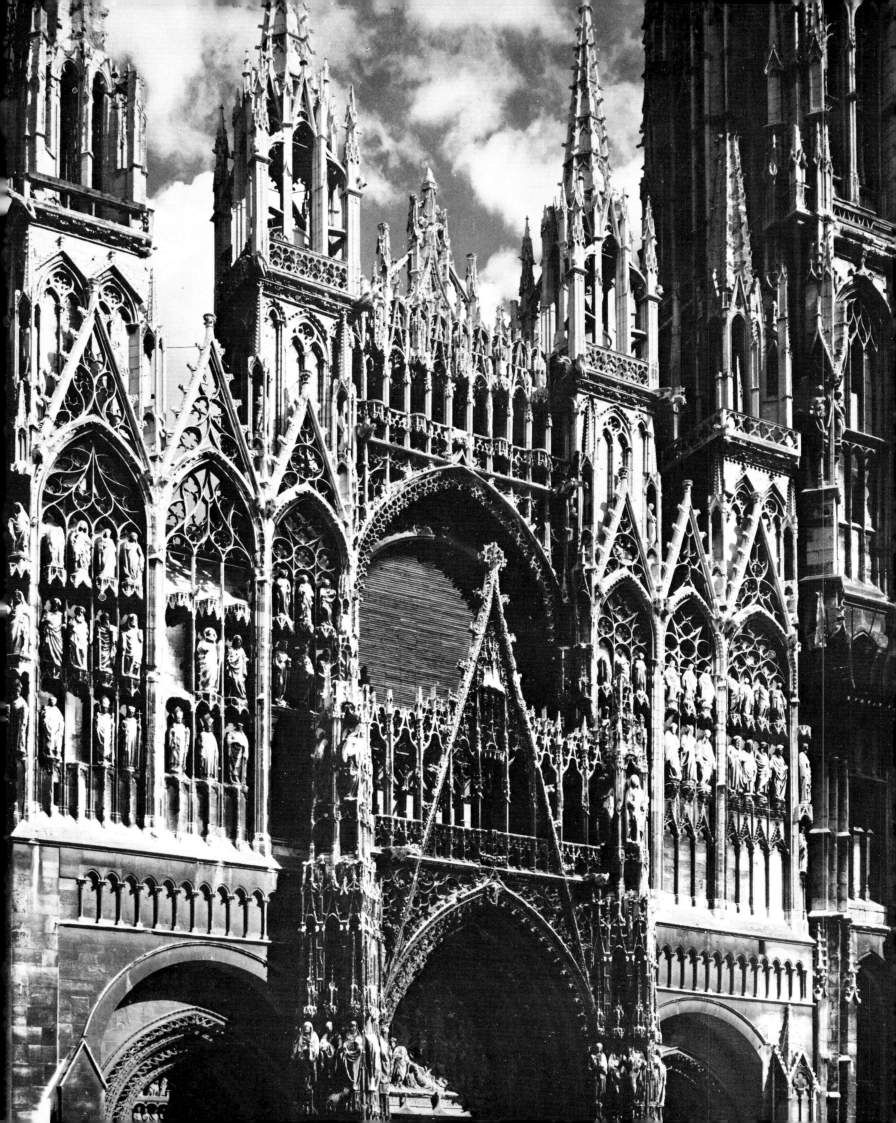

was provided with a sumptuous frontispiece. The new front stretches across the old façade like a great reredos or festive hanging of stone. The decorative treatment masks, rather than expresses, the structure behind, a denial of French logic, but typical of the English screen façade such as can be seen at Salisbury and Wells. This 'English' character is hardly coincidental. Apart from the common Norman heritage, the Duchy of Normandy was particularly prone to English influence during the Hundred Years' War. Rouen itself was under English occupation no less than thirty years (1419-49). In the heads of the six arches and their high-peaked, pierced gables, dating from the period of maximum English influence, are to be found some of the earliest examples in France of those characteristically Flamboyant motifs, the *mouchette* and *soufflet*, and also of the ogee arch, especially in the two northernmost arches (extreme left of the photograph) which appear to have been built last. At the beginning of the sixteenth century the vaults of the westernmost bays of the twelfth-century nave and the central portal showed signs of stress, and in 1509 work was started under the direction of the master of the works, Rouland le Roux, on a new version. The boldly projecting new portal incorporates two massive buttresses to stiffen the old structure, their bulk cunningly minimised by their diagonal placement and profile, and the compelling counter-attraction of the lace-like connecting screen composed of spandrel, tribune gallery and pierced gable, which forms the focal point of the whole façade.

Also in Rouen is that key monument of Late Gothic, the church of St Maclou, commenced in 1434 by Pierre Robin, *maçon du Roi*, but only substantially completed and consecrated in 1521. During World War II a bomb destroyed the choir and threatened the stability of the entire structure. Mercifully it held firm, and reconstruction is now in an advanced stage. It is to the entrance porch, added *c.* 1500-14, possibly to a design by Ambroise Havel, and its subtle relationship to the main structure, that St Maclou owes its unique importance. In the form of a greatly compressed semi-octagon, giving the effect of a bowed front, the porch has five portals, capped by steep, perforated gables connected by a high pierced balustrade, all of such light construction as to create the impression of a delicately-chased chaplet encircling the west front. The insistent diagonals of the flying buttresses form a taut pyramidal composition, climaxed by the central lantern tower with its tall stone spire–a rather uninspired nineteenth-century reconstruction of the original spire of lead-covered wood.

In the porch of St Maclou the forms, despite their richness, retain an astringent architectonic clarity of expression. In the porch of the church of Notre Dame at nearby Louviers we can see what happens when the Late-Gothic sculptor-mason yields to the temptation of virtuosity for its own sake, here justifying Huizinga's critical comparison of the Flamboyant style with 'the postlude of an organist who cannot conclude. It decomposes all the formal elements endlessly; it interlaces all the details; there is not a line which has not its counter-line. The form develops at the expense of the idea, the ornament grows rank . . .'[5].

Just prior to our period, the final phase of French High Gothic in all its formal, if a trifle dry and doctrinaire, perfection, achieved its definitive statement in the great abbey church of St Ouen. A tremendous undertaking, work continued throughout the fourteenth and fifteenth centuries. The great tower over the crossing, commenced by Alexandre de Berneval *c.* 1430, was only completed in a rich Flamboyant style in the early sixteenth century. Roughly contemporary with the Tour de Beurre of

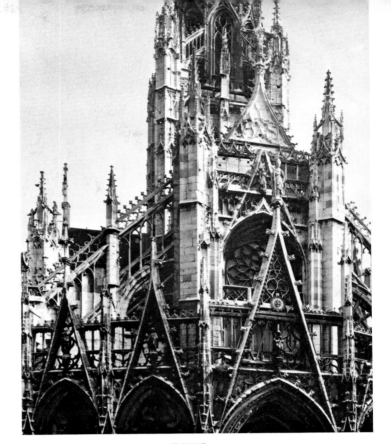

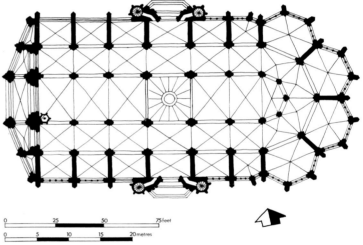

96 *Opposite* Flamboyant Gothic screen of west front. The superb rose window which provided the focal point of the entire composition was blown out during World War II and has not yet been replaced. *Rouen Cathedral*

VII *Above* Plan of St Maclou, Rouen

97 *Top* Detail of view from west, showing the pierced gables of the porch, *c.* 1500–14, encircling the structure like a tiara. *Church of St Maclou, Rouen*

Rouen Cathedral,[6] it offers an instructive comparison: if the treatment of such details as the buttresses is far less successful, the octagon avoids the slightly hunched feeling of the Tour de Beurre and gives an impression of soaring heavenwards.

The great prosperity of Normandy is also reflected in the splendid Rouen Palais de Justice, erected between 1499 and 1526 by Roger Ango and Rouland Le Roux. The planning arrangement is typical for civic structures, with a comparatively low and simple ground floor, a lofty and more richly decorated floor above housing the ceremonial apartments, and a steep roof relieved by an ornamented balustrade and gabled dormers.

Pathetically little survives of the great medieval palaces built in

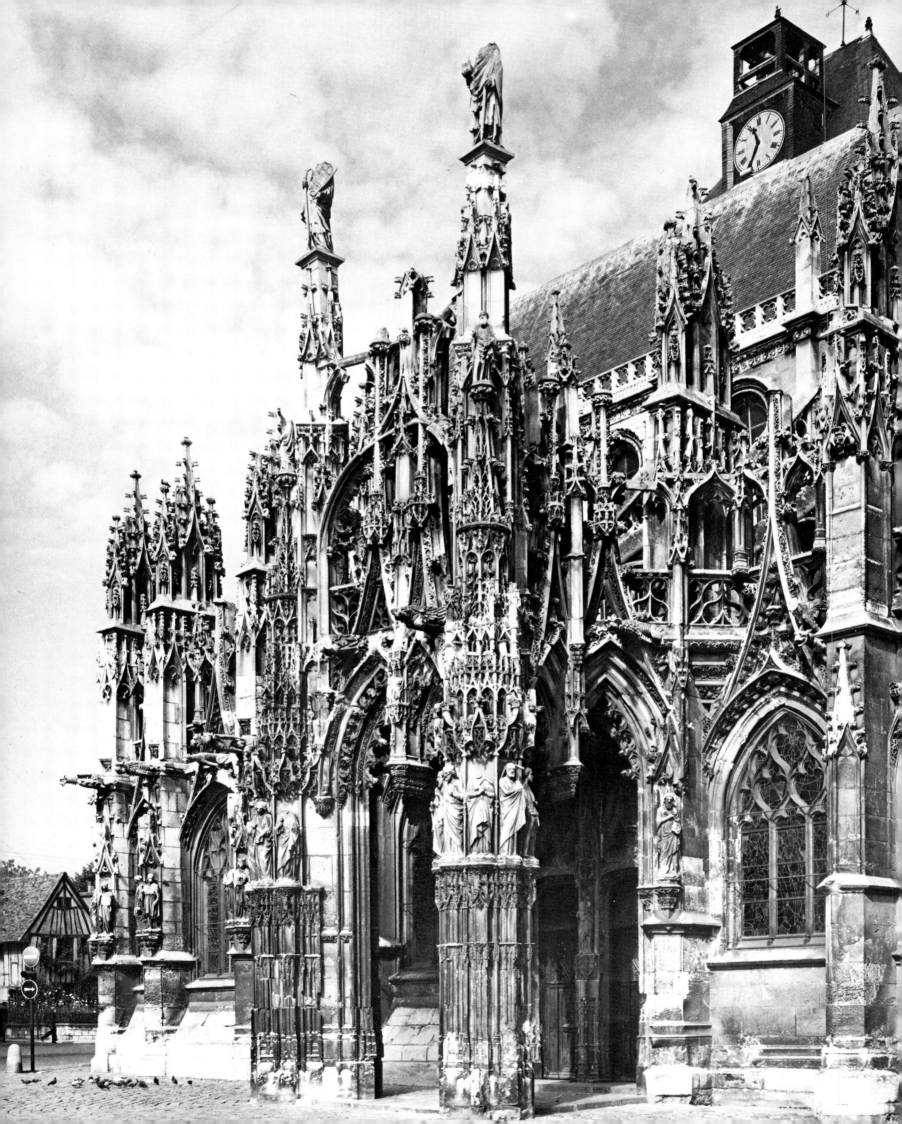

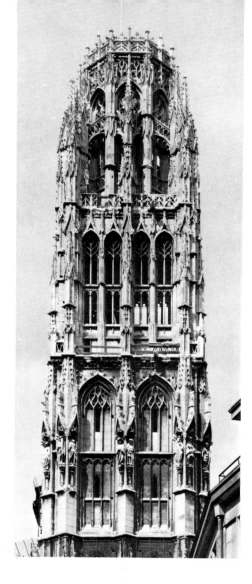

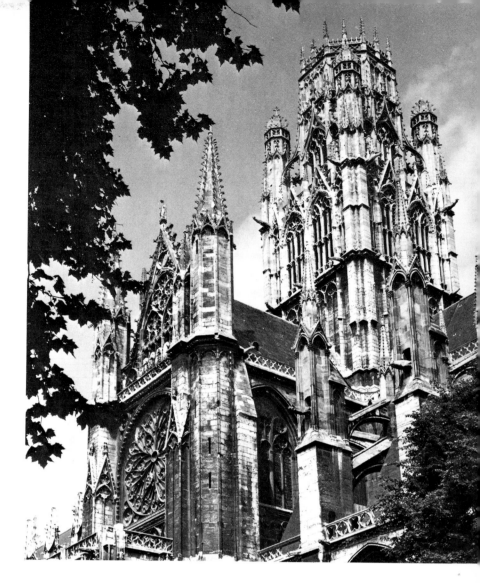

98 *Opposite* South porch, *c*. 1510. *Church of Notre Dame, Louviers*

99 *Above* The upper stages of the '*Tour de Beurre*' (1485–1507), so-called since it was largely financed by indulgences to eat butter during Lent. *Rouen Cathedral*

100 *Above right* Central tower over the crossing. *Abbey Church of St Ouen, Rouen*

101 *Right* The Cour d'Honneur of the Palais de Justice, 1499–1526. The stair is a nineteenth-century addition and restoration after bomb damage is still proceeding. *Rouen*

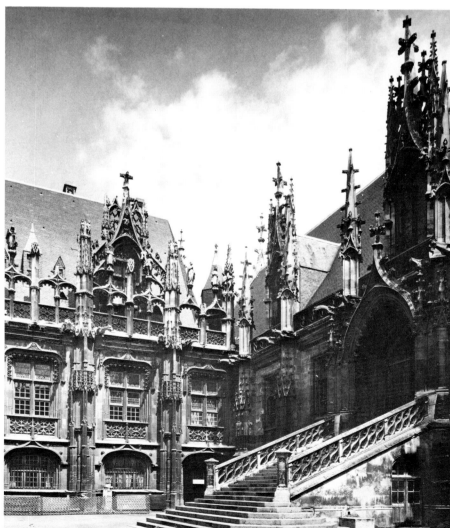

this period. One interesting relic is of the great hall of the Palais des Contes de Poitou, which was rebuilt by the Duc de Berry after it had been burnt by the English in 1345. In front of the end wall with its four pairs of thirteenth-century lancet windows, Guy de Dammartin, the duke's architect, constructed a wall-length, triple fireplace surmounted by a balustraded gallery and three gable-crowned arches with perforated Flamboyant tracery. The supporting piers of the arches, turned at an angle of forty-five degrees, increase the three-dimensional effect and terminate in statues of the duke and his beautiful young second wife, Jeanne de Boulogne, and those of his nephew, King Charles VI and his queen, Isabeau of Bavaria. The staggered placing of the arches in relation to the lancets behind sets up a syncopated rhythm of solid and void.

The finest surviving specimen of Late-Gothic domestic architecture in France, or anywhere in Northern Europe for that matter, is the house, or perhaps more accurately the 'palace', of Jacques Coeur at Bourges. Jacques Coeur, one of the earliest and

103

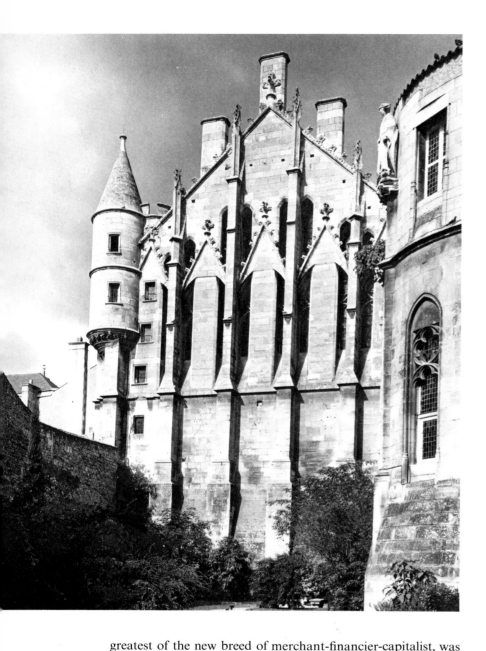

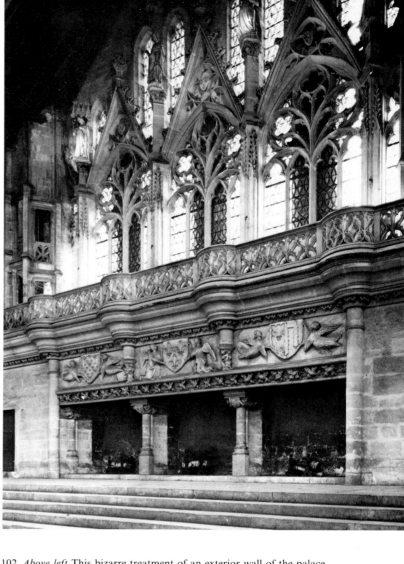

greatest of the new breed of merchant-financier-capitalist, was born at Bourges *c.* 1400. After some slightly dubious business ventures he journeyed to Syria in 1432 and hit upon the idea of exporting French silver to the Middle East and importing gold. This formed the nucleus of his tremendously profitable Levantine trade, expanded within a few years into a veritable mercantile empire. Appointed master of the Paris mint in 1436, and *argentier de la couronne* (banker and steward to the king and court) in 1439, he leased the royal silver mines in Lyonnais and Beaujolais, and with typical initiative, imported Germans – the acknowledged experts in the field – to mine them. His three hundred or so factories produced a wide variety of merchandise for East-West trade, carried in his own fleet of ships and controlled by business houses and agencies all over France and as far afield as Bruges, Barcelona and Beirut. His diplomatic skills and business acumen were keenly sought after. On behalf of Charles VII he negotiated very favourable terms for French merchants in the Levant from the Sultan of Egypt, and for his services to the Papacy he obtained special dispensation to trade with the infidels and permission to transport pilgrims to Jerusalem.

Counsellor and confidant of the king, Jacques Coeur was

102 *Above left* This bizarre treatment of an exterior wall of the palace rebuilt by the Duc de Berry originates from the fireplaces inside; on the right a glimpse of the Maubergeon Tower. *Palais des Contes de Poitou, Poitiers*

103 *Above* Triple gable-crowned fireplaces constructed 1384–86 for the Duc de Berry within the thirteenth-century great hall. *Palais des Contes de Poitou, Poitiers*

ennobled, saw his daughter married into the aristocracy, his son enthroned Archbishop of Bourges. 'Rich as Jacques Coeur', went the saying, and at the height of his fortune he was, in fact, richer even than Cosimo de Medici – a singular fulfilment of his proud and apposite motto: *'à vaillant coeur rien impossible'*.[7]

His success and high interest rates inevitably excited opposition. In 1451 he was arrested and first accused of poisoning the king's mistress, Agnes Sorel, who had died the previous year. When this trumped-up charge was proved groundless, he was found guilty of extortion and 'ruining honest merchants' by speculation. His possessions were confiscated and he was imprisoned for two years before managing to escape and make his way to Rome. The Pope proved a friend in need. Honourably received, Jacques Coeur was placed in command of a small fleet

sent to relieve the Turkish siege of the island of Rhodes; he died on the island of Chios in 1456.

In 1443, at the height of his power and success, Jacques Coeur commenced the construction of a palatial residence at Bourges. Situated alongside the Gallo-Roman ramparts, the plan follows the irregular site (figure VIII). Over the street entrance, with adjacent but separate vehicular and pedestrian access, a canopied niche contained an over-life-size equestrian statue of Charles VII, armed *cap à pied* with sword raised. This was destroyed during the Revolution, but is recorded in a miniature in a Book of Hours.[8] The dais is flanked on either side by *trompe l'oeil* half-length stone figures of a man and a woman leaning over the balustrade of a sham opening as if surveying the street below. This imaginative treatment not only establishes the intimate, personal quality that characterises the entire building despite its size, but also effectively masks the smallness of the windows incorporated in the composition over the sham windows, which perform the very practical function of lighting the oratories opening off the chapel above the entrance. Jacques Coeur is represented on the balustrades with the cockle-shell of his patron-saint, Saint James of Compostela, alternating with a heart (*coeur*). And for good measure the balustrade at the base of the stair tower is emblazoned with his motto. The main building lies across the court from the entrance portal. As on the street façade we find that the free and irregular disposition of forms and elements creates a singularly picturesque massing and skyline. The rich decoration again includes a profusion of cockle-shells and hearts, and in the bas-reliefs of the central stair tower—the focal point of the composition—exotic trees and

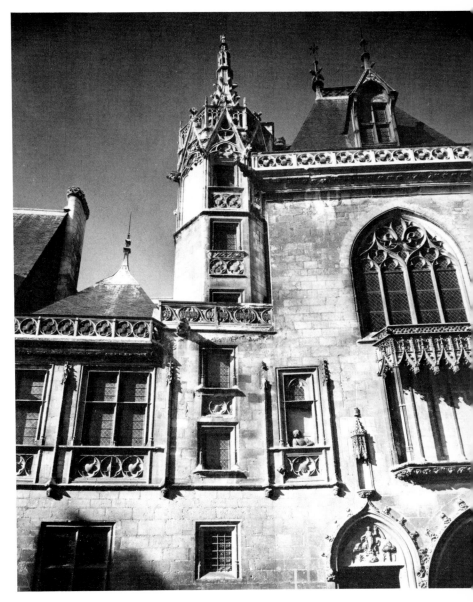

104 *Below* View of the court, showing the contrast between the decorative richness of the residence proper (left), and the more sober treatment of the wings devoted to business (right). The silhouette in the upper-right foreground is that of the dais over the entrance portal that housed an equestrian statue of the owner. *Palais de Jacques Coeur, Bourges*

105 *Right* Detail of the street façade which follows the gentle curve of the site. Note the *trompe-l'oeil* figure of a man looking out over the balustrade of a sham window. *Palais de Jacques Coeur, Bourges*

people appear, among them a figure in a turban, evoking the Levantine source of the great merchant's wealth. Homely genre scenes over the doorway and tympanum leading to the kitchen and domestic quarters represent the triumph of new bourgeois values. Although neither Jacques Coeur's architect nor his sculptors are known, the stylistic evidence points clearly to the influence of Flemish realism.

The Palais de Jacques Coeur was conceived not only as a residence but also as a suitable place to conduct business. To this end the wings enclosing three sides of the court are devoted to loggias and galleries where merchants could gather and goods be displayed or stored. The architectural treatment of these wings is sober and regular, in contrast to the exuberance of the residential building. The whole complex reveals a concern for privacy and convenience in the planning, with a clear separation of public, private and service functions, facilitated by no less than seven spiral stairs. Jacques Coeur's office and vaulted treasury are at the top of one tower for security reasons no doubt, whereas bedrooms have no fewer than three doors, one leading directly, via a narrow corridor in the thickness of the wall, to the latrines situated at mezzanine level and the small steam-rooms that were heated from the furnaces in the service area below.

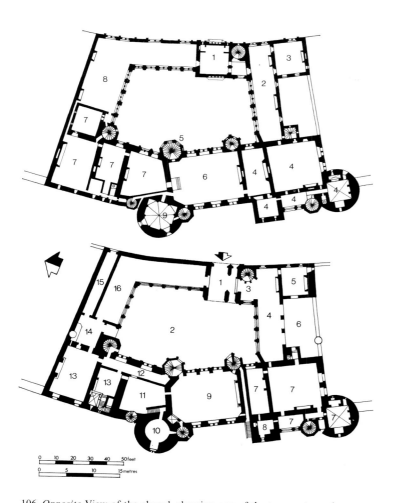

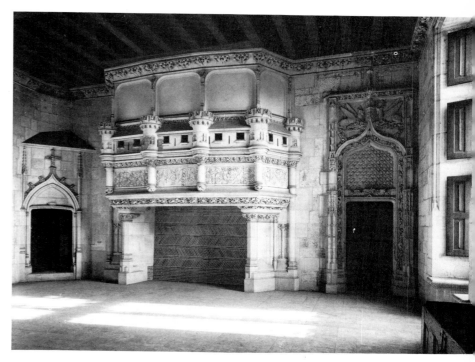

106 *Opposite* View of the chapel, showing one of the two oratory-alcoves provided for the master and mistress. The polychrome wall decoration dates from nineteenth-century restoration. *Palais de Jacques Coeur, Bourges*

VIII *Above* Plan of the Palais de Jacques Coeur, Bourges:
Ground floor: 1 Entrance with separation of horse and foot traffic; 2 Court; 3 Stair providing direct access to chapel above; 4 Portico; 5 Porter's lodge; 6 Court with well; 7 Suite with private circulation; 8 Access to exterior at lower level outside ramparts; 9 Banqueting Hall; 10 Service office; 11 Servery; 12 Service corridor; 13 Kitchen; 14 Service court with well connected by lead conduiting to kitchen; 15 Service entrance; 16 Portico where merchants could display wares under cover and the poor could gather to receive alms and food from the kitchen.
First floor: 1 Chapel also directly accessible from entrance below; 2 Glazed gallery; 3 Office; 4 Private suite; 5 Main stair of residence; 6 Great Hall; 7 Bedrooms with separate service corridors, and private access to toilets and steam baths heated from kitchen below; 8 Glazed gallery; 9 Office of Jacques Coeur with treasure chamber above.

107 *Top right* Main hall with the fascinating, if much-restored, monumental fireplace. *Palais de Jacques Coeur, Bourges*

108 *Above right* This carved corbel bracket from Jacques Coeur's treasure room represents the triumph of anecdote over aesthetics. It depicts a scene from the story of Tristan and Isolde: King Mark watches the lovers from a tree but his reflection is seen in the pool below by Tristan. *Palais de Jacques Coeur, Bourges*

After Jacques Coeur's disgrace his palace functioned subsequently as town hall and law courts and the interiors have suffered a great deal, but the state dining-room preserves an impressive, if over-restored, fireplace and a magnificent doorway with an ogee arch enclosing a panel of *fleurs-de-lys* and, above, winged stags: encased in plaster in the eighteenth century, this

doorway was successfully disengaged in virtually pristine condition. The chapel, placed astride the entrance portal, served not only the family–with twin alcoves for the master and mistress lit, as we have noted, by the small windows over the half-length figures on the façade–but also merchants frequenting the loggias and galleries. Yet ironically it is because it was crudely divided into two storeys that the original decoration of the chapel vaults has been preserved at all. Hidden from the eyes of the Revolutionary vandals, the paintings were glimpsed by chance by Prosper Merimée in 1838, above stacks of judicial papers stored in the upper space. Disposed within the triangular compartments defined by the vaulting ribs, angels against a nocturnal sky spangled with golden stars proffer scrolls with laudatory inscriptions from the Song of Songs and the Gospel of St Luke. The style of the figures represents an unknown French master's interpretation of the Flemish tradition bequeathed by Jan van Eyck and Rogier van der Weyden. The quality of the ceiling decoration makes one regret all the more the destruction of the chapel's furnishings and works of art: the triptych of the altar, for example, described by the Florentine ambassadors in 1462 as 'most beautiful and painted by a great master', and the stained glass of the two identical high windows facing street and court.

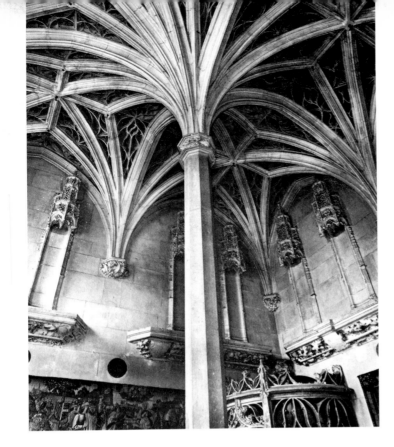

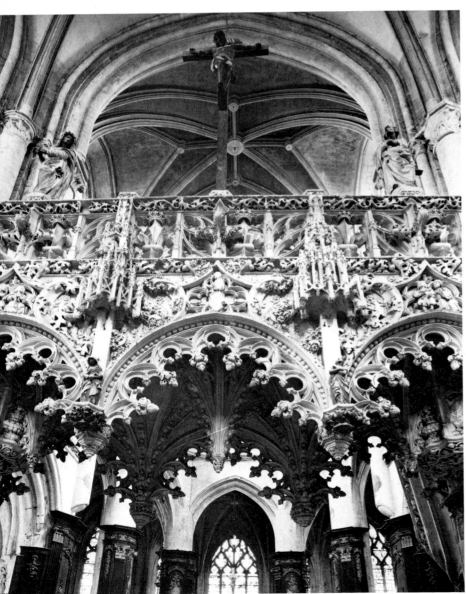

The tracery of the heads incorporates the ubiquitous heart emblem in juxtaposition with a resplendent *fleur-de-lys*, duplicating the design of the window of the chapel of Jacques Coeur in the cathedral of Bourges which, by good fortune, has preserved its magnificent original glass. Executed between 1448 and 1450 from a design apparently by the same artist responsible for the angels of the painted vaults, the central panels depict the Annunciation, flanked by figures of St Jacques and St Catherine, respectively the patrons of the merchant-prince and his wife Macée de Léodepart. Of superb quality, the window is certainly one of the masterpieces of fifteenth-century French stained glass. 112

The other residence on a semi-regal scale to survive relatively unscathed is the Parisian home of the abbots of Cluny, now housing the Musée Cluny, built between 1485 and 1498. The finest interior is that of the chapel with its soaring central pier supporting a vault whose heavy ribs consort strangely with the extremely delicate stone-tracery decoration applied in the vault cells.[9] 109

Both the Palais de Jacques Coeur and the Hôtel de Cluny are in the mainstream of French Gothic. An interesting example of a uniquely regional development is the Chateau de Josselin in Brittany, seat of the celebrated Rohan family. Within the grim fortifications a palatial manor house with an open court façade was erected between 1490 and 1505. The treatment shows a highly original interpretation of standard Flamboyant Gothic motifs, with bold and simple details, well-suited to local craftsmen working the coarse native granite. The façade shows how random elements can be brought together into a harmonious composition by the strong design of the dormers. 113

In church interiors further opportunity for lavish decoration was provided by the rood screens, or *jubés*.[10] Later considered an unfortunate visual obstruction, few survived the passion of the eighteenth-century canons for an uninterrupted vista. A most unusual example is to be found in the church of Sainte Madeleine at Troyes, conceived as a bridge of three suspended bays spanning the entire width of the choir. Noteworthy is the clarity and strength of the composition, despite the decoration, executed in a soft and easily-worked limestone, that covers virtually every square inch, as if in response to an almost pathological *horror vacui*.[11] 110

The cathedral of Sainte Cécile at Albi preserves the finest combination rood-screen and choir enclosure, constructed *c.* 1500 on the initiative of the art-loving bishop, Louis I of Amboise. The cavernous church interior provides a perfect setting for the jewel-like richness of the *jubé*. Particularly effective is the change of scale from vaults over 92 feet high to the intimacy of the *jubé* porch with its pendent vaults and star-inscribed, circular boss ornaments. The choir stalls are surmounted by a high dais with serried rows of angels and intricate canopies so undercut that it is understandable that Cardinal Richelieu, on his 114 115 116 117 118

109 *Above left* Chapel of the abbots of Cluny with central pier and fine tracery decoration of the vaulting cells. *Hôtel de Cluny, Paris*

110 *Left* Detail of the *jubé* (1508–16) bridging the entire width of the choir. *Church of Sainte Madeleine, Troyes*

111 *Opposite* Mid-fifteenth-century painted decoration of the chapel vaulting. *Palais de Jacques Coeur, Bourges*

112 *Overleaf The Annunciation*: detail of a stained-glass window, 1448–50, in the Jacques Coeur Chapel. *Bourges Cathedral*

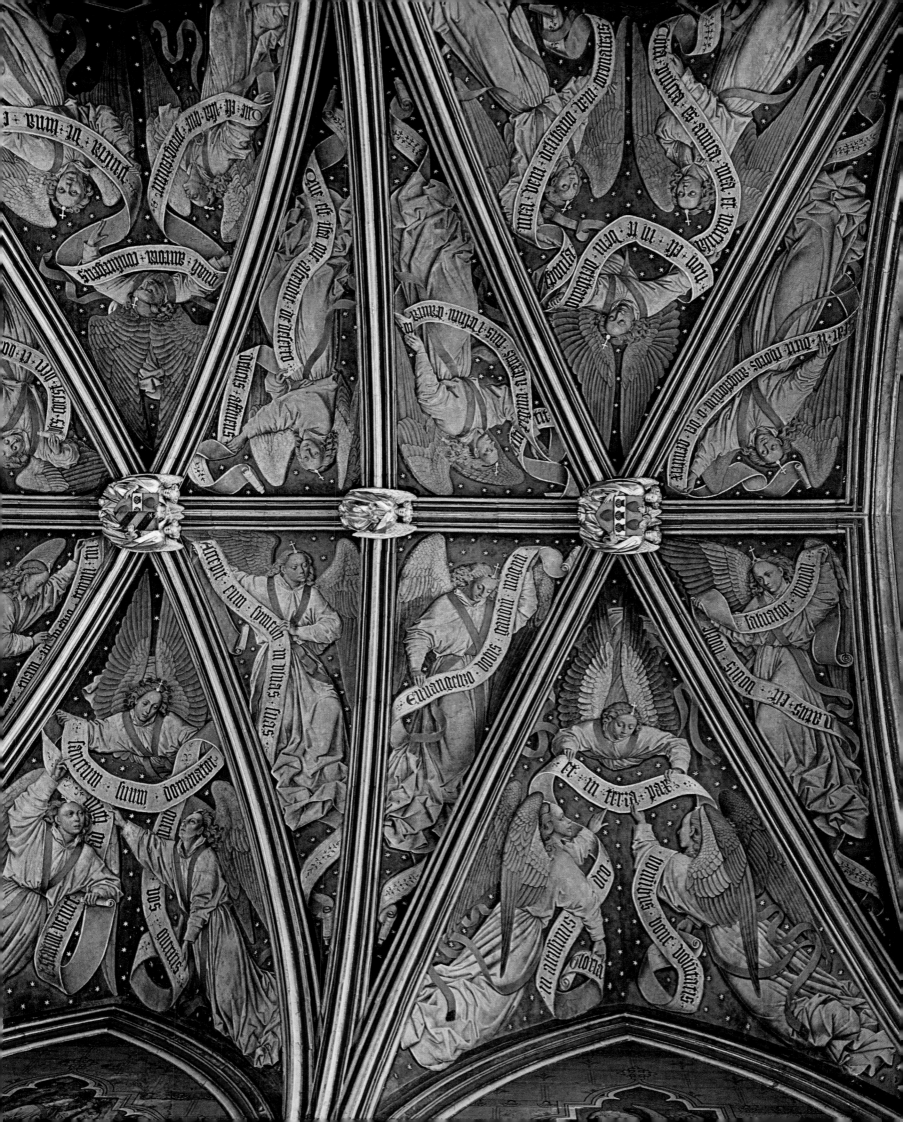

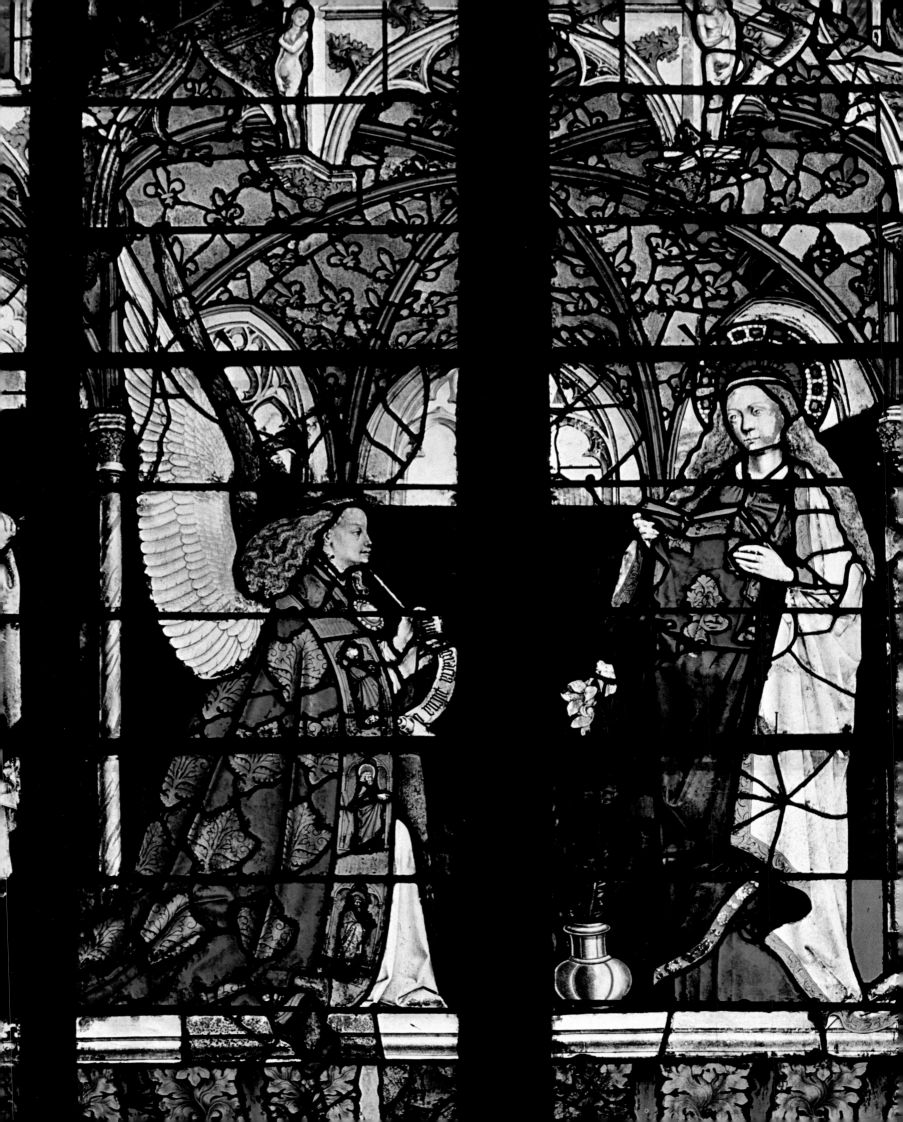

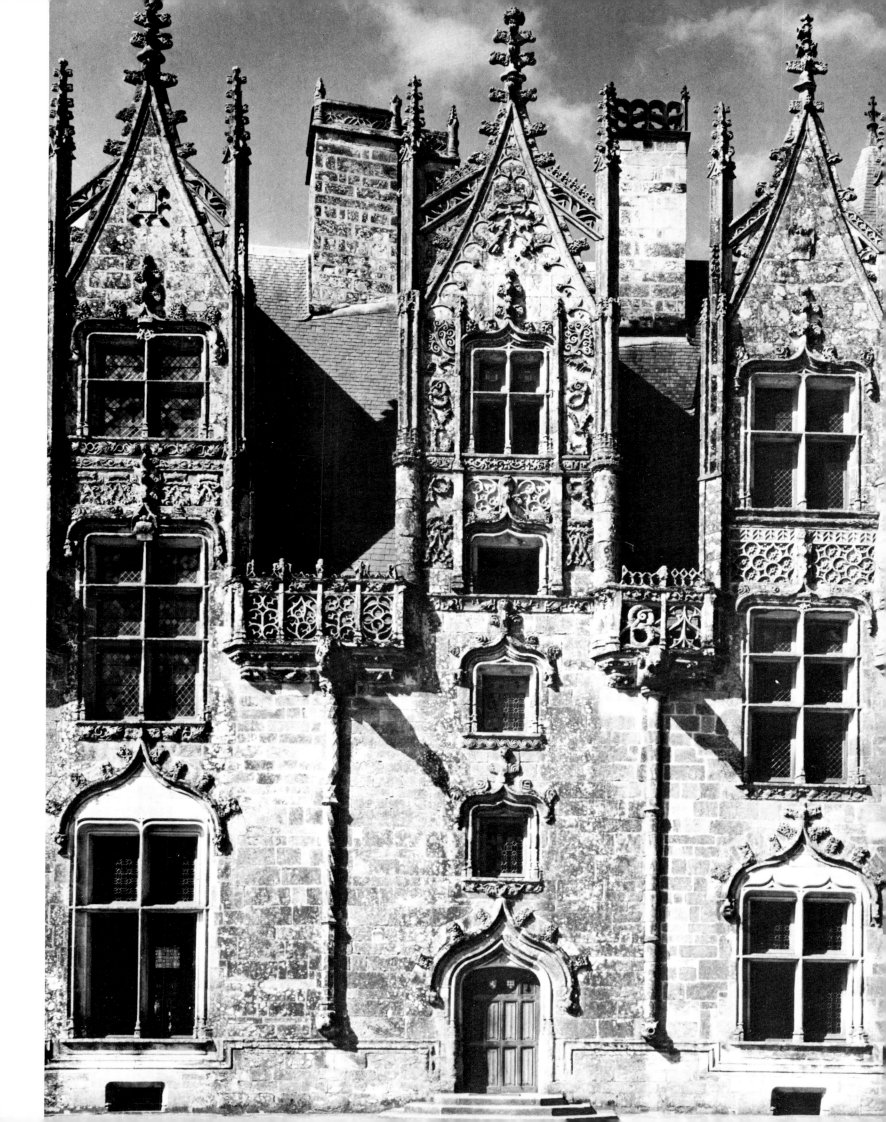

visit in 1629, thought they were made of stucco. Portals on either side of the *jubé* porch give access to the ambulatory around the choir, where statues of Old Testament prophets, kings and heroines on high pedestals adorn the enclosure wall. Unusually well-preserved, the figures have even retained their cloyingly rich polychromy which reinforces the over-blown autumnal mood. Stylistically, these stocky, expressive and highly individualised figures with heavy, voluminous drapery follow the tradition established by Claus Sluter in Burgundy.

Just as the introduction of the *jubé* and choir enclosure had completely altered the character of the interior, so the addition between 1519 and 1535[12] of a sumptuously decorated, monumental south porch, affords a dramatic contrast to the forbidding exterior, conceived as a fortress confronting a hostile world after the brutal suppression of the Albigensian heresy.

The cathedral at nearby Rodez is another fine example of meridional Gothic. The cliff-like wall of masonry of the south transeptal front, which excludes the hot southern sun, is the very antithesis of the 'glass-houses' of Northern Gothic. Of uncommon interest is the great rose with its alternation of two different tracery motifs, asymmetrically arranged to create a swirling vortex, its irresistible sense of movement emphasised by the static

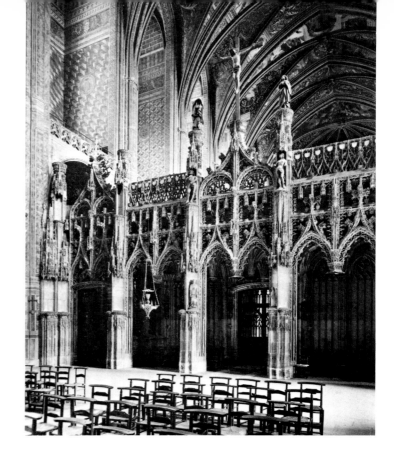

113 *Previous page* Courtyard façade of the addition (1490–1505) built for Jean Rohan II, illustrating the transition from fortification to comfortable country seat. *Château de Josselin, Brittany*

114 *Left* Detail of the vaulting of the *jubé* porch. *Albi Cathedral*

115 *Above* View of the *jubé* or rood-screen, *c.* 1500. *Albi Cathedral*

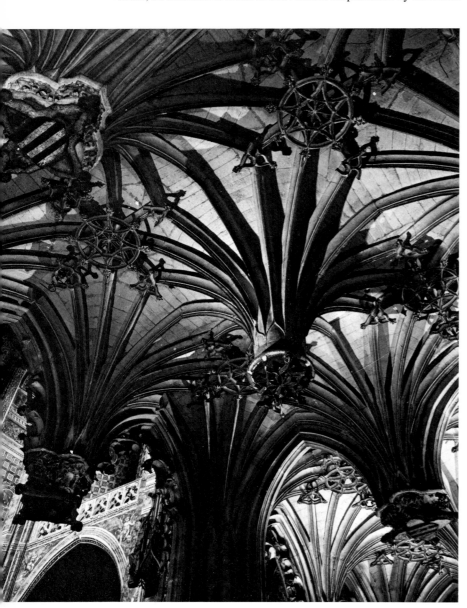

arrangement of tracery in the smaller rose below. A local master, Antoine Salvan, was responsible for the 295 feet high belfry tower (1513-26), in which we find a progressive transition from the stark simplicity of the base to the dazzlingly rich decoration of the uppermost stages – an effective conjunction of elements of diametrically opposed character, which would achieve its ultimate development in Spain.

Between 1508 and 1522 a team of craftsmen, some of whose names are known to us,[13] carved the 120 canopied choir stalls of Amiens Cathedral, 110 of which remain, forming the finest ensemble in all Europe. Carved throughout in stout oak, the style is Flamboyant Gothic at its most lavish, with hardly an intimation of the Renaissance, despite the late date. A vast panorama of Biblical lore, from the Creation to the Redemption, unfolds in ordered progression, augmented by characters from legend and fable – a fox in a monk's cassock preaching to the hens, for example – and a whole gallery of contemporary types: mason, butcher, tailor and moneylender, musicians, beggars, pilgrims and prostitutes. In all there are no fewer than 4700 figures, incorporated within an architectural setting of stupefying virtuosity. So slender are some of the vertical members as to vibrate with a twanging sound when plucked, yet so soundly constructed as to have survived the centuries virtually unscathed. The formidable technique is subordinated to a harmonious overall conception within which the elements evolve in a seemingly organic manner, appearing, as one enthusiast has said, 'to grow like living branches, to leap like living flame . . . canopy crowning canopy, pinnacle piercing pinnacle . . . wreathing itself into an enchanted glade, inextricable, imperishable, fuller of leafage than any forest, and fuller of story than any book'.[14]

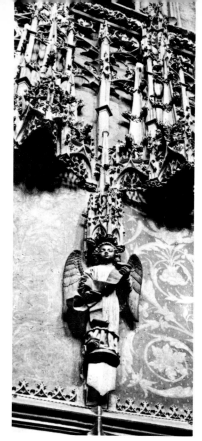

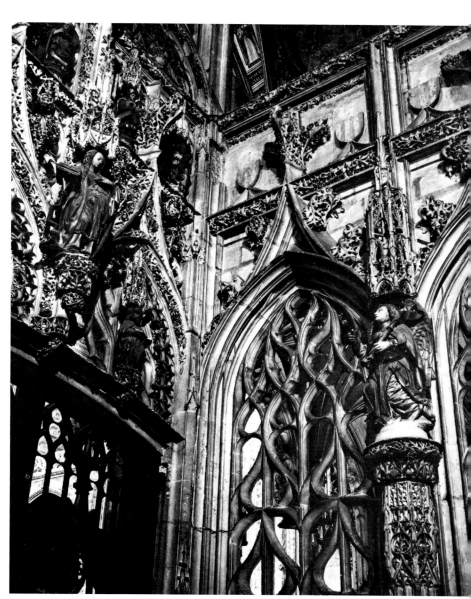

116 *Above* Figure of Judith on the exterior of the choir enclosure. The interlaced ornament in the head of the adjacent ogee arch forms the monogram JHS (*Jhêsus*). *Albi Cathedral*

117 *Above right* Detail of angel and stone canopy over the choir stalls. *Albi Cathedral*

118 *Right* The artist has made a virtue of necessity in this imaginative treatment of the Annunciation at the junction between choir-enclosure and *jubé*. *Albi Cathedral*

A worthy swan-song of Gothic in France is provided by the Église de Brou at Bourg-en-Bresse. This was built between 1513 and 1532 at the command of Margaret of Austria, daughter of the Emperor Maximilian and Mary of Burgundy, to house the tomb of her husband, Philibert-le-Beau, Duke of Savoy, who had died at the age of twenty-four. Margaret had intended to stay in Bourg-en-Bresse, at that period part of the Duchy of Savoy, but on the death of her brother she was appointed Governess of the Netherlands and guardian to her nephew, the future Emperor Charles V, and established her court at Malines. Though destined never to return to Bourg-en-Bresse,[15] Margaret lavished a fortune on the project and followed its progress with great interest. Twice a year the architect, Loys van Boghem, journeyed from Brou to Malines to report on progress, submit designs and recruit artisans.

The exterior of the Eglise de Brou as it stands today is rather undistinguished. The beauty is all within. The Brussels-born van Boghem worked in the currently much-admired Flemish Flamboyant idiom. A particularly interesting feature is the sophisticated detailing of the pier bases, where the shafts which start at different levels give the impression not of dead weight pressing downwards, but rather a subtle suggestion of a living force rising upwards – a sensation accentuated by the continuous line of the shafts, unbroken by capitals, from base of pier to apex of vault. The nave, illuminated by colourless glass, is cool, serene, noble, and a trifle bare, and provides the perfect setting for the ornate *jubé* screen. The choir itself is a treasure-

124

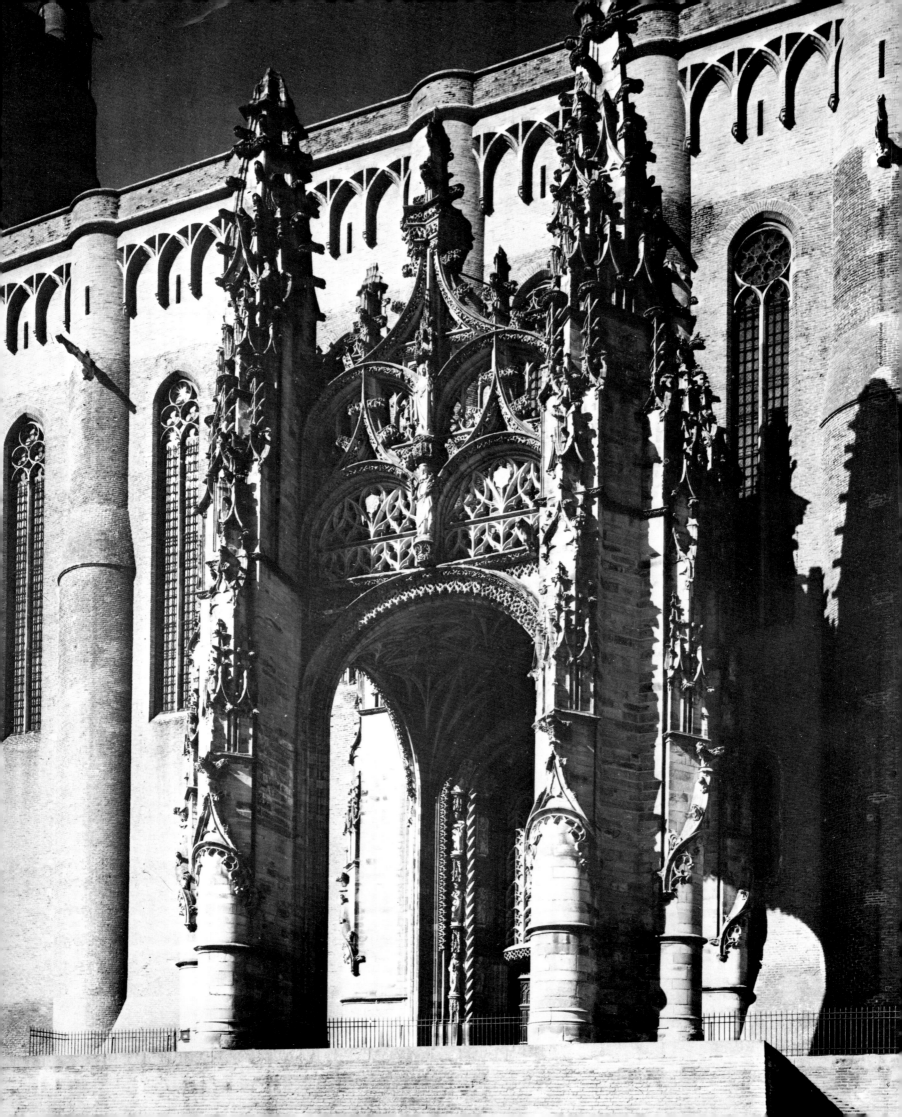

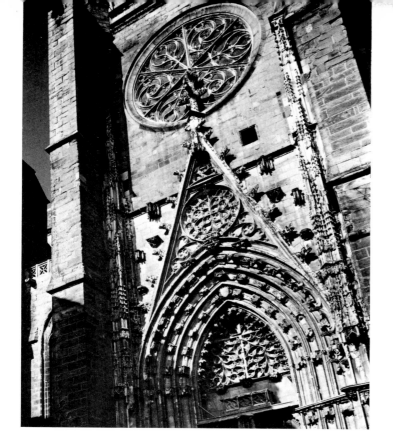

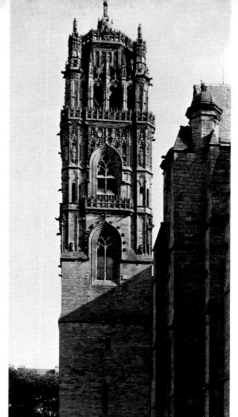

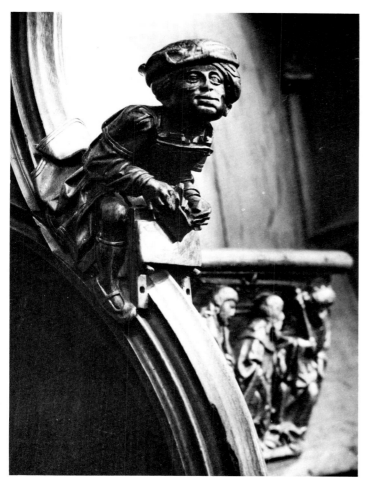

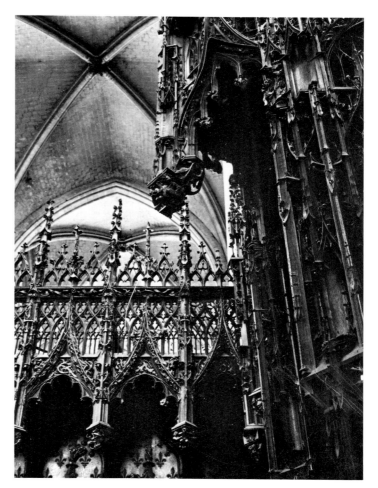

119 *Opposite* The monumental entrance porch (1519–35) which provides such a gracious welcome to the austere fortress of the Faith. *Albi Cathedral*

120 *Top left* South transept façade. *Rodez Cathedral*

121 *Above* Figure of a carpenter decorating an elbow-rest of the choir stalls. *Amiens Cathedral*

122 *Top right* The red sandstone northern tower (1513–26) by Antoine Salvan. *Rodez Cathedral*

123 *Above* Sober quadripartite vaulting high above provides the perfect background for the filigree delicacy of the early-sixteenth-century choir stalls. *Amiens Cathedral*

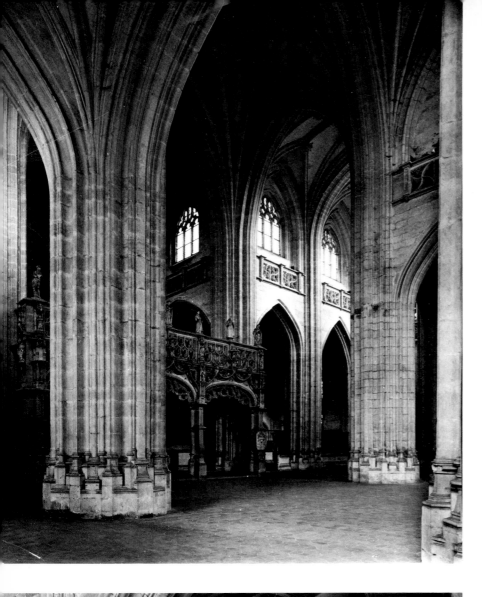

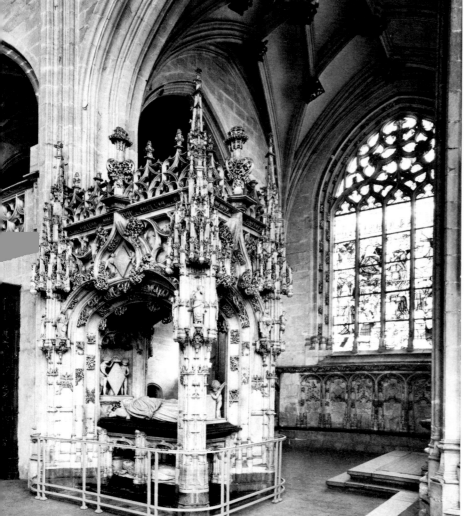

house with its exceptionally fine choir-stalls and three superb 125
tombs – of Philibert-le-Beau, his mother, Marguerite de
Bourbon, and of Margaret of Austria herself – bathed in the
warm glow of rich stained glass.

The large, recumbent effigies of the deceased, in robes of state
above, and as *transi* or corpses below, were executed by Conrad
Meyt (or Meit) of Worms, German by birth but Netherlandish
by training, who contracted to complete them in four years,
aided by his brother Thomas and two assistants. The most
harmonious and beautiful monument is that of Margaret of
Austria, with her twin effigies surmounted by a dais or
baldacchino with Flamboyant ornament of the most extraor-
dinary exuberance, yet of a delicacy and precision one
associates with the work of a goldsmith, and subordinated to
the overall, fundamentally simple design. Yet although the 127

124 *Above left* View across the nave looking towards the *jubé*. *Eglise de
Brou, Bourg-en-Bresse*

125 *Left* Tomb of Margaret of Austria which abuts the pier separating the
choir from the princess's private chapel. The cresting and cornice moulding
continue the line of the balustrade behind. The railing protects not only the
tomb, but also some of the original glazed floor tiles. *Eglise de Brou,
Bourg-en-Bresse*

126 *Above* Detail of the reveal of the southern bank of choir stalls with
lively vignettes of the Nativity, the Adoration of the Magi and, above, the
Presentation in the Temple. *Amiens Cathedral*

127 *Opposite* Detail of the canopy of the tomb of Margaret of Austria,
with interlaced monograms and statuette of St Mary Magdalen. *Eglise de
Brou, Bourg-en-Bresse*

architectural detail is still pure Gothic, the Italianate *putti* at Margaret's feet, carved by Thomas Meyt, clearly announce the advent of the Renaissance.

Royal patronage in France had long been extended to painting and illumination. Our period opened with the disastrous military reverses of the reign of John the Good (1350-64): his likeness in the Louvre is the earliest surviving French – or, indeed, Northern European – example of portrait painting in the modern sense.[16] It combines a profile arrangement in the Italian manner, inspired by the classical medallion, with remarkably shrewd and unflattering characterisation, very different indeed from earlier idealised representations of royalty, which stressed the office rather than the individual. The canvas or panel dates from the period 1356-9 and is generally attributed to the court painter and *valet de chambre*, Girard d'Orléans, who accompanied the king in his captivity in England.

Tapestries were the favoured form of wall decoration in Northern Europe. An inventory during the reign of King John's successor, Charles V, lists no fewer than two hundred

128

128 *Left* Portrait of Jean le Bon, King of France, attributed to the court painter Girard d'Orléans. *Louvre, Paris*

129 *Below* 'The angel sounds the second trumpet and St John weeps to see fire descending from the heavens and the seas engulfed.' *Apocalypse Tapestry*, 1375–81. *Musée des Tapisseries, Angers*

130 *Opposite* Detail of late fifteenth-century Flemish tapestry depicting hunting scenes. *Victoria and Albert Museum, London*

tapestries compared to a mere score of paintings. Practical in excluding draughts and conserving heat, the soft texture and rich colouring of tapestry made an ideal if costly interior furnishing. Like medieval stained-glass it owed its artistic success to its respect for the nature of the medium. Decline set in when, with the advent of the Renaissance, an ever closer approximation to painting became the ideal of both media.[17]

From the reign of Charles V dates the oldest and, paradoxically, the largest surviving series of medieval tapestries, the 'Apocalypse Series' which Louis I of Anjou, the king's brother, commissioned to decorate his castle at Angers.[18] Charles V graciously lent his brother the help of the court painter, Jean Bondol (alias John of Bruges, author of the fascinating miniature depicting King Charles 'the Wise' not as a monarch but in the cap and gown of a Paris Master of Arts)[19], and also a thirteenth-century manuscript with illustrations of the Apocalypse to serve as a model for the iconography.

The *Angers Apocalypse* consists of seven sections, each introduced by a monumental figure seated beneath an elaborate *baldacchino* symbolising the Seven Churches of Asia, and a series of narrative scenes from the Book of Revelations, arranged in two tiers against crimson and blue backgrounds alternating in chequerboard fashion. This arrangement can be traced to the thirteenth-century manuscript model, which has been identified in the Bibliothèque Nationale in Paris from an inscription: *'le roi l'a baillée à Mons. d'Anjou pour faire son beau tappis.'*[20] Although he followed his model closely, Bondol modernised the already old-fashioned designs and imbued them with his personal style, which even survived translation by the weavers and provides a strong sense of continuity through the different sections. The formidable task of production – the total length of the seven sections placed end to end is no less than 432 feet – was carried out between 1375 and 1384 under the direction of the Parisian tapestry maker, Nicholas Bataille. The technical assurance and economy of means are astonishing and presuppose a highly developed art of tapestry. Only thirty different colours of wool thread have been used in the entire work and generally no more than twenty in one scene.

Italian influence on the art of illumination is demonstrated with the work of Jean Pucelle, active from *c.* 1320. Not surprisingly it was the Sienese School, elegant, aristocratic and with an emphasis on decorative pattern and calligraphic line that appealed to the sophisticated Parisian taste. From Duccio Pucelle adopted the Italian practice of placing his figures within an architectural setting seen in perspective, a spatial box like a doll's house with the front removed. Despite initial inconsistencies of scale and rendition, the decisive step towards an interest in pictorial space had been taken. Equally significant, however, was his perfection of the marginal and *bas-de-page* decoration and the whimsical drolleries beloved of the English miniaturists, and their integration with the text and main scene. Pucelle set French book illustration on the path it would follow

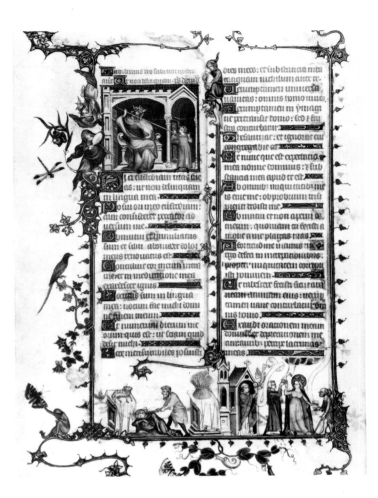

131 *Opposite* Court of the hospital founded by Nicolas Rolin in 1443 and still in use today, partly financed by the vineyards with which he endowed it. *Hôtel Dieu, Beaune*

132 *Above right* Page from the *Belleville Breviary* by Jean Pucelle, dating from 1343. (Ms Lat. 10484, fol. 24v). *Bibliothèque Nationale, Paris*

133 *Right* Charles V of France. Detail of the effigy commissioned from André Beauneveu and completed in 1366. *Basilica of Saint Denis, Paris*

for the entire fourteenth century. This had all the more momentous implications since it was on the diminutive scale of the miniature, rather than in panel painting – except, as we shall see, in Burgundy – that the most significant advances in French Late-Gothic painting were made.

Spectacular achievements in the final chapter of the history

132

of the medieval illuminated manuscript are inseparably linked with the name of a connoisseur, one of the greatest patrons of art of all time: Jean, Duc de Berry. The third son of King John the Good, he was granted the *apanage*, or semi-independent feudal fief, of Berry, but unlike his brothers, the Dukes of Burgundy and Anjou, abjured the paths of political independence and of warfare–at which Jean de Berry proved himself singularly inept–for the pleasures of art and living on a scale calculated eventually to exhaust even his enormous fortune. Small wonder, for the duke betrayed compulsive acquisitiveness with his seventeen luxuriously furnished palaces and chateaux, his 1500 dogs, his 'heraldic beasts', which were bears and swans, his collections of jewels and plate, a series of tapestries which if placed end to end stretched for 1200 feet, and

his wife[22], and of particular interest, his effigy of Charles V, a true portrait from life, which faithfully records even the premature flabbiness due to chronic ill health. The Duc de Berry spent days discussing projects with Beauneveu: the chronicler, Froissart, records that the English embassy was kept waiting for an audience for three weeks while he was with him at the Chateau of Mehun-sur-Yèvre near Bourges. Beauneveu is traditionally credited with the design of this chateau, and seems to have served his patron in many capacities, including that of architect and miniaturist. As the latter his fame rests on a documented series of twenty-four, full-page illustrations of enthroned Prophets and Apostles, facing each other on double pages to symbolise the Concordance of the Old and New Testaments. Not surprisingly, the figures

133

136

135

twenty-four illuminated Books of Hours. His habit of taking a book being illuminated by the artists resident in one chateau with him, to be continued or completed in the next, has had important repercussions in art history, greatly complicating the question of attribution. There is no doubt, however, that his keen interest in their creation inspired his artists to reach new heights of perfection.

André Beauneveu entered the service of the Duc de Berry around 1380 and held the position of court sculptor until his death shortly before 1402. Reputedly the most celebrated artist in the royal domain, Beauneveu had previously been in the service of Charles V[21] and had been responsible amongst numerous other commissions for four of the royal tombs at St Denis, of the king's grandfather, father (John the Good) and

134

134 *Above left The Presentation in the Temple.* Imbued with a classic restraint and tender lyricism, this alabaster group of *c*. 1390 is attributed to André Beauneveu. *Musée Cluny, Paris*

135 *Above* Book illumination by the sculptor André Beauneveu depicting the Prophet Isaiah; from the *Psalter of Jean de Berry, c.* 1380–85. (Ms fr 13091, fol 11v). *Bibliothèque Nationale, Paris*

indicate a sculptor's preoccupation with plastic form, colour playing a strictly subservient role. The danger of monotony inherent in so large a series is avoided by individual characterisations and great variety in the designs of the elaborate thrones.

The ducal inventories record the production of manuscripts at this period by *'Jacquemart de Hodin et autres ouvries de*

Monseigneur'. Jacquemart de Hesdin, a native of the Artois, which at that time was incorporated in Flanders, is first recorded at the court of the Duc de Berry in 1384 and remained in his service until his death around 1409. Under Jacquemart's direction four magnificent Books of Hours were produced for the duke.[23] The assessment of Jacquemart's stature is complicated by the large proportion of studio works and also by later additions, but an example of his personal style at its most elegant is the *St John the Baptist in the Wilderness*, from the earliest Book of Hours, produced between 1380 and 1385, and showing man and nature, great and small, in perfect harmony. It is not the miniature alone, but rather the ensemble of miniature, initial letter, script and border, freely arranged in an asymmetrical yet perfectly balanced composition, that makes this such an outstanding example of the art of the illuminated book.

After his death, Jacquemart de Hesdin's position as chief illuminator to the Duc de Berry was inherited by three brothers, Pol, Herman and Jehanequin, known to history as the Limbourg Brothers. Born in the Netherlands, they were apprenticed in 1399 to a Parisian goldsmith and worked for Philip the Bold of Burgundy until his death in 1404. It is not known when precisely they entered the service of the Duc de Berry, but it is recorded that on New Year's Day of 1411 they presented him with a *'livre contrefait'*: a block of white wood painted in *trompe-l'oeil* style to resemble a volume covered in blue velour and fitted with two silver-gilt clasps enamelled with the duke's arms. Exhorted by their demanding patron and inspired by his collection of the rarest and most beautiful treasures, the Limbourg Brothers in their final work produced their most magnificent manuscript, the *Très Riches Heures du Duc de Berry*. Probably begun around 1413, it had not yet been completed when the duke, and seemingly also the Limbourg Brothers, died in 1416.

The most celebrated feature of the volume is the Calendar. In the form of full-page illustrations of the occupations of the months, the treatment anticipates the development of the panel picture, affording a striking contrast in this respect to Jacquemart de Hesdin's style which, as we have seen, represented the culmination of the earlier tradition in which picture and text were inseparable. The calendars sculpted on the portals of the great Gothic cathedrals traditionally represented January, the month of festivals and enforced rest for the peasant, with a banquet scene presided over by a regal personage. The Limbourg Brothers presented the 'January 139 Feast' at the luxurious court of the duke. Wearing a splendid figured robe and fur hat, the duke presides at the banquet table in a chamber hung with tapestries depicting a battle scene. He is seated with his back to the monumental fireplace, and the artist has cleverly utilised the circular wicker fire-screen to isolate the duke from the background, rather in the manner of a halo. The formality of court etiquette, epitomised by the steward with his baton proclaiming *'Approche, approche'* to the servants bearing the next course, is relieved by the delightfully informal touches of the sleek greyhound in the foreground and the fluffy little dogs sniffing around on the richly laden table next to the duke's boat-shaped salt cellar.

The genre feeling in the treatment of the subject, the delight in observed detail, clearly indicate the Flemish origins of the Limbourgs. 'February' shows a scene of country life set in one of the earliest surviving snowscapes in European art. In the cold the peasant concentrates on his chores, anxious to return to the

136 Illumination by the Limbourg Brothers, *c.* 1415, from the *Très Riches Heures du Duc de Berry*. The ostensible subject is the Temptation of Christ, which has provided the artist(s) with an excuse for a detailed representation of the duke's château of Mehun-sur-Yèvre in a fanciful landscape setting. *Musée Condé, Chantilly*

comforts of the indoors, visible in a cutaway section through the cottage, where peasants warm themselves before the fire. Another contrast, seasonally and socially, is provided by 'April', with the extravagant court dress of the period, 16 displayed to perfection on the mannequin-like courtiers, 'thin and small-headed like overbred animals',[24] enjoying the pleasures of spring in the countryside. Very different from the stylised figures is the realistic treatment of the castle in the distance, identified as Dourdan, one of the ducal properties, a

137 *Above* The noted authoress and feminist, Christine de Pisan, sets about the construction of her ideal city. Illumination from *La Cité des Dames*, *c*.1407. (Ms fr. 607, fol 2). *Bibliothèque Nationale, Paris*

138 *Right* The military pageantry of the Late Middle Ages is evoked by this setting of a field tent emblazoned with the marshal's arms for the Coronation of the Virgin in the *Book of Hours of the Maréchal de Boucicaut*, fol 95, *c*. 1409. *Musée Jacquemart-André, Paris*

139 *Opposite* Banquet scene from the January Calendar of the *Très Riches Heures du Duc de Berry*, illuminated by the Limbourg Brothers, 1416. *Musée Condé, Chantilly*

whole series of which appear in the *Très Riches Heures*.

In the first decades of the fifteenth century three illuminators with distinct personalities dominated the Parisian scene. Anonymous despite extensive research, they are identified for convenience by the patrons or owners of their most celebrated works as the 'Bedford', 'Boucicaut' and 'Rohan' Masters. The Bedford Master takes his name from the Breviary and Book of Hours he executed between 1424 and 1435 for John of Lancaster, Duke of Bedford and Regent of France for the young Henry VI of England. Full of picturesque and accurately observed detail, which furnishes an invaluable source of information on contemporary life,[25] his not overly distinguished style was readily assimilable and exerted a greater influence for a longer period than any of his far greater contemporaries. In the style of the Bedford Master are the naively charming illustrations to Christine de Pisan's *Cité des Dames*. Of Italian origin, Christine (*c*. 1364–*c*. 1430) was the daughter of Charles V's court astrologer who turned to

literature in her widowhood as a means of support for herself and her three children. She shrewdly attuned her strong feminist convictions to the chivalric ideals of the period and was enthusiastically acclaimed by the greatest patrons of the day. In her *Cité des Dames* she extols a female illuminator who may well be the author of the illustrations: 'Speaking of painting, I know a woman named Anastaise who has such skill and cunning in making vignettes for illustrated books and landscape scenes for tales that in Paris, where all such things are well paid heed to, none fails to commend her, nor is there any other who so sweetly and delicately limns as she, nor whose work is more esteemed, so rich and rare are the books to which she has set her hand'.[26] An illumination in a copy which belonged to no less an admirer than the Duc de Berry shows

Christine on the left receiving a visit in her study from three regal women personifying Reason, Virtue and Justice, who proffer assistance in building the 'City of Women', shown under construction on the right. 137

The second master takes his name from a sumptuous Book of Hours produced for one of the most admired men of the day: Jean de Meingre, Maréchal de Boucicaut. This embodiment of chivalry, justice and piety, poet of distinction and outstanding tennis player, won the hand of the beautiful Antoinette de Turenne in competition with a prince of the blood royal in one of the great romances of the period. A natural leader of men and redoubtable exponent of the martial arts, he was created Marshal of France in his twenties. Taken prisoner at Agincourt in 1415, he was honoured even by his captors as the 'verray parfit gentil knight' and died in captivity in 1421, having outlived both his beloved wife and only son.

We have already noted that heraldry was one of the preoccupations of the age. In the Boucicaut Hours it becomes an obsession.[27] That the marshal should kneel before St Catherine in an interior with hangings decorated with his colours and motto seems not unreasonable; that the Coronation of the Virgin in Heaven should take place in a tent conspicuously emblazoned with the marshal's emblems seems to our eyes to border on the sacrilegious. We may be sure that 138 nothing could have been further from the intention of either the artist or a patron renowned for his 'humble piety'. Clearly we are dealing with but one more example of that extreme familiarity with sacred things during the Late Middle Ages which made them seem part of normal daily life.

The Boucicaut Master played a most important role in the evolution of Northern painting as a precursor of the great Flemish masters, particularly in his use of aerial perspective in his landscape backgrounds, which are suffused by light, and the more rational organisation of space in his interiors.

The last and greatest of the three Parisian masters takes his name from a Book of Hours actually executed for the Duke of Anjou, but subsequently in the possession of the Rohan family, who appropriated it to their use by the addition of the family arms. The Rohan Master was a lone genius completely uninterested in the advances in naturalism that so fascinated his contemporaries, or in the niceties of fashionable court taste or a display of impeccable technique. Everything is subordinated to a powerful and dramatic exposition of the theme in an expressionistic style completely at variance with Parisian sophistication, which has prompted the suggestion that he may have been Spanish by origin.[28] The Rohan Master is particularly impressive when evoking a sombre mood. In 'The Vigils of the Dead', a dying man, his emaciated body outstretched in a burial ground transformed by skulls and bones into a symbolic Golgotha, commends his soul to God. A devil has already 140 grabbed the soul – represented according to medieval convention as a naked babe – but is in turn seized by a sword-brandishing archangel at the behest of God the Father, a majestic figure bearing the sword and orb of dominion, who casts a glance of tender compassion on the pitiful supplicant.

140 A dying man commends his soul to God. Page from the *Rohan Book of Hours*, c. 1418–25. (Ms Lat. 9471, fol 159r). *Bibliothèque Nationale, Paris*

4 Burgundy

Politically, the phenomenon of the age was the meteoric rise and fall of Burgundy. This originated, like Berry, as an *apanage* granted by King John, in this case to the youngest of his four sons, Philip the Bold, as a special token of gratitude for saving his father's life at the Battle of Poitiers. Burgundy under its four successive dukes pursued a policy increasingly independent of and inimical to France. When Charles V died young, leaving as heir a minor, subject in maturity to fits of madness, the situation was wide open for the intrigues and ambitions of the contending Burgundian and Orléanist factions at court. In 1407 John the Fearless, who had succeeded as the second Duke of Burgundy, connived at the murder of the Duke of Orléans, which in turn provoked his own assassination in 1419. Obsessed with the filial duty of revenge, the third duke, Philip the Good, allied himself openly with France's arch-enemy England, and by the Treaty of Troyes in 1420 was appointed co-regent of France with Henry V, and after his death, with the Duke of Bedford as co-regent for the infant Henry VI. The dauphin was accepted only in a limited area of central and southern France and derided as the *'roi de Bourges'*. Later there would be a reconciliation between Philip the Good and Charles VII, but only with the death of Philip's successor, the aptly-nicknamed Charles the Rash, in 1477 did Burgundy lose its importance.

The rise of Burgundy and the splendour of her court would not have been possible without the financial resources of rich Flanders, which had become part of the Burgundian domain through the marriage of Philip the Bold to the heiress of Louis de Mâle, the last Count. Henceforth, there would be every incentive to link Flanders and Burgundy, and during the long and brilliant reign of Philip the Good this goal was virtually achieved. Charles the Rash inherited an empire that seemed to need only the seal of an imperial crown to confirm his status as the leading magnate of Europe. He had begun negotiations with the Emperor when he was killed in the last of his ill-advised attacks on the Swiss at Nancy in 1477. At his death the looseness of the ties that had bound the motley collection of territories was revealed. The French Burgundian territories were reabsorbed into the royal domain, while the Netherlands, through the marriage of Charles' heiress, Mary of Burgundy, to Maximilian of Austria became part of the Hapsburg empire.

The century of Burgundian pre-eminence was as significant in the field of the arts as in politics. When John the Good granted the duchy to Philip the Bold in 1363, Dijon, the capital, was a cultural backwater and the duke had perforce to bring in artists and artisans to carry out his ambitious projects. The most important was the construction of the Carthusian

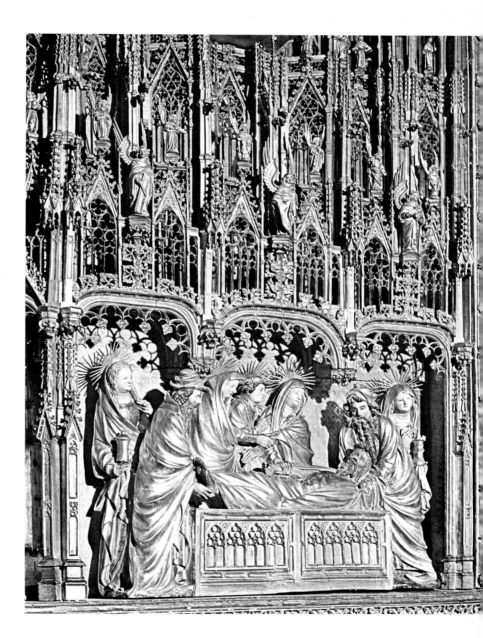

141 Detail of the Entombment from the altarpiece carved by Jacques de Baerze, (1390–99) and painted and gilded by Melchior Broederlam, for the Chartreuse de Champmol *Musée des Beaux Arts, Dijon*

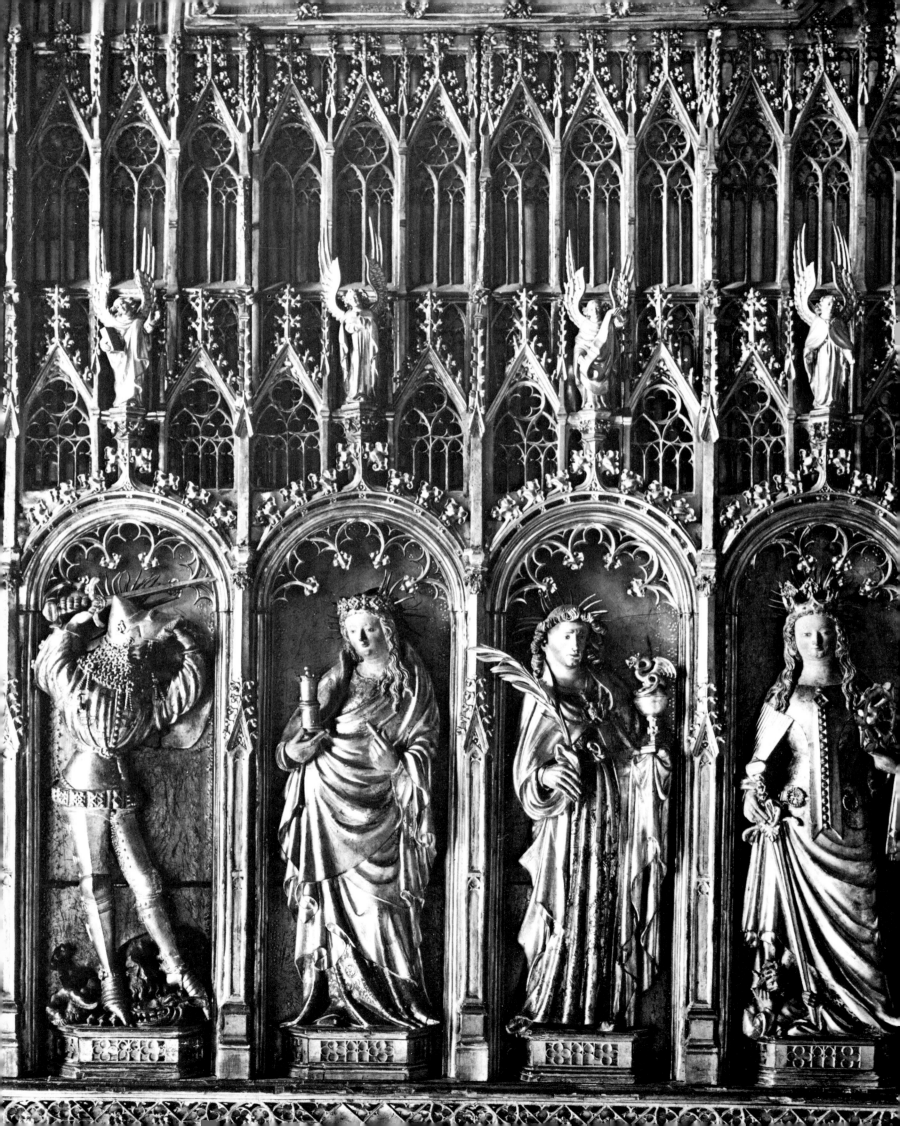

monastery, or Chartreuse de Champmol, just outside Dijon, founded in 1383. Intended as the mausoleum to glorify the new dynasty, a Burgundian equivalent of St Denis, as it were, the influence exerted by its decoration, and particularly by the sumptuous ducal tombs, make it a key monument in the history of art.

The architect was Drouet (or Dreux) de Dammartin, who had previously worked for Charles V on the old palace of the Louvre, and also for the Duc de Berry. He served as Philip's 'master-general of the works for all the Burgundian domains' from 1383 until 1397, when he was recalled by the Duc de Berry on the death of his chief architect Guy de Dammartin.[1]

It was during a visit to Flanders in 1390 that Philip the Bold admired a carved wooden altarpiece by Jacques de Baerze of Dendermonde (Termonde) near Bruges, and commissioned two triptychs from the artist for the Chartreuse de Champmol. The altarpieces are composed of a multitude of small-scale
141 figures and scenes within an architectural setting of exquisite
142 delicacy and complexity. The whole conception recalls the art of the goldsmith, the analogy being heightened by the surface finish with its overall impression of shimmering gold, subtly varied by coloured accents in the architectural setting, drapery and flesh tones. This painting and gilding was entrusted to no less a person than the court painter, Melchior Broederlam of Ypres, who also executed the paintings on the exterior of the wings.

Meanwhile, at the Chartreuse, a sculptor, Claus Sluter, also of Netherlandish origin, was making history. Various references to Sluter's place of origin as 'Orlandes' were greeted by critics with scepticism until confirmed by the discovery of Claes de Slutere (Sluiter) of Haarlem among the members of the *Steenbickeleren* or stonecarvers' guild of Brussels from 1379 onward.[2] So thorough was the iconoclastic fury of the Calvinists in the northern Netherlands that all traces of a monumental sculptural tradition–if one ever existed–have been completely erased. In the south a few fragments have survived[3] which bear a close relationship to Sluter's monumental sculptural concepts and penetrating realism, and it seems probable that he received his training in Brabant. What *is* clear, however, is that in March 1385 Sluter was in Dijon, the highest paid assistant of Jean de Marville, official '*ymagier et varlet de chambre*', then engaged on the sculptural decoration of the Chartreuse. At Marville's death in 1389 Sluter was put in charge of the workshop. The actual sculptures of the entrance portal to the church, if not the conception, would seem to be by Sluter. The Virgin and Child on the *trumeau* are flanked on the one side by the kneeling figure of Duke Philip, presented by
143 a massive St John the Baptist; on the other side by the kneeling Duchess and her patron, St Catherine. The figures are supported on boldly projecting corbels, propelling the expansive forms into the space, and asserting a new sense of sculptural autonomy. No longer are the figures constrained by pedestal and canopy. Architecturally, the relationship between the figures of the Duke and the Baptist and the canopies overhead is casual and arbitrary–in marked contrast to the perfect integration of sculpture and architecture in Romanesque and Early Gothic, epitomised by the 'column statues' of the Portail Royal at Chartres.

142 *Opposite* Four saints: detail of altarpiece carved by Jacques de Baerze for the Chartreuse de Champmol. *Musée des Beaux Arts, Dijon*

143 Philip the Bold of Burgundy and St John the Baptist; portal sculptures by Claus Sluter, dating from 1391–97. *Chartreuse de Champmol, Dijon*

Sluter's elaborate *baldacchino* over the Virgin–which replaced that designed by Jean de Marville and has in turn been lost–was ornamented with angels bearing the Instruments of the Passion. The posture of the Child, looking upward and
144 shrinking away from the Virgin, who also reacts strongly, has been interpreted as the Child's reaction on glimpsing the instruments of torture. Typical of Sluter's style, and prescient of future developments in Burgundian sculpture, is the voluminous drapery falling in elaborate and infinitely varied folds, treated, not as in so much Late-Gothic sculpture, as a decorative enrichment, but as an expressive and dynamic element reinforcing mood and action.

In 1395 Claus Sluter commenced the only surviving work conceived from its inception and completed by the master: a monumental Calvary rising over the well in the monks' cloister at the Chartreuse. The theological concept underlying the design derived from the analogy between the 'Fountain of the Water of Life' (*Puteus Aquarum Viventium*) and the redeeming blood of the Crucified Saviour. The Concordance between the Old and New Testaments was underscored by the hexagonal base of the well head, adorned with six prophets bearing scrolls inscribed with passages foretelling the death of Christ: Moses, David, Jeremiah, Zachariah, Daniel and Isaiah. Moses is a particularly commanding figure and his name has been applied to the entire composition, commonly known as the *Puits de Moïse* or 'Well of Moses'.

The Calvary group, comprising Christ, the flanking figures of

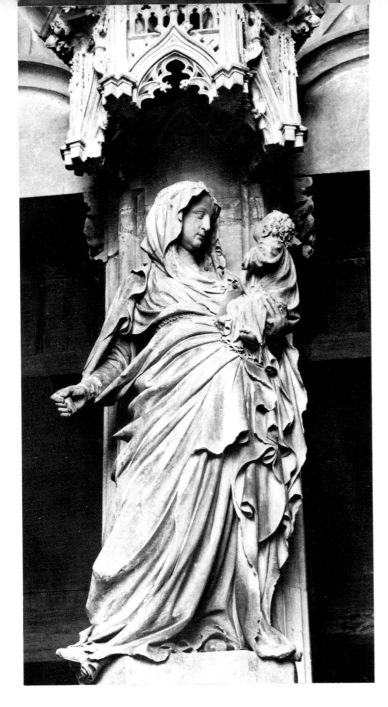

by a pair of metal spectacles commissioned from Hennequin de Hacht, a local goldsmith, for the statue of Jeremiah.[4] The original impression, resplendent in gilt and rich colour, if not entirely to our taste, must have been overwhelming in its impact on contemporaries. Indulgences granted on four occasions for pilgrimages to the Chartreuse de Champmol[5] spread the fame of the monument far and wide, and many echoes of the figures are found in the art of the following half century. Each of the six prophets is treated as a full-length portrait: particularly effective is the bald-pated Isaiah, seemingly weighed down by old age and the tragic import of the prophecy inscribed on his scroll: 'He shall be led like a lamb to slaughter; like a sheep before the shearer He shall be silent and not open His mouth'. The stumpy, disproportionate figure and the awkward–yet

145

144 *Above* Virgin and Child by Claus Sluter on the trumeau of the main portal. *Chartreuse de Champmol, Dijon*

145 *Right* The Prophet Isaiah from the *Puits de Moïse*, the base of the Calvary (1395–1403) by Claus Sluter. *Chartreuse de Champmol, Dijon*

146 *Opposite* The *Puits de Moïse* or 'Well of Moses': left to right Moses, King David and Jeremiah. Sluter has used the angels to contribute positively to the design, by strengthening the angles of the hexagon, carrying the eye upward to the cornice, and framing the figures of the prophets with their outstretched wings. *Chartreuse de Champmol, Dijon*

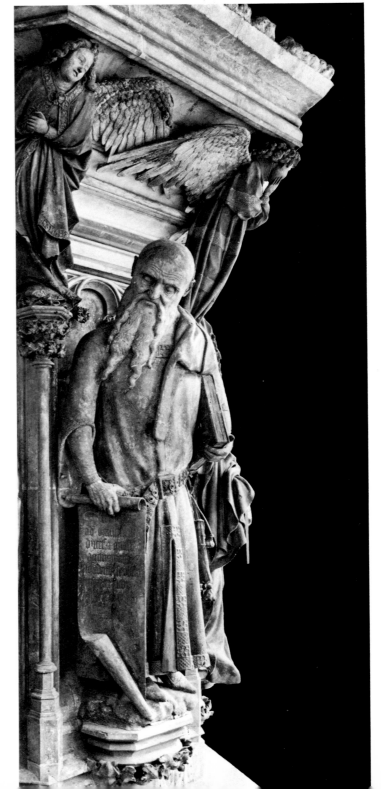

the Virgin and St John, and Mary Magdalen kneeling at the foot of the Cross, was destroyed during the Revolution. Fortuitously, some fragments fell into the well and were later retrieved, notably the poignant head of Christ, depicted at the moment when the pain and grief-wracked features relax with the approach of death. By contrast, the base has survived in a relatively undamaged state, complete to vestiges of the original polychromy. The Late-Gothic passion for realism found expression in the precise delineation of every detail of the costumes and accessories, with the *pièce de résistance* provided

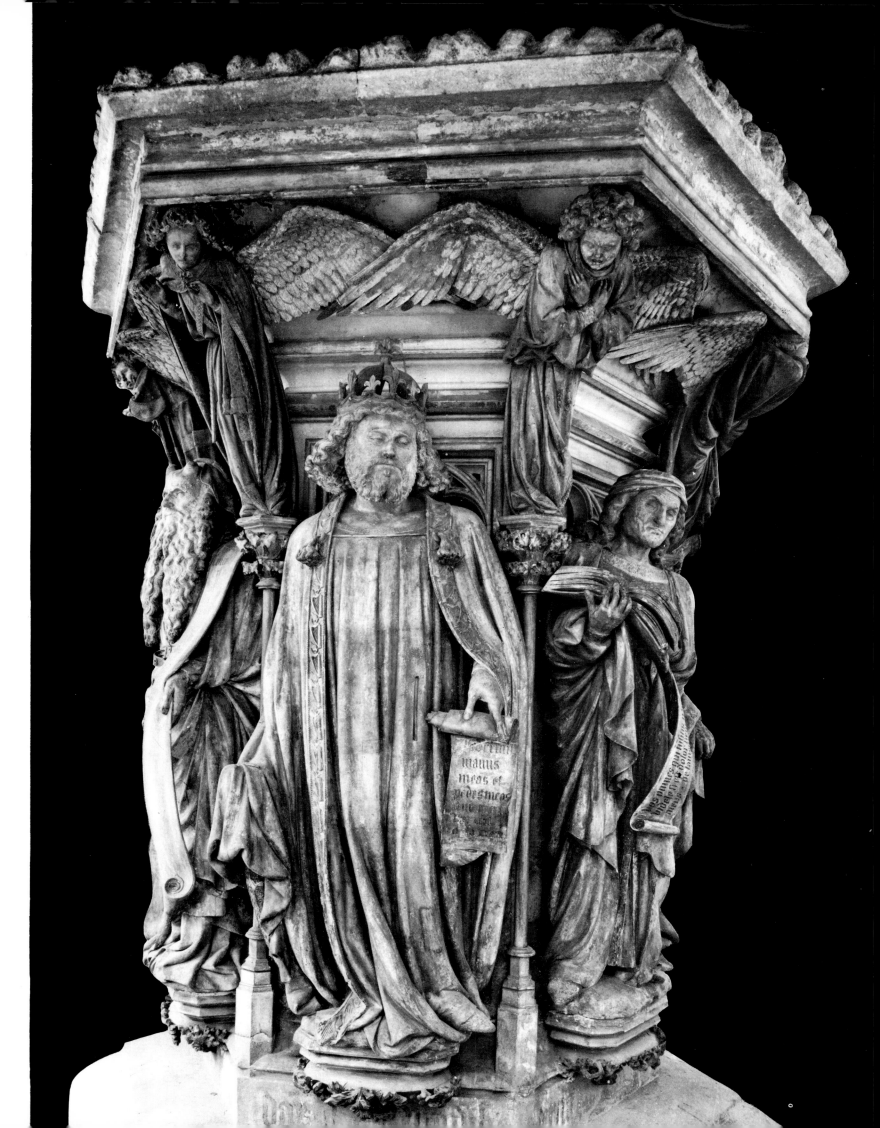

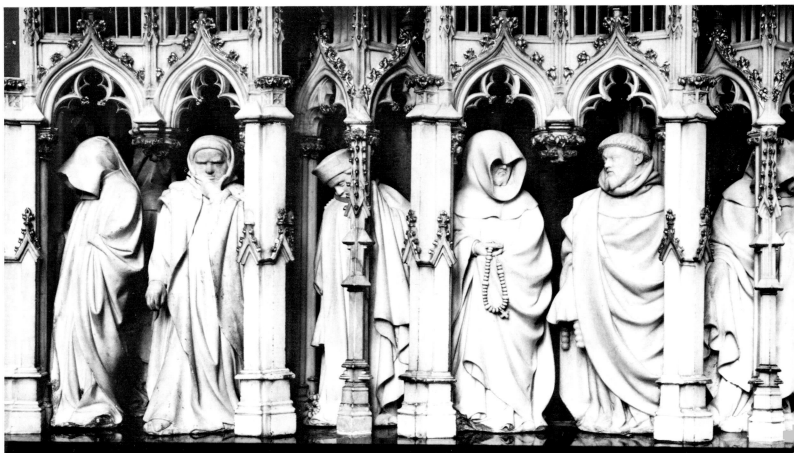

amazingly expressive – attitude, epitomise Sluter's rejection of the grace of 'International Gothic' in favour of acute characterisation and what we now consider a Michelangelesque power. To realise just how original and different was the style evolved by Sluter, one has only to compare his prophets with the figures in the virtually contemporary *Presentation in the Temple* in the Musée Cluny, attributed to André Beauneveu. 134

It would appear that the *Puits de Moïse* was completed by 1404, when Claus Sluter concluded a contract with Duke John the Fearless, who had acceded to the ducal throne in that year, to complete the tomb of Philip the Bold within four years. Already projected in 1380, and in process of construction under the direction of Jean de Marville since 1385, the tomb took the form of an over-life-size alabaster effigy of the duke in robes of state, with a pair of angels at his head supporting the helm with his insignia of rank; the whole to be richly polychromed and gilded. The effigy reclined upon a high plinth of black marble 147 enlivened by a three-dimensional alabaster arcade as a setting for a group of mourners.

There was a long-established tradition of mourning figures on sepulchral monuments. However, until this date the figures had generally been static and isolated within their niches. It was a further step along the road to realism – whether on the part of de Marville or, more likely, by Sluter himself – to represent the mourners in the form of a funeral cortège, a cross-section of the two thousand mourners who had accompanied the duke to his grave in 1404. A censing choir-boy is followed by two others 148 carrying candlesticks, a cross-bearer, members of the clergy, 149 singers, monks, relatives of the deceased and members of the 150 court, slowly wending their way as if through an arcaded 8 cloister. The very anonymity afforded by robes of mourning and deep cowls, all but concealing the features, imprints these figures indelibly upon the mind as timeless symbols of grief. The rhythmic movement of the cortège is augmented by the subtle relationship of the figures to the highly original architectural ordonnance, in which a double bay with pendent arch housing two figures alternates with a triangular bay in which the pier partially obscures the figure placed directly behind.

It would seem reasonable to presume that Sluter personally concentrated on the effigy which, unfortunately, has reached us in a grievous state. Severely damaged during the Revolution, it was so extensively restored as virtually to obliterate all traces of the master's hand. Sluter, who was already dead by January 1406 did not complete many of the mourners, but undoubtedly left detailed models to be followed by his nephew and successor, Claus de Werve, who was occupied on the task for a further five years. Only in 1410 was the monument finally completed.

That same year, while still working on the tomb of Philip the Bold, Claus de Werve was commissioned by John the Fearless

147 *Opposite top* The guard room of the palace, now part of the Musée des Beaux Arts, housing the ducal tombs formerly at the Chartreuse de Champmol: that of John the Fearless and his duchess in the foreground and that of Philip the Bold in the background. *Musée des Beaux Arts, Dijon*

148 *Opposite bottom* Procession of mourners from the tomb of Philip the Bold. *Musée des Beaux Arts, Dijon*

149 *Above left* Alabaster figurine of mourner from the tomb of Philip the Bold (photographed *ex-situ*). *Musée des Beaux Arts, Dijon*

150 *Left* Praying mourner from the tomb of Philip the Bold (photographed *ex-situ*). *Musée des Beaux Arts, Dijon*

to execute a double tomb for himself and his duchess, Marguerite of Bavaria. However, the assassination of the duke and the subsequent turmoil delayed the project indefinitely, and it was only after the death of the aged and almost penniless Claus de Werve in 1439, that Philip the Good at last proceeded with the project in 1443. The work was entrusted to Juan de la Huerta, an itinerant sculptor from Daroca in Aragón. The contract[6] stipulated that the tomb was to be almost identical in size and treatment to that of Philip the Bold, except for the two effigies. To ensure a likeness, the features were to conform to a 'pourtraict' of the long-deceased duke and duchess, probably a drawing by Claus de Werve. The tomb was to be completed within four years at a cost of 4000 *livres tournois*,[7] payment to be made at the rate of 1000 *livres* per year. In addition, the duke would provide a house in a suitable location to serve as a dwelling and studio. 'Master Jehan' (Juan) in turn would provide all the material necessary at his own expense, except for the black marble for the base, which would be provided by the duke, delivered to Dijon, and six pieces of white alabaster of the size and length agreed upon, from a quarry near Salins, which were to be quarried at the duke's expense, but transported to Dijon at the expense of Master Jehan. The latter also undertook to supply the metal for the construction of the gilded copper wings of the angels, the painting of the effigies, etc. Work proceeded very slowly, largely due to de la Huerta's numerous other commissions and activities. He and some colleagues even obtained a licence from Philip the Good to prospect for gold, silver, lead and azurite. By 1449 the tomb was adjudged only a third complete, and de la Huerta was henceforth paid on a daily basis. However, failure to supply him with material promised

under the conditions of the contract would appear to be also responsible for the delay. Only in 1451 did the large blocks of alabaster for the effigies finally arrive from Salins, and then the stone was found to have flaws and the effigies were rejected. In 1456 the artist started a second time on the duchess's effigy, but again there were setbacks and in December of that year he left Dijon on the pretext that the promised black marble for the plinth had not yet arrived. In 1461 this did finally arrive and de la Huerta was promised 'two beautiful large blocks of alabaster' from a different quarry in a vain attempt to lure him back. The following year he is reported poor and ill in Mâcon; then is heard of no more.

At his departure from Dijon it would appear that Juan de la Huerta left the kneeling angels completed, as also the architectural setting and the majority of the mourners. The cortège closely follows the precedent established by the earlier tomb. However, even in the figures which are virtual copies, a subtle difference is apparent: the mood is less introspective, gestures more emphatic, and the folds of drapery further elaborated.

The mayor of Dijon commissioned de la Huerta to carve a Virgin and Child, flanked by figures of the two Saints John, for the family chapel in the church of Rouvres-en-Plaine in 1445. By 1448 the statue of St John the Evangelist was still outstanding, and apparently never was completed, for the inferior quality of the existing statue clearly points to a different hand. The Virgin and Child, almost certainly by Juan de la Huerta, is a work of outstanding quality. The garment of double thickness falls in 152 ample Sluteresque folds, and the somnolence of Late-Burgundian sculpture is epitomised by the heavy-lidded eyes and drooping lips of the Virgin.

The *pleurants* of the Burgundian ducal tombs were widely emulated, both at the level of sophistication of the figures on the tomb of the Duc de Berry,[8] or that of the slightly gauche, if 151 captivating, figures of the Beauchamp tomb at Warwick, 45 already noted. The mourner theme attained its ultimate grandeur of conception and monumentality of scale in the tomb of Philippe Pot, Grand Seneschal of Burgundy, and one of the few great patrons left in the duchy after the death of Charles the Rash in 1477. Originally erected at the Abbey of Cîteaux, c. 1480, the tomb incorporates eight shrouded mourners moving 153 in slow and rhythmic procession, bent beneath the weight of the tomb-lid on which reposes a larger than life-size figure of the Seneschal, clad in armour and with hands folded in prayer. Attributed to Antoine le Moiturier from Avignon, who between 1466 and 1470, after Juan de la Huerta's departure, had completed the tomb of John the Fearless,[9] the design of the 147 Philippe Pot monument with these medieval atlantes celebrates the final and total emancipation of sculpture from its dependence on architecture. With this masterwork of the very first order, the century-long chapter of Burgundian funerary sculpture ended on an appropriately triumphant note.

The Chartreuse de Champmol was sold during the Revolution and its buildings demolished, only the portal of the

151 *Left* Mourner from the tomb of the Duc de Berry, following the tradition set by the tomb of Philip the Bold. *Hermitage, Leningrad*

152 *Opposite* Juan de la Huerta's close attention to the goffering on the edge of the headdress typifies the ultra-realistic tendencies in Late-Burgundian sculpture. *Church of Rouvres-en-Plaine*

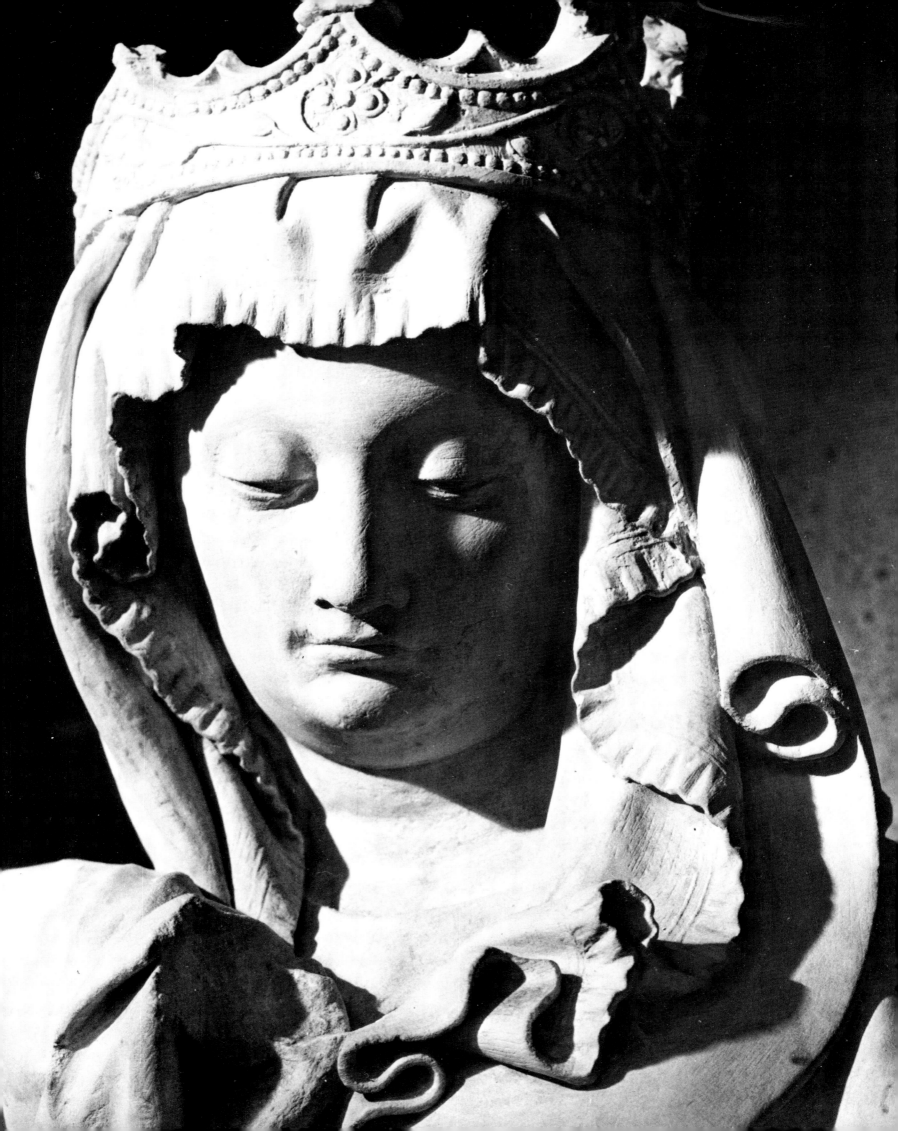

153 Tomb of Philippe Pot, Grand Seneschal of Burgundy, attributed to Antoine le Moiturier, c. 1480. *Louvre, Paris*

chapel and the Cavalry base miraculously escaping destruction.

Architecturally perhaps the most fascinating legacy of Burgundian greatness is the Hôtel Dieu, or 'Hostel of God', at Beaune. The donors were Nicolas Rolin, the astute and worldly chancellor of Philip the Good, notorious for his ambition and avarice, and his pious wife, Guigone de Salins. The foundation charter survives and is most revealing of the motives behind the donation:

'I, Nicholas Rolin, knight, citizen of the town of Autun, lord of Authume in the diocese of Besançon, chancellor of Burgundy, on this day of Sunday, 4th August, 1443, do put aside all earthly concerns and think only of my salvation. Desiring by a happy transaction to exchange for heavenly wealth the worldly goods that have been bestowed on me by the grace of God, and by this exchange to render them eternal, now, in perpetuity and irrevocably, I do found, institute, construct and endow in the town of Beaune . . . a hospital for the reception, care and lodging of the needy sick . . .'

Before the first patient was admitted on January 1452, he obtained the services of six nuns from the Hospital of St James at Valenciennes. However, his administrative experience warned Rolin that the rigour of their Order was incompatible with hospital duties, and in 1459 he compiled a statute of twenty-eight articles governing the administration of the hospital. Henceforth, the nursing nuns would be recruited from girls between the ages of eighteen and thirty, or, if sufficient

recruits were not available, from 'unmarried women . . . of good reputation and conduct'. Instead of being required to take solemn and irrevocable vows, they would abide by a simpler rule of obedience, chastity and poverty. The statute, radical in its time, as was also the costume of the nuns, has remained virtually unchanged to our day.

The discreet understatement of the street façade offers no hint of the almost bizarre magnificence of the Cour d'Honneur. The composition is dominated by the steep roof of glazed tile in a striking interlaced lozenge and chequerboard pattern. Particularly remarkable is the skill with which the enormous mass of the roof, which would otherwise be visually overpowering, is relieved by the upward surge of the gable ends of the large dormers, solid above and open below, to admit additional light to the interior and at the same time integrate the gable with the wooden gallery. In contrast to this dramatic treatment around two sides of the court is the austere expression of the main structure of the hospital, the Grand-Salle, which has always been roofed with sombre slate. In continuous use as the main ward until 1948, the Grand-Salle is a monumental space 170 feet long and 52 feet high to the crown of its open-timber 'keel-roof'. In keeping with the medieval concern with succour for both body and soul, a chapel was incorporated at the end of the room, separated from the actual ward by an open screen, so that the patients could observe the services from their beds ranged along the walls.

The chapel bore the brunt of Revolutionary fury and the present furnishings and glass are nineteenth-century restorations. Its greatest treasure was, however, hidden and saved, and is still in the possession of the hospital: the

131

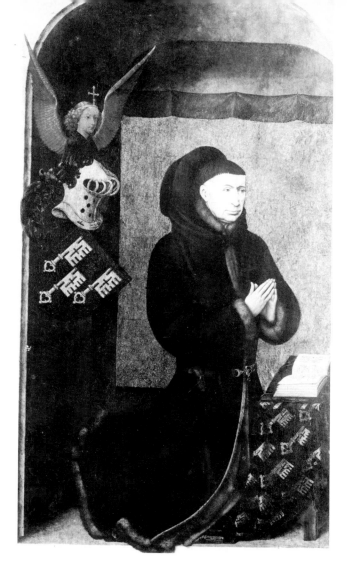

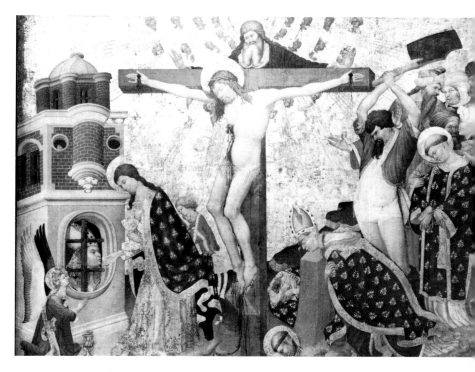

154 *Above* Portrait of Philip the Good's chancellor Nicolas Rolin, depicted in an attitude of uncharacteristic piety on an outer panel of *The Last Judgement* polyptych which he commissioned. *Hôtel Dieu, Beaune*

155 *Above right* The informal grouping of elements characteristic of Gothic residential architecture: the courtyard in Flamboyant style, dated 1490, of the Hôtel Chambellan. *Dijon*

156 *Right Martyrdom of St Denis, c.* 1416, attributed to Jean Malouel and Henri Bellechose. *Louvre, Paris*

154 monumental polyptych commissioned by the chancellor in 1443 for the altar as an indication of his intense piety. The painter was Rogier van der Weyden (Roger de la Pasture in French), one of the supreme masters of the Flemish School which at this time exerted a comparable liberating influence on painting to that which Sluter performed for sculpture. The
157 subject is *The Last Judgement*, and the vision of Christ triumphant over death and suffering, and the promise of Paradise, must have offered inspiration and solace to the sick and dying, while the flames of Hell reinforced the all-important need to die in a state of grace.[10] The grandeur of conception and the radiant spirituality are characteristic of Rogier's style. Scale is determined by hierarchical importance, not by the laws of perspective – an intention made doubly clear by silhouetting the tiny human figures in front of the roseate cloud defining the heavenly sphere, with its monumental figures, where the dual scale is echoed in the angels blowing their oliphants or holding the Instruments of the Passion in the two small wing panels above. These panels are hinged and close to conceal the upper portion of the figure of Christ. The three central panels are similarly extended on each side by two further panels, giving a total width twice that shown. Open, the altarpiece is seven feet high by no less than eighteen feet four inches in length.

Burgundy seems never to have been an important centre of manuscript illumination. The works acquired or commissioned

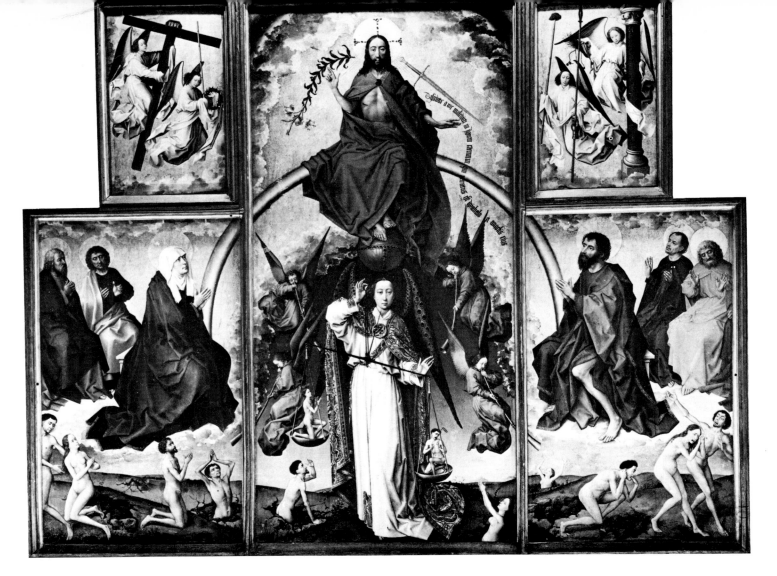

157 *Above* Central portion of *The Last Judgement, c.* 1446–48, by Rogier van der Weyden. *Hôtel Dieu, Beaune*

158 *Opposite* Detail of *The Flight into Egypt* from the *Champmol Altarpiece* by Melchior Broederlam. *Musée des Beaux Arts, Dijon*

by the dukes of Burgundy were produced in Paris, by the Limbourg Brothers and their school, or in Flanders. The significant contribution of Burgundy was in the field of panel painting.

Documents record that Jean Malouel, or Maelweel, the uncle of the celebrated Limbourg Brothers, who had worked in Paris for Queen Isabeau before entering the service of Philip the Bold, was commissioned in 1398 to paint five large altarpieces for the chapel of the Chartreuse de Champmol. A painting of the *Martyrdom of St Denis*, conforming to the stated dimensions, is generally considered to be one of these Malouel panels.[11] A crucifixion surmounted by the figure of God the Father with an aureole of red angels occupies the centre of the painting. On the left Christ in person appears to administer the Last Sacrament to the imprisoned saint; on the right is the martyrdom of St Denis and his two companions. St Rusticus has already been decapitated and St Eleutherius awaits his turn with meek resignation while the executioner swings his axe for a second attempt at beheading St Denis, the dubiously beneficial 'miracle of the blunted axe' having thwarted his first attempt. Despite its monumental scale, many aspects of the work are strongly reminiscent of miniature painting and, hardly surprisingly, of the work of Malouel's nephews, the Limbourg Brothers. There are, however, a few details that reveal a spirit so different as to suggest another hand, notably God the Father, the executioner and the turbaned group behind him, all far more sculptural in concept and betraying a strong debt to Claus Sluter.

Certainly by the same hand responsible for the major portion of the *Martyrdom of St Denis* is the beautiful *Pietà* in the form

of a tondo, also believed to come from the Chartreuse de Champmol. God the Father holds the body of Christ while the Virgin gazes intently into her son's face. Both the style of the painting, with its delight in elegant linear rhythms – apparent even in the gory detail of the clotted stream of blood flowing from Christ's wound – and the physical types are models of aristocratic refinement and restraint.

These are the last adjectives one would use to describe *The Flight into Egypt*. Incompatible with either Italian idealism or French elegance, the figure of St Joseph with a bundle of clothes slung over his shoulder is one of the earliest and most extreme examples of that passion for realism which would be an abiding feature of Flemish art. The scene is a detail from the one fully documented painting to have survived from the Chartreuse: the diptych on the outer face of the shutters of the carved altarpiece by Jacques de Baerze which we have already discussed. The greatest northern altarpiece of the pre-Eyckian period, the painting is the work of Melchior Broederlam of Ypres, the esteemed *'peintre monseigneur'* of Philip the Bold.

Here, for the first time in a fairly large panel painting, we find a relatively successful resolution to the problem of integrating figures within an architectural or landscape setting, depending on whether the action is set indoors or out[12] – a problem

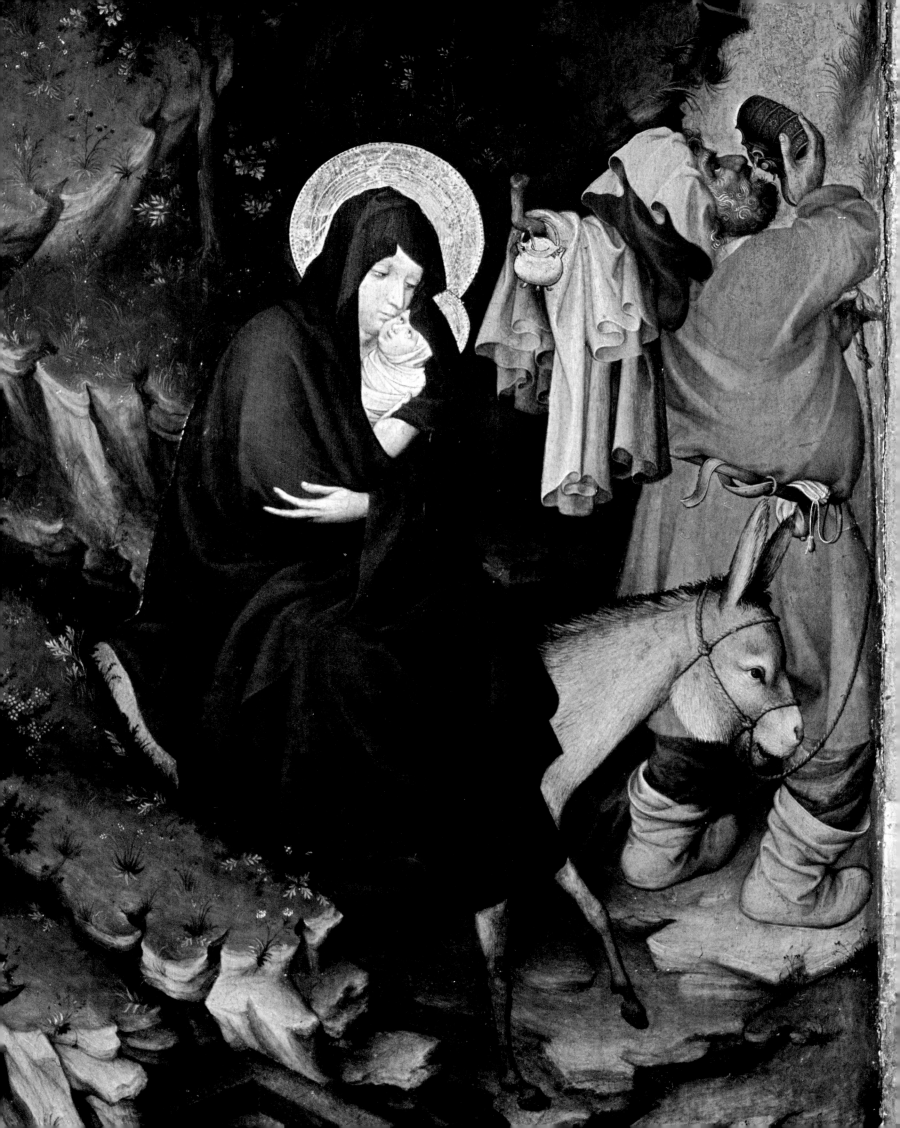

intimately related to the quest for greater naturalism, in which the illuminators had hitherto led the way. There is a convincing handling of *chiaroscuro* and the landscapes are enveloped in atmosphere. Here, too, we have perhaps the first important example of that 'mystic naturalism' which would be a hallmark of the style of the Flemish masters. This combined a realistic style, conforming with optical experience, with an apprehension of the symbolic significance of what might otherwise be considered an attractive detail. As one critic has explained it: 'The more the painters rejoiced in the discovery and reproduction of the visible world, the more intensely did they feel the need to saturate all of its elements with meaning. Conversely, the harder they strove to express new subtleties and complexities of thought and imagination, the more eagerly did they explore new areas of reality.'[13] In the scene of *The Annunciation*, for example, the airy Gothic loggia symbolises the new dispensation suffused by the *lux nova* of Christianity, while the cupola-crowned circular building with a dark interior is intended to evoke the oriental architecture of Jerusalem and the Judaic faith, 'lost in the blindness of ignorance'. Technically, too, the altarpiece shows an astonishing advance in the assurance of the brushwork and the glowing colour which anticipates the luminous depth of true oil painting. With Broederlam's achievement the stage has been set for the triumphs of Flemish painting.

159 *Pietà, c.* 1400, attributed to Jean Malouel. *Louvre, Paris*

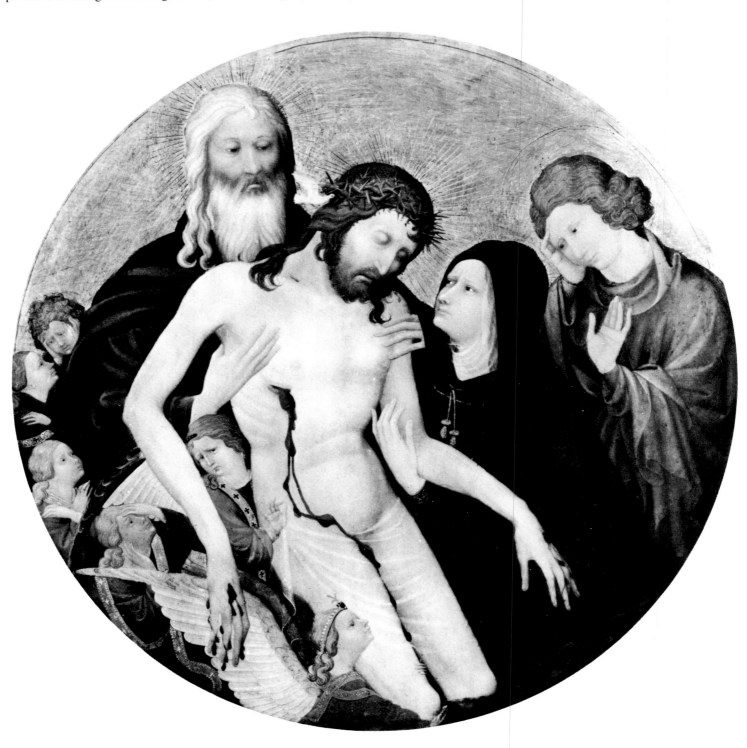

5 The Netherlands

It will not have escaped the reader's notice that many of the greatest artists working in France and Burgundy during the Late-Gothic period hailed from the Netherlands.[1] Among the illuminators and painters there were Jean Bondol from Bruges, Jacquemart de Hesdin from Artois which at the time formed part of Flanders, the Limbourg brothers and their uncle, Jean Malouel, Henri Bellechose from Brabant and Melchior Broederlam from Ypres; and the sculptor Jacques de Baerze from Termonde and Claus Sluter, possibly from Haarlem.

With the exception of Broederlam and de Baerze, all the artists mentioned had been compelled to live abroad to pursue their careers. When Philip the Good moved the capital of his Burgundian empire from Dijon to Brussels in 1420, the position was reversed. The presence and patronage of the prestigious Burgundian count, coupled with that of the wealthy bourgeoisie, made the prospects at home attractive for the Flemish artist, all the more so since the disaster of Agincourt in 1415 and the death of that Maecenas the Duc de Berry in 1416 had drastically reduced patronage in France.

The quality of the surviving examples of Netherlandish painting dating from the first two decades of the fifteenth century,[2] whether miniatures or panels, hardly prepares us for the explosion of genius in the third decade, that would carry the fame of Flemish painting throughout Europe, and cause it by universal consent to be ranked, together with Italian painting, as an incomparable achievement.

The view that Jan van Eyck was the father of the Flemish School can no longer be upheld. This honour must be reserved for the Master of Flémalle,[3] who is today generally identified with Robert Campin of Tournai, born. c. 1375, some fifteen years before Jan van Eyck. The records of Tournai contain several references to Campin. Already mentioned as a master in 1406, he operated a flourishing studio with numerous pupils. As head of the painters' guild he became a member of the ruling council when the guilds assumed control of Tournai in 1423. When the nobility regained power five years later, he retired from public life under a cloud, but continued to practise his art. In 1432 the fact that he was openly living with his mistress, Leurent Polette, provoked the wrath of the authorities, and he was sentenced to banishment for a year and to an enforced pilgrimage to the Abbey of St Gilles in Provence. However, the ruling princess,

160 Right side of the *Mérode Altarpiece, c.* 1420, by the Master of Flémalle (Robert Campin?) showing St Joseph in his workshop. *Metropolitan Museum of Art, The Cloisters Collection, New York*

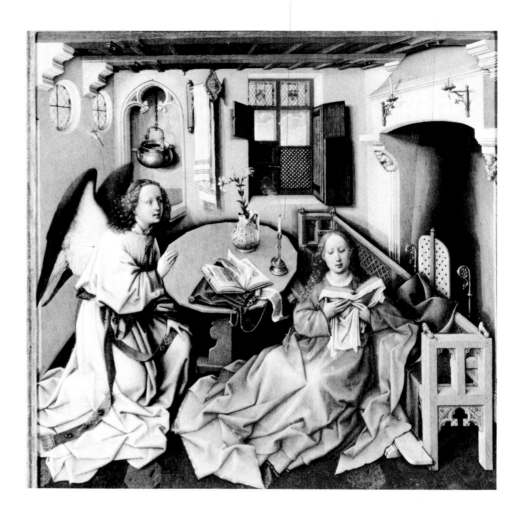

161 *Above* Left side of the *Mérode Altarpiece* showing the donors kneeling in devotion. *Metropolitan Museum of Art, The Cloisters Collection, New York*

162 *Above right The Annunciation*: centre panel of the *Mérode Altarpiece. Metropolitan Museum of Art, The Cloisters Collection, New York*

Jacqueline of Bavaria, interceded on his behalf and the sentence was reduced to a moderate fine of 50 *sols*–a commutation that undoubtedly reflects a patron's interest in a favourite artist. Campin died in 1444.

The Master of Flémalle deliberately eschewed the weightless, fairy-tale elegance and aristocratic emotional detachment so characteristic of 'International Gothic' in favour of a forthright sincerity, homely figures and realistic bourgeois settings. A characteristic work of his middle period is the *Mérode Altarpiece*.[4] Excessive foreshortening and the somewhat erratic use of several vanishing points, in what approaches a one-point perspective system, betray an intuitive rather than scientific use of perspective by a pioneer. The central panel is devoted to the Annunciation. The Virgin, represented as a 'Madonna of Humility', sits on the floor before a settle poised to read by the light of a candle still smoking after being extinguished by the rush of air caused by the angel's approach. Perhaps this symbolises how physical illumination is reduced to nothing compared with the radiance of the Holy Spirit, here depicted as a babe holding a cross, descending on a ray of light through one of the round windows on the left.[5] The pleasantly cosy interior bespeaks the tremendous advance in domestic comfort in the homes of the prosperous Flemish bourgeoisie at this period,

from the window with its flexible combination of glass, wood latticework and bifold shutters, ensuring varying degrees of light penetration, security and privacy, to the refined detailing of the fireplace, and the high standard of workmanship and artistry in wooden objects, pottery and metalwork.

The system of 'disguised symbolism' observed in Broederlam's Champmol altarpiece was further elaborated by the Master of Flémalle. The lilies, the laver suspended in the wall recess and the hand-towel are all familiar symbols of Marian purity, while the lions carved on the ends of the settle with its reversible back – giving the choice of facing either towards or away from the fireplace – transform this practical piece of furniture into a symbol of the 'Throne of Solomon', the *sedes sapientiae* or seat of wisdom. The symbols are, however, so successfully integrated into the composition that their symbolic meaning could well be overlooked.

In the left-hand panel the donors kneel in an enclosed garden, facing towards the open door which provides a link, both physical and psychological with the action of the central panel of the Annunciation. The right-hand panel depicts St Joseph at work in his shop. His characterisation as a worthy if humble artisan is far removed from Broederlam's caricature, and reflects the reassessment of St Joseph's status by theologians, which was going on in this period.[6] The tools of his trade are lovingly delineated, as are the two specimens of his craftsmanship on the table and window-sill. These are mousetraps in allusion to St Augustine's comparison of the Virgin's marriage and the Incarnation to a *'muscipula diaboli'* or mousetrap set to catch the Devil: 'He held out to Satan the mousetrap of His Cross, and placed therein the bait of His Blood.'[7]

The Master of Flémalle played a decisive role in the development of the two greatest masters of the Flemish School: Jan van Eyck and Rogier van der Weyden.

Jan van Eyck appears to have been born around 1390 at the little town of Maaseik (Maaseyck) on the Meuse, some eighteen miles north of Maastricht. The first record of his well-documented life dates from 1422 when he was employed by John of Bavaria, Count of Holland, engaged on the decoration of the palace at the Hague and already a 'master painter' with several apprentices. On the death of the count two years later he moved to Bruges and entered the service of Philip the Good of Burgundy. After a stay in Lille, where he married and started a large family, he returned to Bruges in 1430 and two years later bought a house 'with a stone front' – status symbol, indeed, in the brick towns of the Netherlands – where he lived until his death on the 9 July 1441.

Relations between the duke and Jan van Eyck were most cordial and familiar, particularly taking into account the date and the fact that this was Northern Europe and not Italy. Not only did the duke pay him well – 100 *livres* per annum and the title of *'valet de chambre'* when he was first engaged in 1425, increased in later years to 350 *livres*, while allowing him freedom to continue his career as an independent painter in Bruges – but personally visited his home and on at least one occasion acted as godfather to one of Jan's children. Significant in an age and society that set great store on rank and status was the position of precedence he was accorded on official occasions and the fact that his servants were permitted to wear the ducal livery. Two striking instances of the duke's esteem occurred in 1426, when Jan was exempted from a general reduction of

salaries during an economic crisis, and in 1435, when some of the duke's officials demurred at granting Jan a pension and he consequently considered leaving the duke's employment. On this latter occasion Philip's reprimand to his officials is eloquent of his regard for his favourite painter: '. . . we are about to employ Jehan on certain great works and could not find another painter equally to our taste, nor of such excellence in his art and science. Therefore, we bid you, on receipt of this, to register our letters granting the pension without further argument, delay . . . or difficulty whatever, under pain of incurring our displeasure and wrath.'[8]

Like Rubens later, Jan van Eyck played the role of confidant and diplomat for his patron. On the death of his second wife, Duke Philip was still childless and Jan was included in an embassy sent to Catalonia in 1427 to solicit the hand of a Spanish princess. When this mission failed, a second embassy, this time successful, was despatched to Lisbon, to arrange a marriage with Isabella, eldest daughter of King João I of Portugal. Again Jan was included in the entourage and travelled extensively in the Peninsular, where the embassy even paid an official visit to the Moorish ruler of Granada, which could account for the convincing palms and other exotic plants that appear in the backgrounds of some of his paintings. The fact that van Eyck's portrait of the prospective bride had already been despatched to Philip on 12 February 1429 would seem to confirm the tradition of a 'secret mission', for there must have been some very good reason for the duke's favourite painter to be kept away from his duties until the return of the embassy to Sluis with the princess on Christmas Day. All told, including a stay in England on both the outward and return voyages, the mission had taken more than fourteen months.[9]

Following the example of the nobility, but without precedent for an artist, Jan van Eyck adopted a personal motto, *'Als ich kan'* ('as I can' or 'as best I can'). In pseudo-Greek form[10] the motto, together with his signature and the date, are often found inscribed with assertive pride on the picture frame, for example in the *Man in a Red Turban*. In this brilliant portrait, the sitter directs at the beholder a gaze so penetrating as to be positively disconcerting.

Bartolommeo Fazio, a humanist at the court of Naples, in his *De Viris Illustribus*, a collection of biographies of famous men written in 1455-6, has no hesitation in handing the palm to Jan van Eyck as the greatest painter of the age: *'Joannes Gallicus nostri saeculi pictorum princeps judicatus est'*. This international fame was due in large measure to Jan being credited with the invention of oil painting, a tradition perpetuated by Giorgio Vasari in his *Lives*.[11]

There are far earlier references to the use of oil painting. The monk, Theophilus, in his celebrated treatise on art techniques,[12] probably written in the twelfth century, recommends the use of linseed oil as a painting medium, and a modern scholar discovered more than fifty references to oil painting in fourteenth-century records.[13] Significantly, however, these latter always occurred in connection with mural painting, or the decoration of furniture or banners, for all of these receive more wear and tear than a small panel would. In 1395, for example, Melchior Broederlam was painting banners in oils for Philip the Bold at virtually the same period that he commenced work on

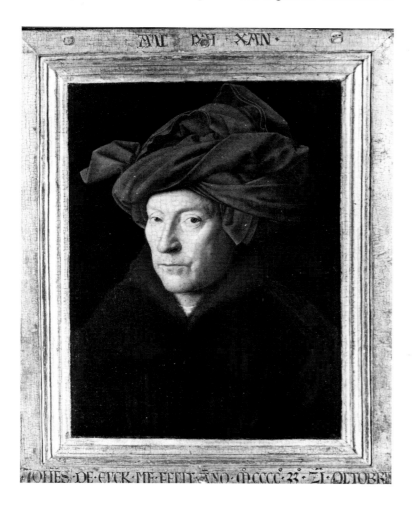

163

163 *Man in a Red Turban*, possibly a self-portrait by Jan van Eyck; dated 1433. *National Gallery, London*

his famous diptych for the Chartreuse de Champmol in tempera. Clearly oil painting was known, but for some reason had never become popular for panel painting. One simple explanation advanced[14] for this is that at the beginning of the fifteenth century the simple process of distillation made the diluent turpentine easily available so that the problem of achieving a desirable consistency of pigment was solved. The technique of oil painting could then be rapidly perfected. It does not, however, explain the peculiar luminosity, depth and brilliance, comparable to that of precious stones, in the works of the great Flemish masters. Somehow or other they realised that the optical qualities of translucent pigments could be exploited by layering them over a glowing white ground.[15] If not the 'inventor' of this radically improved technique of oil painting, Jan van Eyck must certainly be accorded the credit due to the first great exponent of the new technique.

Considering their long and rewarding association, it is ironical that not a single work executed by Jan van Eyck for Philip the Good has survived.[16] It was an alderman and later burgermaster of Ghent, Jodocus Vijd, who financed the greatest masterpiece of Flemish painting: *The Adoration of the Mystic Lamb* in the Cathedral of St Bavon.

Usually the shutters of the altarpiece were closed, except on special occasions. In the lower register the donor, Jodocus Vijd, and his wife, Elisabeth Borluut, kneel in adoration, facing representations of the patron saints of the church at the time, the two Saints John.[17] Painted in *grisaille* in a *trompe l'oeil* style, the 'statues' further enhance the naturalism of the donors' portraits.[18] In the upper register the Annunciation is set in a tower room. Holding a spray of lilies, the graceful figure of the Archangel Gabriel delivers his message to the demure Virgin, whose response is written upside down, addressed as it is, not to the spectator, but to God in Heaven above. Separating the protagonists in the drama are two narrow panels, extending the view of the interior, with the symbolic laver, basin and hand-towel of the Master of Flémalle and a fascinating prospect of a medieval town. The enigmatic emptiness of these panels, without a precedent in the Eyckian tradition, reinforces the mood of mystic quietude. In the lunettes above are depicted Old Testament prophets and pagan sibyls who had predicted the coming of the Messiah.

The view presented when the shutters are opened reveals an unforgettable grandeur of conception, richness and variety, matched by a superlative quality of execution. The central theme of the composition is the Adoration of the Mystic Lamb by the community of saints in Paradise, based upon the prophecies of the Book of Revelation. The radiant, sacrificial Lamb stands upon an altar in the middle distance, surrounded by angels swinging censers, kneeling in adoration or holding the symbols of the Passion. In the foreground the 'Fountain of the Water of Life' discharges twelve jets into a porphyry basin, and high above, the Holy Ghost in a golden aureole suffuses the throng of the Blessed that converges on the altar with the radiant beams of the Spirit. In the foreground, on the right, are the twelve Apostles, followed by martyrs in splendid ecclesiastical attire. The balancing group on the left depicts Old Testament prophets and patriarchs and notable pagan witnesses to Christ's coming, including the poet Virgil, robed in white and holding a laurel bough. In the distance a throng of Holy Virgins on the one hand, and Confessors on the other, advance in procession, bearing palms. The concourse of the Blessed is continued on the side wings: on the right hermits and

pilgrims, including a giant St Christopher, tread the stony path to Salvation; on the left a cavalcade of Knights of Christ and Just Judges rein in their horses at the sight of the Lamb.[19]

The setting for the Adoration of the Lamb is a verdant flower-strewn meadow bordered by hedgerows and trees. Behind, the landscape stretches into the far, far distance where the Heavenly Jerusalem, conceived as a contemporary town,[20] raises its spires and towers into the limpid, cloud-flecked sky. The plants, in particular, are painted not only with such precision as to make each identifiable botanically, but with such a sense of celebration that they, no less than the saints, seem to raise a paean of praise to the Creator. The sense of absolute verisimilitude – of looking not at a representation but at heightened reality itself – is unique to van Eyck. The miracle is that the microscopic detail is achieved without any loss of breadth and vigour, indeed, almost without sign of human participation.[21]

Three monumental figures occupy the upper register over the panel of the Lamb: the Virgin crowned and St John the Baptist flanking the central figure of an enthroned Deity wearing a papal tiara and representing Christ in Glory.[22] The upper shutter panels depict a group of singing and music-making angels and the ancestors of the human race. Overtones of the Biblical correlation between nudity and sin and shame are still apparent in the figures of Adam and Eve, because iconographically they must represent the Fall of Man and their attitude and bearing reflect this. However, although Eve's figure with its protruding stomach might appear unbecoming to us now, it does reflect the current Northern ideal of feminine beauty and was undoubtedly to be admired!

With the Ghent Altarpiece we are brought face to face with one of the most enigmatic figures in art history: Hubert van Eyck. On the frame of the shutters is a damaged inscription to the effect that the work was commenced by Hubert van Eyck, 'than whom none was found greater', and that it was completed by Jan, 'second in art', at the expense of Jodocus Vijd and dedicated on 6 May 1432.[23] There is the widest possible divergence of critical opinion on the respective contributions of the two brothers, ranging from those who accept the inscription at its face value and credit Hubert with the conception and the major part of the execution (and Jan simply with finishing his brother's work after the latter's death), to those who interpret the inscription as a pious and exaggerated tribute to the elder brother, or even an outright fabrication by Ghent patriots eager to ascribe their greatest treasure to a local artist, rather than to one so closely related with the rival city of Bruges. Historically, the evidence is evenly matched. Albrecht Dürer, who on his visit to the Netherlands in 1521 arranged to have the altarpiece opened specially, speaks only of Jan; yet in 1495 a German doctor, Hieronymous Münzer, was shown the grave of the painter in the chapel, when Jan was known to be buried in Bruges; and during the visit of Cardinal Louis of Aragon in 1517 his secretary was informed by the canons that the painter was a 'Master Robert' who had not been able to finish it, due to his death, and that it had been completed by his brother, also a great painter. On the other hand, considering Jan's great reputation and the numerous records of his career, it is very surprising that no mention of Hubert has been found.

It would have seemed that a comparison on stylistic grounds with authenticated works by Jan would reveal which portions were by his hand, but no final agreement has been reached on this. Perhaps the most plausible hypothesis is that the

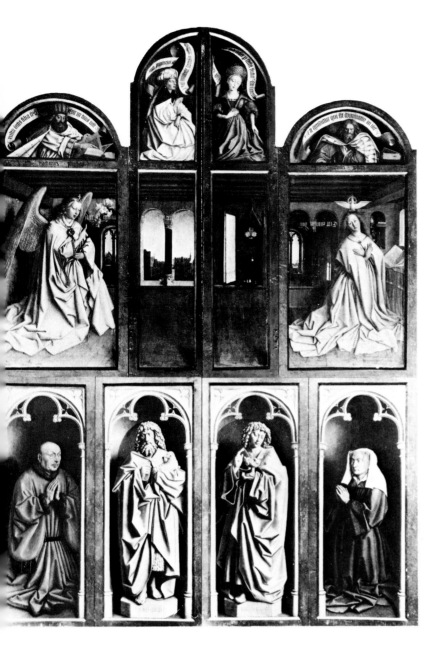

164 *Above The Ghent Altarpiece*: view with shutters closed. *Cathedral of St Bavon, Ghent*

165 *Overleaf The Ghent Altarpiece: The Adoration of the Mystic Lamb* by Hubert and Jan van Eyck, *c. 1425–32. Cathedral of St Bavon, Ghent*

theological concept and the general layout of the lower five panels, the groups in the foreground of the central panel, as also the monumental figures of the Virgin, the Baptist and the Deity above, all revealing archaic tendencies in the treatment of volumes, drapery and perspective, should be attributed to the older brother; and probably also the music-making angels. The Adam and Eve and the whole exterior, as well as the extensive reworking and the coordination of Hubert's unfinished panels – which it has been suggested might originally have been intended for two or three different altarpieces – would be ascribed to Jan.

Recently, another solution to the mystery has been proposed: it has been suggested that the original altarpiece, before the removal of the painted panels to safety during the iconoclastic disturbances of 1566, was set within an elaborate

sculptured tabernacle and that the Hubert referred to in the inscription was the sculptor responsible for this frame.[24] In the Middle Ages such stone settings were almost invariably executed, and often even commissioned before the painting.[25] The artist responsible for the frame would, therefore, logically be mentioned first, and the reference to Jan as 'second' relate to the time factor rather than importance.[26]

One of the most coveted paintings in the world is Jan van Eyck's double portrait of *Giovanni Arnolfini and his Wife*. The 167 wealthy couple from Lucca, long domiciled in Bruges, are depicted in a high-ceilinged bedroom with fine furnishings lovingly delineated and suffused with a soft, late afternoon light. The genre atmosphere is, however, partially dispelled by the formal pose and the mysterious inaccessibility of the couple, seemingly absorbed in some private ritual. This, surprisingly, is none other than the taking of marriage vows. Marriage according to canon law was concluded by the parties taking an oath, accompanied by the joining of hands and by the groom raising his right hand in a manner perpetuated to this day in courtroom procedure.[27] A priest, if present, merely blessed the union, since the sacrament of marriage was not dispensed by the Church but bestowed by the couple themselves. The two participants could conclude a perfectly legal marriage without any witnesses in the Middle Ages. It was only in 1563 that the Council of Trent, largely as a reaction against the abuses that could ensue when one partner to the contract denied that it had taken place, henceforth required the presence of a priest – still merely acting in the capacity of a *testis qualificatus* – and two other witnesses.

This was still far in the future when Giovanni Arnolfini and his bride took their marriage vows in their bridal chamber,[28] witnessed by the two persons who can be seen entering the room in the reflection in the convex mirror. One of the two was undoubtedly the painter, who commemorated the event with the commissioned painting, and testified, in the manner of a witness on a marriage certificate, with the inscription on the wall above the mirror, executed in formal Gothic script: *'Johannes de Eyck fuit hic'* (Jan van Eyck was here). In keeping with the sacramental nature of the subject, it is not surprising to find numerous examples of disguised symbolism in the painting: such as the crystal rosary beads and the mirror with its ten tiny roundels with scenes from the Passion which are emblems of purity; the carving on the knob of the chair near the bed which represents St Margaret, the patron saint invoked in childbirth; the little dog so often found on medieval tombs nestling against his mistress's skirt symbolises fidelity, and Giovanni's discarded clogs, striking such an apparently incongruous note with his resplendent costume, complete to wide-brimmed, high-crowned beaver hat, remind us that the nuptial chamber is holy ground.[29]

For an example of the Eyckian style applied to manuscript illumination, we can turn to some fifteenth-century miniatures added to Jacquemart de Hesdin's *Très Belles Heures de Notre Dame*.[30] Attributed to the youthful Jan van Eyck, one shows a 169 Mass for the Dead being conducted in the choir of a Late-Gothic church. A wooden hearse or catafalque ablaze with candles, the latest fashion in funeral accessories, stands over the draped coffin. Nuns keep vigil while the ceremony of the mass is watched by a group of onlookers with a child and two dogs bringing up the rear – a telling illustration of the unselfconscious attitude to religion characteristic of the day. The illuminated initial R depicts the Last Judgement, and below is a

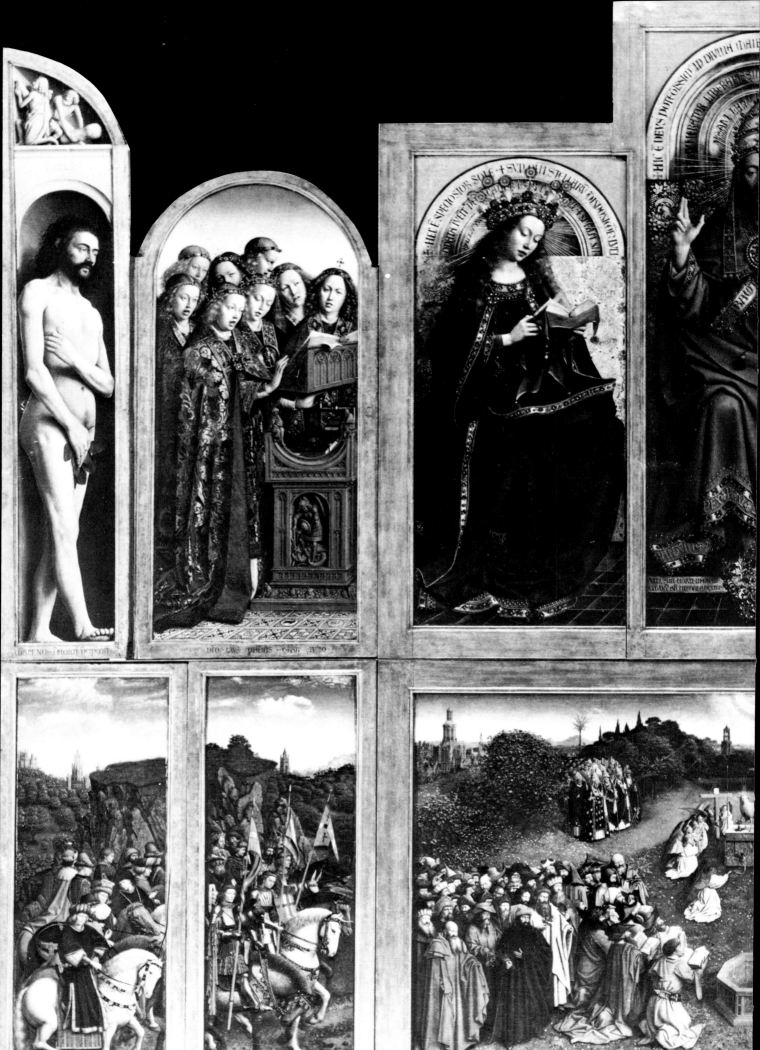

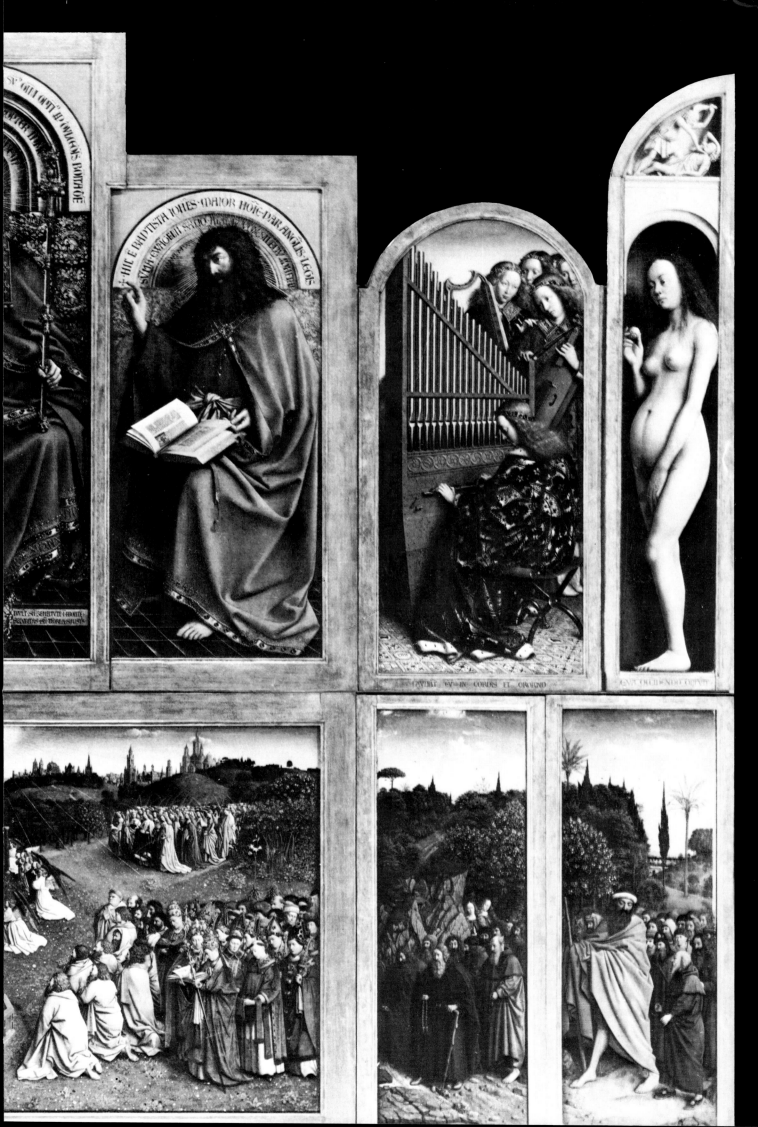

rendition of the Benediction of the Grave, remarkably advanced for the period, with the figures of the clergy and mourners and a host of crosses on the graves silhouetted against the unpainted page as if against a hazy, back-lit sky.

A most interesting surviving record pertaining to the life of Robert Campin (alias the Master of Flémalle) is that concerning one Rogelet de la Pasture who commenced his apprenticeship with Campin in March 1427 and qualified as a master in 1432. This, it would appear, refers to 'Rogier van der Weyden', who adopted the Flemish translation of his name after moving from Tournai to Brussels.

Rogier was born c. 1399-1400 at Tournai, the son of a master cutler. He married in 1426, his wife hailing from Brussels and apparently related to the wife of Robert Campin.[31] By 1435 he had settled in Brussels where he remained for the rest of his life, except for a visit to Rome for the Holy Year celebrations of 1450. Internationally renowned, he was also the official city painter (der stad scildere), in which capacity he painted a series of panels on the theme of 'Justice' for the town hall. Among the most admired paintings in all Europe, they were destroyed during the bombardment of Brussels by Louis XIV's forces in 1695.[32]

In Rogier van der Weyden we sense the conviction and intense emotional involvement of the man of faith. Probably the greatest, certainly the most moving and influential, of Rogier's many masterpieces is his early *Descent from the Cross*, c. 1438. The surviving central panel of a monumental triptych commissioned by the Guild of Archers for their chapel in the Church of Notre-Dame-hors-les-Murs at Louvain, the painting was later sold to Maria of Hungary, regent of the Netherlands for her brother, the Emperor Charles V, and passed into the royal collection at the Escorial and thence to the Prado. Rogier dispensed with the by then customary naturalistic background and reverted to the earlier tradition of a gold background against which the figures are posed as if on a shallow stage. The resemblance is further heightened by the carved corner brackets framing the scene. Within this opening, the Deposition is enacted with a dramatic intensity and pathos; movement and

166

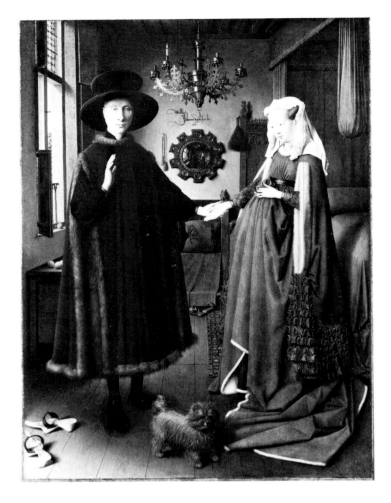

166 *Below left* The Deposition by Rogier van der Weyden, c. 1438. *Prado, Madrid*

167 *Above* Giovanni Arnolfini and his Wife by Jan van Eyck, dated 1434. *National Gallery, London*

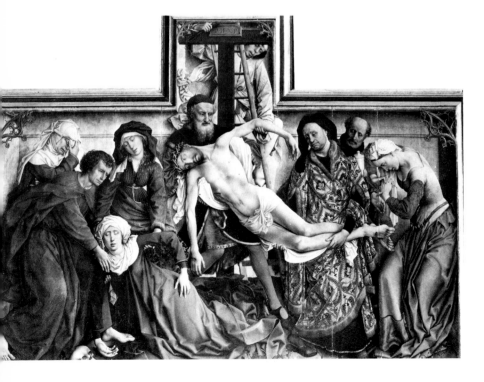

gesture are used to express the most profound emotions. A series of sweeping curves and counter-curves links all the figures in a compelling compositional and psychological unity. Note, for example, the subtle rapport between the sagging curves of the figures of the dead Christ and the swooning Virgin. The genuine religious feeling characteristic of the Flemish School reached its highest expression in the art of van der Weyden, whose pathos is always superbly controlled.

197

Although highly individual in their characterisation, Rogier's portraits, taken as a whole, form a remarkably homogeneous group in their similarity of pose and their faithfulness to an aristocratic ideal. The background is usually dark[33] or neutral, the sitter's station and interests being indicated by such accessories as the Order of the Golden Fleece, or by an object held in the hand: a sword, an arrow or a jeweller's hammer, for example. The way the objects are held, gingerly, firmly or irresolutely, as in the portrait of Charles the Rash, provide a penetrating insight into the personality of the sitter. Of Rogier's female portraits the well-known *Portrait of a Lady* in the National Gallery, Washington, is inimitable for its powerful yet decorative composition, and the enigmatic allure of the sitter. Exceptionally fine, too, and seldom reproduced, is the Rockefeller portrait known as *The Persian Sibyl* from the inscription on the background, dating from the late 1440s, and now considered to be of Isabella of Portugal, wife of Philip the

170

171

168 *Above* Christ, the Unseen Witness, symbolized by a simple lighted candle, and the signature of the painter, Jan van Eyck, attesting to his presence at the marriage ceremony. Detail of plate 167

169 *Above right* Illumination of a Mass for the Dead, probably by the youthful Jan van Eyck, from *Les Très Belles Heures de Notre Dame* (fol 93v). *Museo Civico, Turin*

170 *Right Charles the Rash of Burgundy, c.* 1457, by Rogier van der Weyden. *Gemäldegalerie, Berlin-Dahlem*

Good – the same Isabella whose portrait had been painted by Jan van Eyck in Portugal some twenty years earlier, when the marriage was being arranged.

The Flemish painters of the second generation all built upon the twin legacy of van Eyck and van der Weyden, leaning towards one or the other, or selecting features from both, as their training and temperament dictated. Petrus Christus, probably born at Baerle near Tilburg in Holland around the beginning of the century, appears to have worked in van Eyck's studio and to have completed some at least of Jan's works left unfinished at his death in 1441. Petrus followed in the master's footsteps, rather slavishly at first, but with more independence in his middle period when he was clearly also much influenced by Rogier. In his last period he returned to the Eyckian tradition, now interpreted more freely, allowing scope for the development of his own personality. Characteristic in its simplification of form and porcelain-like smoothness of the skin, but not so typical in its elegance, which perhaps owes as much to the sitter[34] as to the artist, is the late and utterly enchanting *Portrait of a Young Girl* in Berlin.

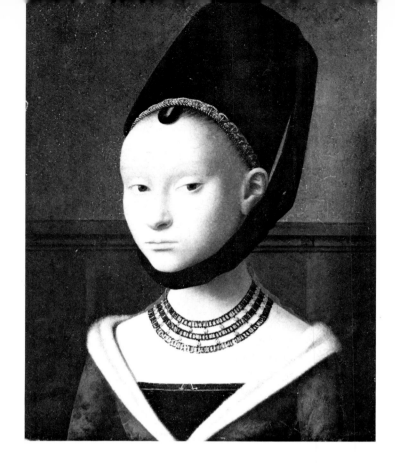

Of far greater importance than Christus is Dirck Bouts, a name abbreviated from Theodorik Romboutszoon, born *c.* 1420 at Haarlem. The documented portion of his career was spent at Louvain where he married a wealthy woman nicknamed *Katharina Metten Gelde'* ('Catherine with the money'), and established himself as the leading painter. He contributed to the adornment of the two great Late-Gothic structures of Louvain: for St Pierre he painted two superb altarpieces, and for the town hall a series of panels on the subject of 'Justice', which were left unfinished at his death in 1475.

His masterpiece is the *Sacrament Altarpiece*, painted for St Pierre and still in the possession of the church.[35] The work was commissioned by the Confraternity of the Holy Sacrament, the unusual iconographic programme being prescribed by two professors of theology at the University of Louvain. The central panel depicts the institution of the Eucharist at the Last Supper, the wing panels four episodes from the Old Testament interpreted as portending the event.[36] The contract was signed in March 1464 and the receipt for the final payment of 100 *gulden*, due one year after completion, and signed by the artist, is dated 1468. Bouts was not particularly successful in depicting movement, and it is singularly fortunate that the theologians chose not the customary moment of Christ's announcement of His betrayal, with its dramatic overtones, but the mystic institution of the Eucharist, where the very rigidity and immobility of the figures add immeasurably to the solemnity of the occasion. The intimation of cosmic significance is underlined by the strong geometric basis of the composition with its insistent verticals and stable equilateral triangle (defined by the front edge and the sloping sides of the tablecloth, projected upward to intersect on the lintel of the fireplace) with the Perfect Being at the very centre of the 'perfect' geometric form. Significantly, too, the Saviour holds not the customary piece of bread, but the Host, further emphasising the universal implications rather than the historical event. Bouts' greatest contribution lay in his handling of pictorial space, whether in interiors or in his atmospheric landscape backgrounds, which

171 *Above left Portrait of a Lady, c.* 1455, by Rogier van der Weyden. *National Gallery of Art, Washington*

172 *Above Portrait of a Young Girl, c.* 1468–73, by Petrus Christus. *Gemäldegalerie, Berlin-Dahlem*

point the way to landscape painting pure and simple. In either case the deep and uncluttered space is suffused with light and air, and the superb colouring shows an acute sensitivity to the changes wrought by light and atmospheric conditions.

Towards the end of the fifteenth century two great painters illustrate in particularly telling fashion the ambivalent nature of the culture of the Late Middle Ages. Hans Memlinc epitomises the serenity and sense of fulfilment of the golden autumn of the Age of Faith; Hugo van der Goes gives expression to the growing doubts and questions that would give birth to the Renaissance and the Reformation.

Hans Memlinc (or Memling) was born around 1433 at Seligenstadt on the Main near Frankfurt. Where he received his early training is not known. It might quite possibly have been in Cologne, where the sweet and languid charm of Stephan Lochner could have been a formative influence. Stylistically, it seems highly probable that he worked in Rogier van der Weyden's studio in Brussels before settling in Bruges, where he was already registered as a citizen in 1465, and as a master in the following year. He established himself as the leading painter in the declining but still prosperous city, and was numbered among the 140 citizens of Bruges who paid the highest tax in 1480. Memlinc died in 1494. Extremely prolific, a large number of his works have survived, many in the original setting of the medieval Hospital of St John at Bruges, a place which evokes the age most powerfully.

Rated as the greatest of the Flemish 'primitives' by nineteenth-century art historians, who saw in Memlinc the personification of their romantic ideal of the Middle Ages, he suffered the inevitable reaction and was in turn grossly underrated by twentieth-century critics who set store by different values and discounted the very characteristics – grace, refinement, tender sentiment – that the nineteenth century had

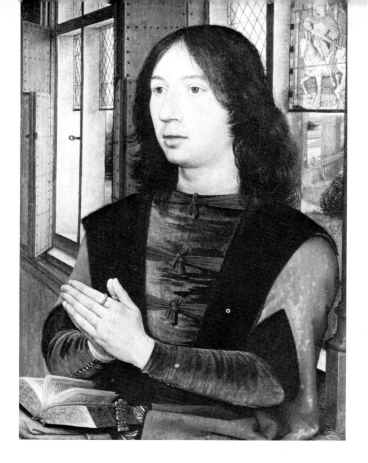

173 *Above left and above The Virgin and Child adored by Martin van Nieuwenhoven*, dated 1487, diptych by Hans Memlinc. *Hôpital Saint-Jean, Bruges*

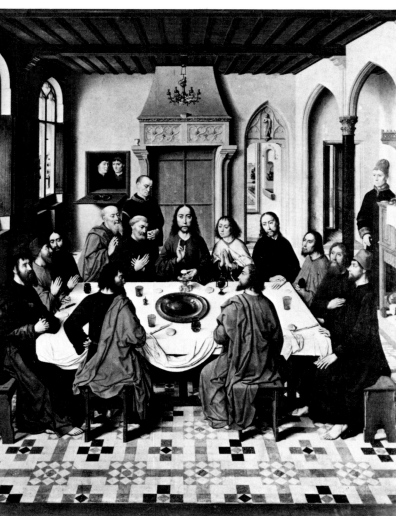

174 *Above The Last Supper*: central panel of the *Sacrament Altarpiece*, 1464–67, by Dirck Bouts. *Collegiate Church of St Pierre, Louvain*

found so appealing. Like all supremely accomplished eclectics, the very effortlessness with which Memlinc assimilated influences and resolved technical difficulties tends to conceal the progressive and original aspects of his art, which are being given due credit in the more balanced assessments of recent critics.[37]

The diptych of the *Madonna and Child adored by Martin van Nieuwenhoven* shows his art at its splendid best in a reinterpretation of the Rogierian combination of votive image and donor portrait. The refined spirituality of the Madonna is 173 perfectly complemented by the spontaneous expression and unidealised features of the young donor. The technical brilliance in conveying the essential character of different surfaces and textures, including such studio properties as the convex mirror, recall van Eyck. Note the subtle reference to Martin's patron saint, shown dividing his cloak for the beggar in the stained-glass panel. The juxtaposition of the static background of the Madonna panel, with the wall parallel to the picture plane, and the dynamic plane receding sharply into space behind the donor, stresses the difference between the immutable order of the sacred and the fortuitousness of the secular. In addition, it imparts a sense of tension between the two panels which provides just the needed touch of astringency which Memlinc's lesser paintings lack.

Hugo van der Goes is closely associated with Ghent. Most probably born there–both place and date of birth remain unknown–he was admitted as a master of the painters' guild in 1467, being vouched for by the distinguished painter, Joos van Ghent,[38] and a local paint merchant, and was elected head of the guild in 1474. In 1478, at the height of his fame, Hugo van der Goes renounced the world and retired to the monastery of the *Roode Klooster* or 'Red Cloister' near Brussels. He retained a certain measure of freedom, continued to paint, received visitors, including Maximilian of Austria, and in 1480, as

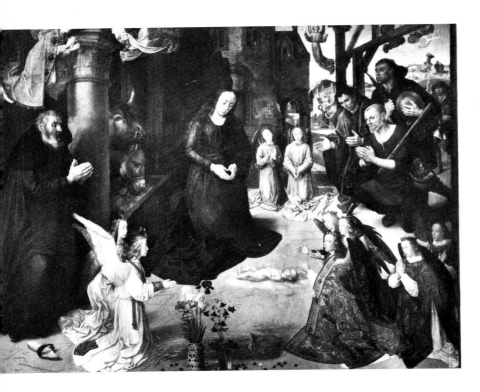

175 *Above The Portinari Altarpiece*, c. 1474–76, by Hugo van der Goes. *Uffizi, Florence*

176 *Below right* Detail of shepherds in adoration from the *Portinari Altarpiece* by Hugo van der Goes. *Uffizi, Florence*

reputedly 'the most distinguished living Flemish painter', was appointed to assess the proportion of the fee due to the heirs of Dirck Bouts for the unfinished 'Justice' panels in the town hall of Louvain. In 1481 his mind became deranged, he suffered ever more frequent attacks of melancholia and died insane the following year. A fellow brother in the monastery recorded the tragic course of Hugo's illness, apparently a form of religious mania compounded with a growing despair that he would not live to complete the work he had in mind. Not long after his death a visiting German doctor, Hieronymous Münzer, recorded the already current legend – which may well contain more than a grain of truth – of an artist of insatiable ambition driven to distraction by his inability to rival the perfection of the *Adoration of the Mystic Lamb*.

175 Hugo's *magnum opus* is the *Portinari Altarpiece*, commissioned by the wealthy banker, Tommaso Portinari, agent for the Medici and leader of the Italian community at Bruges, for the family chapel in Florence. Over eight feet high and no less than nineteen feet in width, the triptych introduced a new monumentality of scale and conception to Flemish art, while exploiting the joint legacy of van Eyck, van der Weyden and Bouts in a highly original manner. On the wings of the triptych the donors and their children kneel in adoration, dwarfed by huge figures of their patron saints. This same deliberate disparity of scale is also used with striking effect in the Nativity of the central panel, where the diminutive angels – strangely wan and ageless beings, anything but childlike – enhance the grandeur of the other figures. The age-old device of according figures a size commensurate with their symbolic importance, rather than that dictated by the laws of perspective, here achieves a heightened psychological effect, precisely since the

scientific laws of perspective are so scrupulously observed in the architecture and landscape setting. How effectively the barren rock formations, bare trees and wintry sky reinforce the subtle mood which oscillates between the joy of the moment and a presentiment of tragedy. There are numerous examples of disguised symbolism. The harp carved on the tympanum identifies the building in the background as the deserted palace of King David; the irises in the Spanish jar evoke the sword that pierced the heart of the *Mater Dolorosa*; and the sheaf of wheat is a reference not only to the town of Bethlehem (literally, 'House of Bread', in Hebrew), but also to the Eucharistic message: 'I am the bread', a concept underlined by the analogous cylindrical form of sheaf and Christ Child, both laid upon the bare earth. This patch of bare earth is a compositional masterstroke, providing a moment of respite for the eye which might otherwise be sated with so much interest and movement. The pensive, introverted Virgin and the radiant Child, lighting the angel overhead with a strange phosphorescent glow, form a kernel of silence and repose at the heart of the animated encircling throng of worshippers, human, animal and supernatural. The uncompromising realism and intense emotional involvement of the shepherds, propelled by a seemingly irresistible momentum, exerted a tremendous fascination on Hugo's contemporaries, especially in Italy where the picture went directly on completion.[39] In the background minute scenes, such as the Flight into Egypt, the Annunciation to the Shepherds and the Journey of the Magi, further amplify the narrative. The miracle is that all these multifarious elements have been orchestrated into a compelling unity.

 The final phase of Gothic illumination in Flanders is of

176

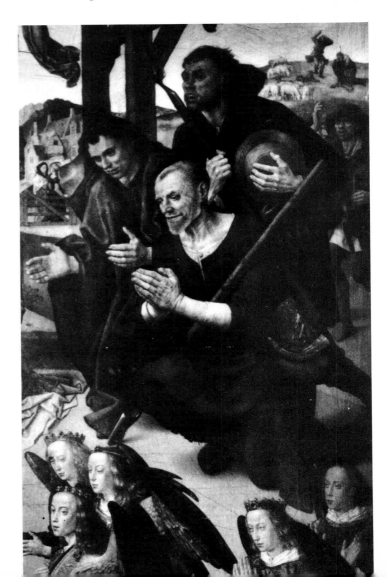

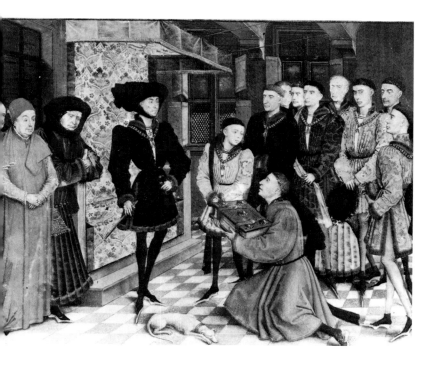

towards the end of the thirteenth century in a severe style that recalls the civic buildings of Tuscany.[41] The belfry originally terminated in a pyramidal spire of wood, but after this had thrice been consumed by fire, the present splendid crowning stage in the form of an octagonal lantern was added in 1482. Soaring to 352 feet, its majestic bulk, looming over the narrow streets and reflected in the now still waters of the canals, is as inescapable as the penetrating peal of its bells and carillon.

At Antwerp it was the cathedral tower that served as 'stadstoren' or 'city tower'. Commenced in 1422, the lower stages as far as the gallery immediately below the elegant, open-work clock faces, were designed by Peter Appelmans, master of

177 *Left* The presentation of the *Chroniques de Hainault* to Philip the Good of Burgundy by the publisher Simon Nockart: the duke's young son, the future Charles the Rash, is on his left; the chancellor Nicolas Rolin and the Bishop of Tournai on his right. Illumination on the dedication page of the *Chroniques* (Ms 9242, fol 1). *Bibliothèque Royale, Brussels*

178 *Below* The piety and worldliness of Burgundian court life find equal expression in this miniature from a Book of Hours executed *c.* 1480 for Mary of Burgundy, daughter of Charles the Rash. (Ms 1857, fol 14v). *Österreichische Nationalbibliothek, Vienna*

secondary importance compared to the developments in panel painting. However, the dukes of Burgundy were also enthusiastic patrons of the *livre de luxe* and during the reign of Philip the Good, in particular, there was a prolific production of manuscripts of high quality. Rogier van der Weyden, no less, has been proposed as the designer of the dedication page of the *Chroniques de Hainault*. Yet the fall of Burgundy and the concurrent development of printing spelled the death of illumination: the great tradition found a final worthy exponent in the Master of Mary of Burgundy,[40] named for two Books of Hours illuminated for the daughter and heiress of Charles the Rash. His style is characterised by an illusionistic naturalism and an original and varied treatment of borders. In a fascinating miniature from his Book of Hours in Vienna, the customary marginal decoration has been replaced by an intimate genre scene depicting a demure young lady dressed in the height of fashion – presumably Mary herself – reading a Book of Hours before a window which opens onto the ostensible main subject: an Adoration of the Virgin and Child set in a church interior. The intended effect was no doubt of a window opening in the mind through the lady's devotions.

In the Late Middle Ages Flanders and Italy were the two pre-eminent European centres of industrial and commercial activity, concentrated in towns and cities that had won a remarkable degree of independence. One of the major privileges granted in a town charter was the right to a watch-tower and a bell to rouse the citizens. Apart from its practical function, which customarily included the safe storage of charters and deeds (once fireproof brick and stone had replaced wood construction), the belfry became the symbol of civic pride, and its demolition the ultimate humiliation. To this end, Henry, King of the Romans, ordered the destruction of the belfry of Cambrai in 1226 as punishment for a revolt, and it was on the belfry of the Brussels town-hall that Marshal de Villeroi trained his cannon in 1695.

The belfry could rise over a gateway or be attached to a variety of structures, commercial, civic or ecclesiastical. At Bruges it was constructed in conjunction with the market-hall

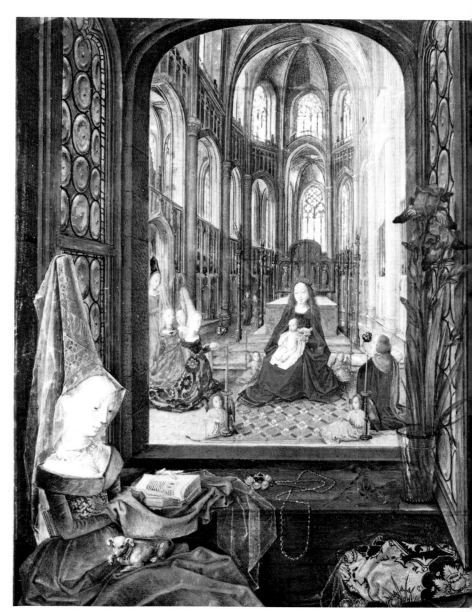

179 *Above left* The belfry with its Late-Gothic octagonal lantern. *Bruges*

180 *Above* The 406-feet high cathedral tower (1422–1521) soars triumphantly over the old town. *Antwerp*

181 *Above right* Brick-gabled façade (*c.* 1420) facing a small canal; one of the oldest and least restored portions of the Hôtel de Gruuthuse, the splendid mansion built by Louis de Bruges. *Bruges*

182 *Right* Diagonal vistas assume added significance in the vast triple-aisled cathedral, commenced in 1352. *Antwerp*

the works from 1419-34. Up to this point the intention was undoubtedly to build a twin-towered west front in the classic French tradition. The next stage reveals the birth of a totally new spirit. The balance and symmetry of the total cathedral composition is no longer foremost in the mind of the designer.[42] Attention has now focused on a single tower – considered in virtual isolation. The creation of Herman de Waghemakere, master from 1473-1502, this stage has enormous *élan* with its flying buttresses rising virtually to the height of the octagonal lantern. The quality of the uppermost stage, the work of Domien de Waghemakere, master in turn from 1502-30, falls sadly short of the standard set by his father, both as regards such basic criteria as massing, proportion and silhouette, and in the coarse nature of the detail with its hybrid assortment of florid Gothic and Renaissance motifs. The overall impression of the 406 foot tower is, however, superb.

Apart from the belfry, the earliest important secular building-type to develop in Flanders was that of the *'Halles'*, the finest specimen of which was the great Cloth Hall of Ypres (1200-1304)[43] with a façade no less than 500 feet in length. The *Halles* housed a multiplicity of functions, both commercial and civic, and were noted for their monumental scale but sparse ornament. They also generally antedate our period.

In the second half of the fourteenth century the increasing complexity and sophistication of Flemish urban life found expression in a differentiation of commercial and civic

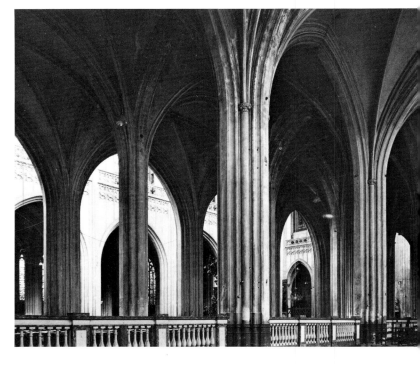

functions, the latter henceforth housed in a new building type: the *Hôtel de Ville* or city hall. In 1376 Louis de Mâle, Count of Flanders, laid the foundation stone of the first, and most beautiful, of the Flemish town halls: that of Bruges. Completed in 1387, the building typifies the trend to moderate scale but elaborate decoration. At ground-level is the so-called *'Salle des Pas-Perdus'*, from its function as waiting hall during sessions of the courts. On the first floor the large and lofty chamber housed the meetings of the municipal officials and magistrates and also splendid festivities on civic occasions. Internally, the most interesting feature of the Grande Salle is the original timber vault of 1402, the work of Master Jean de Valenciennes, with its elaborately carved pendent bosses. The main façade is a model of harmony and elegant opulence. Coats-of-arms of the twenty-

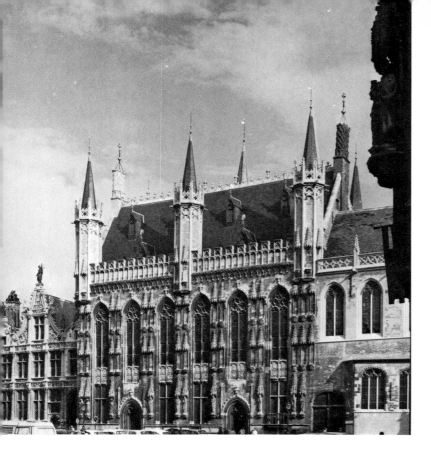

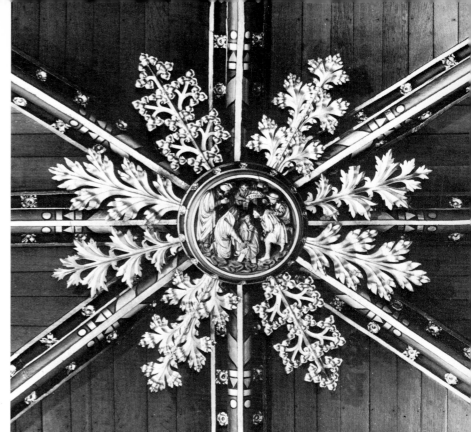

183 *Above* Façade of the town hall, 1376–87, the earliest of its kind in the Netherlands. *Bruges*

184 *Above right* Carved wooden boss from the timber vault of the Grande Salle of the town hall. *Bruges*

185 *Right* View from the Grand Place of the town hall showing the original wing, commenced in 1402, and the belfry by Jan van Ruysbroeck, commenced in 1449. *Brussels*

four towns under the jurisdiction of Bruges ornament the recessed panels that link the ground and first-floor windows, and tiers of canopied niches house statues of the Virgin, Old-Testament prophets and the long line of counts and countesses of Flanders since the celebrated Beaudoin 'Bras-de-Fer'. No less an artist than Jan van Eyck in 1435 painted and gilded six of the original statues, later destroyed during the French Revolution. Above, a balustrade with mock crenellations and a high crested roof pierced by dormers and relieved by turrets, completes the composition.

The second great Hôtel de Ville is that of Brussels: an elaboration of the Bruges prototype, combined with a monumental belfry. Facing the Grande Place, the left-hand wing, as far as an apparently existing belfry, was commenced in 1402 by Jakob van Thienen; the right-hand section, slightly smaller as dictated by the site, in 1444 by an unknown master; and finally the new belfry by Jan van Ruysbroeck commenced in 1449 and completed to its sixteen-foot-high gilded weather-vane 320 feet above the pavement in 1454. Jan van Ruysbroeck modified the stern character of the existing belfry that seems to have extended to just above the roof ridge, and added an airy superstructure in three stages, crowned by a spire. Note how skilfully, almost imperceptibly, the transition from square to octagon is effected by the minaret-like, gallery-encircled pinnacles that are such a characteristic feature of Netherlandish Late-Gothic. A symbol of civic pride and independence, the flaunting belfry was left miraculously unscathed by the French bombardment of 1695 which reduced the rest of the medieval city to ruins.

The University of Louvain, founded in 1426, ushered in a new period of prosperity for the former capital of Brabant, whose flourishing cloth industry had been suppressed after the bloody rebellion of 1379. The town hall built between 1448 and 1463 captures the resurgent *joie d'esprit*. If reliquaries tended to take the form of architecture in miniature, the town hall of Louvain in turn resembles a reliquary magnified to the scale of architecture to exalt and enshrine civic pride. Mathieu de Layens, *'maître ouvrier des maçonneries de la ville'*, displays a master's hand in his subordination of the bristling ornament to the basic form. The fanciful design culminates in the unique, if unlovely, turrets with their bulging sculpture-encrusted piers.

Opposite the town hall stands Louvain's other great example of Late-Gothic architecture: the Collegiate Church of St Pierre. Construction of the present church, built of stone, but with brick infilling of the vaults, began in 1425 under Sulpice van Vorst, followed by Jan Keldermans of Malines and, from 1448, by Mathieu de Layens. In 1507 a grandiose scheme for the west façade, featuring a central tower no less than 535 feet high, flanked by two towers 430 feet high, was commenced by Josse Metsys according to the model still preserved in the church. However, the foundations were set on shifting sand, and following several failures, the incompleted towers were gradually lowered to reduce their weight, and today stand at merely a fifth of the intended height. The glory of St Pierre is its interior. Despite its modest scale this has a strong claim to be the most beautiful of the Late-Gothic period in the Netherlands. The overall pattern of tracery – strongly reminiscent of English Perpendicular – unifies solid wall surface and triforium, and echoes the subdivision of the clerestory window above, while the pier mouldings rise without the interruption of capitals into the vaulting, accentuating the effect of soaring height.

St Pierre, now restored with exemplary skill, was severely damaged during World War II. Fortunately, most of its important furnishings were removed to safety or spared. In the choir stands the 40 feet high tabernacle by Mathieu de Layens, its florid, Flamboyant style contrasting effectively with the chaste lines of the architecture. Of exceptional beauty and one of the rare surviving examples, is the rood screen with its Crucifixion of 1490. The Crucified Christ and mourning Virgin and St John have been attributed to Jan Borman the Elder, the leading wood carver of the day, who operated a successful studio.[44]

The elder Borman is known to have executed, *c.* 1491, the wooden model for the effigy of the beloved Duchess Mary, daughter and heiress of Charles the Rash, who was killed in a hunting accident at the age of twenty-five. Cast by Renier van Thienen between 1491 and 1498, and gilded by the goldsmith Pieter de Beckere, the bronze effigy successfully combines a poetic mood of reverie and an exquisite purity of line, with great vivacity and the new preoccupation with realistic detail. Very different in their emotional detachment are Borman's carved

186 *Below left* The apotheosis of Late-Gothic civic pride and extravagance: the Hôtel de Ville, 1448–63. *Louvain*

187 *Below* View of the choir with ambulatory and radial chapels, and the monumental tabernacle by Mathieu de Layens, 1450. *Collegiate Church of St Pierre, Louvain*

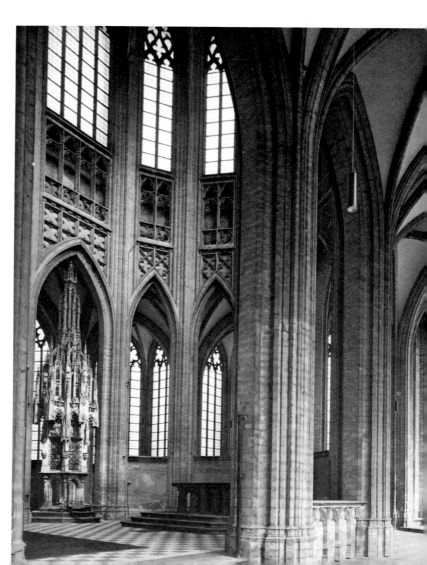

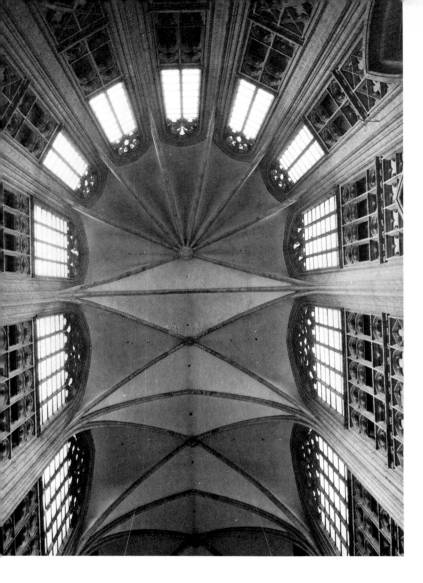

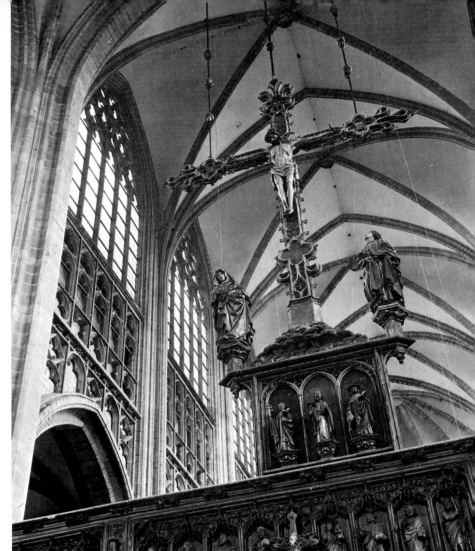

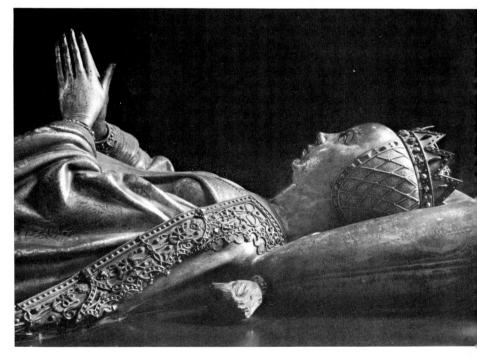

188 *Above* View up into the vaulting of the choir. Note the continuous line of the vaulting shafts, uninterrupted by mouldings or capitals. *Collegiate Church of St Pierre, Louvain*

189 *Above right* Crucifixion surmounting the rood-screen of 1490. *Collegiate Church of St Pierre, Louvain*

190 *Right* Detail of bronze effigy, 1491–98, of Mary of Burgundy, after the wooden model made by Jan Borman the Elder. *Church of Notre Dame, Bruges*

altarpieces with their multitude of small figures in theatrical groupings, no doubt inspired by the Miracle Plays. Of outstanding virtuosity, these altarpieces somehow lack the spark of life, and even the most lurid scenes of martyrdom leave one strangely unmoved.[45] Yet such was the fame of these Netherlandish carved altarpieces during the fifteenth and sixteenth centuries, that they were virtually mass-produced and despatched all over Europe, duly furnished with an official stamp and certificate, guaranteeing origin and quality of workmanship.

A new direction in the treatment of the mourning figures of Burgundian sculpture appeared in monuments executed for the ducal house in the Netherlands. The anonymous shrouded figures were replaced by highly individualised figures of relatives of the deceased – a theme that would attain its ultimate expression in the life-size array of persons, real or legendary, surrounding the tomb of the Emperor Maximilian in the Hofkirche at Innsbruck. The most striking surviving examples from our period are the bronze figurines preserved in the Rijksmuseum in Amsterdam. Much disputed as to provenance,

date and the personages portrayed, most modern critics considered that they formed part of the tomb of Isabella of Bourbon, the first wife of Charles the Rash, erected in Antwerp in 1476.[46] The animated figurines, seeming to commemorate one of the high points in the history of costume, are enchanting *objets-d'art*, but lack any religious conviction. Their style would

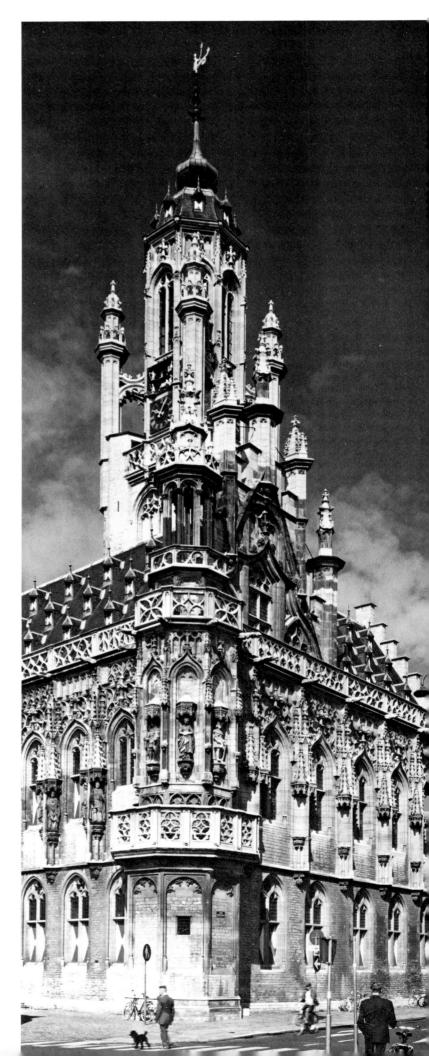

191 *Above* Detail of bronze figurine, probably representing Philip of
Nevers, surmised to have come from the tomb of Isabella of Bourbon,
c. 1476. *Rijksmuseum, Amsterdam*

192 *Right* The combined town hall and meat hall with its great tower.
Middelburg

193 *Opposite* Realistic figures straddle the flying buttresses of the nave and
transept. *Cathedral of 's-Hertogenbosch (Bois-le-Duc)*

seem to be inspired by painted figures rather than Sluter's
powerful, plastic forms.

Holland's great days were yet to come, and in the late
medieval period the northern province still lagged behind. It is,
therefore, not surprising that the few noteworthy examples of
civic architecture should be located in the province of Zeeland
united by strong cultural ties to Flanders. The one really
outstanding monument is the town hall of Middelburg.
Commenced in 1452, several members of the celebrated
Keldermans family of master builders from Malines contri-
buted to the design. Between 1506 and 1520 a meat market and
great tower were added to the original building and unified
behind a single façade – this at a time when commercial and
civic functions were being clearly differentiated in the more
highly developed south.

Churches in the north during the Late-Gothic period
generally followed Franco-Flemish precedent, with some
Germanic influence from the east. The single superb Late-
Gothic church within the present borders of the Netherlands is
the Cathedral of St John[47] or St Janskerk at 's-Hertogenbosch
(Bois-le-Duc) in northern Brabant. The conservative plan of

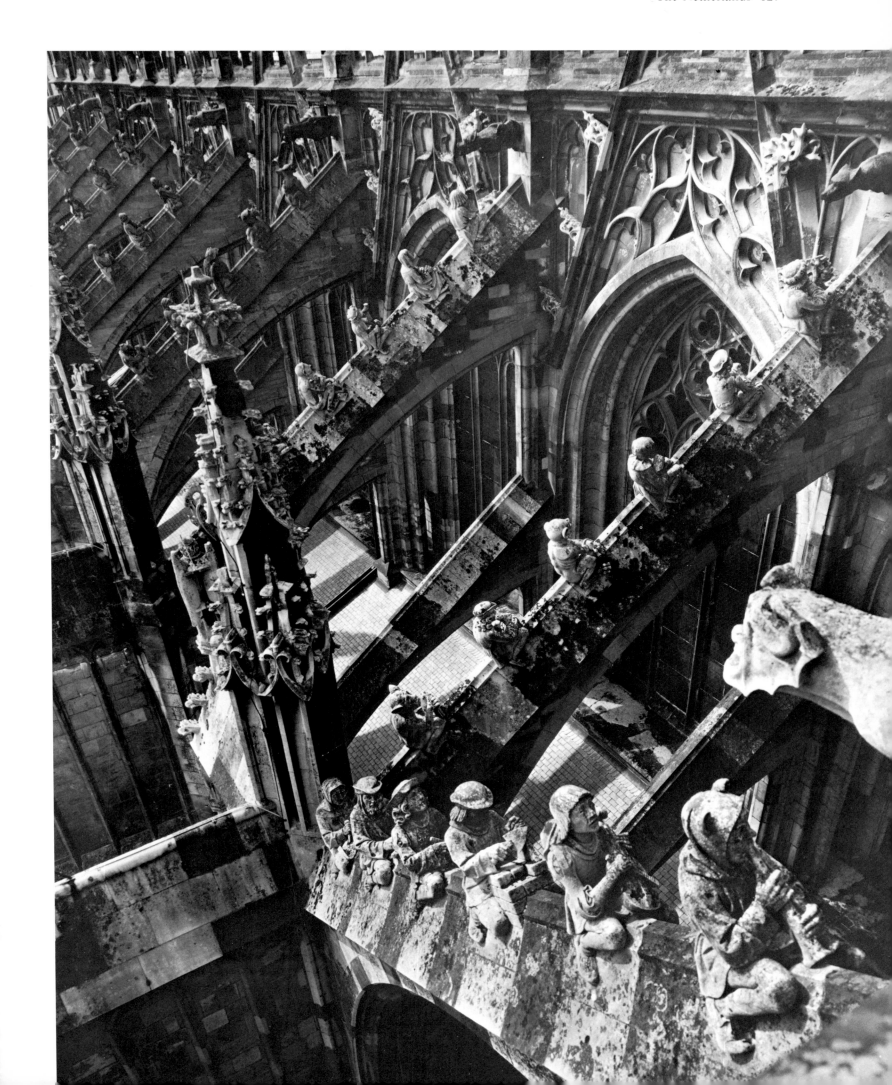

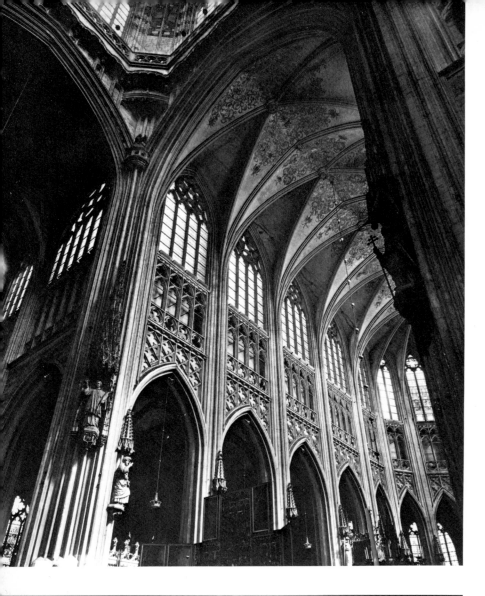

the rebuilding, commenced in 1419 after a disastrous fire, is modelled on Amiens Cathedral, via Cologne and Utrecht, and the interior treatment bears quite a close relationship to that of St Pierre at Louvain. It is to the decoration, of an exuberance and richness that would be exceptional even for Flanders, that the St Janskerk owes its fame. Blind tracery and sculpture enliven the exterior surfaces and the flying buttresses are straddled by realistic figures of townsfolk, musicians and craftsmen, interspersed with an occasional demon. The unique and utterly fantastic effect of mass-transit by broomstick to Heaven is worthy of the home town of the greatest master of the surreal and phantasmagoric in all art: Hieronymus Bosch.

Both his father and grandfather were painters, the latter having settled in 'den Bosch from Aken' (Aachen or Aix-la-Chapelle). Hieronymous van Aken was born *c*. 1450 at 's-Hertogenbosch where he spent his entire life and died in 1516. His eerie genius, divorced from the mainstream of Netherlandish art, bloomed like a night cactus in the dark',[48] an

194

193

194 *Above left* View up into the vaulting of the choir. *Cathedral of 's-Hertogenbosch (Bois-le-Duc)*

195 *Left* The façade facing the market square. *Town hall, Middelburg*

196 *Above* The great tower (1321–82) of the *Domkerk*, the former cathedral, designed by Jan van Henegouwen (Hainault), and left isolated after the destruction of the nave by a cyclone in 1674. *Utrecht*

197 *Opposite* Detail of Rogier van der Weyden's *Deposition of Christ*, *c*. 1438. *Prado, Madrid*

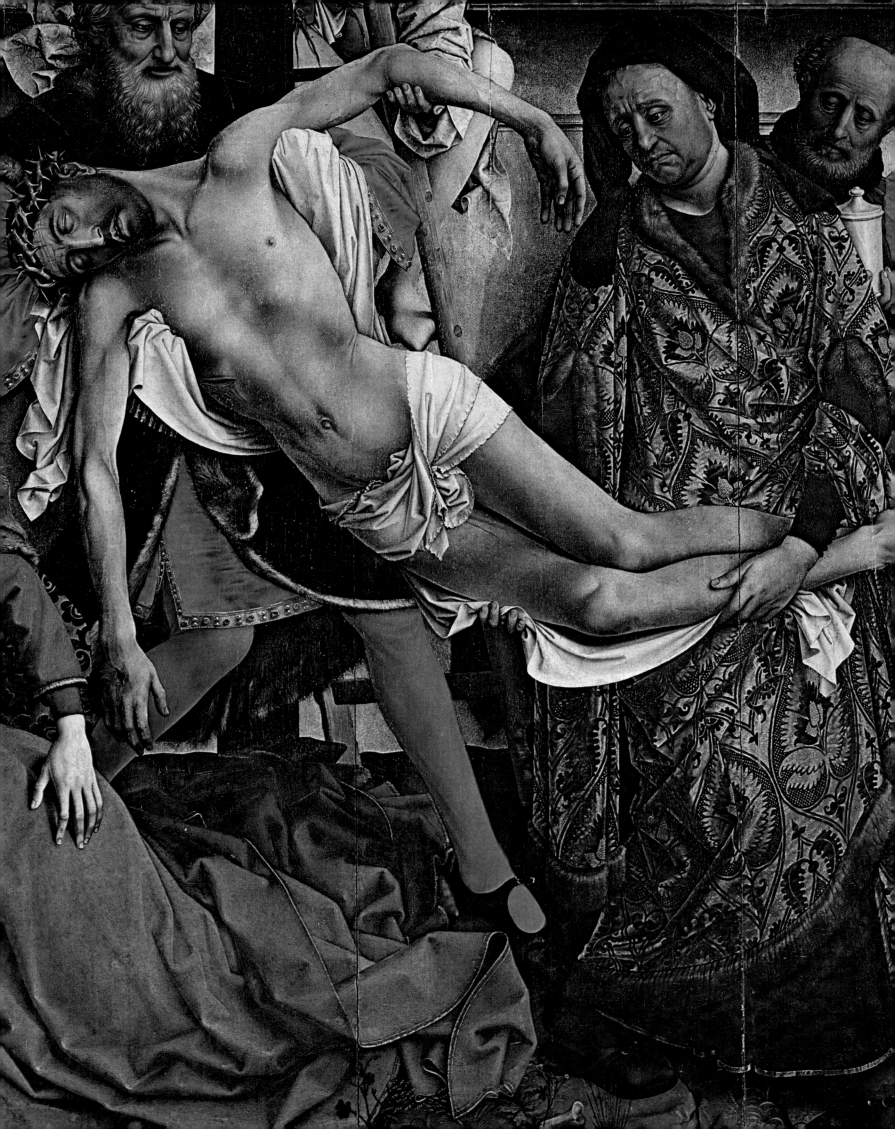

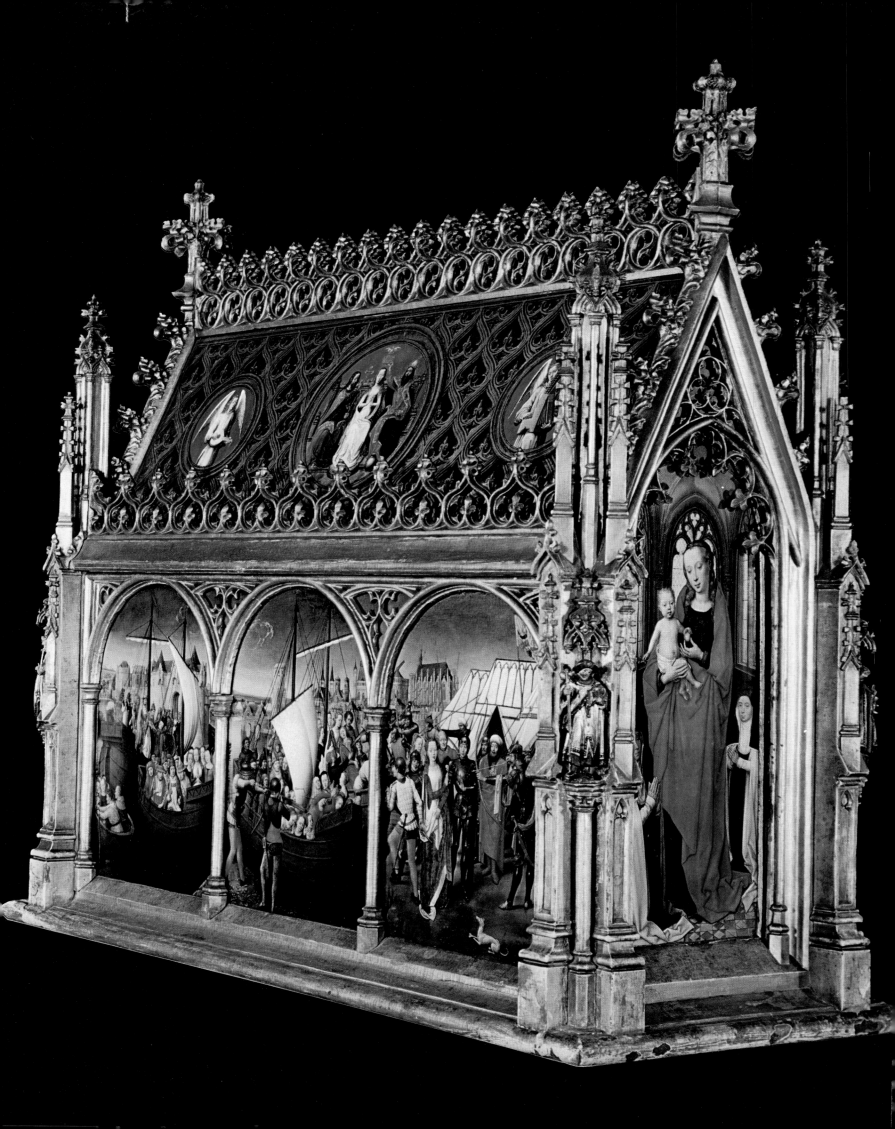

embodiment of subconscious fears and desires surfacing in visions of extraordinary beauty and horror. With Bosch we have the supreme manifestation of that delight in the bizarre and fantastic that found an outlet in the marginal drolleries of the medieval scribe. The weirdest distortions and transmogrifications, the most improbable monsters, the most unspeakable tortures – often fraught with perverse sexual imagery and symbolism – are presented with a childlike naivety that has prompted certain scholars to surmise that Bosch was a member of some such heretical sect as the Adamites.[49] However, this would seem to be highly unlikely, judging from the recorded details of his life, which stress his devoted membership of such organisations as the Confraternity of Our Lady, and the fact that his work was acceptable to the

Church and such patrons as Philip the Fair, who advanced a considerable sum for a huge *Last Judgement* in 1504. Are we to see in Hieronymus Bosch, as the consensus of critical opinion would have us believe, an ardent moralist appalled by the folly of mankind and the retribution of eternal hell fire? If so, we are dealing with the not too uncommon case of a moralist obsessed and fascinated by the very evils he is castigating. From our vantage point in the post-Freudian era, the sadistic sexual overtones of the punishments inflicted on the Damned in the Hell scene depicted on a wing of the great triptych, *The Garden of Terrestrial Delights*, provide a fascinating psychiatric exposé of the artist and his times. Much of his symbolism no doubt derived from local folk-lore, now lost, but fortunately the

199

198 *Opposite* The Shrine of St Ursula by Hans Memlinc, 1489. *Hôpital Saint-Jean, Bruges*

199 *Above left* Detail from 'Hell', one of the side panels of the triptych, *The Garden of Terrestrial Delights* (c. 1485) by Hieronymus Bosch. *Prado, Madrid*

200 *Above* The south porch (c. 1470–90) of the cathedral. *'s-Hertogenbosch (Bois-le-Duc)*

obscurity of the artist's message need not interfere with our enjoyment of his work as pure art: the spontaneous and lively brushwork, at once strong and delicate, the ravishing colour, the seemingly limitless invention, the enchanting landscape backgrounds, all make his works a never-ending source of fascination and delight.

Hieronymus Bosch painted no less than six altarpieces and also designed stained-glass for the St Janskerk, all, now, lost. He was a friend of Alard van Hameel (or Duhameel), master of the works from 1478 to 1495 and author of the imaginative sculptural programme, including the amazing decoration of the flying buttresses.

Alard van Hameel was also responsible for the most distinguished architectural feature of the entire church, the south porch, c. 1470-90, of truly noble conception and scale. Original in the extreme is the calligraphic interplay of ogive, ogee and inverted arch, the latter apparently suspended from the pinnacles like bridge cables, and stabilised by the uncompromising horizontals of the balustrade. Note, too, the subtle manner in which the bipartite division of the tracery of the rose window echoes the twin bays of the porch.

The baptismal chapel preserves a monumental brass font cast by Aert van Maastricht in 1492. On the elegantly lobed base stand six mock atlantes bearing the huge basin. Representing the lame and crippled cured at the miraculous spring of Bethsaida, they reveal an acute interest in the physiognomy of the common man.[50] The expressive attitudes also celebrate the new-found freedom of sculpture from its subservience to architecture. Dynamism is stressed to the point of contortion in the convincing, but anatomically inconceivable, position of the feet of the central figure.

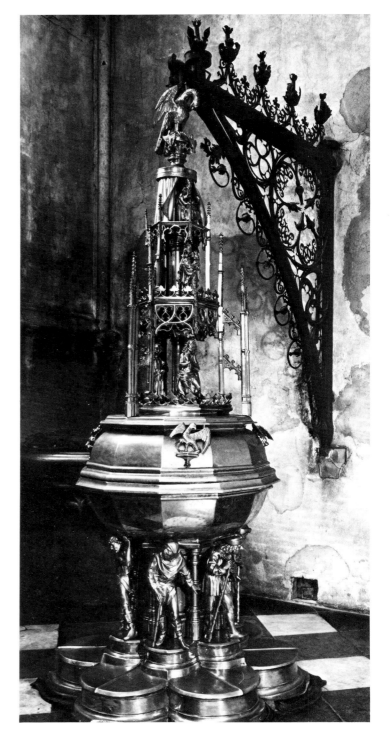

201–202 Monumental brass baptismal font cast by Aert van Maastricht in 1492, and a detail showing the bearer figures at the base. *Cathedral of 's-Hertogenbosch*

6 Germany and Austria

The death of Frederick II in 1250, and the end of the Hohenstaufen dynasty a few years later, initiated an interregnum. Henceforth, even the few outstanding Emperors – notably Charles IV of the House of Luxembourg and, later, the more able members of the House of Hapsburg – would wield power more by virtue of their inherited lands and wealth than by their Imperial dignity. In the Late-Gothic period the Empire comprised a patchwork of semi-independent states, ranging from the vast territories ruled by the Margrave of Brandenburg or the Wittelsbach Dukes of Bavaria[1] to petty demesnes comprising little more than a castle and a few square miles; from prosperous *Reichstädte* or Imperial Free Cities, ruled by a patrician oligarchy or the guilds, to ecclesiastical principalities such as Salzburg, Mainz or Cologne, where the superb gilded sword used by the prince-archbishop in his secular capacity bears eloquent witness to the union of temporal and spiritual authority. In the field of international politics the virtual impossibility of reconciling the conflicting interests of so heterogeneous a group and presenting a united front proved a disaster, and the Empire suffered losses in extent and spheres of influence. The growth of German commercial and political influence in the north and east by the powerful association of trading cities in the Hanseatic League and colonisation by the order of the Teutonic Knights outside the Empire was checked and then reversed. East Prussia was isolated with the occupation of West Prussia by Poland in 1466; and territory was lost to Denmark, to France and especially to Burgundy, while the independence of the Swiss cantons was reluctantly recognized. On a regional basis, however, the system often worked surprisingly well, with the local authority – be it prince, bishop or town-council – assuming effective sovereignty, jealously guarding its independence and encouraging a rich diversity of arts to add lustre to its name, a situation analogous to that in Italy.

The three outstanding examples of medieval urban culture

203 *Left* The scabbard of the Prince-Archbishop of Cologne's jurisdictional sword, made of filigree silver-gilt ornament with red velvet backing. *Treasury of Cologne Cathedral*

204 *Above* Woodcut view of Nuremberg, its closely-knit streets dominated by the martial silhouette of the *Burg* and the spires of the two main churches, St Lorenz and St Sebaldus—a medieval city that survived almost intact until World War II. From the *Nuremberg Chronicle*, 1493.

outside Italy were the Low Countries, Catalonia and Germany, where decentralisation favoured the establishment of numerous medium-sized centres, rather than a metropolis. Secure and prosperous within their walls, the German towns and cities offered a rich social life, functioned so well and proved so congenial to the spirit, that many preserved their medieval aspect virtually intact until their destruction in World War II – a particularly grievous loss to the world, since it was as examples of medieval 'townscape', inimitably picturesque, yet truly organic in structure, rather than for the intrinsic quality of individual monuments, that they were irreplaceable. The terraced houses of the prosperous merchants and artisans on

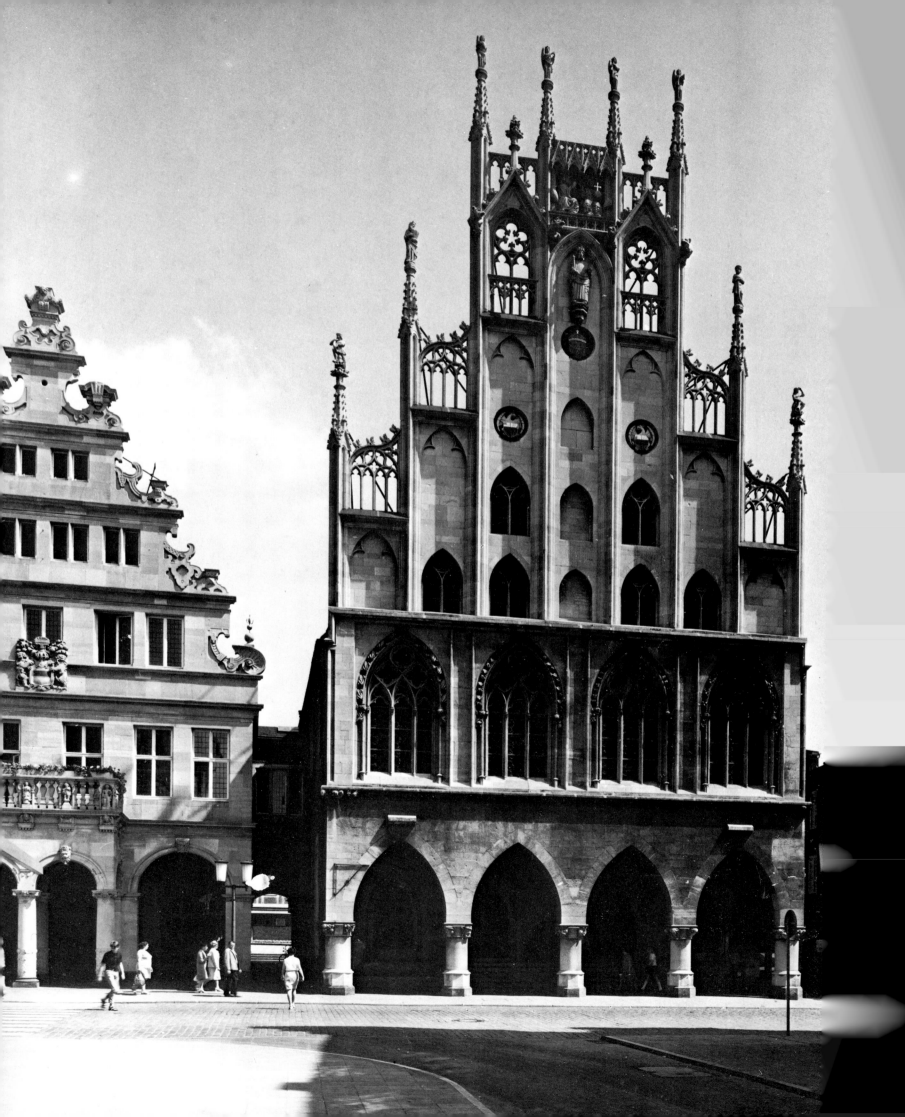

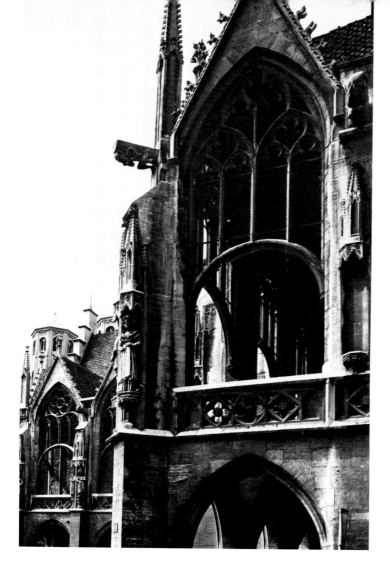

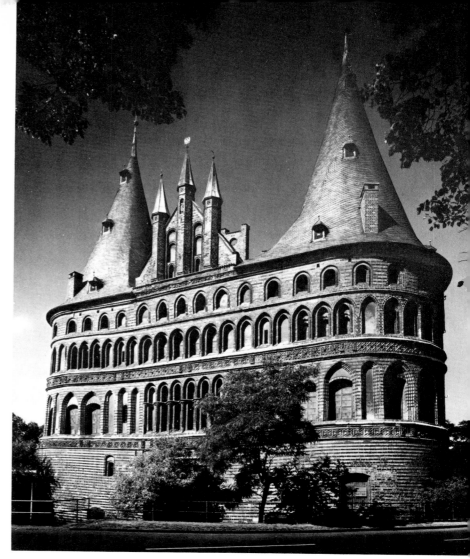

deep and comparatively narrow lots, and often five or six storeys high, including the attic storeys within the steeply pitched roof, usually present their gable-fronted façades to the street, either half-timbered, stuccoed, of stone or of brick, depending on the region.

The two basic elements of the German town hall are a loggia at ground level, providing shelter from the weather and a place for merchants to do business, and the ceremonial chambers on 205 an upper level.[2] At Münster we have what is in essence an elaborated version of the gabled *Bürgerhaus*, with the civic character imparted by the decorated windows of the great chamber, the purely decorative screens of tracery, and the 206 crowning pinnacles. At Brunswick the original L-shaped structure with gabled ends, commenced in 1302, on the corner of the old market square, was transformed by the addition of a double-storeyed loggia, first along one side (1393) and then along the other (1447) to make it architecturally the most distinguished Late-Gothic town-hall façade in Germany.

205 *Opposite* Façade of the town hall. *Münster*

206 *Above* View of the arcades added to the town hall in 1393 and 1447. *Brunswick*

207 *Above right* View of the less restored, east façade of the Holsteintor, a distinguished example of German Gothic architecture in brick, dating from 1477. *Lübeck*

208 *Right* Detail of the upper portion of the east wing or *Neues Gemach*, erected between 1442 and 1444 to extend the facilities of the town hall. *Lübeck*

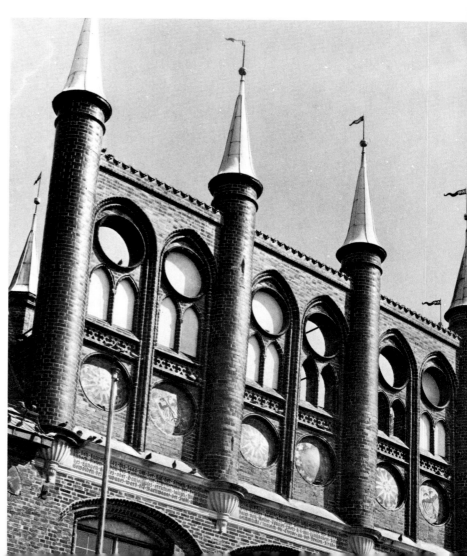

Buttresses rising through two levels, and bearing canopied statues of Saxon and Welf princes, divide each face into four bays, terminating in high, peaked gables. The top half of the upper arcade is filled with tracery, the vertical members of which are, however, interrupted half-way down by a semi-circular skeletal arch, which echoes the opening of similar proportions to the arcade of the squat lower floor – an extremely curious treatment that in its abrupt conjunction of arch and vertical recalls a characteristic feature of the English Perpendicular style.[3] Combining dignity and intimacy, the upper loggia provides a perfect setting for civic ceremonial. Yet the architectural vocabulary was appropriated straight from ecclesiastical Gothic.

In the town hall of Lübeck it is rather the world of chivalry – the castle and, even more so, the make-believe of the tournament – that is evoked by the jaunty round turrets with their glittering pennants, the pierced screen wall with its suggestion of crenellation and the great roundels with painted heraldic crests. The building material is brick, the natural choice in these northern plains rich in clay deposits but deficient in building stone – an area stretching from Holland through the

lands bordering both sides of the Baltic as far east as the Gulf of Finland. Throughout this area a style of brick Gothic evolved which creatively exploited the inherent potential of the material and gave to the cities and castles arising under the aegis of the Hanseatic League and the Teutonic Order a distinctive, remarkably homogeneous character. The delicate sections and complicated mouldings feasible in soft sand-stone were less likely to be attempted in brick, nor did the severe climate favour the classic Gothic glass-house. The solution was a style employing broad planes of walling, cubical massing and simplified detailing, in which monotony was avoided by such devices as the polychrome diaper patterns so easy to achieve in brick, by contrasting matt and light-reflecting glazed brick, by recessed blind-panelling that provided a rich play of light and shade, and – in order to maintain the vertical *élan* of the Gothic spirit – by closely-spaced elements such as buttresses, terminating not in sculptured and crocketted pinnacles and finials, but in a bristling palisade of turrets. As the acknowledged leader of the Hanseatic League, it is fitting that Lübeck should possess the tallest brick church of the north in its Marienkirche which, however, not only antedates our period but in its basilican form is not typically Late-Gothic.[4] We shall, therefore, consider the second superb example of secular *Backsteingotik* ('brick gothic') architecture in Lübeck, the Holsteintor, a twin-towered gateway erected in 1477, when the proud city feared no invader, but wished for a symbol of civic pride. Above the level of the actual gateway – now sunken in relation to the roadway – rise three storeys of arcading, much of it blind, and friezes of moulded ceramic ornament, prototype of the mass-produced terracotta ornament that would be used *ad nauseam* during

208

209 *Below* Gothic diversity in unity: the *Schöner Brunnen*, or 'Beautiful Fountain' (1385–96), and the Frauenkirche (1352–61). Above the porch is the west choir constructed by Adam Kraft between 1506 and 1509, with its elaborate mechanical clock. At noon figures of the Seven Electors pass one by one around that of the Emperor Charles IV, who graciously acknowledges their homage. *Nuremberg*

210 *Below right* Castle interior with painted beams and mural decoration. *Burg Eltz in the Moselle Valley*

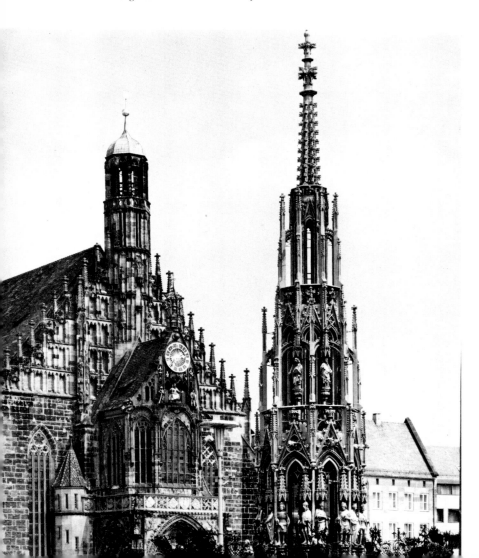

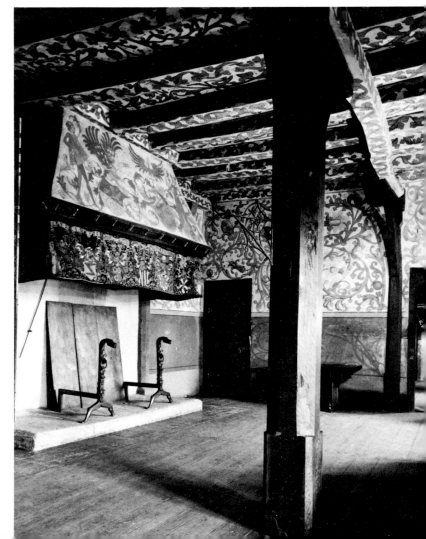

the Victorian era, but here lively and charming.

The same celebration of civic pride can be seen in the treatment accorded the source of drinking water. Most main squares in Germany to this day sport a fine fountain, perhaps the most spectacular in Germany being the *Schöner Brunnen* ('Beautiful Fountain') in the market square of Nuremberg. Above the octagonal basin rises a slender, sixty-foot-high, pyramidal structure, a lacy, lavishly decorated spire at ground level. Incorporated within the elaborate architectural setting is a sculptural programme whose iconography must have seemed to contemporaries to represent all knowledge and secular history: first seated figures of women personifying Philosophy and the Seven Liberal Arts,[5] with a group of the Four Evangelists and Four Church Fathers; next standing figures of the Seven Electors[6] and the Nine Worthies, three pagan (Hector, Alexander and Caesar), three Jewish (Joshua, David and Judas Maccabeus) and three Christian (King Arthur, Charlemagne and Godfrey de Bouillon); and in the uppermost tier eight Old Testament Prophets. The *Schöner Brunnen* was supplied with a water pipeline of its own in 1388, lead or wooden piping being used for such a purpose. The medieval city was, in fact, not nearly so deficient in matters of cleanliness and hygiene as we sometimes imagine. Hot baths in private houses are recorded as early as the thirteenth century, and the public bath-house, usually under municipal management, thrived in Germany. In the Late Middle Ages seven are recorded in Würzburg, eleven in Ulm, twelve in Nuremberg, seventeen in Augsburg and twenty-nine in Vienna.[7] Customarily frequented once a fortnight, the medieval German bath-house was a social centre for the community.

A distinctive German contribution to Gothic architecture is the *Hallenkirche* or 'hall-church', in which a single vast roof covers the entire width of nave and aisles. The form, typical in a crypt, where the horizontal plane of the floor above enforces an equal height of central bay and aisles, had already been used on a monumental scale centuries before in France,[8] but had never become popular there or in England, and certainly never challenged the classic basilican section with high nave lit by clerestory windows over the aisles. The basilican section is characterised by strong directional movement towards the choir, owing to the additive nature of the bay structure, whereas the hall-church, especially in its developed form with widely-spaced piers that open up tantalizing diagonal vistas, is in fact a columnar hall with space spreading in every direction – an essentially congregational rather than processional space, that reflects the influence both of the preaching friars and of the changed focus of patronage in the German cities from bishop to burgher. The source of light is now restricted to the aisle windows, which can be immensely tall and suffuse the interior with an all-pervading light, which, in sharp contrast to the transcendental overtones associated with clerestory lighting

209

213

high above, has a quasi-secular character and an implied kinship with the everyday world congenial to bourgeois life.[9]

Whereas the Gothic style in England had evolved from the interaction of French example and native traditions, which had a powerful Gothic potential of their own, in Germany the new style had been imported in a fully-developed form from France

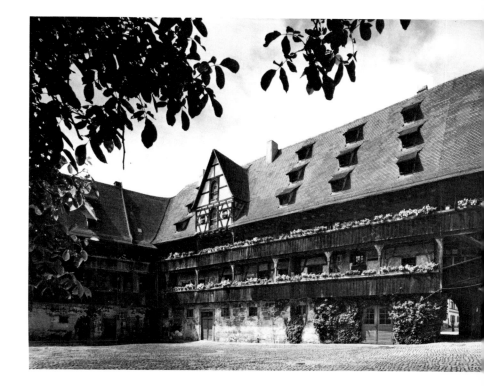

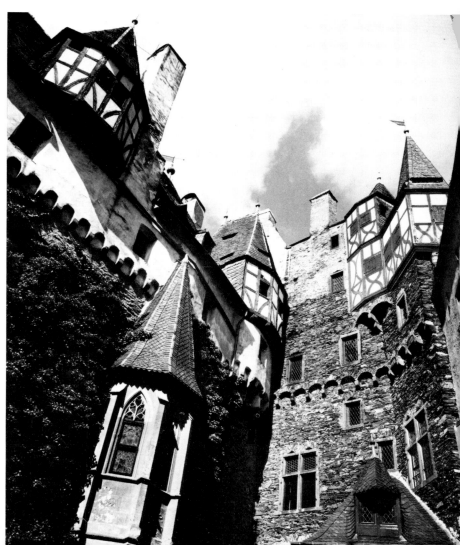

211 *Above right* Courtyard of the *Alte Hofhaltung*, or 'Old Residence' of the bishops, built between 1475 and 1489. The wooden galleries give access to the domestic quarters in the superstructure; its huge roof is of a pitch steep enough to shed the heavy snowfalls of Central Europe. *Bamberg*

212 *Right* Peculiarly Germanic as a building type is the *Ganerbenburg* or fortified castle under multiple ownership. In Burg Eltz four branches of the same family were housed, each with separate entrances from the courtyard which, in its organic growth over the centuries, resembles a medieval town in microcosm. The oriel (lower left) was added to house an oratory. *Burg Eltz*

and it was some time before German masters felt secure enough to depart from French precedent. One of the earliest intimations of an independent spirit is found at Marburg, where the great Church of St Elizabeth, with its nave in the form of a hall-church, was substantially completed by 1283. However, classic basilican form continued to prevail in the design of the cathedral – to whose function it was still the more appropriate form – and it was not until the *opus Francigenum* had been thoroughly naturalised that the *Hallenkirche* came fully into its own in the context of parish-church design.

Considered a key example of the development of this form is the Heiligkreuzkirche, or Church of the Holy Cross, at Schwäbisch Gmünd. Here around 1320 the nave was rebuilt with a flat ceiling covering nave and aisles of equal height, separated by an arcade supported on round columns. In the new choir, commenced in 1351, the same round columns were used as in the nave, but raised to a greater height, giving an exhilarating effect of expanding space. The principle of the hall-church was here applied to the east end, with the ambulatory at the same height as the choir; both vaults, which are later insertions of about 1500, but show the type developed and used throughout the preceding century or so, are covered with a close-meshed overall pattern of lozenges. These build up into star patterns, and totally ignore the bay division, thereby lending further unity to the interior design. Superbly decorative but completely lacking in any structural rationale, these vaults irresitibly call to mind the English lierne vault at its most complex, at Gloucester, for example.

Both nave and choir are attributed to Heinrich Parler – from the French *'parlier'* (a foreman), in which capacity he had worked in the cathedral lodge of Cologne, his native town, as a young man. Sceptical critics have doubted that the same master could be responsible for two such different designs, but the change evident in the design of the choir may reasonably be explained by the contribution of his son, Peter Parler, who must already have demonstrated extraordinary talent to be summoned from Schwäbisch Gmünd to Prague, capital of the Holy Roman Empire, to complete the Cathedral of St Vitus.[10]

The Emperor Charles IV, of the House of Luxembourg, was educated at the court of France and married a daughter of the king. When he chose Prague as capital of the Empire and persuaded the Pope to elevate the see to an archbishopric, he summoned as architect for the splendid new cathedral Master Mathieu d'Arras, who had worked on the cathedral at Narbonne. Mattieu died in 1352 when French fortunes and prestige were on the wane, and a German master was chosen as his successor. Peter Parler and his family were responsible not only for the completion of the choir of the cathedral of Prague, but also for the design of the Charles Bridge and its tower, and

213 *Left* View of the east choir erected between 1361 and 1379; an enchanted forest offering tantalising views in every direction. *St Sebaldus, Nuremberg*

214 *Below* View from the nave towards the choir, commenced in 1351; the thickened column marks the transition. *Heiligkreuzkirche, Schwäbisch Gmünd*

215 *Opposite* Detail of the superb ceramic stove in the lavishly decorated 'Golden Room', built for Leonhard von Keutschach, Prince-Archbishop of Salzburg (1495–1519). *Hohensalzburg*

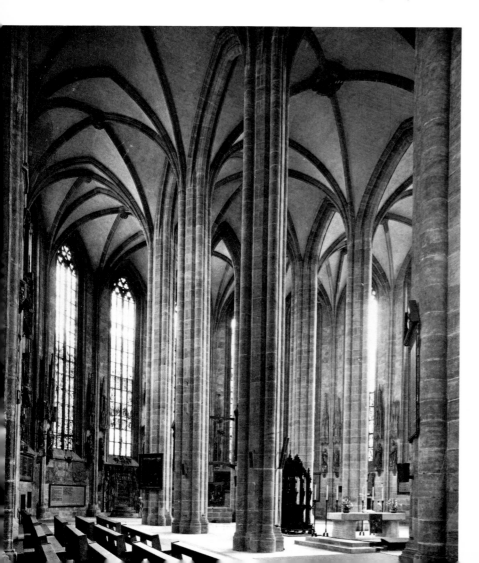

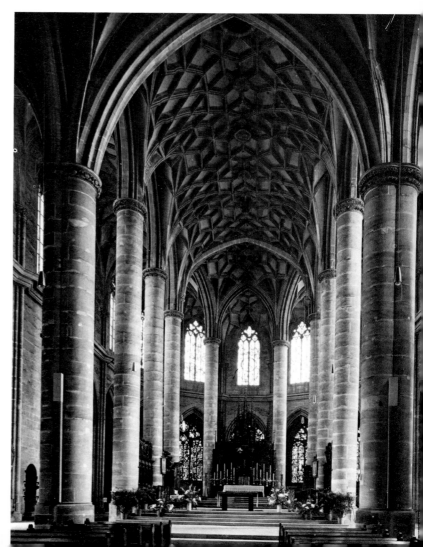

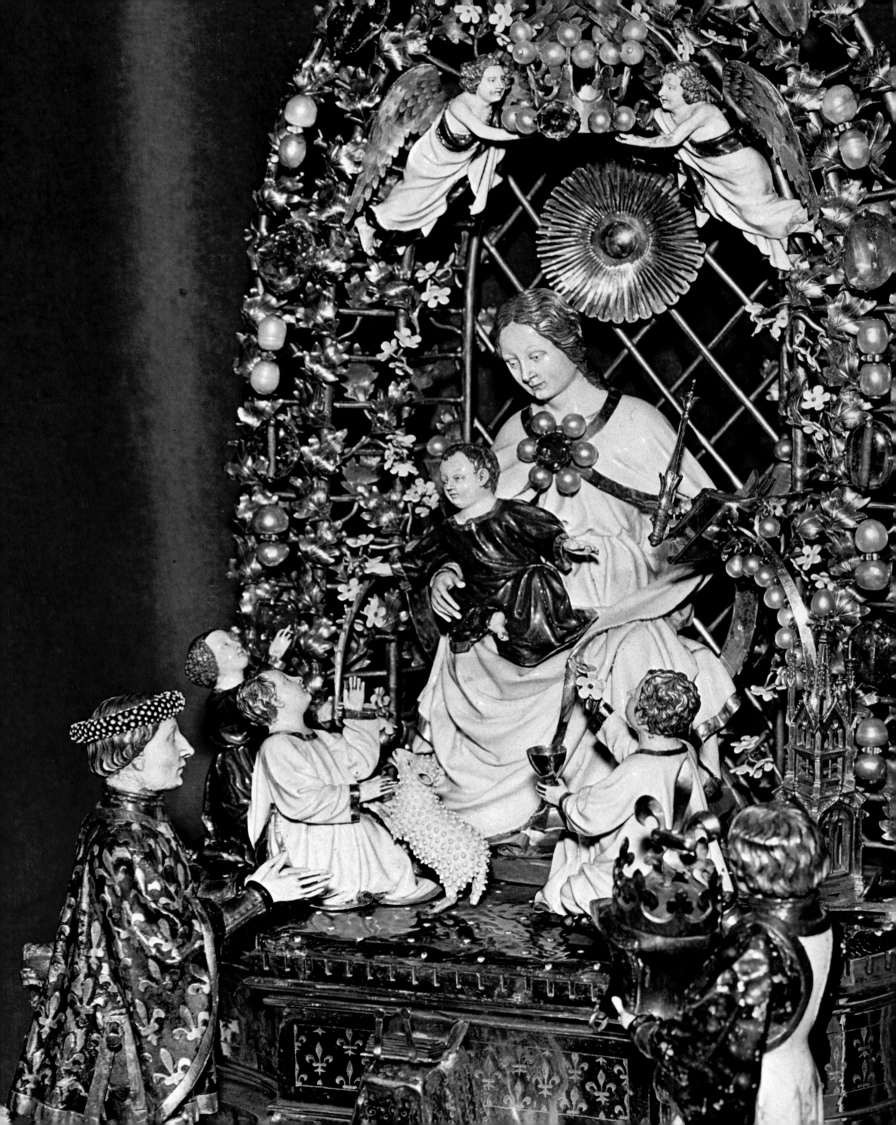

many churches throughout the land. The brilliant flowering of Bohemian art and culture initiated by the Emperor was, however, cut short by the turmoil of the Hussite Wars that commenced in 1419, and the centre of the Empire moved to Vienna under the Hapsburgs.

The style evolved by Peter Parler was truly international, showing an awareness of contemporary developments not only in Strasbourg and Cologne, but in France and, particularly, in England. There is no evidence that Peter Parler ever visited England, but he may well have done so; at the very least he must have been familiar with drawings of English lierne vaults and flying ribs. In the high vaults of the choir of Prague Cathedral, built some time after 1353, he designed a series of net vaults which mask the bay divisions in the church and are significant for the development of German decorated vaults. Later examples of this particular patterning can be seen in its final classic form in the choir of the Minster of Freiburg-im-Breisgau and the *Parlatorium* of Maulbronn Abbey. In both these examples the structural expression of the rib has succumbed to an overall surface texture.

On the other hand, the expression of rib construction – albeit a perverse expression – is the *raison d'être* of the skeletal vault. Again, there are English precedents, in this case dating back almost to the beginning of the century,[11] but Peter Parler, in the

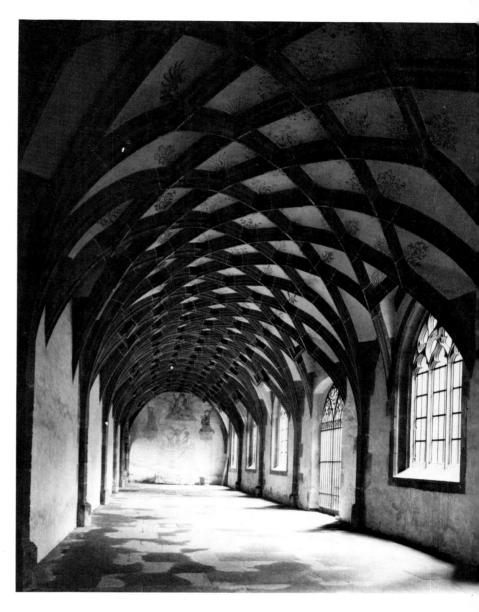

216 *Opposite* Detail of the *Goldenes Rössel*—pure gold beneath the enamel—a New Year's gift from his queen to Charles VI of France. The king and his marshal kneel before the Virgin and Child and the patron saints of the king's three children, themselves represented as children. *Treasury of the Pilgrimage Church of Altötting, Bavaria*

217 *Below* Interior of the choir consecrated in 1513. *Minster of Freiburg-im-Breisgau*

218 *Right* The 'New *Parlatorium*', or Monks' Parlour, erected in 1493 by a lay-brother, with its heavy network of ribs enlivening what is in essence a simple barrel vault. *Maulbronn Abbey*

219 *Below right* Flying vaulting ribs in the chapel of St Catherine. *Stephansdom, Vienna*

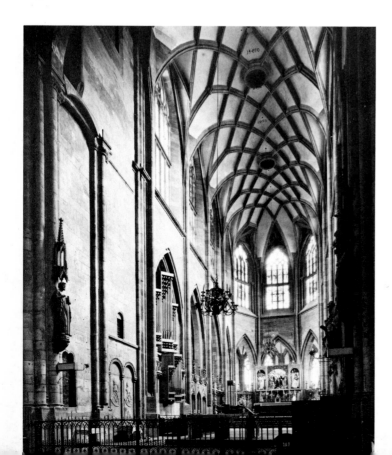

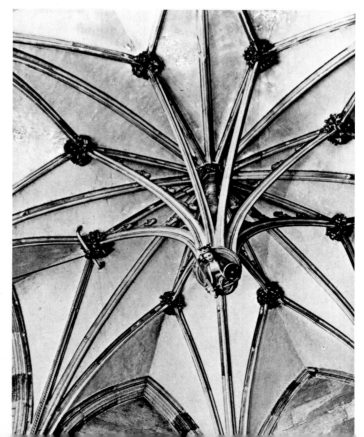

sacristy (1355-60) of Prague, was the first on the Continent to build a pendent skeletal vault. The interest here is primarily historical, since the design could hardly be judged a success visually, but in the Chapel of St Catherine in the Stephansdom in Vienna, completed in 1396, although commenced long before,[12] the effect is stunning.

Peter Parler (c. 1330-99) together with his brothers and their sons, and other members of the Parler clan, formed a veritable dynasty of master-builders. They were dubbed the *'Junker von Prag'*, and not only dominated the lodge there, but diffused the style perfected by Peter, the basis of the *Sondergotik*, over a wide area through their work and example in Vienna, Ulm, Freiburg-im-Breisgau and Basle, and also through their personal and professional connections: Peter, for example, was married to the daughter of a leading mason from Cologne and numbered among his pupils Peter von Prachatitz who designed the upper part of the great tower of the Stephansdom. So great was the prestige of the family that 'Enrico da Gamondia' (Heinrich II, a grandson of 'Heinrich of Gmünd') was called to Milan in 1391 as consultant in connection with the design of the cathedral there, an event that provoked the celebrated confrontation between the Northern and Italian schools of design.[13]

Externally the two most prominent features of the German church were the huge roofs and a single tower, preferably located over the west portal, and customarily terminating in an openwork spire. When the Late-Gothic nave of the Stephansdom in Vienna was erected, it was decided to retain the Romanesque west-front, and to compensate for the meagre scale of its single portal by additional transeptal entrances protected by imposing porches culminating in spired towers. The southern tower, the *Alte-Steffl*, was completed between 1368 and 1433, and work commenced on the north tower in 1450. In 1511, when it was still only half completed, work ceased temporarily, and then was never resumed. As it is, the balance between the titanic bulk of the roof and the slender obelisk of the 448 foot tower is extremely satisfying.[14] Wenzel Parler, a brother of Peter, had been consulted on the design of the southern tower in the 1390s and Peter von Prachatitz, as we have noted, was a Parler pupil, so the design naturally reflects the Parler style and particularly its search for overall unity, here achieved by merging one stage almost imperceptibly into the next.

The foundation of the present minster at Ulm dates from 1377, when Ulm became the head of the Swabian League. Significantly, the stone was laid not by prince or prelate but by the mayor. The aisleless choir was built by a succession of three members of the Parler family,[15] but after Heinrich II resigned in 1391 to go to Milan, he was succeeded by Ulrich von Ensingen – founder of another great dynasty of master-masons – who, followed by his son and grandson, was in charge of the *Münsterbauhütte* (minster lodge) from 1391 to 1471. It was Ulrich von Ensingen who vastly increased the scale established by the already spacious Parler choir, with a wide-aisled, lofty, basilican nave, ten bays long, terminating at the west in a single gigantic tower. The body of the church had been completed and work was proceeding on the third stage of Ulrich's tower when Matthäus Böblinger became master of the works in 1474 and proposed an even more ambitious crowning octagon and spire. His plan was, however, never implemented, for in 1493 there were signs of failure of the tower piers. The next decade was spent stabilising the structure, including the

aisles,[16] and then, with only the third stage of the tower completed, work ceased. Only in the nineteenth century were the octagon and the openwork spire constructed, in the main following Böblinger's detailed elevation drawing of 1482, still in the possession of the minster. Towering to 528 feet, the spire remains to this day the highest stone structure ever built, and a permanent testimony to the civic pride of the burghers of the 'free cities' of the Empire at the close of the Middle Ages.

The highest tower actually to have been built in the Middle Ages was the 466 feet high spire of Strasbourg Cathedral, 'an aerial fantasy representing the mystical aspiration of its designer and a whole people'.[17] The magnificent west front which predates our period followed the classic French pattern with twin west towers as far as the third stage. Then the native preferences asserted themselves and a radical change of plan was announced by the cliff of masonry linking the third stages of the towers, intended to carry a single, centrally placed tower, as shown on Master Michael Parler's ink drawing on

220 The two most characteristic features of the German Gothic church, the steeply-pitched roof and the single tower of gargantuan scale, here achieve a perfect balance. *Stephansdom, Vienna*

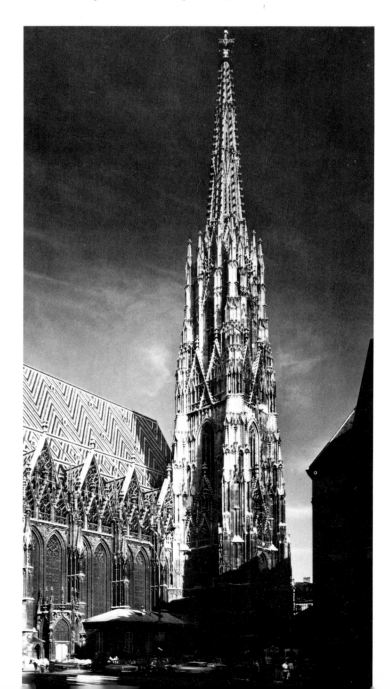

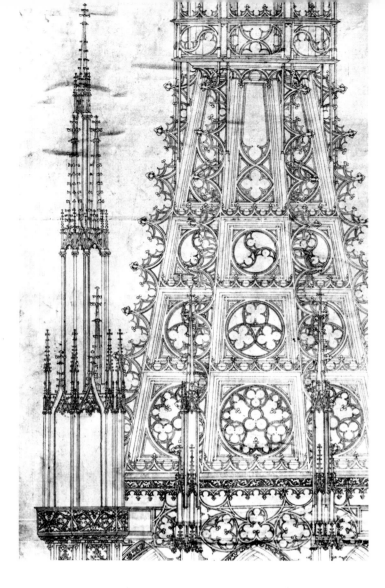

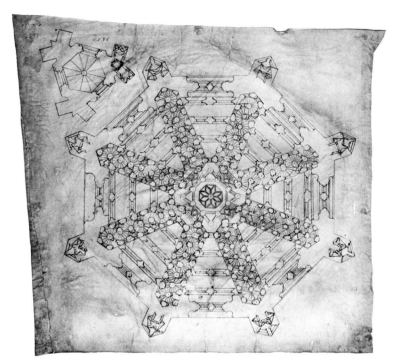

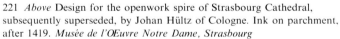

221 *Above* Design for the openwork spire of Strasbourg Cathedral, subsequently superseded, by Johan Hültz of Cologne. Ink on parchment, after 1419. *Musée de l'Œuvre Notre Dame, Strasbourg*

222 *Above right* Measured drawing of the octagonal spire of Strasbourg Cathedral. In one corner is a ground plan of one of the angles of a tower containing a newel staircase. *Victoria and Albert Museum, London*

223 *Right* View of Strasbourg Cathedral in 1630 by Wenceslaus Hollar, engraved in 1645.

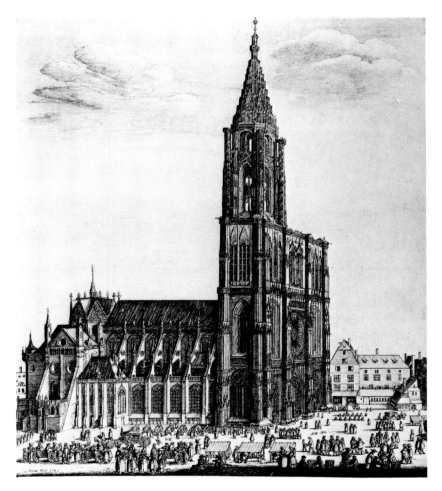

parchment of *c.* 1385, preserved in the Musée de l'Œuvre Notre Dame. This concept, which even on the drawing did not augur well, was fortunately abandoned, and between 1399 and 1419 Ulrich von Ensingen erected the fourth stage of the north tower in the form of an octagon with turrets at the angles enclosing spiral stairs, the design being marked by the most complex interpenetration of forms and a truly heroic grandeur of scale.

221 His successor, Johan Hültz, designed an almost perversely original structure: an octagonal spire encrusted with a veritable forest of bristling pinnacles arranged to create *aediculae* within which claustrophobically narrow and vertiginously steep open stairs – definitely not for the faint-hearted – ascend like Jacob's

224 Ladder to Heaven. It was on the strength of this tower, completed in 1439, that the master-builders of the Empire conferred the title of Grand-Master on the master of the Strasbourg Lodge, while the city became the Grand Chapter of the Order – both honours granted in perpetuity.[18]

 Between 1390 and 1420 the Austrian master, Hans von Burghausen – often formerly referred to, incorrectly, as Hans Stetheimer[19] – produced half a dozen churches, each with a

distinctively different character, two of which deserve special notice. In his design for St Martin at Landshut the keynotes are simplicity, scale and structure. The plan has been reduced to essentials: an aisleless choir and a box-like hall, within which simple octagonal piers hardly more than three feet wide rise to a height of nearly seventy feet, their vertical line further stressed

225
226

by the attached shafts picked out in a different colour. Between the modest openings into the side chapels and the windows above, there is a large expanse of uncompromisingly blank walling emphasising the sense of containment, that makes the three tall windows of the apse, their sills brought down low behind the altar, all the more inviting. This sense of direction, not always present in a hall-church, is further reinforced by the richer vaulting pattern of the choir and the gigantic suspended rood.

How different from the forthright simplicity of St Martin is the extremely sophisticated treatment of the choir of the Franziskanerkirche[20] at Salzburg, some thirty miles south of

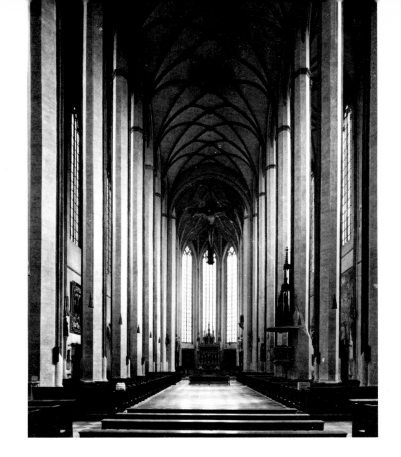

224 *Below* Detail, looking upward, of Johan Hültz's spire with its vertiginous stairways ascending within the aedicular pinnacles-cum-buttresses (top right). The hollow octagon is pierced with openings fretted with delicate tracery (bottom left). *Strasbourg Cathedral*

225 *Right* Interior looking towards the choir, commenced in 1392 by Hans von Burghausen. *St Martin, Landshut*

226 *Below right* A strong vertical emphasis gives this version of the hall-church its particular character. *St Martin, Landshut*

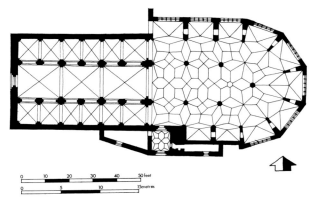

IX Plan of the Franziskanerkirche, Salzburg

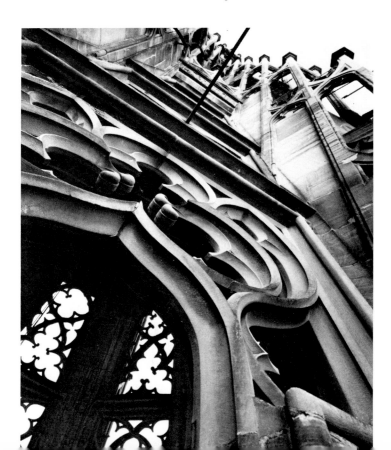

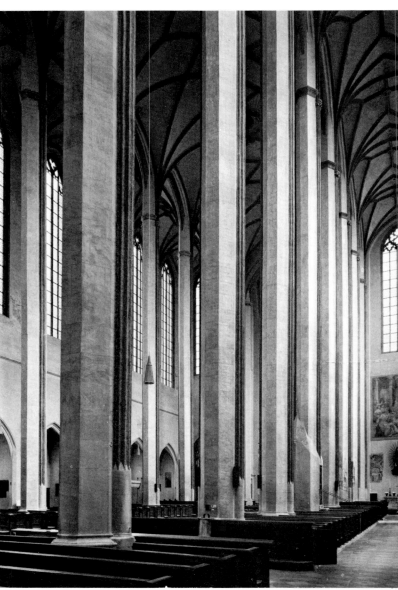

227 *Bottom left* The sombre Romanesque nave leads to Hans von Burghausen's Late-Gothic choir housing a Baroque altar which incorporates Michael Pacher's Madonna of 1495. *Franziskanerkirche, Salzburg*

228 *Right* Mature Late-Gothic vaulting at its most assured. A web-like membrane is used to effect the transition from pier to vaulting. *St Georgskirche, Dinkelsbühl*

229 *Bottom right* Interior of St Georgskirche (1448–92) by Nicolaus Eseler. *Dinkelsbühl*

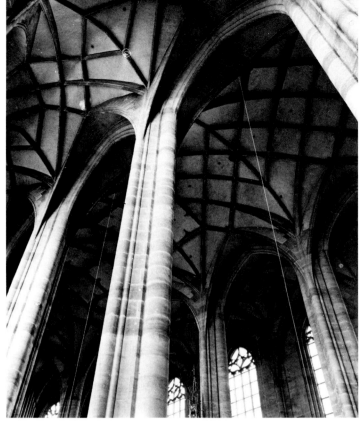

227

Hans' native Burghausen. Although a complete reconstruction was planned, only the choir was rebuilt, an historical accident which leaves the striking contrast between the gloomy Late-Romanesque nave and the radiant choir, seeming to symbolise the pilgrim's journey towards the light. The focal point of the choir is the centrally placed column rising behind the high altar, its vertical impetus continued into a star vault which rises at an unusually steep angle, creating the effect of an opening blossom. Such axial piers deflect the eye from its east-west path to explore the diagonal vistas which, as we have noted, held such a fascination for Late-Gothic designers in Germany.

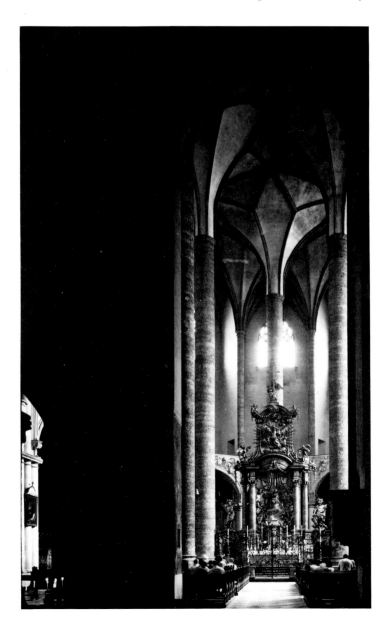

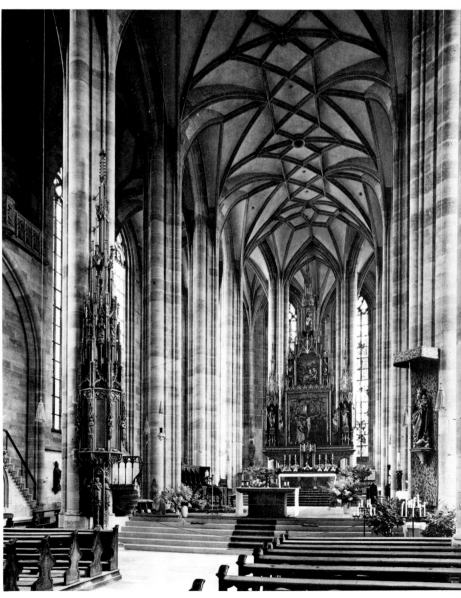

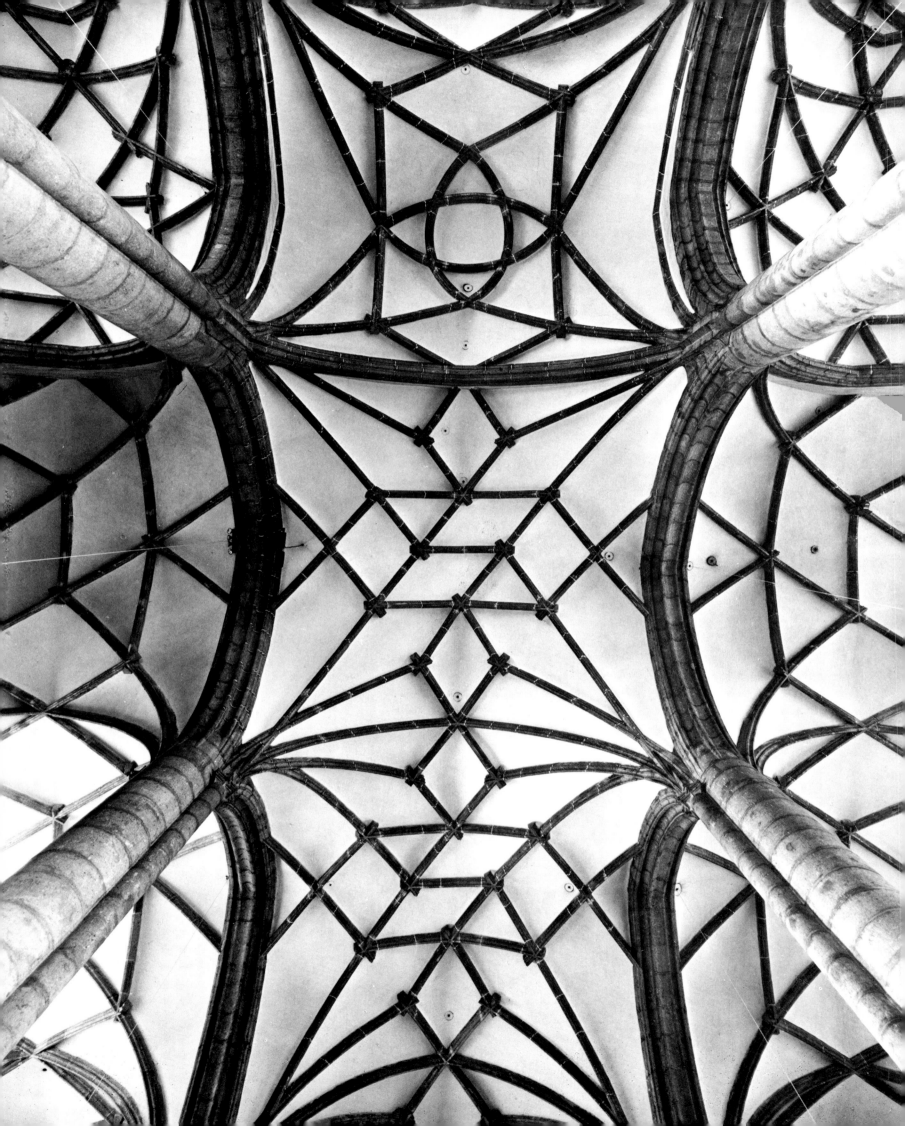

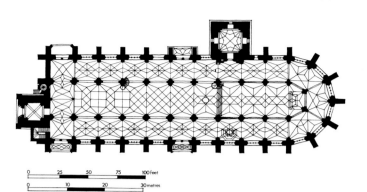

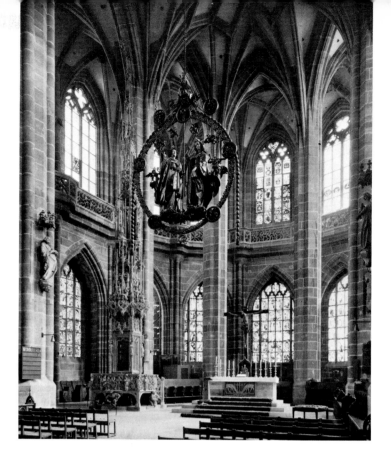

230 *Opposite* This view up into the vault reveals the asymmetry in the rib pattern of the two lower bays, where one might logically have expected the central lozenge pattern to continue; this sets up a tantalising syncopated rhythm that recalls the 'Crazy Vaults' of Lincoln Cathedral centuries earlier. *St Georg, Nördlingen*

X *Above* Plan of St Georgskirche, Dinkelsbühl

Here at the Franziskanerkirche the emancipation from the discipline of the bay and axis is complete. The plan (figure IX) shows that choir and ambulatory have merged imperceptibly, the vaulting being organised around five touching star vaults, springing from the five piers. If one substitutes touching circles for the touching stars the analogy with later English fan vaults is obvious.

In the hall-churches of the next generation there is a measured restraint 'tranquil and reassuring, noble and un-

231 *Above* View of the choir (1439–77) begun by Konrad Heinzelmann, and continued by Konrad Roritzer. Suspended from the vault is Veit Stoss's *Angelic Salutation*, and on the left is the towering ciborium by Adam Kraft. *St Lorenz, Nuremberg*

232 *Below* View up into the vault designed by Konrad Roritzer. *St Lorenz, Nuremberg*

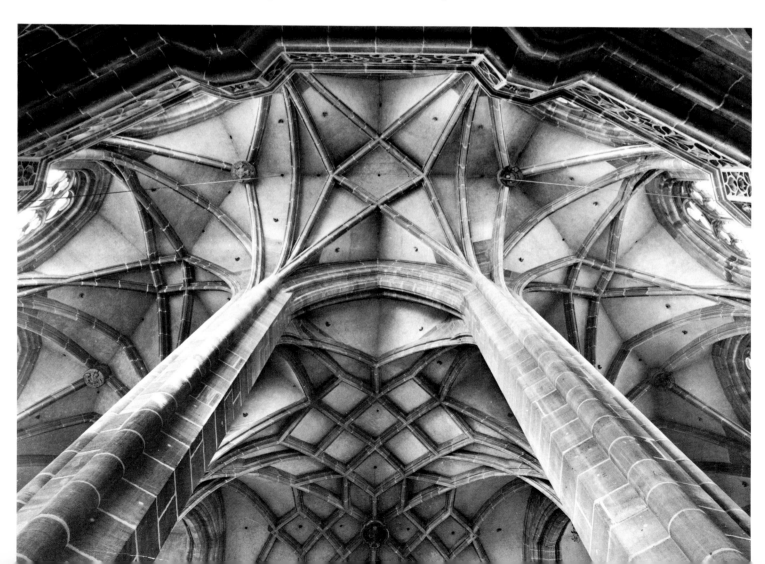

hurried, in spite of the agitation within them'.[21] St George at Dinkelsbühl by Nicolaus Eseler (c. 1448–92), perhaps best illustrates this phase. The plan (figure X), uncompromised by existing work, except for the Romanesque west tower, is of classic simplicity: a single unified space without transepts or chapels. Eseler's treatment of the interior admirably fulfils the potential: the articulation of the vaulting shafts is singularly elegant, and the transition from pier to vault achieved with great finesse. The variations in the vaulting provide additional interest without breaking the continuity of movement, and even the axial pier terminating the vista falls unobtrusively into place.

In the Heiligkreuzkirche at Schwäbisch Gmünd the apsidal chapels had precluded the use of a single window running the full height. Peter Parler appears to have realized that this need not necessarily be a liability, and that the desired vertical line of the piers could be emphasised perhaps even more effectively by a contrast of vertical and horizontal than by a repetition of verticals. Why else would he have underscored the horizontal division with a heavy string course; why else have severed the vaulting shafts with the curious triangular projections that send the eye ricochetting back and forth in a horizontal plane? This concept of a design based on a conscious interplay of verticals and horizontals found its most subtle and assured expression in the choir of St Lorenz at Nuremberg. This, like the choir of the Franziskanerkirche in Salzburg, was the replacement of an earlier choir, and provides the same sense of exaltation and spiritual release towards the east end. The designer contrasts the solidity of the wall with its twin tiers of windows, and the powerful horizontal of its encircling balustrade with the vertical momentum of the piers that soar up into the penumbra and spread out to form a canopy.

Looking at the rich sculptural furnishings of the choir, culminating in Veit Stoss's *Angelic Salutation*, it is interesting to consider that we are standing in a church which has been Lutheran since Nuremberg espoused the Reformation in 1525.[22] The church interiors of Protestant Germany, birthplace of the Reformation, have preserved their heritage of medieval painting, sculpture and glass better than any other part of Europe, simply because the Reformation was endorsed by the ruling faction, whether prince or city fathers, and a peaceful transition was generally effected to the Lutheran doctrine. Since this was very lenient to the visual arts, compared to violently iconoclastic Calvinism, and since most of the Late-Gothic works of art in the city churches had been donated by the leading families, the result was twofold: many treasures survived intact, but little new work of a devotional character was commissioned, and the interiors consequently often look as

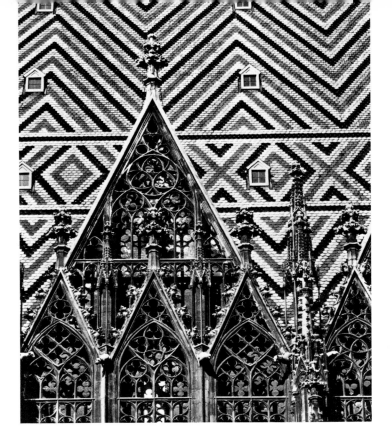

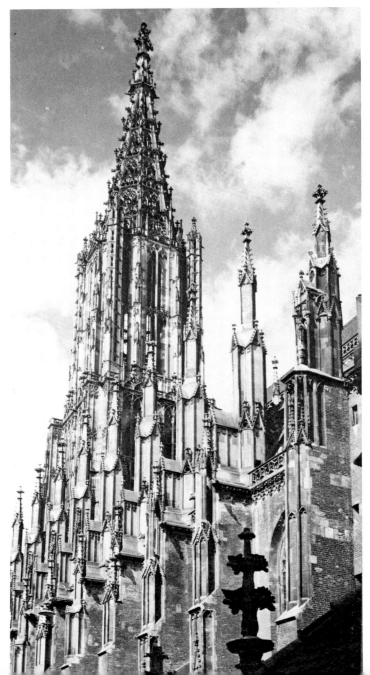

233 *Above right* This fifteenth-century openwork gable by Hans Puchsbaum is an example, like the openwork spire, of a functional architectural element assuming a purely decorative and symbolic form. Behind the mock gable rises the chevron-patterned tiled roof. *Stephansdom, Vienna*

234 *Right* View of the octagon and spire erected in the late nineteenth century according to Matthäus Böblinger's original design of 1482. *Ulm Minster*

235 *Opposite* Detail of the great wheel window of the west front, thirty feet in diameter, dating from the second half of the fourteenth century. The disposition of the tracery spokes off-centre from the vertical axis creates a dynamic sensation of rotation. *St Lorenz, Nuremberg*

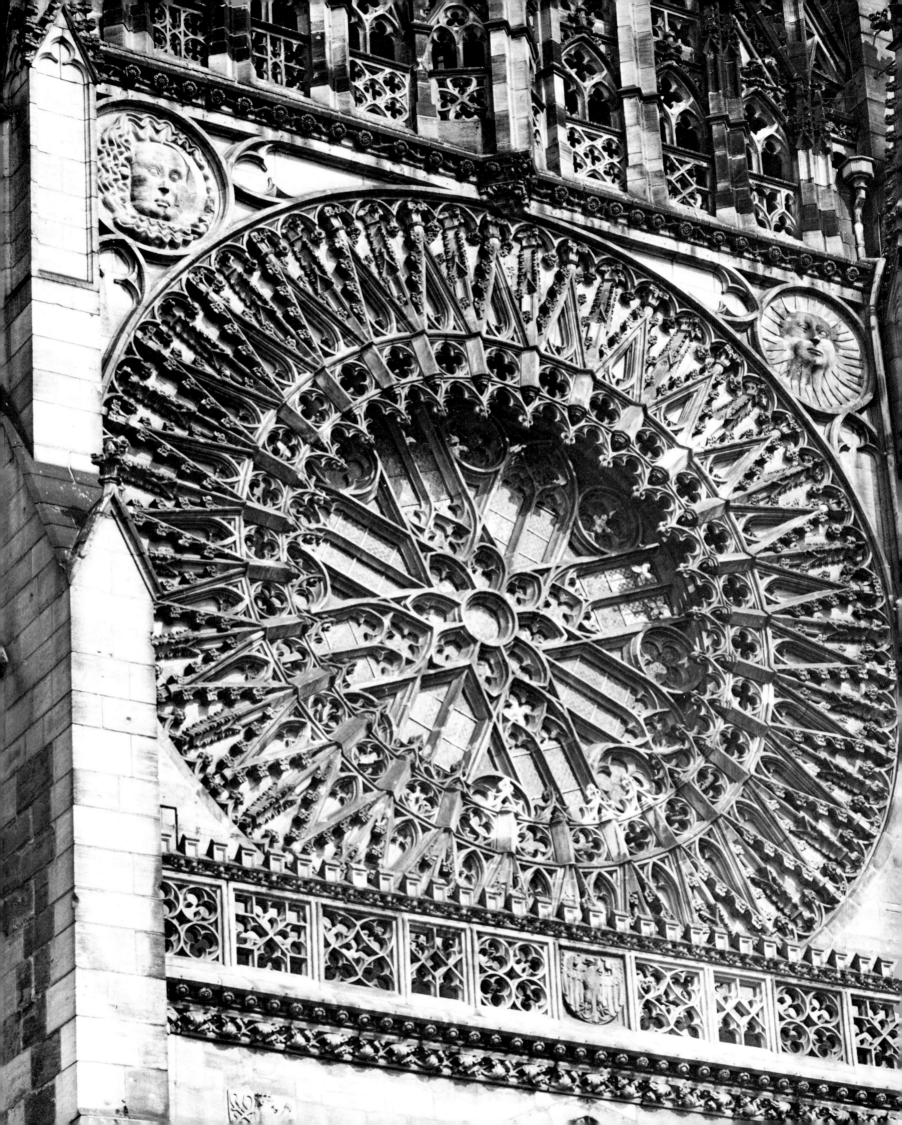

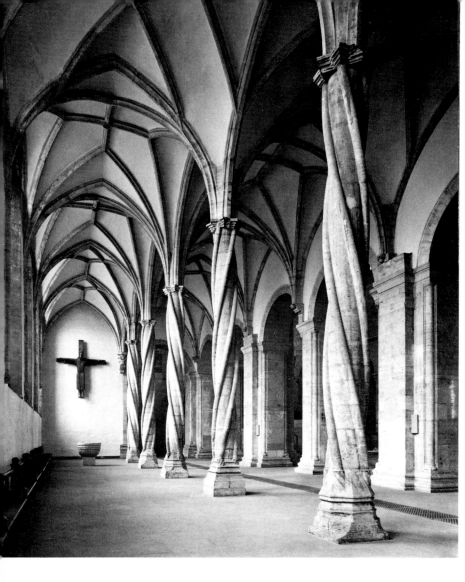

if time had stood still since the Reformation – this in marked contrast to regions that remained Catholic or reverted to Catholicism, where there was a continuous transformation, particularly into the Baroque style, during the Counter-Reformation.[23]

In earlier centuries the Sacrament had commonly been suspended in a pyx, often in the form of an enamelled metal dove, behind the high altar; or, later, enclosed in a wall-closet or aumbry, a particularly fascinating example, incorporating an elaborate sculptural programme, being that in St Sebaldus. 237 Only in the fifteenth century did a third form, a tabernacle surmounted by a traceried stone canopy which came to resemble a miniature church spire, become popular. Fine specimens are those in the Collegiate Church of St Pierre at 187 Louvain, dating from 1450, and in St Georg at Dinkelsbühl, dating from 1480-1. In 1493 the patrician Hans Imhoff commissioned the masterpiece of the genre from the Nuremberg sculptor, Adam Kraft, for St Lorenz. Soaring to a height 231 of sixty-four feet, which necessitated bending the top to follow

236 *Left* The north aisle of the Romanesque cathedral was replaced in 1469 by a double aisle constituting a miniature hall-church. Its design exploits the 'Baroque' dynamism of spiralling piers to its ultimate degree by reversing the direction on each alternate pier. *Brunswick Cathedral*

237 *Below left Shrine of the Holy Sacrament*, 1370–80, recessed in the wall of the ambulatory behind the high altar. The door of the aumbry preserves its original ironwork, an art in which the Germans excelled. *St Sebaldus, Nuremberg*

238 *Below* Self-portrait of Adam Kraft from the base of his monumental *Sakramentshaus*, 1493–96. *St Lorenz, Nuremberg*

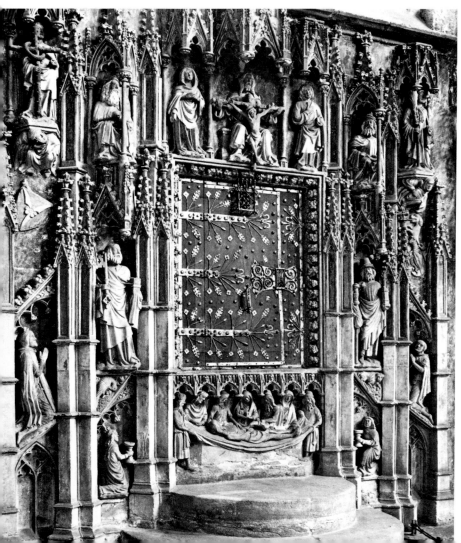

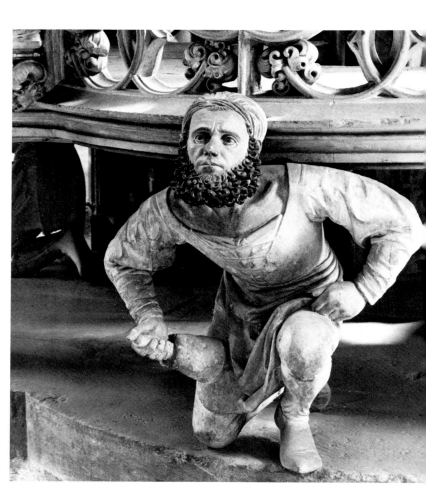

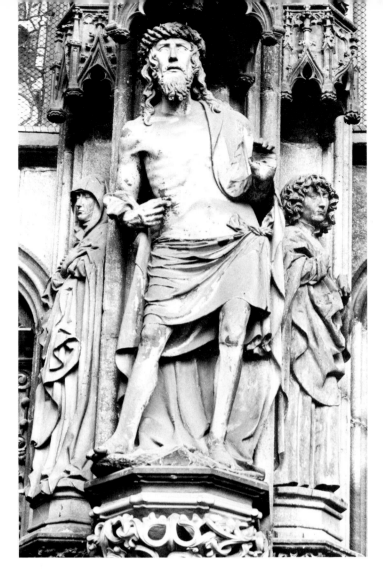

famous example is the Krumau Madonna, *c.* 1390, once in the chapel of the castle at Krumau (Český Krumlov) in Bohemia, a figure of supreme elegance, sensitivity and harmony. The swing between aristocratic and burgher patronage–from idealism to realism–is mirrored in Germany in the evolution towards the homely charm and almost dumpy figure of the late 'Fair Virgin', within a flaming aureole, *c.* 1425-30, in St Sebaldus at Nuremberg. A new development, too, is the change from stone to wood, which comes ever more into its own as the century progresses, and finds its most spectacular expression in elaborately carved altarpieces. 3

240

Contemporary with the Virgin at St Sebaldus is the poignant *Schmerzenmann*, or Christ as 'The Man of Sorrows', dated 1429, of stone as befits its architectonic function. The artist was Hans Multscher, renowned both as a painter and sculptor, who operated a studio in Ulm, famous for its wealth of sculptural talent in the mid decades of the century. Comparatively large numbers of important sculptured works have survived in pristine condition from the sixty years between the 1460s and the Reformation – a situation quite different from that in, say, England and France, where it was precisely the finest pieces that were singled out for destruction or mutilation. 239

One of the most significant Late-Gothic sculptors was Nicolaus Gerhaerts of Leyden in the Netherlands, where wholesale destruction has left hardly a clue that Holland was once a prime contributor to sculpture as well as painting. Nicolaus Gerhaerts clearly reveals the influence of Claus Sluter, his countryman, and may well have received his training in Burgundy. First heard of in Trier, where in 1462 he signed and dated the tomb-lid effigy of Archbishop Jacob von Sierck,[25] in the following

239 *Above* This forthright treatment of the 'Man of Sorrows' (1429) by Hans Multscher, on the central pier of the west portal, provides an interesting contrast with the sophisticated Internationalism of Master Francke's almost precisely contemporary pictorial treatment (254). *Ulm Minster*

240 *Right* A typical early fifteenth-century 'Fair Virgin' in carved and painted wood and backed by a gilded nimbus, mounted against a pier of the choir. *St Sebaldus, Nuremberg*

the curvature of the vaulting, the canopy is in the form of a complex, yet clearly articulated, openwork spire housing a multi-tiered *theatrum sacrum* as it were, within which one glimpses scenes from the Passion: Christ's Farewell, The Crowning with Thorns, The Crucifixion, and The Resurrection. Interestingly enough, the contract acknowledged that in a work of this magnitude and complexity, while the lower scenes were to be executed with the greatest care, higher portions did not require quite the same degree of finish, and the topmost stage had to be executed only 'as well as need be'. Master Adam, honest craftsman that he was, more than complied with the requirements of the contract and received a bonus of seventy guilders. Curiously enough, had he followed the stipulation literally, he would have devoted the greatest care to his own portrait, for the towering mass rests on the three crouching figures of Adam Kraft and his two assistants in an attitude and position combining humility and pride. 238

The aristocratic Austro-Bohemian court culture of the late fourteenth century found its most delectable sculptural expression in a group of devotional images with certain features in common, known collectively as the 'Fair Virgins'.[24] One

year he was associated with the cathedral lodge at Strasbourg, where he remained until 1467. The surviving works of this period include a fine memorial in high-relief to Canon Conrad von Busnang strongly Eyckian in flavour,[26] and an over-life-size Crucifixion, dated 1467, in the Old Cemetery at not far distant Baden-Baden. In this same year he was summoned to Vienna by the Emperor Frederick III to carve his tomb for the Stephansdom. By 1469 Gerhaerts had actually commenced work and was still engaged on the monument at his death in 1473. The height of the tomb-chest unfortunately prevents more than an oblique glimpse of the effigy on the tomb lid – carved from a single slab of red Salzburg marble ten feet long – and in this respect the design must be accounted a failure. Clad in coronation regalia of the utmost splendour, the figure is surrounded by an aureole of heraldic emblems and by his celebrated bilingual motto, A.E.I.O.U. (*Austriae est imperare orbi universo* or *Alles Erdreich is Oesterreich untertan*), which must have had a singularly hollow ring during his disastrous reign, but which would ring prophetically true for his son Maximilian who was to marry the heiress of Burgundy, and so bring the Netherlands within the Hapsburg Empire. Ironically, it was not in this sumptuous and perfectly preserved monument, but in a few battered fragments of his work in Strasbourg Cathedral which survived later changes of taste and the destruction of the French Revolution, that Nicolaus Gerhaert's genius is best revealed. These are the 'busts' associated with two contemporary stone constructions within the cathedral. From the portal to the 'New Chancellery' of 1463-4 come two heads from demi-busts that, like the *trompe-l'oeil* figures at the Palais de Jacques Coeur at Bourges, apparently surveyed the scene as

from a window.[27] Popularly identified with Count Jakob von Hanau-Lichtenberg and his beloved Bärbel von Ottenheim, they more likely represent a prophet and a sybil. Even more remarkable is a bust surmised to have come from the demolished choir enclosure of 1467, depicting a man, chin in hand, lost in reverie. The other hand originally held an implement and this, together with the intensely personal characterisation, has led most critics to agree that we are dealing with a self-portrait. As technically accomplished and realistic as any work by Sluter – notice, for example, the scored treatment of the eyebrows or the veins and creases of the hand – the naturalism is never obsessive, never interrupts the rhythmic flow of the forms, or detracts from the profound spiritual quality.

Between 1469 and 1474 Jörg Syrlin the Elder, 'master carpenter and joiner', carved the choir stalls of Ulm Minster, distinguished for the magnificent series of busts on the stall ends. Those on the north represent famous men of antiquity; those on the south the sybils who had foretold the coming of the Messiah. Syrlin is recorded in Ulm twenty years previously and hardly surprisingly the choir-stalls reveal the influence of the flourishing 'Ulm School' and its most illustrious exponent, Hans Multscher; and also that of Nicolaus Gerhaerts who, in addition to his work in stone had carved the lost high altar of Constance Cathedral, completed a few years previously. All these formative influences were, however, transformed by Jörg Syrlin into something uniquely original.[28] His technique combines great strength with an extraordinary delicacy of touch, while displaying acute psychological insight into the appropriate symbolic type – whether seer or man of action.

The outstanding sculptor in the North was Bernt Notke (*c.* 1440-1509), a member of a prominent Hanseatic family, born in Lassan in Pomerania. His residence is documented from 1467 in Lübeck where he practised as both painter and sculptor. Lübeck at this period enjoyed a great reputation for its monumental carved altarpieces which were exported throughout the Baltic and Scandinavia. Notke himself carved high altars for Aarhus (Denmark) and Tallin (Estonia), as well as an

241 *Below* The so-called 'Bärbel von Ottenheim', fragmentary red sandstone sculpture from the portal to the demolished *Neue Kanzlei*, 1463–64, of Strasbourg Cathedral, by Nicolaus Gerhaerts of Leyden. *Städtische Galerie Liebieghaus, Frankfurt-am-Main*

242 *Below right* Presumed self-portrait of the sculptor Nicolaus Gerhaerts of Leyden, probably from the demolished choir-enclosure of 1467. *Musée de l'OEuvre Notre-Dame, Strasbourg*

equestrian group of St George and the Dragon for the Storkyrka in Stockholm.[29] One of Notke's earlier works is the figure of St Mary Magdalen from his Triumphal Cross for the cathedral of Lübeck. The Magdalen here wears an enormous gilt headdress encrusted with jewels, that seems to weigh down upon the pathetic kneeling figure, wringing her hands in impassioned grief. Both gesture and features, with swollen lids and drooping mouth set in a face of mask-like impassivity, convey the sense of an overwhelming grief disciplined and turned inward.

262

Among the wealth of sculptors of great talent active in the decades from the 1470s on, three stand out far above the others: Michael Pacher, Veit Stoss and Tilman Riemenschneider. The eldest was Michael Pacher, an Austrian born in 1435 in the southern Tyrol near Brixen (now Bressanone in Italy), and in 1467 established in nearby Bruneck (Brunico), engaged in the production of the carved altarpieces that had become the mainstay of the German sculptor. Like Multscher, Pacher was both a painter and sculptor of equal distinction, and hence ideally suited to execute the type of altarpiece where the central panel was carved and the folding wings painted. Working south of the Alps, Pacher was directly exposed to the Italian Renaissance, and the varied influence it exerted on his painting and sculpture is most interesting. Although the restless movement and violent contortions of his figures are typically Late-Gothic or proto-Baroque, rather than Renaissance, his painting shows a thorough awareness and assimilation of the art of Andrea Mantegna. His fondness for sharply fore-shortened forms in perspective and the accurate anatomy of his nudes, above all the convincing use of scientific perspective construction to indicate deep space in his architectural settings–though the architectural vocabulary itself remains Gothic–clearly betray the influence of the Northern Italian Renaissance. Pacher's painting, in fact, achieves such a successful synthesis of Gothic and Renaissance as to exclude it from the scope of our study. His sculpture, on the other hand, shows much less direct influence of Italian artists–such as Donatello, who himself influenced Mantegna. Perhaps the difference in the media they used, bronze as opposed to wood, partly accounts for this, and a deep affinity with the antique must have seemed irrelevant to the production of a *Schnitzaltar*. Nevertheless, something of the Italian Renaissance spirit can sometimes be felt in Pacher's sculptured work.

To appreciate Michael Pacher's sculptural genius and his *Gesamtkunstwerk* at their finest we must follow in the pilgrim's footsteps to St Wolfgang am Abersee in the craggy Salzkammergut region not far from Salzburg. According to legend, St Wolfgang, the Bishop of Regensburg († 994), became disillusioned with his position during a period of civil war and went into retreat, first to the Monastery of Mondsee, then to the wilderness of the Abersee, to live the life of a hermit. After spending some time in a cave on the Falkenstein, he decided to throw down his mattock from the rocky heights, vowing to

243 *Above left* Pythagoras, 'the inventor of music', plucks a mathematically perfect harmony from his lute. Bust from the choir-stalls carved between 1469 and 1474 by Jörg Syrlin the Elder. *Ulm Minster*

244 *Left* St George, a youthful dandy, steps mincingly over the defeated dragon whose tail encircles the lance with a spiral movement. Polychrome wood sculpture (*c.* 1465) from the high altar, by an unknown master. *St Georg, Nördlingen*

build a chapel and his cell where it landed. After three days he found the mattock and started to build on the present site. St Wolfgang lived there for seven years before his refuge was discovered and he reluctantly agreed to return to his see. However, at his death he predicted that no miracles would occur at his tomb at Regensburg; those that sought his intercession would have to come to his chapel in the wilderness. Canonised in 1052, St Wolfgang became one of the most beloved of saints and St Wolfgang am Abersee one of the most celebrated places of pilgrimage in the Middle Ages.[30] On 13 December 1471, Abbot Benedict Eck of Mondsee, within whose jurisdiction the chapel lay, entered into a contract[31] with Michael Pacher for a new high altar worthy of so important a place of pilgrimage. The fee was set at 1200 Hungarian *gulden*, or their equivalent in ducats or other coin, and the sculpture and painting were stipulated to be by Pacher's own hand. Since the commission would be executed at Pacher's studio in Brunico, there are clauses relating to the responsibility for the transport of the dismantled sections—which had then to be carried by cart across the Alps and by boat and raft along the river Inn and the lakes—including a proviso that any parts damaged in transit be completely remade. We know from an inscription on the frame that the altarpiece was completed in 1481, ten years later.

The sculptured portion of the St Wolfgang Altarpiece comprises a predella with the Adoration of the Magi, the centre stage of the *theatrum sacrum* depicting the Coronation of the Virgin, flanked by St Wolfgang and St Benedict, beneath a carved canopy, and overhead, a series of openwork spires housing a Calvary group and figures of saints. Only when the painted shutters are closed are two sculptured guardian figures of St George and St Florian, standing on consoles at the side of the shrine, visible. It is the central scene which constitutes the most splendid testimony to Pacher's sculptural genius. The classic grandeur of the gestures,[32] the serenity of the facial expressions, and the restraint in controlling the ever-present tendency of the German artist to exaggeration, are surely a reflection of the Italian Renaissance spirit? Remarkable, above all, is the clarity of the disposition of the figures in deep space, an application to sculpture of the lessons Pacher had learned, not from Italian sculpture, but from Mantegna's painting.

While Michael Pacher was working on the St Wolfgang Altarpiece, the second of our pre-eminent triad was engaged on the most monumental of all German altarpieces. Veit Stoss was born at Horb in Swabia around 1445 and was already well established in Nuremberg when, in 1477, he moved with his family to Cracow in Poland[33] to carve the high altar for the Marienkirche, the chief church of the German community. The altarpiece took twelve years to complete, a tremendous achievement merely in physical terms, since it measured an unprecedented forty feet in height by thirty-five feet with the carved shutters open; and though we will meet altarpieces with even greater overall dimensions in Spain, these are built up of a large number of small scenes, very different from the heroic scale of the Cracow altarpiece, where the figures of the Apostles in the central drama of The Death of the Virgin are no less than nine feet tall. Coupled with the superb quality of the carving

245

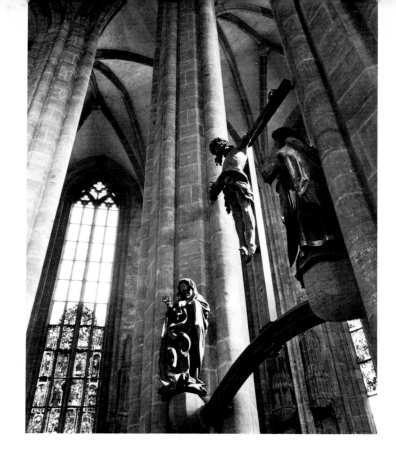

246 The isolation of Christ on the Cross is emphasised by the soaring verticals of the pier shafts. All three wood sculptures are by Veit Stoss, the Virgin and St John dating from 1505–07, the Crucifixus from 1520. *St Sebaldus, Nuremberg*

and colouring, it must have created an overwhelming impression, and was followed by a commission from King Casimir Jagiello to carve his tomb, completed and signed by Veit Stoss in 1492. Highly esteemed by both the German and Polish communities, and enjoying many privileges, including an exemption from taxes, Veit Stoss stayed in Cracow nineteen years in all before returning to Nuremberg in 1496. There, in 1503, although wealthy and celebrated, he was convicted of fraud by the city council, heavily fined and publicly branded on both cheeks, and forbidden to leave the city without permission. This he promptly did, fleeing to the house of his son-in-law in Münnerstadt, where he got into further difficulty. In 1505 he was permitted to return to Nuremberg but had to serve a prison sentence. Although he continued to receive commissions, even from the Emperor Maximilian, who granted him a pardon, which the council refused to honour, much of his wealth was spent on endless litigation, and he died in 1533 an embittered old man, ostracised by his fellow artists and deprived even of the company of his four artist sons who had long emigrated to Eastern Europe.[34]

Veit Stoss's tempestuous temperament found expression in a style combining great strength with an almost unparalleled emotionalism, which in the Cracow Altarpiece threatens to get out of control. One might have expected that the personal tragedy of his later life would have increased this tendency to excess still further. On the contrary, age and adversity seem to have added a measure of restraint and self-control that, paradoxically, permit the spectator to identify more closely with the subject. Dating from the years immediately after his ignominious return to Nuremberg in 1505 are two figures of the mourning Virgin and St John from a Calvary group, now in St Sebaldus, very likely the 'two figures below the Cross' for which the Council of Nuremberg in 1506 provided the artist with 'a

245 *Opposite* Central scene depicting the Coronation of the Virgin, flanked by St Wolfgang (left) holding a model of his chapel and by St Benedict; detail from the St Wolfgang Altarpiece, 1471–81, by Michael Pacher. *Pilgrimage Church of St Wolfgang am Abersee*

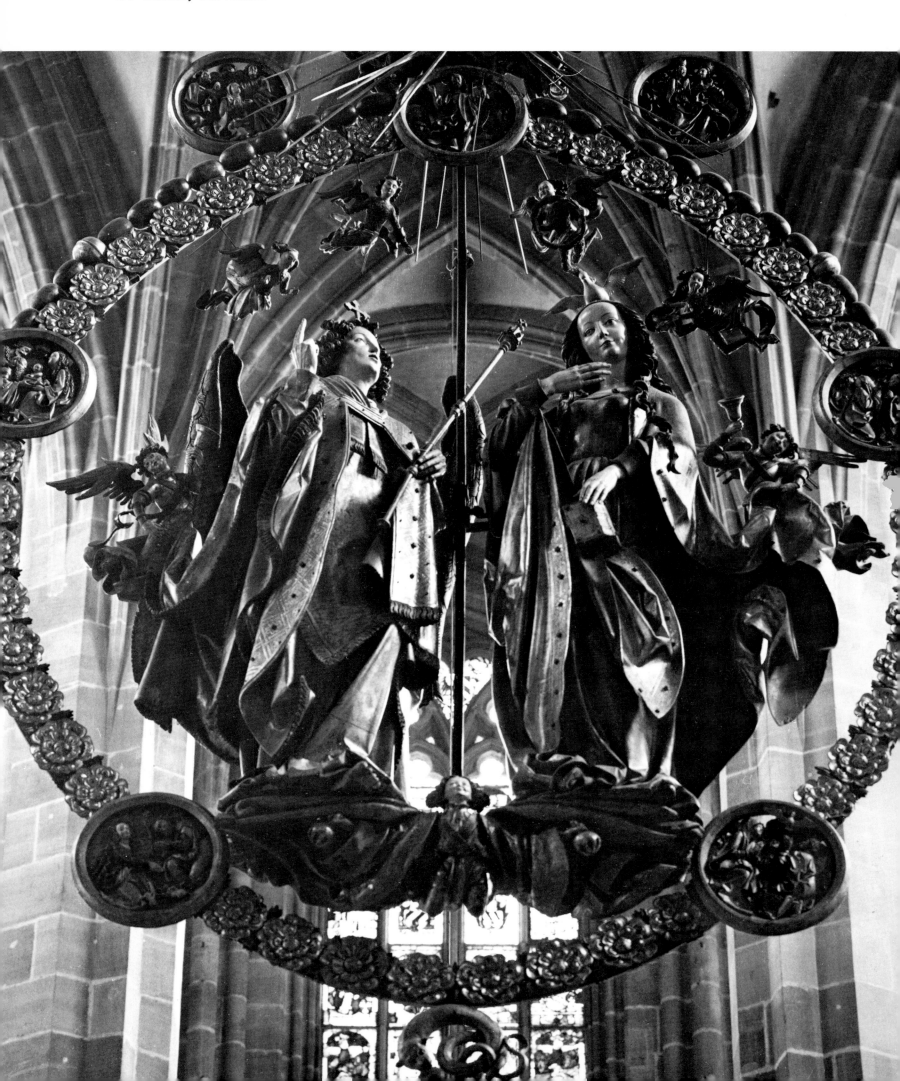

lime tree from the forest'. Was he compelled to contribute his talents gratis to the city? Certainly, in their intense but controlled emotion, 'we sense not the outcome of workshop activity, but a kind of personal confession – both artistic and human'.[35] By the time Veit Stoss carved the Nuremberg Christ on the Cross in 1520, he must have been in his seventies yet never more in command. Throughout his career he exploited drapery as a vehicle of communication to marvellous effect. Indeed, the crumpled style of drapery found in the painting of Robert Campin, popularized by Rogier van der Weyden and extended also to sculpture, achieved an unparalleled emotional expressiveness with Veit Stoss, the deeply undercut folds eddying around the figures, defying the law of gravity and suggesting a Divine source. Note, for example, the robes of the Virgin and the Archangel in the *Salve Regina*. We have already glimpsed this openwork medallion on high in the choir of St Lorenz. The work was commissioned in 1517 by Anton Tucher II, the leading financier of Nuremberg, and probably conceived as a *'Wandelaltar'*, or altar-station on the round of worship on great Feast Days, when the candles would be lit and the

medallion normally covered with a shroud would be exposed.[36] The decision at a later date to leave the image permanently exposed is symptomatic of the new Renaissance attitude to the work of art. The Annunciation in which the Archangel Gabriel, combining grace with hieratic authority, advances towards the initially confused Virgin – the acute psychological insight in the features and gestures amplified, as we have noted, by the treatment of the drapery – is set within a rose garland adorned with medallions depicting the Seven Joys of Mary, and a rosary which hangs down on either side. Small angels throng around the central figures, and, overhead, God the Father extends his blessing, while the serpent, symbol of Satan foiled by the Incarnation, lies coiled disconsolately beneath the garland. Carved with consummate skill and love, the *Salve Regina* was the city's last great tribute to 'Our Lady', so beloved of the Middle Ages. In the very year that it was commissioned, Martin Luther was pinning to the door of the University Church at Wittenberg his attack on the sale of indulgences that would set the Reformation in motion.

The third of the triad was Tilman Riemenschneider, born around, but not later than, 1460 in Heiligenstadt, the son of a coppersmith, who together with his clerical brother, became embroiled in a dispute between the Abbey of St Martin and the town council.[37] Exiled from Heiligenstadt, in 1465 the father settled in Osterode not far distant, where Tilman spent his childhood. The uncle, meanwhile, had moved to Würzburg and attained eminent status as procurator-fiscal to the prince-bishop, a position he held from 1458 until his death in 1478. The uncle provided unfailing assistance to his troublesome brother, and doubtless also encouraged the youthful artist to settle in

247 *Opposite* Detail of *The Angelic Salutation* 1517–18 by Veit Stoss. *St Lorenz, Nuremberg*

248 *Above* Detail of sandstone figure of Eve, 1491–93, by Tilman Riemenschneider, from the portal of the Marienkapelle. *Mainfränkisches Museum, Würzburg*

249 *Above right* Head of sandstone figure of Adam, 1491–93, by Tilman Riemenschneider, from the portal of the Marienkapelle. *Mainfränkisches Museum, Würzburg*

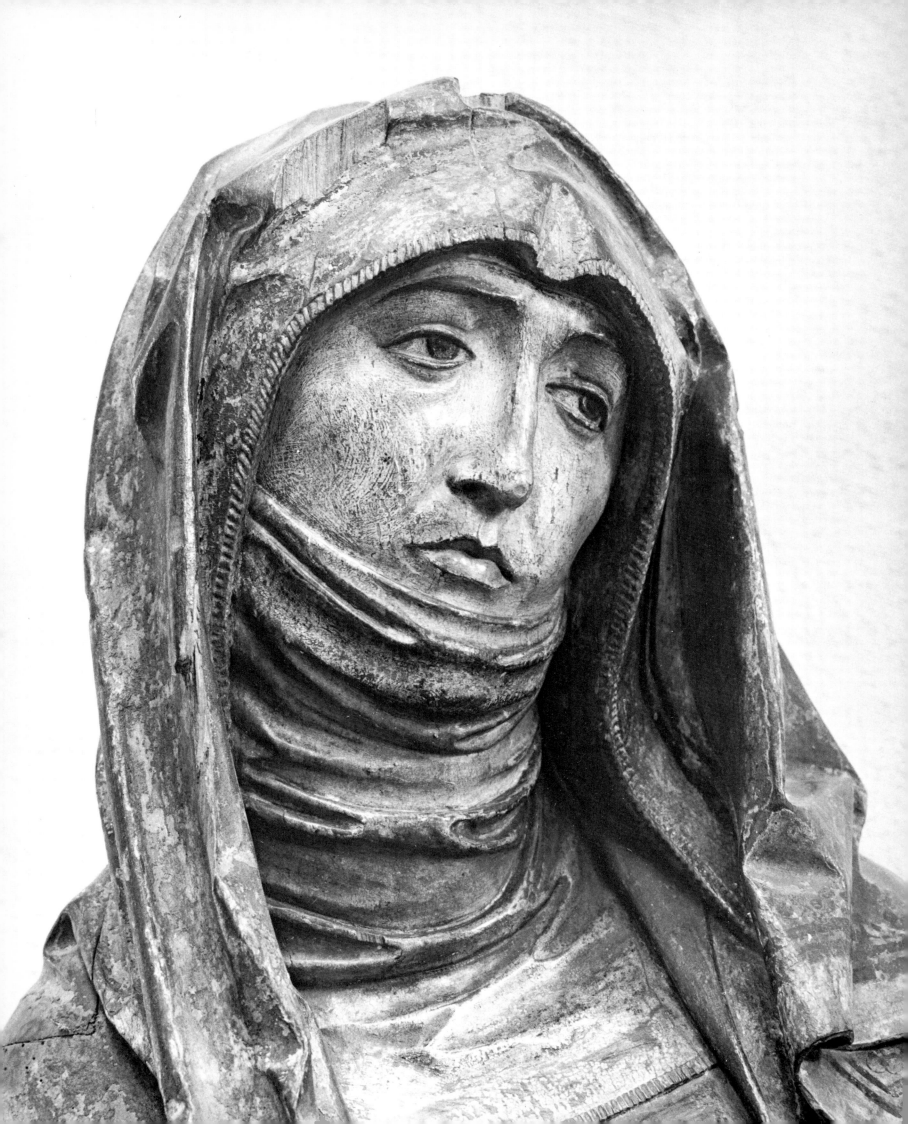

Würzburg in 1483, where he remained for the rest of his life. In 1485 Tilman became a citizen and also a master of the local guild, and must, therefore, have reached the statutory age of twenty-five for admission. He rapidly established himself, assisted by his uncle's connections and a judicious first marriage to the well-to-do widow of a goldsmith. A member of the city-council from 1505, he held a succession of increasingly important positions, culminating in his election as mayor in 1520-1.

In 1524-5 the peasants of Franconia and Swabia, inspired by the liberal religious ideas of Luther, which they extended to the social sphere, rose in revolt against their rulers, ecclesiastic and lay. In Würzburg these positions were united in the person of the prince-bishop, at that time the tyrannical Konrad von Thüngen, who had succeeded Riemenschneider's friend and patron, the art-loving Lorenz von Bibra. The majority of the council members, including Riemenschneider, who was precipitated into playing a leading role, took a stand sympathetic to the peasants' cause; and after the revolt had been crushed, Riemenschneider was thrown into a dungeon in the Marienburg fortress and so cruelly tortured that his career was effectively at an end. He died, broken in spirit, in 1531.[38]

Riemenschneider's conscious involvement in revolutionary action seems, at first sight, totally irreconcilable with his well-ordered, law-abiding existence, and with the physical and spiritual harmony of his work; but is it not precisely the moral conviction that informs such a head as that of Adam that found expression in Riemenschneider's refusal to compromise his principles even under torture? The life-size stone sculptures of
248
249 Adam and Eve that flanked the main portal of the Marienkapelle – rare examples at this late date of architectonic sculpture in the earlier Gothic tradition – were commissioned by the city-council of Würzburg in 1491, and are hence among the earliest of his works associated with his city of adoption. Already here we encounter the pervasive air of gentle melancholy and reticence, and the avoidance of the histrionic expressions and gestures so characteristic of the style of Veit
250 Stoss and his school, that would remain a constant feature of Riemenschneider's oeuvre.

These sculptures, like the associated set of Christ and the Apostles also from the Marienkapelle, are of stone, but it is with wood sculpture that we typically associate the name of Tilman Riemenschneider, and specifically with unpainted wood sculpture. His early contacts with Netherlandish sculpture in Osterode, is apparent on stylistic grounds, and these wood altarpieces were occasionally left natural. This must have strengthened his own convictions, for in his very first major commission, the high altar for the parish church at Münnerstadt, executed between 1490 and 1492, he chose to leave the wood unpainted. In this case he proved to be too far ahead of his time, for a dozen years later no less a master than Veit Stoss, a fugitive in Münnerstadt, was commissioned to paint and gild the altarpiece. Riemenschneider had, however, anticipated a trend which would become general, and in the Renaissance universal. The Bamberg Altarpiece, created by Veit Stoss himself towards the very end of his career, was left unpainted and special precautions were taken to avoid darkening the wood: for example, the directive that 'no large candles be placed before it on account of the smoke'.[39] Painted sculpture can still

be very effective even in poor lighting, but with natural wood the lighting becomes critical, particularly if subtle surface modulations are to be appreciated. Riemenschneider was particularly sensitive to the problem in the monumental carved altarpieces.[40] Customarily, the figures in the central *tableau vivant* were posed against a solid background, which Riemenschneider pierced with windows – sometimes even glazed – as if the scene were taking place in a chapel. When the altarpiece was so located that the basic frontal lighting was augmented by back-lighting through the 'windows', the effect could be extraordinarily dramatic, throwing some figures into silhouette, and illuminating the detail in the shadows. The concept seems to have first occurred to Riemenschneider in his depiction of The Last Supper, the central scene of an altarpiece 252 commissioned by the town-council of Rothenburg-ob-der-Tauber for the local Jakobskirche, with its venerated relic of a drop of the Saviour's Blood. The cabinet-maker who had constructed the shrine enclosure in 1499, with a solid background, was paid to remake it after Riemenschneider signed his contract for the sculpture in 1501, presumably to conform with the artist's inspired decision to place the figures before three glazed oriel windows, thereby creating a whole new spatial dimension.

Riemenschneider's loveliest work is to be found in a pilgrimage chapel in a country churchyard outside Creglingen. Here, according to legend, a farmer ploughing came upon a Host lying pristine and untainted in the ground. By 1389, five years later, the Counts of Hohenlohe-Brauneck had erected the present little church, but more than a century elapsed before Tilman Riemenschneider was commissioned to erect a *Schnitzaltar* over the stone altar-slab that marked the site of the miraculous discovery. Its additional function as a mortuary chapel no doubt suggested the reassuring themes of Resurrection and Intercession, conveyed by scenes of the Assumption of the Virgin, her reception in Heaven, and the 251 figure of the Risen Christ standing triumphant over a canopy of bristling, interlaced pinnacles – a Crown of Thorns transmuted to a Crown of Glory. The theme of assumption is reinforced by the upward thrust of the composition and the pierced openings behind the figure of the Virgin, which not only increase the sensation of space – it is difficult to believe that the central shrine is a mere sixteen inches in total depth – but contribute not a little to the uncanny effect of levitation in the figure of the Virgin.

Under the auspices of the Emperor Charles IV there was, as we have seen, a brilliant, if brief, flowering of art and culture centred on Prague. Compounded of French and Italo-Byzantine influences, with an admixture of native mysticism, Bohemian painting represents a unique development of superlative quality. Bohemian court art exercised a profound influence on Austria and eastern Germany, as far north as Hamburg. The Emperor on his historic visit to the neighbouring city of Lübeck in 1375 is said to have been accompanied by his court painter, Master Theodoric.[41]

This might account for a particularly strong influence on the local master who may justly be called the first individual and distinct personality in German painting. Master Bertram was listed as a member of the Hamburg guild in 1373, and from the frequent subsequent references would appear to have been the leading painter in the city. In 1390 he made his will before a journey to Rome; in 1410 made a second will, including

250 *Opposite* Detail of head of the Mourning Virgin by Tilman Riemenschneider, *Mainfränkisches Museum, Würzburg.*

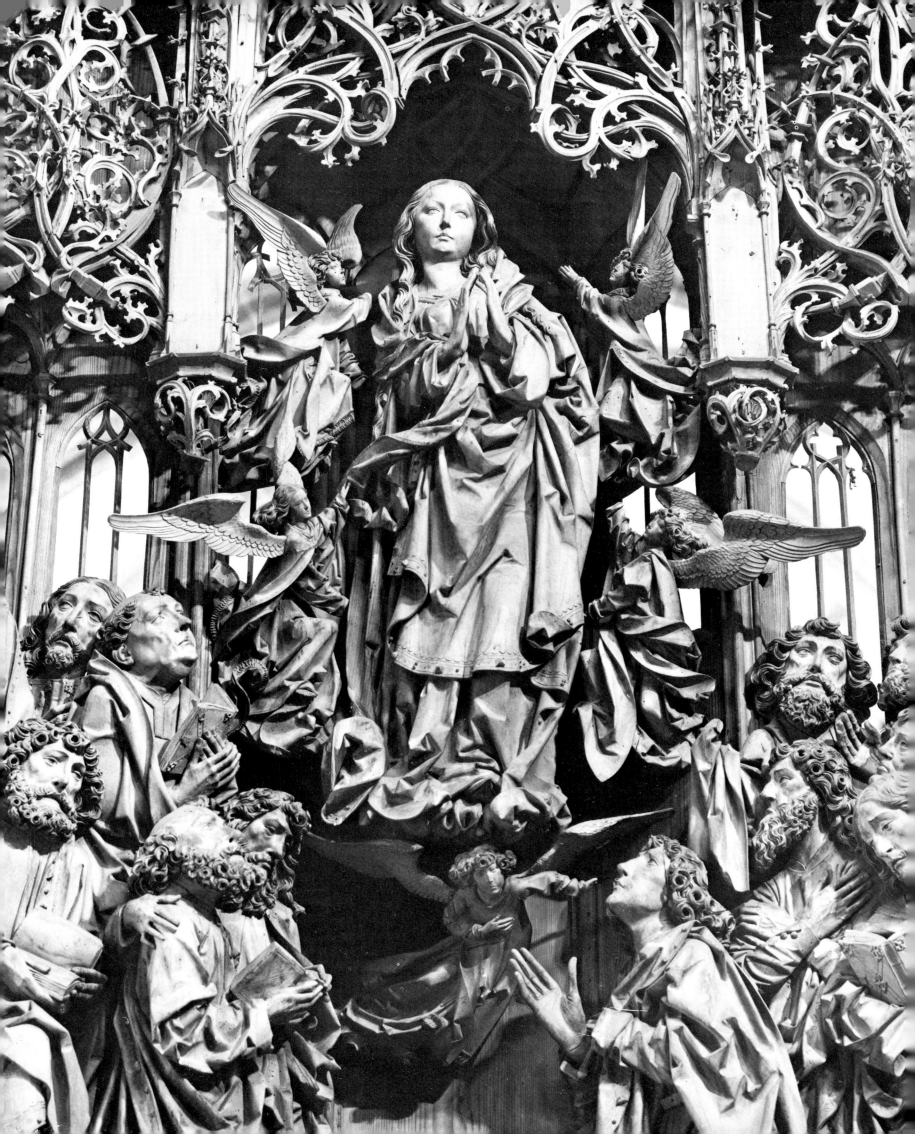

bequests to the nunneries of Harvestude and Buxtehude,[42] and had presumably died shortly before May 1415, when his estate was filed. His major work is the *Grabow Altarpiece*, identified with the main retable of the Church of St Peter in Hamburg. Conceived as a *Gesamtkunstwerk*, with a carved centrepiece protected by painted wings, the altarpiece is known to have been in place by 1383. The twenty-four painted scenes include a particularly celebrated sequence illustrating the Creation.[43] Against a stylised gold background and a rudimentary landscape of fissured rocks and plants treated in a *millefiori* tapestry style – a provincial transposition of the ultra-sophisticated, court style of the Master of Hohenfurt (Vyšší Brod) – Master Bertram's stocky figures enact their roles with a grave dignity and fitness of gesture that make one think fleetingly of Giotto.

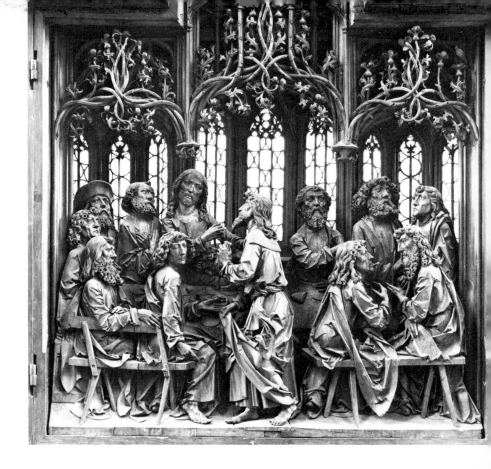

Master Bertram was succeeded in Hamburg as the leading painter by Master Francke. His origin and date of birth are unknown, the one indisputable date being that of the completion in 1424 of an altarpiece commissioned by the *Englandsfahrer*, a Hamburg company trading with England. The altarpiece features cycles from the life of Christ and that of the traders' patron saint, St Thomas à Becket. If Master Francke's origin remains unknown, his artistic allegiance is clearly to the French International Gothic style in its final phase. His sophisticated and confident handling of its stylistic idiom makes a Paris training seem highly likely. Master Francke's masterpiece is a small *Man of Sorrows*, combining French delicacy and restraint with German mysticism. The pathos is heightened by the gesture of the hands, drawing attention to His Wounds, and the sloping lines of the eyebrows – a stylization, probably drawn from Italo-Byzantine tradition, in the interests of expressiveness, which recurs in German art. Despite its icon-like character, the panel is far more naturalistic than Master Francke's earlier work. Particularly accomplished is the play of light and shade on the nude, with a sharp delineation against the blood-red cloak on one side, an almost imperceptible gradation on the other.

That the achievements of Master Francke were not developed further may be attributed, at least in part, to the decline in Hamburg's fortunes at this period. Meanwhile, another member of the Hanseatic League was developing the style which to most people epitomises German Late-Gothic painting. Of all the cities of medieval Germany, the largest, with 40,000 inhabitants within the walls, the most cosmopolitan, and the richest both in tradition and material splendour, was Cologne. It was ideally located both to absorb and to transmit influences from France and the Netherlands. It was also the centre of the corporate mysticism of the Dominican preacher, Master Eckhart (1260-1327), and his successors of the next generation, Heinrich Suso and Johann Tauler, who profoundly influenced the religious climate of the region. The most

251 *Opposite* Detail of the Assumption of the Virgin, from the altarpiece (1505–10) by Tilman Riemenschneider. *Herrgottskirche, Creglingen*

252 *Above right* Central scene depicting the Last Supper from the *Heiligblutaltar* (1501–05) by Tilman Riemenschneider. *St Jakob, Rothenburg-ob-der-Tauber*

253 *Right* Interior, showing Tilman Riemenschneider's Altarpiece of the Assumption of the Virgin which was commissioned to stand on the site of a miraculous discovery. *Herrgottskirche, Creglingen*

outstanding painter of the first-flowering of the Cologne School is the Master of St Veronica, so-called after two similar paintings of St Veronica with the Sudarium, by far the finer version being that from the Church of St Severin.[44] The three elements of the composition, each handled in a distinct and complementary manner, have been combined to create an *Andachtsbild* or devotional image of extraordinary power. The saint holds a huge cloth imprinted with the magisterial, over-life-size face of Christ, so dark, except for the mysteriously spotlighted Crown of Thorns, as to be almost inscrutable. The bristling spines achieve an added intensity by contrast with the soft and well-rounded forms elsewhere, particularly of the childlike angels.

An atmosphere of innocence before the Fall pervades every corner of the *Little Paradise Garden*, *c*. 1420, from the region of the Middle Rhine. The setting is a flower-starred meadow enclosed by a crenellated wall, silhouetted against a sky of lapis-lazuli intensity. The Virgin reads while St Catherine teaches the Christ-Child to play the zither and two attendants pick cherries and scoop water from a well. A winged St Michael converses with St George, whose vanquished, salamander-like dragon lies

254 *Above Man of Sorrows* (*c*. 1430) by Master Francke. *Kunsthalle, Hamburg*

255 *Above right* Eve rises from Adam's rib at the beck of the Creator. Detail from the *Grabow Altarpiece*, dated 1379, by Master Bertram. *Kunsthalle, Hamburg*

256 *Right St Veronica with the Sudarium* (*c*. 1400) by the Master of St Veronica. *Alte Pinakothek, Munich*

belly uppermost in the grass. At the Saint's feet a very human monkey, symbol of the baser passions to medieval man, listens to the edifying conversation – or, more likely, court gossip, for the saints are surely merely youthful courtiers? The fairy-tale quality is reinforced by the jewel-like brilliance of the colours and the decorative, two-dimensional composition, as of a tapestry reduced to the size of a miniature (the panel measures only thirteen by ten and a quarter inches).

In the fourth decade of the fifteenth century a new sense of weight and volume began to infuse the human form under Flemish influence, and the Cologne School experienced a second flowering under Stephan Lochner. Born at the little town of Meersburg on Lake Constance, some time after 1405, the earliest surviving record of his activity in Cologne dates from 1442 when he was paid for work on decorations for the visit of the Emperor Frederick III. In 1447 he was elected a councillor of the painters' guild, and again in 1450, but died of the plague shortly before his term of office expired on Christmas Day of 1451. His most celebrated work is a monumental *Adoration of the Magi*, augmented on the wings of the triptych by St Ursula and St Gereon with their companions. Painted for the chapel of the town-hall, it now functions as the main votive painting in the Cathedral, or *Dombild*. Sumptuous and superbly decorative, the altarpiece fulfils its civic function to perfection, the city basking in the reflected glory of the magnificently attired Magi and patron saints, with their special relationship to Cologne,[45] who pose graciously as if for a civic function. Of emotional involvement or religious mysticism there is none.

Lochner's genius found even more congenial expression in the exquisite little *Madonna of the Rose Bower*, irresistible in its touching sincerity and delicacy. Yet it seems typical of the Late Middle Ages that the author of this idyll could, when the subject demanded, produce a scene of blood-curdling horror such as that of the *Martyrdom of St Bartholomew*. Martyrdom scenes were, of course, a stock in trade for the medieval artist. What is new here is the degree of savage realism, in the figure with his knife between his teeth, tearing the skin from the saint's arm, and

258

257 *Above left The Paradise Garden* (*c.* 1420) by the Master of the Frankfurt Paradise Garden. *Städelsches Kunstinstitut, Frankfurt*

258 *Above Martyrdom of St Bartholomew*, detail from a wing of the *Last Judgement Altarpiece* (*c.* 1435–40) by Stephan Lochner. *Städelsches Kunstinstitut, Frankfurt-am-Main*

259 *The Miraculous Draught of Fishes*, panel from the *Altarpiece of St Peter*, dated 1444, by Conrad Witz. *Musée d'Art et d'Histoire, Geneva*

the manner in which the very quality of line in the bizarre silhouettes of the darkened figures creates an atmosphere of indefinable terror.

Contemporary with Lochner is Konrad Witz from Rothweil in Württenberg in Swabia, who spent most of his working life in Basle. He became a member of the painters' guild there in 1434 and a citizen in 1435, the year also of his marriage. By 1446, however, his wife is already referred to as a widow, so that his career was tragically short. The vanquished *Synagogue*, contrasted with a companion figure of the *Church Triumphant* is one of a series of single figures from the exterior of Witz's early *Heilsspiegel Altarpiece, c.*1435. She holds the Tables of the Law with their pseudo-Hebrew characters, and her eyes are bound with gauze – so lightly as to be virtually imperceptible in reproduction – symbolising the blindness of the Old Dispensation to the New Truth.[46] The lines of the broken lance repeat those of the opening with its glimpse of sky which relieves the claustrophobic atmosphere of the cramped cubicle. The bent posture of the figure echoes the line of the broken lance yet again, an effective use of analogous forms much favoured by Witz. The strongly directional lighting accentuates the vigorous modelling of the figure and the characteristically voluminous drapery. Witz is clearly indebted to van Eyck and, to a far greater extent, to the Master of Flémalle, and would seem to have also been familiar with Claus Sluter's sculpture at Dijon, not too far distant from Basle. The formative influences have, however, been assimilated in a personal style which combines extraordinary power with occasional *naïveté*. Most remarkable is the panel, *The Miraculous Draught of Fishes*, from his last work, the fully documented *Altarpiece of St Peter*, commissioned by the Bishop of Geneva for a chapel in his cathedral. The scene is set on the shore of Lake Geneva with the *massif* of Mont Blanc in the background, perhaps the earliest example of true topographical painting.[47] The integration of the action and setting of the drama, is matched by a feeling for materials and an observation of the play of light on surfaces, extending to the effect of refraction on the half-submerged boulder in the foreground.

Preceding Gutenberg's experiments with movable type, much effort was expended in providing multiple copies of devotional pictures, from which evolved the graphic techniques of the wood-block print and the engraving. The earliest surviving European woodblock[48] is the *Bois Protat*, dating from the period 1380-1400 and apparently of French origin. In a fragmentary state, one side preserves a portion of a Crucifixion, the other side a portion of an Annunciation. Stylistically, it derives from contemporary manuscript illumination. The effect of black line on a white background was obtained by cutting away the background so that the remaining raised portions registered when ink was applied. The nature of the medium precluded very thin lines, which would tend to break off under pressure. Yet within the limits imposed by the medium pleasing effects could be achieved. Among the earliest wood-block prints to exploit the inherent aesthetic potentialities of the medium is a *St Dorothy, c.* 1420. The scene illustrates one of the most popular episodes from the lives of the Saints: the appearance, on her way to execution in the dead of winter, of a barefoot Child bearing a basket of fruit, at whose approach the trees burst into blossom – confirming the saint's vision of the Paradise that would be her reward for martyrdom. Typical of the period are the 'hairpin-loop' drapery folds, the broad outlines and the bold rhythms.

An important step in the evolution of the printed book was taken when single prints intended to be hung on the wall as a substitute for pictures were combined to form the 'wood-block book', a development that appears to have originated in the Netherlands. Popular subjects were The Apocalypse of St John and the *Biblia Pauperum* or 'Poor Man's Bible'; another perennial favourite was the *Ars Moriendi*, or 'Art of Dying', a subject of obsessive concern to medieval man. Such sins as anger, impatience or avarice at the moment of death could jeopardise the future of the soul for all eternity. The twenty-four page booklet with eleven full-page illustrations facing full pages of block-cut text ends on a comforting note with the soul of the deceased received by angels, while the demons howl with disappointment. The introduction of hatched lines to give a rudimentary effect of shading betrays a comparatively late stage in the development of the wood-block print, just as similar hatching on memorial brasses marks the later examples. It is interesting to note that wood-block books continued to be made in quantity for at least a century after the invention of movable type. It is surmised that one of the major reasons was the financial outlay required for printing equipment. Furthermore, the soft metal initially used for type permitted three hundred copies at most to be printed before the type became too worn. Particularly for books with a limited amount of text, the labour in cutting the text in wood was at least partially offset by the larger number of prints obtainable.

Shortly before the middle of the fifteenth century an alternative to the wood-block for illustrations, offering far greater potentialities, was developed in Germany. It is probably

260 *Left* Symbolic figure of the vanquished Synagogue; detail from the *Heilsspiegel Altarpiece* (c. 1435) by Konrad Witz. *Kunstmuseum, Basel*

261 *Opposite* Life-size figures of Christ and St John, with the original polychromy revealed by the recent restoration, from the Last Supper (c. 1470–80) by an unknown artist in an exterior chapel inserted between the buttresses of the choir. *St Georgskirche, Dinkelsbühl*

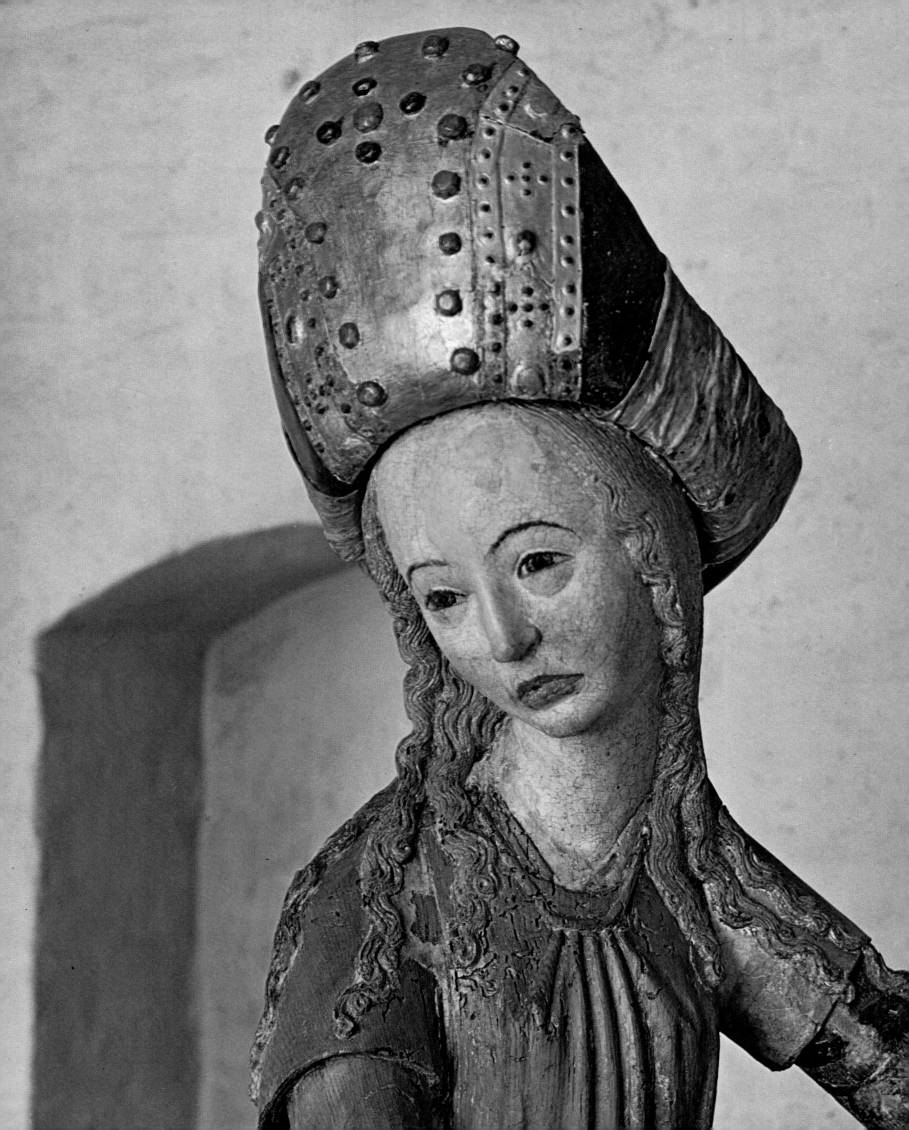

to the goldsmiths that we owe the discovery that designs gouged into the surface of a metal plate would retain printing ink when the plate was wiped clean, and could be transferred to paper: the process known as 'engraving'. Among the most interesting early exponents of the new technique were the 'Master of the Playing Cards' – so-called from his work in a field that was among the quickest to profit from the mechanical reproduction of designs – and the artist named from his signed initials E.S. 'Master E.S.', active in the region of the Upper Rhine from *c.* 1450 to *c.* 1470, worked in a variety of styles, ranging from such ambitious compositions crowded with figures, as the *Einsiedeln Madonna*, to the whimsical flights of imagination seen in his *Fantastic Alphabet*. Embodying the spirit of the marginal drolleries of the illuminators, the series shows remarkable skill in adapting the lively compositions to the shape of the letters. The letter G provides a caustic social comment on the suspected debauchery of the monastic orders.

The only German master to enjoy an international reputation before Albrecht Dürer was Martin Schongauer. Born around 1435 in Augsburg, where his father was a goldsmith, the family moved early to Colmar where Martin spent most of his working life, and where his one documented painting, the celebrated *Virgin of the Rose Bower*, dated 1473, is preserved in the Church of St Martin. Schongauer died in 1491, apparently a victim of the plague, while working on a mural of the *Last Judgement* in the nearby town of Breisach. His style reveals the influence of the Flemish masters, especially Dirck Bouts, and his earliest engravings[49] still give the impression that they were conceived in terms of the brush rather than the burin; but by the time he created his *Temptation of St Anthony, c.* 1470-5, he was completely in command of the new medium. The saint is depicted borne aloft by a horde of clawing and cudgelling demons, improbable · yet frighteningly convincing combinations and transmogrifications of man, beast and denizen of the deep, that anticipate by a decade the hallucinations of Hieronymus Bosch. In contrast to this seething movement, St Anthony, in the eye of the storm, maintains an imperturbable composure, a magisterial image of unassailable virtue. The composition created a deservedly tremendous impression. Vasari relates that Michelangelo was so fascinated by it that he painted a copy. Dating from Schongauer's final period is the engraving of a censer, testimony not only to his artistry and technical brilliance, but also to the extraordinary richness and spatial complexity of the German Late-Gothic design vocabulary. The subject reflects Schongauer's home background and may well have been intended as a model for the goldsmith, for with the perfection of engraving, pattern-books capable of transmitting complex designs to a wide audience also became feasible. Schongauer's international reputation certainly rested primarily on his engravings, the finest in the Gothic style – for with Albrecht Dürer we arrive at the Renaissance.

262 *Opposite* Head of St Mary Magdalen from Bernt Notke's Triumphal Cross (1477), carved for Lübeck Cathedral. *St Annenmuseum, Lübeck*

263 *Above right* A dying man overturns his bedside table and kicks his doctor, while a demon gloats. Woodcut from the fourth edition of the immensely popular German *Ars Moriendi* or 'Art of Dying', 1465–70. *Pierpont Morgan Library, New York*

264 *Right* St John the Evangelist sentenced to exile and sailing to the Island of Patmos. Woodcut from the first edition of the *Apocalypse of St John*, 1460–65. *Pierpont Morgan Library, New York*

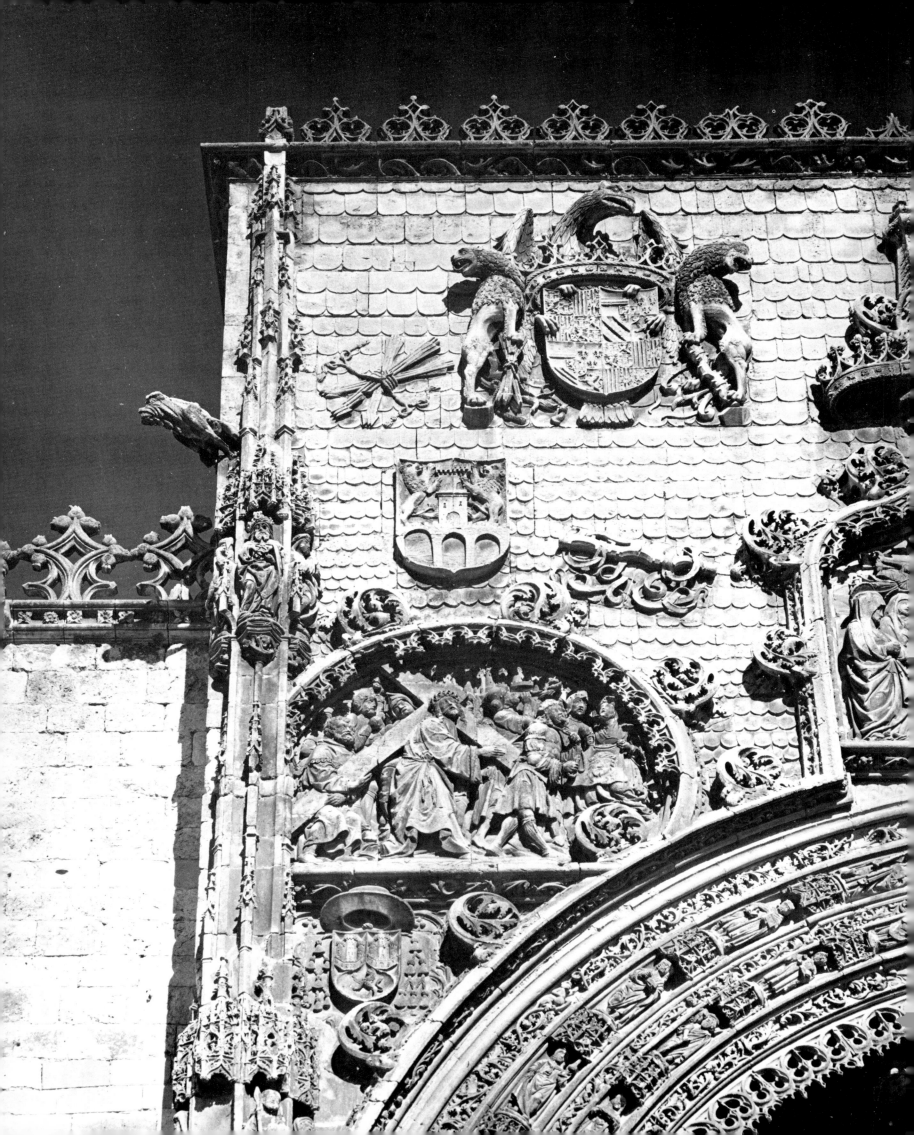

7 Spain

From the Moorish invasion in 711 A.D. the Iberian Peninsula had witnessed the struggle between Christianity and Islam; but, paradoxically, it was also the scene of exceptionally fruitful cultural contacts with the rich civilisation of Islam, which had assimilated so much of the wisdom of the classical world, of Persia and even of India. It was from Spain that the works of Aristotle, Euclid and Ptolemy–often in translations from the Arabic or with Arabic commentaries–were introduced to Europe to precipitate the intellectual renaissance of the eleventh and twelfth centuries, and right through the fourteenth century Christian, Jew and Arab lived in relative amity in the cosmopolitan cities of Spain, while scholars enjoyed an intellectual freedom greater than anywhere else in Europe.

The tomb of St James the Greater (Santiago), brother of St John the Evangelist, at Santiago de Compostela in Galicia, was the goal of one of the three great pilgrimages of the Middle Ages, together with Rome and Jerusalem, and the traffic of pilgrims along the road to Santiago from as far afield as Eastern Europe and Ireland, sporting the cockleshell emblem of St James, is an example of the degree of contact maintained between the peoples of Europe during the Middle Ages.

Known in Spain as the *camino francés*, or 'French Road', it was along the road to Santiago that the first great Romanesque and Gothic churches in Spain arose, the work of foreign architects and sculptors that tended initially to reflect French models.[1]

Two factors in particular, however, soon stamped the adopted forms as unmistakably Spanish. The first was the climate. In the torrid Spanish summer the glass-walled Gothic cathedral of Northern Europe only too readily became a hot-house, and many of the huge windows of the early churches were subsequently blocked with masonry. Later structures were provided with smaller windows from the start, and the wall as an architectural element reasserted itself. The Spanish climate, furthermore, generally rendered steep roofs unnecessary, and the standard treatment for monumental buildings soon reverted to a low-pitched, tiled roof hidden behind a modest parapet. In a country deficient in supplies of building timber, stone, rubble-walling and brick were the standard building materials for practically all construction, and the Spanish urban scene presents a homogeneous assembly of masonry

forms very different from the juxtaposition of half-timbered frame and monumental stone construction in the Gothic North.

The second factor was the legacy of centuries of Muslim rule, particularly persistent in architecture and the decorative arts in view of the universal admiration evoked by Hispano-Moresque achievements. Even after the Christians had resumed power in an area, the Muslim craftsmen who comprised a significant, if not the major, portion of the skilled building force, continued to apply such forms as the squinch (used to convert a square to an octagon) in the construction of the typical *cimborio* (or lantern tower) over the crossing in major churches, and to ornament wall-surfaces with repetitive patterns. Known as *Mudéjar*, this kind of decoration produced by Moorish craftsmen under Christian rule, found its chief application in domestic architecture and provincial churches, but the delight in rich effects of overall pattern–often contrasted dramatically with starkly simple wall surfaces–was deeply ingrained in the Spanish subconscious and persisted through the centuries.

Although hampered by conflict between the rival Christian kingdoms and frequent dynastic upheavals, the Reconquest of Moorish Spain during our period proceeded apace. With the marriage of Ferdinand and Isabella, the heirs of Aragon and Castile respectively, in 1469, the foundation for the unity of the rival states was laid, and the final chapter in the *Reconquista* culminated in the fall of Granada, the last Moorish foothold in Europe, in 1492–the year also of Columbus's discovery of America.

The dual emblems adopted by the Catholic Monarchs, the sheaf of arrows and the yoke, symbolising subjection of rebellion whether by force of arms or by voluntary submission, left no doubt of their intention to rule a united Spain as absolute monarchs.[2] Strong rule was not all that unacceptable after the long years of near anarchy, but unfortunately the Catholic Monarchs, and particularly the fanatically devout Isabella, were determined to enforce religious as well as political unity on the mixed population. First the Jews (1492) and then the Moors (1502) were faced with the choice of conversion or expulsion. It would, however, be only after the end of the Gothic period that art and architecture would reflect the new orthodoxy. Indeed, one of the special attractions of Spanish Late-Gothic is the visible interaction of numerous styles and influences, compounded by the hypnotic *genius loci* into a uniquely Spanish synthesis, even when the architects and artists were foreigners. It was, furthermore, a great age of cathedral building, especially in the reconquered cities.

265

265 *Opposite* Detail of the portal with sculptured reliefs of Christ Carrying the Cross, the devices of Ferdinand and Isabella—the yoke and the sheaf of arrows—and three heraldic crests: of the Catholic monarchs, of the town and of the bishop. *Collegiate Church of Santa María la Real, Aranda de Duero*

Although relatively modest in scale, the memorial chapels erected in Castile are of particular interest. The Chapel of Santiago in Toledo Cathedral is one such example: it was commenced in 1432 by the able commander and counsellor of the weak-willed King Juan II, the High Constable Don Álvaro de Luna, who eventually fell victim to the intrigues of the queen and nobility and was executed. The rich but disciplined architectural decoration of the chapel is in the Flemish Flamboyant style associated with Hanequin de Bruselas, *maestro de la obra* of Toledo Cathedral from 1448. In the centre of the chapel stand the twin tombs of the luckless constable and his wife, depicted as if lying in state on the tomb lid, with four kneeling figures holding vigil, Knights of the Order of Santiago (of which the constable was Grand Master) around his bier, and

Franciscan monks around that of his wife. The quality of the carving, by the Toledan sculptor Sebastián de Almonacid, is equal to the grandeur of the concept. Indeed, in such Spanish monuments, 'Flemish realism was able to inspire works of a power and a vigour greater than any to be found in the Netherlands themselves'.[3]

Between 1482 and 1494 the far more ambitious memorial Capilla del Condestable was constructed at Burgos Cathedral to house the tomb of another high constable of Castile, Don Pedro Hernández de Velasco, Count of Haro, and his wife. Planned as an eastern extension on the main axis,[4] the octagonal chapel spans over fifty feet and has a spectacular stellar vault with a central star of openwork tracery, suffusing light from a skylight above. On the faces of the octagon flanking the towering *retablo* in Renaissance style are enormous, diagonally-placed coats-of-arms, carved in stone with tremendous *brio*,[5] and higher on the wall, directly above, are arched recesses, each framing a pair of free-standing heraldic bearers, depicted as 'woodwoses', hairy men and women inspired by medieval travellers' tales, and featuring prominently in armorial bearings all over Europe. The arches of these recesses are decorated with tiny *putti* holding religious emblems treated in pierced low-relief which resolves at a distance into a lace-like pelmet, offset by the dark, perfectly plain wall surface of the niche – a characteristic Spanish gesture towards restraint when the richness of the decoration becomes oppressive. The same

266

267

266 *Left* Memorial chapel with the twin tombs of the Condestable Álvaro de Luna and his wife by Sebastián de Almonacid (1489) and a contemporary reredos. *Santiago Chapel, Toledo Cathedral*

267 *Below left* The furry wild women of medieval heraldry support the arms of Doña Mencia de Mendoza, the wife of the Grand Constable of Castile. *Capilla del Condestable, Burgos Cathedral*

268 *Below* General view showing the Late-Gothic upper half of the west front by Juan de Colonia. Its openwork spires may have been inspired by the drawings for the towers of his native cathedral of Cologne, which were not actually completed until the nineteenth century. *Burgos Cathedral*

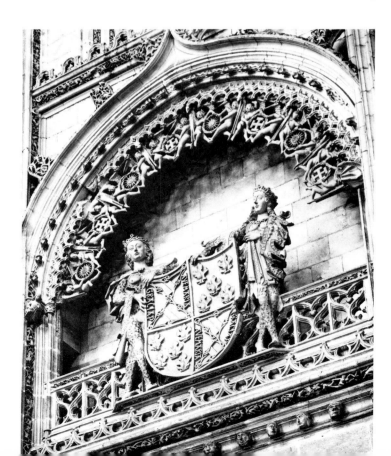

heraldic enthusiasm informs the treatment of the exterior, with a further selection of giant crests and heraldic bearers vaunting the noble birth of the founders.

The Capilla del Condestable was designed by Simón de Colonia whose family were masters of the works at the cathedral for about a hundred years, starting in 1442. Simón's father, Juan de Colonia (Johann von Köln) was brought to Burgos by the bishop, Alonso de Cartagena.[6] Of Jewish birth, this most celebrated *converso*, not to be outdone by the pedigrees of the Spanish grandees, claimed to trace his descent to the family of the Virgin! It was Juan de Colonia who, as master in charge of both the architecture and sculptural decoration of the cathedral, first gave a Germanic imprint to the hitherto predominantly French structure with the upper portion of the west front and its openwork stone spires. Juan's son by a Spanish wife, Simón de Colonia, was a celebrated and prolific master whose work achieved a strangely potent fusion of his dual Germanic and Iberian inheritance. Simón's son, Francisco, in turn, supervised the rebuilding of the lantern-tower over the crossing, after the original structure, reputedly his grandfather's masterpiece, collapsed in 1539. Francisco's *cimborio* completed the riotous medley of towering spires and crocketed pinnacles at Burgos, a combination of Gothic and Renaissance Plateresque[7] detail which often does not bear detailed examination.

To make assurance doubly sure after the collapse of the original tower, the piers of the crossing were thickened to huge, ungainly cylinders to take the weight of the new *cimborio*. The effect internally is anything but happy, and the decoration of the squinches above, effecting the transition from square to octagon, and also that of the interior walls of the lantern itself are both coarse and uninspiring; the effect is redeemed, however, by the stellar vault of *Mudéjar* character which achieves a perfect harmony of Islamic and Gothic ideals.[8]

The son of Juan II of Castile was an even more incompetent

269 Detail of central openwork motif of the vault of the early-sixteenth-century Capilla de la Presentación. *Burgos Cathedral*

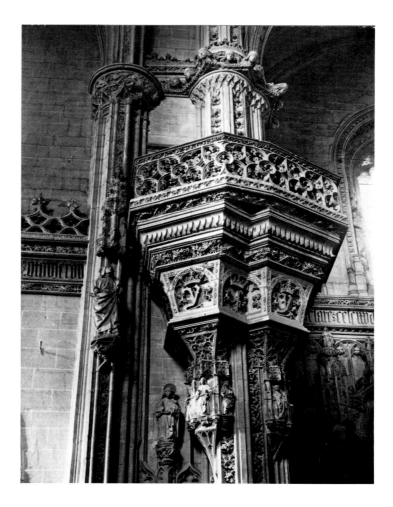

270 Detail of the royal tribune or balcony. *San Juan de los Reyes, Toledo*

ruler than his father and was deposed in favour of his daughter, Juana, nicknamed 'La Beltraneja' after her reputed father, Beltran de la Cueva, the queen's lover. A general determination not to have a bastard on the throne led to a reaction first in favour of the king's young brother, Alfonso, and on his sudden death, in favour of his sister Isabella. Juana was, however, championed by Portugal, and only after the defeat of the Portuguese invaders at the Battle of Toro in 1476 did Isabella become the undisputed ruler.

In thanksgiving for the victory,[9] Isabella and Ferdinand of Aragon built the splendid monastery of San Juan de los Reyes at Toledo, whose church was intended to serve as their burial place–subsequently moved to Granada after their capture of that city. The architect was Juan Guas, a Frenchman from Lyons, who had worked for Hanequin de Bruselas on Toledo Cathedral.

The exterior of San Juan de los Reyes is austere and the feature most likely to linger in the memory is the bizarre display of fetters taken from Christian captives of the Moors by the victorious Catholic forces. Arranged in serried rows in the blank arcading, they are surprisingly interesting visually. By contrast, the interior of the church and the cloister could hardly be more splendid in decoration. The end walls of the transepts overlooking the intended location of the royal tombs beneath the typical octagonal *cimborio* on squinches, present a sculptured composition which compares with the exploitation of heraldry as architectural embellishment found at King's

interest is the introduction of Moorish stalactitic vaulting over the tribune, beneath the row of realistic heads that project boldly beyond the angular string-course, and the way in which the nodding ogee arches at the top of the standard pier are detailed to emphasize their analogy with the adjacent stalactite vaults. Muslim motifs were, as we have noted, widely used, particularly in secular architecture. Juan Guas used stalactite vaulting at the castle of Manzanares el Real, designed a few 271 years later, to create a major monument of *Mudéjar* architecture.

The cloister of San Juan de los Reyes exhibits a consummate 272

271 *Left* Around 1480 Juan Guas, the architect of San Juan de los Reyes, added this elaborately decorated gallery to the castle of the Duke of the Infantado. The blind machicolations in the style of Moorish stalactite vaulting provide another example of the conversion of fortresses to palaces at the end of the Middle Ages. *Castle of Manzanares el Real, Castile*

272 *Below left* View of the cloister walk with its rich tracery and canopied statues of saints. *San Juan de los Reyes, Toledo*

273 *Below* The cloister seen through the traceried openings of the arcade. *San Juan de los Reyes, Toledo*

College Chapel, Cambridge, which, as we have seen, may have
11 been inspired by Spanish precedent. Hieratic eagles bearing the royal arms, surmounted by intricately ornamented crowns, alternate with figures of saints standing on pedestals beneath towering canopies; and over the entire composition runs a continuous inscription in Gothic characters lauding the founders, which at a distance bears an uncanny resemblance to the monumental Kufic inscriptions of Islam – the undoubted source of inspiration. A unique feature of the interior is the pair
270 of royal tribunes or balconies corbelled out from the additional piers that strengthen and visually accent the junction of nave and transept. The wealth of ornamental motifs is nothing short of staggering. To have combined them so successfully represents an artistic *tour de force* of the first order. Of particular

wood are assembled to form interlocking geometric designs, here further embellished with painted emblems of the Catholic Monarchs, including the yoke and sheaf of arrows.

Juan Guas was also in charge of the rebuilding of the ancient Dominican Monastery of Santa Cruz, just outside Segovia. Largely financed by wealth confiscated from the Jews, Queen Isabella personally contributed the funds for the construction of the portal, where she is depicted, together with her husband, kneeling before the *Pietà* in the lunette over the doorway. A distinctive feature of the design is the flaring curve that sweeps up from the archivolt to enclose the focal point of the composition, a Crucifixion, within a heart-shaped form, while flanking curves circumscribe the ubiquitous royal escutcheons.

276

274 *Left* Detail of the upper gallery of the cloister with its *artesonado* ceiling of Moorish workmanship and the flying arches that brace the corner piers. *San Juan de los Reyes, Toledo*

275 *Below left* Detail of the escutcheons and *trompe-l'oeil* stone chain, all on an heroic scale. *Capilla de los Vélez, Murcia Cathedral*

276 *Below* Portal of the former Monastery of Santa Cruz by Juan Guas. *Segovia*

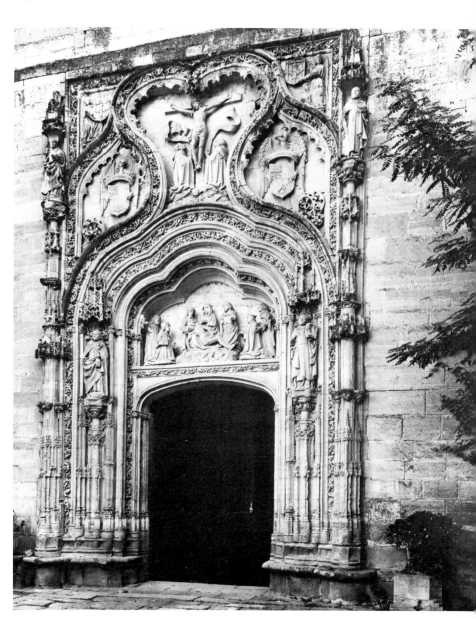

273 mastery of Gothic form and has an appropriate stately splendour. The royal apartments in the monastery are at the level of the upper gallery of the cloister and also, incidentally, at that of the tribunes in the church. This upper cloister gallery has a
274 coffered *artesonado* ceiling, a Moorish speciality particularly associated with palace architecture,[10] in which small pieces of

and was virtually at a standstill when, early in her reign, Queen Isabella instructed Juan's son, Simón de Colonia, to complete the church, and commissioned Gil de Siloé to sculpt the double tomb of her parents, and also that of her young brother, the Infante Alfonso, whose death at the age of sixteen changed the course of history. Gil de Siloé produced his sketch design in 1486, but actual work was delayed until 1489.[11]

Nothing is known of Gil de Siloé's nationality or place of origin, although his unusual name has given rise to much speculation, one suggestion being that it was derived from the Biblical spring in Jerusalem, and hence that Gil might well have been a converted Jew, like the Bishop of Burgos himself.[12] While thoroughly Spanish in character, his work has strong stylistic affinities with Flanders and the Lower-Rhine region, but so strong was Flemish influence in Spain at this period that he could easily have acquired a Flemish technique without ever leaving Spain. However, whatever the formative influences, Gil's accomplishments are marked by great originality. The basic form of the double tomb of Juan II and his queen, Isabella of Portugal, for example, is based on the Moorish eight-sided star consisting of two superimposed squares, one placed diagonally over the other. But the distinctive characteristic is Gil's decorative genius which finds full expression in the treatment of these sumptuous embroidered robes and accessories with their deeply-undercut, filigree-like ornament. This is of a delicacy reminiscent of the finest goldsmith's work, yet free from even a suggestion of dryness or fussiness in execution. The base of the tomb with its innumerable allegorical and decorative figures and its lavish architectural ornament is equally impressive and only the portrait heads are conventional. The royal couple lie side by side, the king holding his sceptre and robe, the queen her prayer book. They are 280 separated by a low openwork grille and have their heads turned slightly to the outside, the better to be viewed by the spectator, but also symptomatic of the lack of psychological insight in the portraits.[13] Although technique and artistry are beyond praise, this remains essentially decorative sculpture, albeit on the very highest plane.

The tomb of the Infante Alfonso is recessed within a niche, the effigy following an innovation in tomb sculpture, the representation of the deceased at his or her devotions, rather 281 than in a recumbent position. The prince kneels before a *prie-dieu*, facing the high altar as if attending Mass, his fur hat slung behind his back; the varying textures of the prayer book, silk coverlet, pillow and the heavily fringed covering of the *prie-dieu* are all exquisitely rendered. Interestingly the artist has extended the distance between elbow and knee to give added height and dignity to the figure. The most irresistible feature of the design is the foliate ornament, among which frolic *putti* and a variety of birds, animals and insects, which might almost have been transported from the margin of an illuminated manuscript. The openwork cresting suspended within the arch originally extended down both sides of the opening, but only a small segment has survived, with an acrobatic *putto* clinging to the volute. Fortunately the added space in front of the kneeling

All these somewhat capricious forms are handled by Guas with masterly assurance.

Contrasting with the sophisticated elegance of San Juan de los Reyes in metropolitan Toledo is the little-known Capilla de los Vélez in provincial Murcia, added to the cathedral in the late fifteenth century. The exterior boasts escutcheons and a *trompe-l'oeil* chain of stone, of heroic scale. A fine star-shaped 275 277 vault encloses the decagonal chapel, which has a decorative wall treatment of great vigour, if somewhat lacking in finesse – in short, a flawed but fascinating work. The design also constitutes a compendium of contemporary styles and motifs: Flamboyant (the tall canopies and gables); Perpendicular (the rectilinear wall panelling); *Mudéjar* (the stalactitic corbelling); Portuguese Manueline (the interlacing arboreal forms – and also, the gigantic chain on the exterior), and Renaissance (the wreath-encircled heraldic crests).

A short distance from Burgos, on the site of a former royal hunting-lodge, stands the Carthusian Monastery, or Cartuja, of Miraflores. After a fire in 1452, Juan II of Castile entrusted Juan de Colonia with the erection of the present monastery and the church which he intended as his final resting place. However, work had not proceeded far before the king's death,

277 *Above left* Interior of the Capilla de los Vélez (*c.* 1495–1507) constituting a compendium of styles and motifs. *Murcia Cathedral*

278 *Opposite* Detail from *St Bernardino and the Guardian Angel* (1485) by Jaime Huguet. *Chapter-house, Cathedral of Barcelona*

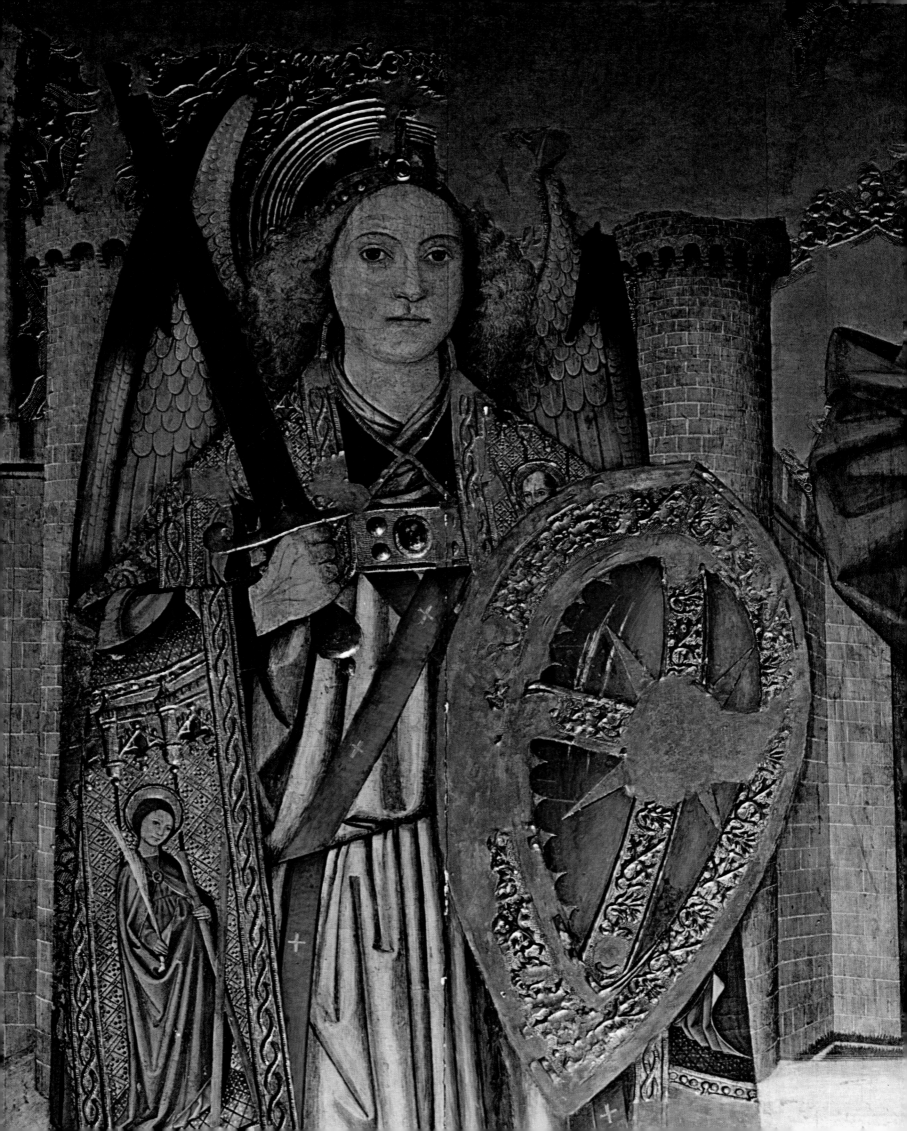

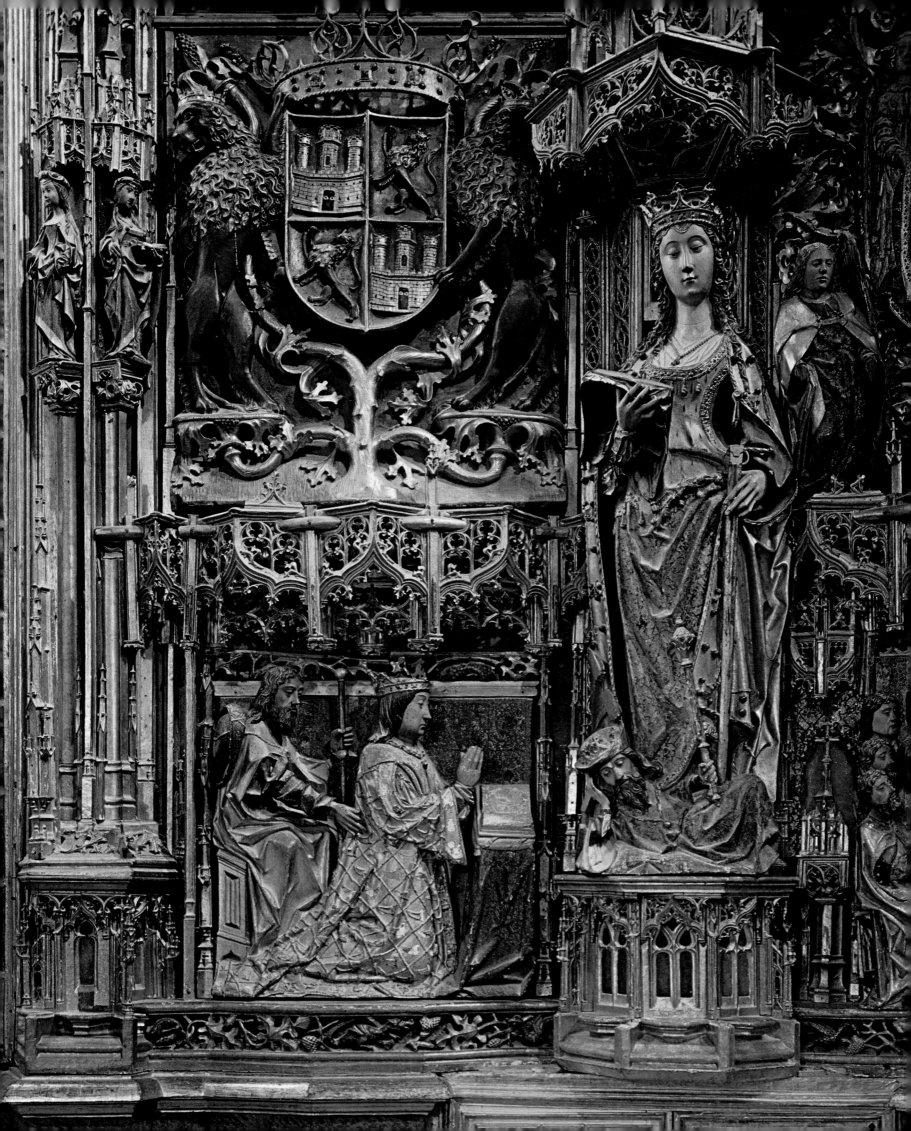

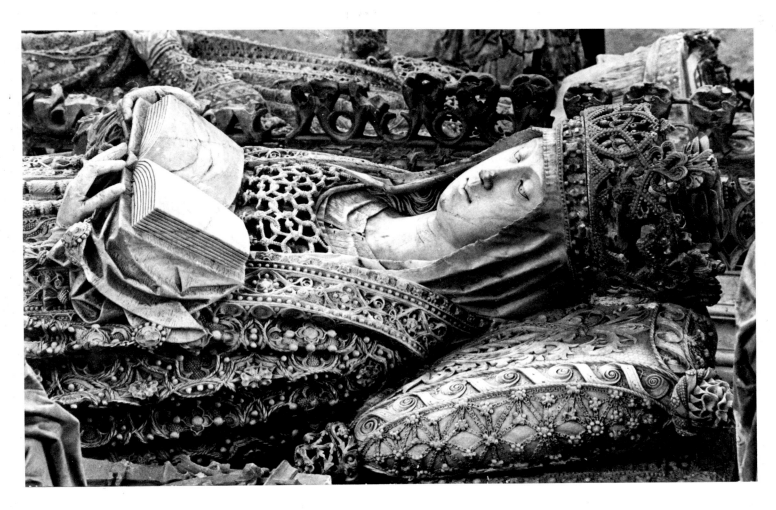

figure focuses attention far more successfully on the centre of interest, the head and the gloved hands.

The royal tombs were completed in only four years, and in 1496 Gil de Siloé, again, we may assume, with a host of assistants, commenced the great altarpiece for the same monastery. The large-scale, coherent composition, so different, as we shall see, from the customary pigeon-hole-like aggregation of scenes in the typical Late-Gothic *retablo*, makes an overwhelming impression. The theme has been interpreted as an allegory on the sacrifice of the Lord's table.[14] The focal point of the composition, as of the Eucharistic mystery, is the crucified Christ. Above is a further symbol of self-sacrifice, the pelican which, according to medieval legend, pierced its breast to feed its young.[15] The arms of the Cross are supported by God the Father and a youthful Holy Ghost—an extremely rare iconographic arrangement. At the foot of the Cross stand the customary mourning Virgin and St John, superimposed over a circular aureole of angels which frames the central scene. Minor circles, within and outside the main *tondo* contain episodes

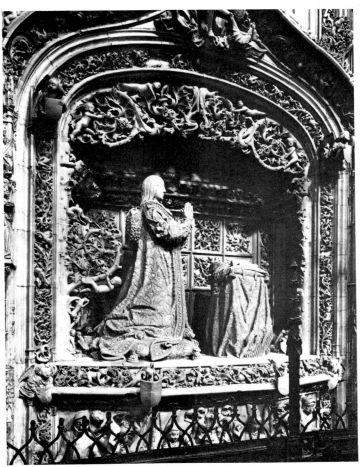

279 *Opposite* Beneath the royal arms of Leon-Castile, Juan II kneels in worship, attended by St James (Santiago), patron-saint of Spain; and on the right Saint Catherine stands triumphant over the king who had caused her martyrdom. Detail of Gil de Siloé's wooden *retablo*, still preserving its original polychromy. *Cartuja de Miraflores, Burgos*

280 *Above* Detail of the effigy of Isabella of Portugal by Gil de Siloé (1489–93). *Cartuja de Miraflores, Burgos*

281 *Right* Detail of the tomb of the Infante Alfonso, brother of Isabella la Catolica, by Gil de Siloé (1489–93). *Cartuja de Miraflores, Burgos*

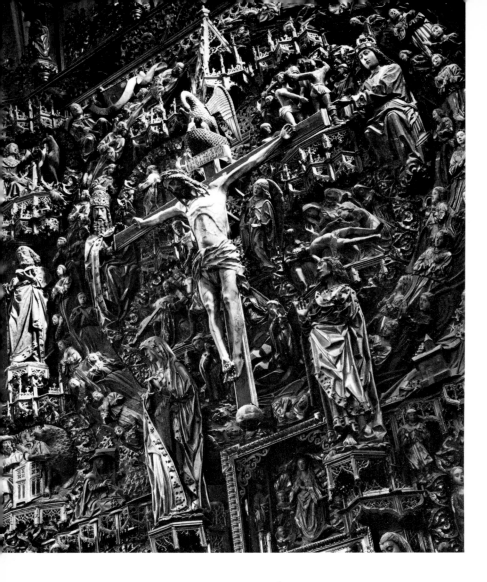

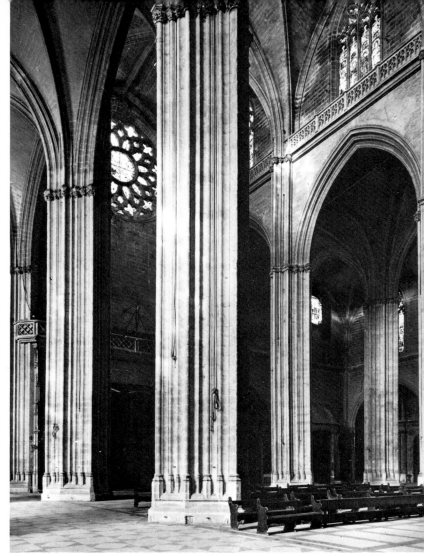

282 *Top* Detail of the central portion of the *retablo* (1496–99) by Gil de Siloé. *Cartuja de Miraflores, Burgos*

XI *Above* Plan of Seville Cathedral

283 *Above right* Interior looking towards the western rose. *Seville Cathedral*

284 *Right* View of the crossing showing the vaults rebuilt by Juan Gil de Hontañón in 1518, with their barnacle-like encrustation of ornament. *Seville Cathedral*

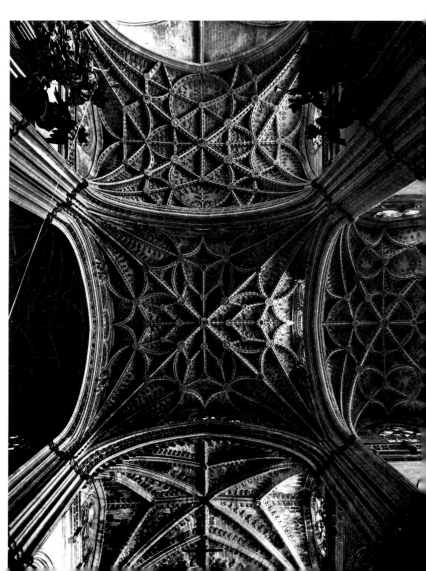

from the Passion and figures of the Evangelists, respectively, reinforcing the circular shape of the sacred wafer. One Diego de la Cruz, *'pintor'*, collaborated on the *retablo*. It is he who must, presumably, be credited with the superb colour, mercifully untouched by the restorer, which has survived in virtually perfect condition.

Although the archives of the Cartuja were destroyed when the monastery was sacked by French troops in 1808, during the Peninsular War, accounts published during the eighteenth century, based on the existing archives, record the remuneration of Gil de Siloé.[16] He was paid 1340 *maravedis* for the initial design of both tombs and a further 600,919 for the actual execution (442,667 for the labour and 158,252 for the cost of the alabaster), a total of 602,259 *maravedis* in all. For the design and execution of the *retablo* he received a total of 1,015,613 *maravedis*. The amounts are difficult to assess in terms of modern currency,[17] but the comparison of the sums shows that the moment of inspiration, captured in the initial sketch outlining the concept, was thought worthy of a mere token reward, whereas the surprisingly high relative cost of the *retablo* in relation to the tombs was undoubtedly due to the liberal use of gold in its polychrome decoration.

The most ambitious architectural achievement of our period, not only in Spain but in all Europe, was the rebuilding of the cathedral of Seville on the site of the twelfth-century mosque. Decided upon in 1401, the vast structure, subsequently surpassed in size only by the new St Peter's in Rome, was completed by 1506, barely a century later, vindicating the boast of the Chapter, 'to build a church so fine that none shall be its equal . . . so great and of such a kind that those who see it completed shall think that we were mad'. Apart from later accretions the plan covers a rectangle 400 feet long and with a width of some 250 feet (figure XI); it is made up of a nave and double aisles with vaults rising to 132 feet and 85 feet respectively, and a further outer row of chapels inserted between the buttresses, the interior thus having an unprecedented continuous width of seven bays. The interior is restrained in detail, even austere, particularly considering the late date, but is saved from bleakness by the fine glass and the richness of the furnishings. One of the peculiarities of cathedral plans in Spain is the separation of the sanctuary containing the high altar (*Capilla Mayor*) and the choir (*coro*), and the removal of the latter to a position west of the crossing. Since this is the standard arrangement even in completely new structures where the eastern arm could easily have been designed to provide adequate space for both activities, the separation must have been deliberate and it has been suggested that, to the Spanish temperament, the transcendental nature of the Sacrifice at the Altar made it unfitting that the same space be shared by any lesser function.[18] At Seville the *Capilla Mayor* and *coro*, of proportionately enormous scale, are located virtually in the middle of the interior. In practice, as in the case of the English cathedrals, the obstructions are exploited as an asset to give a heightened sense of mystery and expectation to one's pilgrimage. In 1511, only five years after the completion of the structure, the lantern over the crossing collapsed. It and the damaged adjacent bays were rebuilt by Juan Gil de Hontañón with florid lierne vaults whose bizarre magnificence, in striking contrast to the balance of the vaulting, effectively accentuate the liturgical nucleus.

The exterior of the cathedral is spoilt by nineteenth-century accretions, but a superb view of the original Gothic cathedral

285 View from the crossing showing the Renaissance *reja* or grille closing off the High Altar. The piers are covered with antique velvet for the Holy Week celebrations. *Seville Cathedral*

can be achieved from the surviving minaret of the mosque: the incomparable Giralda Tower. From the top of this can be seen its roofscape with tiles laid directly on the vaulting – feasible only in this dry, sunny climate – and the superbly engineered flying buttresses taking the thrust of the high vaults.

Of the original sculpture on the exterior, the most interesting is by the Breton, Lorenzo Mercadente, notably his terracotta tympanum over the Portal of the Nativity. The style is Late-Burgundian,[19] the treatment realistic and anecdotal. Behind St Joseph sinking to his knees, a midwife hurries in who, according to an apocryphal legend, testified to the Virgin Birth.[20] Both figures with their instantaneous movement reflect a totally different spirit from the former hieratic and static order symbolised by the canopies over the three main participants. An incongruous survival, the canopies serve to remind us, more forcibly than the music-making angels assembled around the star-illumined crib, that this genre scene has a Divine import. The dancing shepherds over the stolid ox and ass in their wicker-laced-enclosure, and the distant village scene cramped beneath the right-hand canopy, reinforce the pictorial character of the composition.

The plan of Seville Cathedral had been to a certain extent predetermined by that of the existing mosque. Just how congenial this rectangular plan with its Islamic emphasis on a seemingly limitless horizontal extension of space and sheer area was to the Spanish temperament, is apparent from its adoption,

279
283
284
287
286

on a slightly less ambitious scale, for another great project commenced just as the Cathedral of Seville was nearing completion.

Towards the end of the fifteenth century, the Romanesque cathedral of Salamanca, *'muy pequeña y escura y baxa'* ('very small, dark and low'), according to the Catholic Monarchs,

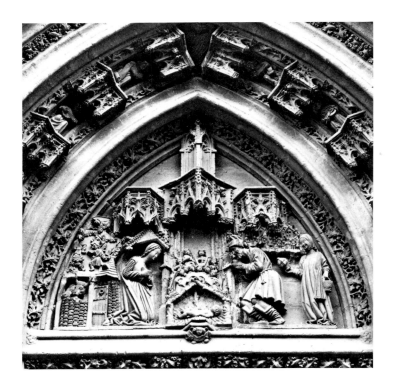

seemed incompatible with the importance and aspirations of the thriving university town, ranking second among the four leading European seats of learning – Paris, Salamanca, Oxford and Bologna – and larger than Oxford and Cambridge combined. In 1491 the Chapter resolved to rebuild the cathedral, but nothing was done for years, and only in 1509 were Alonso Rodríguez and Antón Egas, masters of the works at the cathedrals of Seville and Toledo respectively, summoned by royal decree 'instantly to leave all other things and come to the city of Salamanca . . . to see the site and make a drawing for the new cathedral, most suited to the Divine Offices and the embellishment of the said church'. The two masters met in May 1510 and drew up a plan for the new cathedral on parchment. They could not, however, agree on the proportions of the *Capilla Mayor* and decided to consult a third party and then transmit their decision to the Chapter within ten days. For some reason no conclusion was reached and in 1512 the Chapter determined to resolve the *impasse* by convening a *junta*, or commission of experts, in this case nine leading master-masons, including Antón Egas (Rodríguez having died in the meantime). The report of the *junta* is of the greatest interest for the light it throws on the state of the profession at the end of the Middle Ages, and is reproduced in full in the notes.[21] The precise dimensions assigned to every major

288

286 *Left* Terracotta Nativity (1466–67) by Lorenzo Mercadente. *Seville Cathedral*

287 *Below* A skeletal 'space-frame' of flying buttresses and pinnacle-weighted piers reveals the ordonnance of the double aisles below. In the distance the very modest lantern over the crossing. *Seville Cathedral*

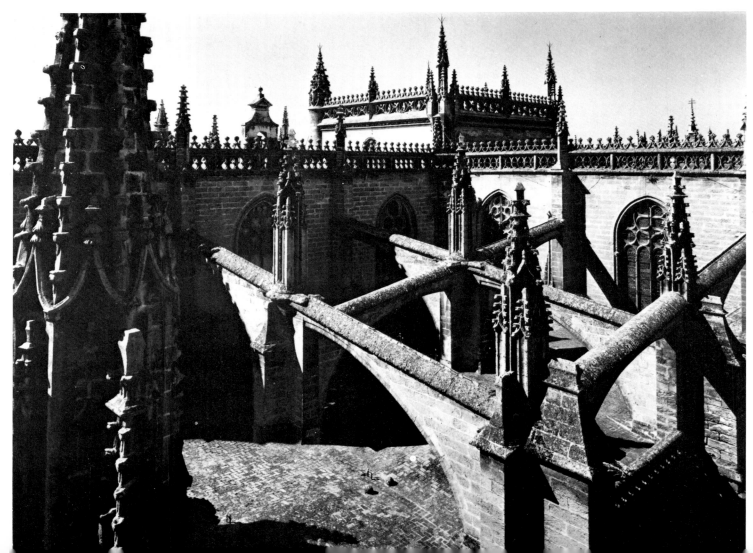

architectural element in the report clearly imply that the members had a plan before them, presumably that drawn up by Rodríguez and Egas. By the rarest good fortune for architectural historians, it had been decided that the old cathedral should be preserved, and most of the report is concerned with the precise location of the new cathedral in relation to the old, its cloister and its much-admired west tower. Since this was a contentious issue, 'both among the members of the Chapter and without', the *junta* was instructed to give its reasons for its selection of site and also against the most favoured alternatives, so as to forearm the Bishop and Chapter against criticism. The reasons given reveal a shrewd analysis of considerations ranging from the effect of the proposed building on the townscape in general and the impact on the nearby 'Schools' of the University in particular, to desirable orientation, approaches and circulation patterns, down to concern about depriving existing buildings of natural light or sparing houses whose demolition would involve a loss of revenue to the Chapter. The Chapter accepted the recommendations of the *junta* and appointed one of its members, Juan Gil de Hontañón, master of the works with an annual salary of 40,000 *maravedís*, and an additional 100 *maravedís* for each day that he assisted at the works. The inference of this latter clause is that he would not be devoting all his time to this one project, and this is borne out by the fact that he is known to have worked

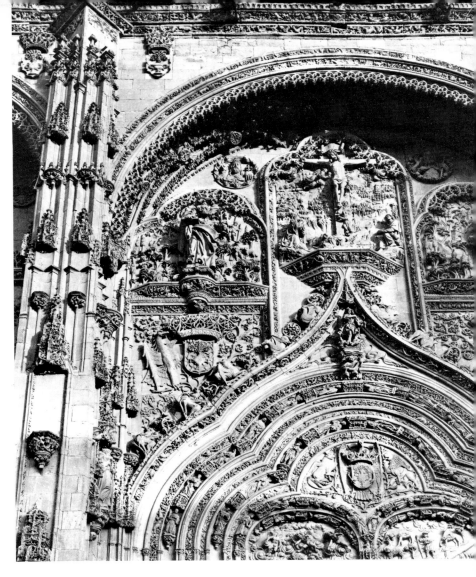

288 *Right* Detail of the Plateresque ornament over the main portal. *Salamanca 'New' Cathedral*

289 *Below* View of the chevet of Segovia Cathedral, *Segovia*

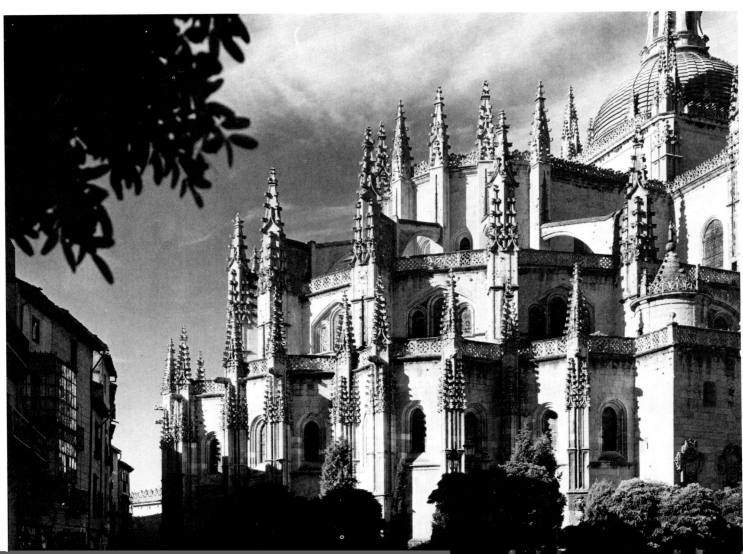

simultaneously on several others, including, as we have seen, the rebuilding of the lantern and surrounding vaults of Seville Cathedral, and ten years later, the design and construction of the new cathedral of Segovia.

The cathedral of Segovia is almost identical to that of Salamanca in plan. The main difference lies in the treatment of the choir. Although the *junta* at Salamanca had determined, 'the head of the Trascoro (the east end) may be octagonal', a note in the margin reads, 'It has been built square'; this turned out to be one of the least successful features of the design. The chevet of Segovia, on the other hand, with its seven identical apsidal chapels, follows the classic French model and is, in fact, almost identical in plan to that of the thirteenth-century cathedral of Beauvais. The architectural treatment and effect could, however, hardly be more different. In place of the web of flying buttresses and tie-rods supporting a veritable glass-house at Beauvais, the stepped, cubical masses of almost solid walling, pierced by openings small enough to exclude excessive heat and glare, epitomise the uniquely Spanish interpretation of Gothic that had evolved by this date. Particular interest attaches to the

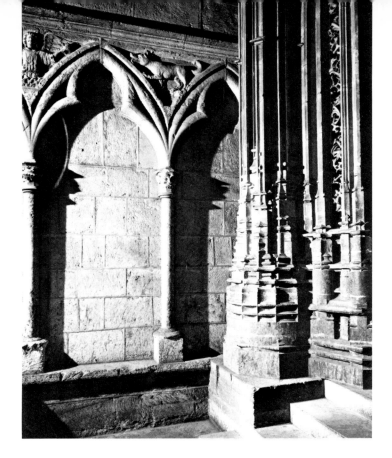

290 *Below* View of interior. *Salamanca 'New' Cathedral*

291 *Right* Detail of pier of the portal to the Santiago Chapel (1492–1507). *León Cathedral*

292 *Opposite* Detail of the *Retablo Mayor*. The Circumcision of Christ is one of forty-five large scenes, each over a yard square, designed by the Flemish sculptor, Pieter Dancart, who worked on this enormous altarpiece from 1482 to 1489. *Seville Cathedral*

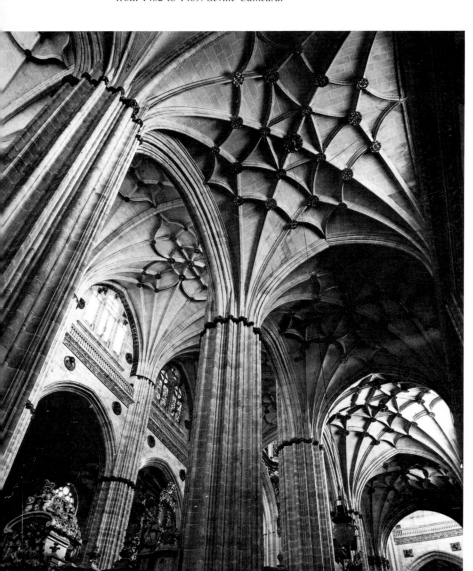

cathedral of Segovia since it was the last great cathedral in all Europe to be built in a consistently Gothic style, and as such may be regarded as the swan-song of the medieval master-mason's art. The sections of medieval mouldings were customarily set out to full size on templates by the designer himself, and it has been observed that they are as revealing of his artistic personality as a painter's brush strokes.[22] A comparison of the piers of the cathedrals of Seville, Salamanca and Segovia is particularly instructive in illustrating just how profound a difference the profile of shafts and mouldings can make to piers of very similar proportions. At Seville the pier is 283 in the form of an octagon with hollowed sides and the overall impression of the sequence of bowtels and concave mouldings is of a delicately rippled plane surface. The octagons have, furthermore, been rotated so that the edges, rather than the sides are on the main axes, giving rise to a dynamic diagonal movement and a knife-sharp transition from light to dark. This minimises the mass and imparts a buoyant upward thrust that is, however, partially negated by the horizontal band of the capitals. At Salamanca both the base and the pier are circular, 290 convex shafts predominate and there is a gradual transition from light to dark. Here the effect is to increase the apparent bulk of the piers to such an extent that they actually appear to contract above the constraining capitals. In the chevet of Segovia Cathedral, constructed by Rodrigo Gil de Hontañón, son of Juan, between 1563 and 1591, there is a subtle balance of concave and convex mouldings and a return 289 to the diagonal movement at Seville a century earlier, with a clear, though not quite so abrupt, transition from light to dark. Once again, the effect of bulk is minimised, and the shafts soar up into the vaulting, now unrestrained by any capitals. The greatest sophistication and inventiveness in the design of mouldings can be seen in the pier bases of the portal giving access to the Santiago Chapel, a late addition to the cathedral of León, where the virtuoso performance in the interpenetration 291 of complex mouldings is underscored by the forthright simplicity of the adjoining thirteenth-century arcading. The architectural ornament inside the chapel, constructed between

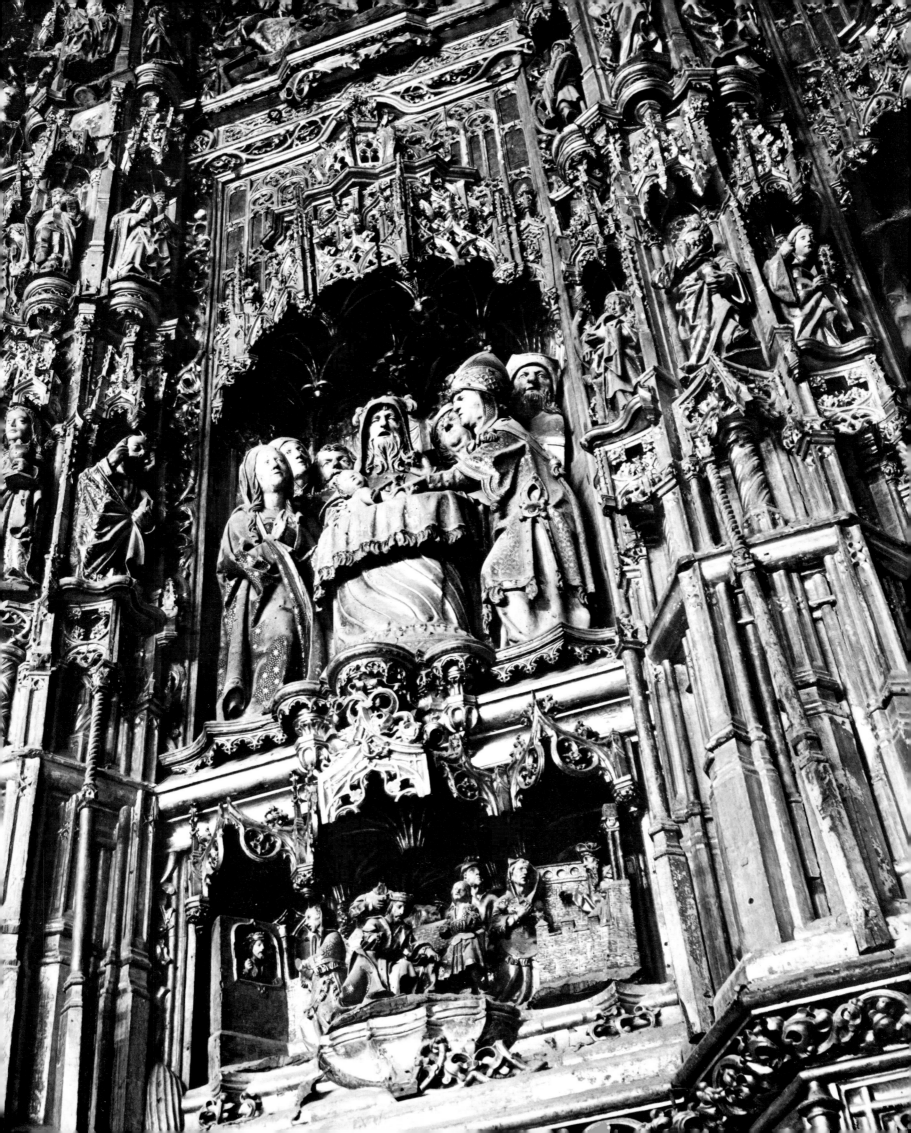

1492 and 1507 by Juan de Badajoz (one of the members of the *junta* at Salamanca), is of the same superlative quality.

It is to the carved, painted and gilded altarpieces or *retablos* of monumental scale, gleaming even in the darkest interior, more than to any other feature, that Spanish church interiors owe their sumptuous grandeur. By the Late-Gothic period the *retablo* customarily stretched the full width of the chancel or chapel, sometimes even encroaching on the side walls, and towered to the very vaults. Involving a prodigious amount of sheer labour – wood-carvers might spend the greater part of their working life on a single project – such altarpieces of necessity constituted a team effort, and in their usually compelling unity bear striking testimony to the deliberate subordination of individualism, even in the case of artists whose other work bears witness to a very distinctive artistic personality. In addition to the actual carvers many other specialists were involved: the *trazador* or author of the original sketches, who was often a painter, the *encarnadores* and *estofadores*, or tinters of flesh-colouring and painters of drapery and ornament, and the *doradores* or gilders.

The two most spectacular *retablos* in Spain are those in the cathedrals of Toledo and Seville. Above its sculptured *predella* the larchwood *Retablo Mayor* of Toledo rises in three further tiers, sloping upward towards the centre to counteract the natural perspective effect of the concave form, each tier separated from the next by exquisitely carved canopies which assume the character of a lace altar-frontal in relation to the scene above. Each tier, in turn, is divided into five bays, and within the deep niches naturalistically coloured figures enact scenes from the Life and Passion of Christ, as if performing a Miracle Play.[23] The focal point at the base of the composition below the central vertical axis showing the Nativity and Crucifixion is a gilded *custodia* where the Host is kept. Outstanding even among the splendid furnishings and liturgical objects of the Spanish cathedrals (which have generally been spared the ravages of war and revolution) is the processional *custodia* made for Toledo by Enrique de Arfé in gilded silver, weighing more than 350 lbs and in the form of a fantastically intricate Gothic steeple nearly ten feet high, studded with jewels and surmounted by a cross of pure gold made from the first gold brought back by Columbus from the New World; it is carried through the streets draped with precious tapestries on the Feast of Corpus Christi.

An even larger but less beautiful *retablo* is at Seville, designed by the Flemish sculptor, Pieter Dancart, who worked on it from 1482 until his death in 1489. The central portion was only completed in 1536 and the canted wings in 1564. Fifty-nine feet high, this is the largest *retablo* in all Spain, and contains forty-five major figure compositions set within an elaborate architectural framework.

The Spanish infatuation with the *retablo* found an extended application in two Isabelline structures in Valladolid, the church of the Monastery of San Pablo and its annex, the

293

292

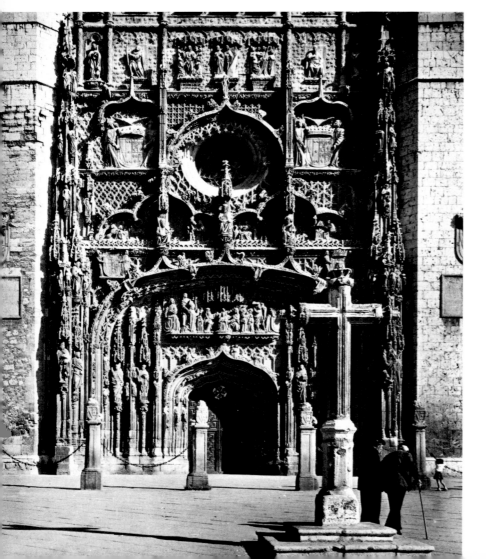

293 *Above left* Partial view of the *Retablo Mayor*, carved in larchwood between 1498 and 1504 by an international team of artists. *Toledo Cathedral*

294 *Left* Detail of the lower portion of the west front, 1486–92, by Simón de Colonia. *Monastery of San Pablo, Valladolid*

295 *Opposite* Gallery of the cloister-court by Simón de Colonia, 1487–96. *Colegio di San Gregorio, Valladolid*

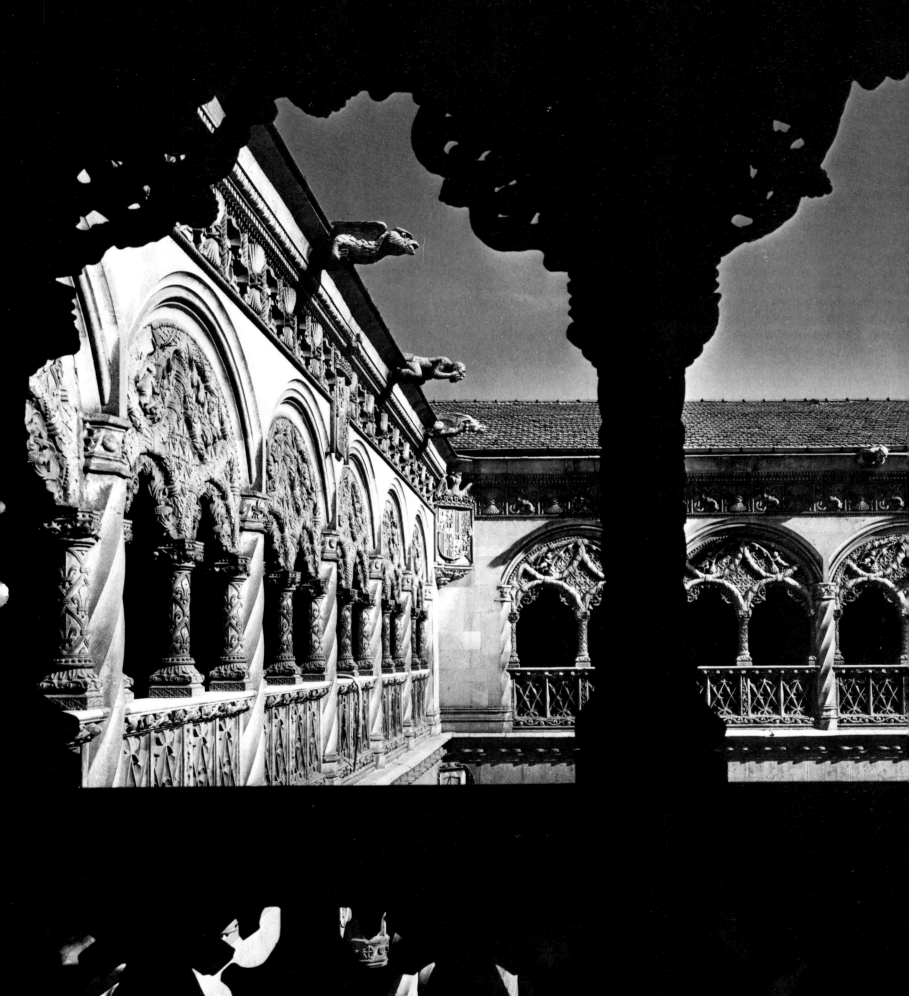

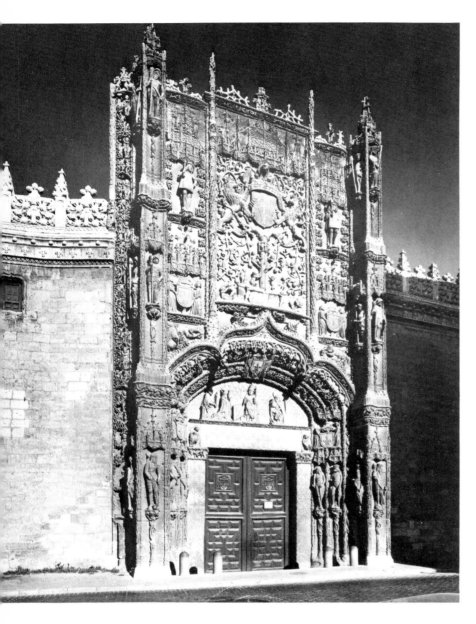

296 Portal of the Colegio di San Gregorio. *Valladolid*

The façade of San Pablo flaunts its splendour on a spacious square, while the beautiful portal of the Colegio di San Gregorio opens onto a narrow lane. Both structures owe their grandeur to the initiative of Alonso de Burgos, Bishop of Palencia and Confessor to Queen Isabella; but whereas the iconography of San Pablo is predominantly religious, that of the portal of San Gregorio, with the exception of the relief in the lunette over the doorway depicting the donor-bishop kneeling before St Gregory, celebrates court life and martial prowess – peculiarly appropriate in this capital city[24] and favoured royal residence, the scene of so many festivities, including the marriage of Ferdinand and Isabella.

The central motif of the portal is an escutcheon with the 296 royal arms, borne aloft in the branches of a huge pomegranate tree, a clear reference to the recent conquest of Granada, since *granada* in Spanish means pomegranate. *Putti* disport in the tree and around the marble basin from which it sprouts. Beneath the canopies at the sides stand not saints but mace-bearing pages, warriors in armour and the hairy woodwoses we have already met in the Capilla del Condestable in Burgos, while the *fleur-de-lys* emblem of Alonso de Burgos is everywhere in evidence. The cresting of dry twigs was a device used in Germany and France, but the overall effect is distinctively Spanish. The actual carving is of high quality, and part at least has been attributed by some authorities to Gil de Siloé who, it will be recalled, carved the lost *retablo* of San Gregorio. There is certainly a family resemblance between the children clambering in the fruit-laden pomegranate and the *putti* amid the foliage of the tomb of the Infante Alfonso at the Cartuja de Miraflores.

It should be emphasised that the marriage of Ferdinand of Aragon and Isabella of Castile united kingdoms with very disparate historical backgrounds and interests. Aragon and Catalonia[25] had a long-standing tradition of constitutional rights respected by the sovereign which had no real equivalent in Castile, and also a Mediterranean, rather than a Peninsular bias, resulting from the acquisition by the Crown of Aragon – or by blood relatives – of the Balearic Islands, Sardinia, Sicily and Naples. Singularly important from an architectural point of view was the vitality of corporate and municipal life in such thriving mercantile centres as Barcelona, Palma de Mallorca and Valencia, which found expression in exceptionally fine civic buildings.

Between 1399 and 1402 the *Ayuntamiento*, or town-hall, of 297 Barcelona was provided with a splendid new façade. The master in charge was Arnau Barguès who had also been the architect for the royal lodging commenced in 1397 at the Monastery of Poblet. Although never completed, the façade of the palace boasts some fine architectural ornament. It would appear that Master Barguès brought his team of craftsmen from Poblet, for both mouldings and sculptural detail are remarkably similar, and there is, in fact, documentary evidence that some of the workmen were engaged on both projects. The sculptor responsible for the carving of the heraldic crests over the doorway of the *Ayuntamiento* was one Jordi de Deu, an enslaved bondsman of Greek origin, who had served for many years as the assistant to Jaume Cascalls, sculptor of the much-restored royal tombs in the pantheon of the kings of Aragon at the Monastery of Poblet. Jordi de Deu was probably freed at the death of Cascalls and took the name of Jordi Johan. The façade of the *Ayuntamiento* is particularly fascinating for its successful synthesis of two opposed aesthetic systems. The balance and repose of the composition, the emphasis on the

Colegio di San Gregorio, where entire façades are treated as decorative frontispieces, pure and simple, bearing no organic relationship to the structure behind. The west front of San 294 Pablo is quintessentially Spanish in its dramatic juxtaposition of riotous ornament and the stark simplicity of the flanking towers, ill-proportioned seventeenth-century additions in their present form, which project unduly, but nevertheless help to focus attention on the sculptured centrepiece. The lower half, up to and including the oculus, was designed by Simón de Colonia and is extremely accomplished in its fluent rhythms of curve and countercurve and its rich play of light and shade. The upper half, probably by Simón's son Francisco, reveals an inferior hand and the uncertainty of an age of transition, in the regimentation of the sculpture into rectangles against a star-spangled background. A triangular, proto-Renaissance pediment bearing the royal arms on a richly scalloped field and surmounted by Gothic cresting, completes the unlikely assemblage of disparate elements, welded into a coherent composition by the overall textural consistency.

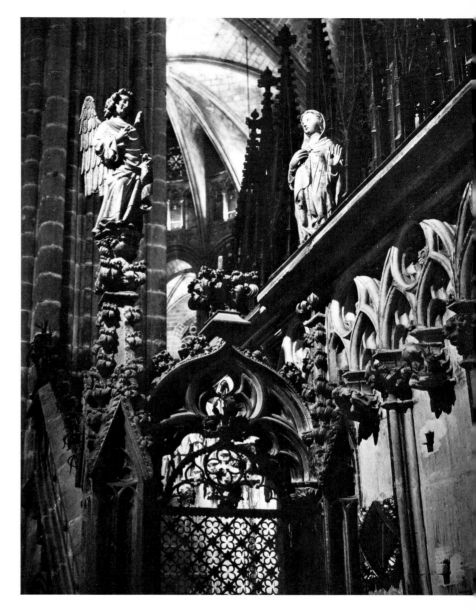

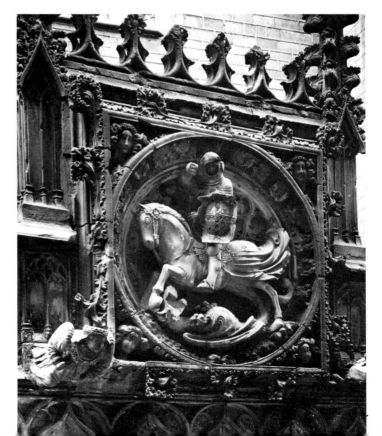

horizontal line and the respect for the integrity of the wall surface, are eloquent of the potent, albeit subconscious classical heritage of the Mediterranean world; while the Gothic detailing, unlike so many contemporary examples in Italy, preserves its stylistic purity intact, with no hint of being an alien intrusion. Thanks to the superb weathering properties of the Montjuich stone, the sculptured detail has survived virtually unscathed. The front has, however, been shortened on one side by a nineteenth-century addition, resulting in the loss of one window and the curious truncation of one escutcheon and the huge voussoirs of the arch over the doorway.[26]

The statue of the Archangel Raphael over the entrance was commissioned in 1406 by a private citizen to adorn the impressive *Salón de Ciento* (Chamber of the Hundred), constructed to serve as the municipal council chamber and completed in 1373.[27] However, the councillors decided that the place of honour in the chamber should be given to St Andrew, patron of the city. This statue was duly commissioned from Pedro Ça Anglada and the original statue of the Archangel moved, with the donor's consent, to its present location and fitted by Ça Anglada with the enormous bronze wings that seem to pronounce a benediction over the city. In fact, the whole statue may have been by him too;[28] he also worked on the choir stalls of the cathedral of Barcelona and the pulpit with its picturesquely placed Annunciation.

The Parliament, or *Cortes*, of Catalonia, dating back to the reign of Jaime I (1213-76), was housed in the picturesque

297 *Above* Detail of the façade of the *Ayuntamiento* or town hall, dating from 1399. *Barcelona*

298 *Above right* Stairway with iron grille giving access to the pulpit, all dating from the beginning of the fifteenth century. The sculptured Annunciation figures serve as the prelude to the annunciation of God's word to the people from the pulpit. *Barcelona Cathedral*

299 *Right* Tondo depicting St George slaying the Dragon by Pedro Johan, 1418, notable for its vigorous balance of curve and counter-curve. Detail of gateway to the *Diputación* or ancient Parliament of Catalonia. *Barcelona*

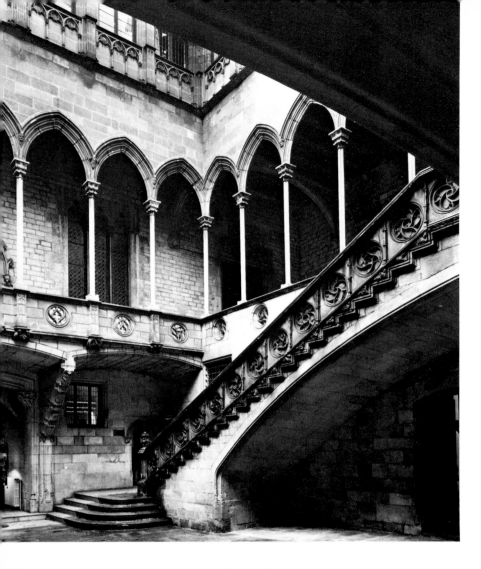

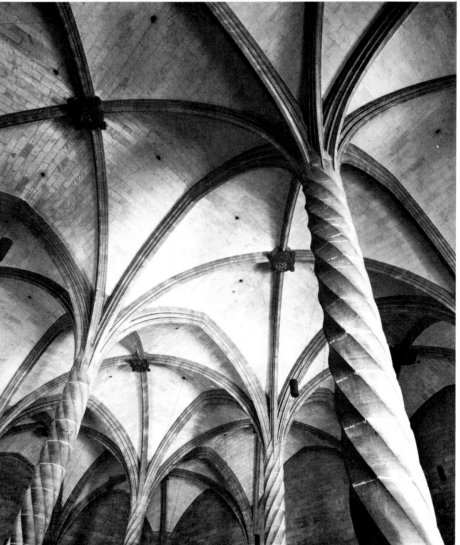

complex now known as the Palacio de la Generalidad or *Diputación*. At the beginning of the fifteenth century Marc Çafont was commissioned to design an enclosing wall facing the narrow street that served as the principal approach. His solution solved the practical problems and at the same time provided a suitably ceremonious approach. The gateway and barred openings set in plain walling are models of restraint, but the wall is crowned by a sumptuous cornice decorated with blind arcading, gargoyles and a pierced balustrade and, over the gateway, the *pièce de résistance*, a circular medallion of St George slaying the Dragon, set within a richly ornamented rectangular surround. This is the masterpiece of the great Catalan sculptor of the early fifteenth century, Pedro or Pere, Johan, son of the enfranchised Jordi de Deu.[29] So delighted were the deputies that they rewarded the artist by doubling his fee from the contracted ten to twenty florins.

The portal leads to a fifteenth-century court which has survived extensive later rebuilding. The upper storey projects, forming an arcade supported on attenuated stone colonnettes. The clarity of expression, with the load transferred to dropped arches borne on corbels, and the clean sweep of the supporting arch of the external stair, evince that delight in a structural *tour de force* that gives to Catalan Gothic its unique, quasi-engineering character. The severity is mitigated by the few, subtly disposed, ornamental accents, notably the marble stair balustrade with its elegant roundels, no two identical.

In the early fourteenth century the then independent kingdom of Mallorca maintained consular relations with commercial centres as far afield as Fez and Tunis, Venice, Constantinople, Bruges, London and Paris. In 1426 the Mallorcan master, Guillermo Sagrera, signed a contract to build a *Lonja* or commercial exchange at Palma de Mallorca.[30] He looked to familiar building types to provide a precedent: his 'hall-church' interior, with its elegant vaulting carried on delicate spiral columns, recalls the chapter-houses of the Dominican Order, while the exterior with its crenellations and octagonal corner towers – two containing spiral stairs giving access to the roof, the remainder included merely for the sake of symmetry – derives from military architecture. Sagrera has, however, succeeded in fusing the source material into a singularly inspired and original building. The prosaic title 'Defensor de la Mercadería' (Protector of Trade) hardly prepares one for the image adorning the tympanum over the entrance doorway from the plaza: an angel of extraordinary beauty, whose great plumes, of exaggerated scale, are without a hint of grossness and hover weightlessly against the serene, uncluttered background – a fortuitously happy combination, since the contract specifies that the angel 'have on one side the royal escutcheon, and on the other that of the said city of Mallorca'. The angel is documented as being carved by Sagrera, who was also personally responsible for the expressive figures of St Peter and St Paul on the *Puerta del Mirador* of the cathedral of Palma. As a sculptor of distinction and the architect for a great variety of religious, civil and military

300 *Above left* Fifteenth-century court of the *Diputación*, formerly the Parliament of Catalonia, an example of Gothic functionalism at its most elegant. *Barcelona*

301 *Left* Interior of the *Lonja*, showing how subtly the spiral fluting on the columns is blended into the vaulting ribs. *Palma de Mallorca*

architecture, Sagrera must be accounted an exceptionally versatile artist, the scenes of whose practice, Roussillon (the Collegiate Church of St John in Perpignan), Mallorca (the *Lonja*) and the Kingdom of Sicily (the Castel Nuovo at Naples), recall the extent of Aragonese dominion in the Western Mediterranean.

The three most important examples of Catalan Gothic religious architecture, the cathedrals of Barcelona and Palma de Mallorca and the church of Santa Maria del Mar at Barcelona, antedate our period, but the engineering bent of the Catalan masters achieved its ultimate expression in a structure that does concern us: the nave of Gerona Cathedral. Here the choir, on typical French lines with an ambulatory and radiating chapels, had been commenced in 1312 and completed by 1347. Thereafter, work ceased for many years, and when it was finally decided to proceed with the building of the nave in 1416, the idea of continuing on the relatively modest scale established by the choir did not inspire the master of the works, Guillermo Boffiy, who championed an audacious concept:[31] a nave the width of choir and aisles combined, with a clear span of no less than 73 feet–the greatest of any medieval vault (figure XII). The proposal, hardly surprisingly, provoked much opposition and the Chapter convened a *junta* of twelve masters who were questioned under oath as to the merits of Boffiy's plan. Their testimony reveals a remarkable professional objectivity. Even certain members who disapproved of the design on aesthetic grounds, readily admitted that it was structurally feasible and could be built more quickly and more economically. These latter considerations were perhaps decisive, and Boffiy's plan, though actually recommended by only five of the twelve

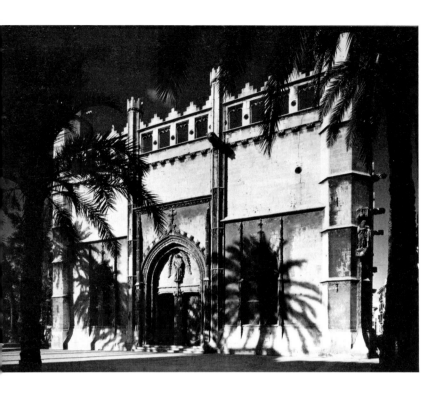

302 *Above* Northern Gothic transplanted to a sub-tropical setting. The *Lonja* or Commercial Exchange, commenced by Guillermo Sagrera in 1426. *Palma de Mallorca*

303 *Below* View of the great nave of Gerona Cathedral looking towards the older choir. Engraving from *Some Account of Gothic Architecture in Spain*, published by the Victorian Gothic Revivalist, G. E. Street, in 1865.

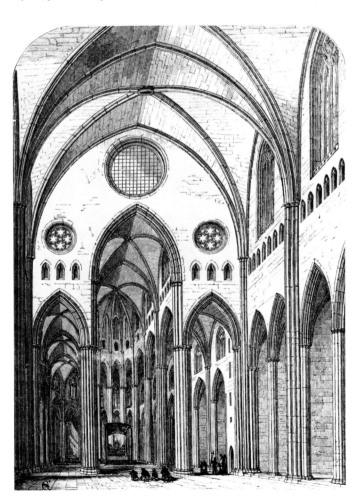

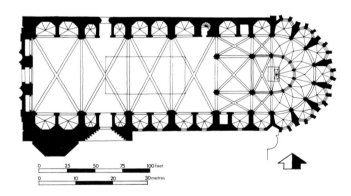

XII Plan of Gerona Cathedral

members of the *junta*, was adopted. The effect of the single vast volume is extremely dramatic, particularly in the view towards the east, with the choir seen, as it were, in a cutaway section. Surmounted by a vast cliff of walling pierced by three rose windows and triforium openings to reach the height of the nave, the choir arcades provide the necessary point of reference to appreciate the gigantic scale of the addition. The construction of the nave proceeded slowly and only towards the end of the sixteenth century was the keystone of the last of the four vaulting bays placed in position, bringing to a successful conclusion this triumph of medieval engineering.

Gothic painting in Spain may conveniently be divided into four phases.[32] The first, the Linear style, flourished during the

303

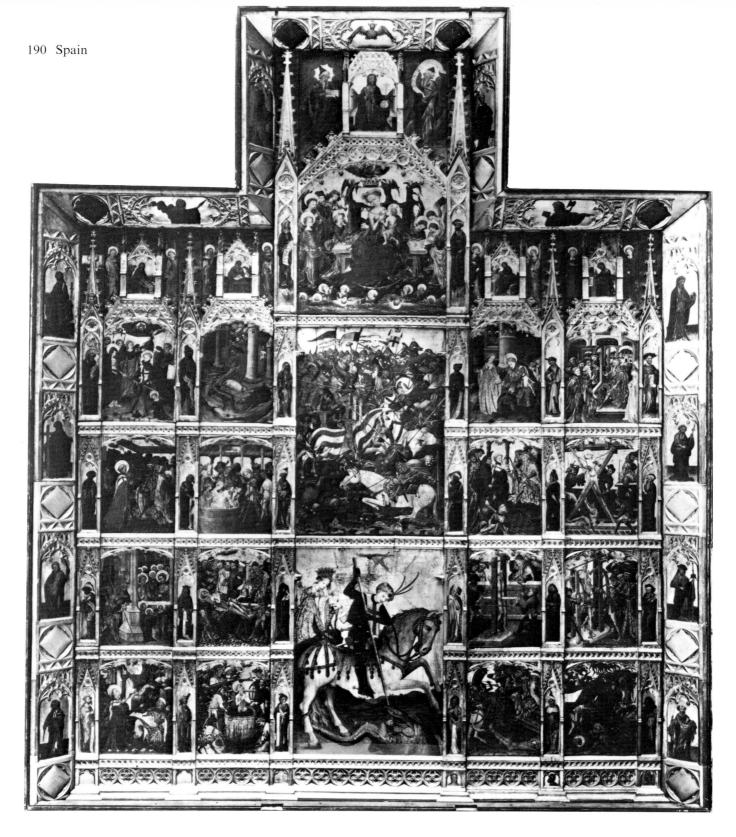

first half of the fourteenth century. Of Northern inspiration, it is essentially decorative and two-dimensional, with an emphasis on a rhythmic, calligraphic line. Typical, and probably the finest examples of the style are the murals from the refectory of the cathedral of Pamplona.

The second phase, the Italo-Gothic style, entered Spain during the second quarter of the fourteenth century through the Kingdom of Aragon with its close relations with Italy and the south of France, where the long sojourn of the Sienese master, Simone Martini at the Papal Court at Avignon exerted such an important international influence. The dominant Italian influence was therefore, not surprisingly, Sienese – to such a degree as to prompt the generalisation by one critic that 'fourteenth-century Spain was, artistically, a Sienese colony.[33]

304 *Retablo of St George* (*c.* 1400) by Marçal de Sax. *Victoria and Albert Museum, London*

As a manifestation of Italian Gothic the style falls outside the scope of our study. One feature was, however, to have such far-reaching consequences as to demand mention. The Sienese *Trecento* altarpiece with its numerous small panels within an architectural framework, in the manner of an *iconostasis*, that provided such ideal scope for the narrative bent of the Spanish artist, was the ancestor of the *retablo*, whether painted or carved, that was to become the dominant artistic element of the Spanish church interior. A superb example of the painted *retablo* in its naturalised Spanish form is the *Retablo of St George* (*San Jorge del Centenar de la Pluma*) *c.* 1400, recently 304

restored to pristine condition. Active between 1394 and 1405 in Valencia, the artist Marçal de Sax, was of German origin as his name implies. The sumptuous decorative effect and the 'languorous, faintly decadent charm',[34] so typical of the Valencian School, are particularly evident in the central panel of St George, sporting an elegant plumed chaplet, slaying the dragon in a schematic landscape setting against a gold sky. By contrast, the panel above, a singularly well-composed battle scene depicting the reconquest of Valencia from the Moors by Jaime I, as also the sixteen flanking panels with narrative scenes, and the predella with scenes from the Passion, reflect a new interest in realistic detail and a plausible environment. These interests, plus a return to the suave linear rhythms of the first phase of Spanish Gothic painting, yet without relinquishing the new-found sense of solidity, are typical of the third phase, the Spanish variant of the International Gothic style, of which Marçal de Sax was the most distinguished exponent in Valencia.[35]

The final phase was the so-called 'Hispano-Flemish' style which represented a synthesis of Spanish International Gothic and the style evolved by the great Flemish masters, together with a change in technique from tempera to oil. Although Castile traditionally had closer ties with Flanders and would ultimately prove far more receptive to the new style, it was, paradoxically, through the Kingdom of Aragon that the Hispano-Flemish style entered Spain. The first native master was Luis Dalmáu who was sent to Flanders to study the technique of tapestry-making by the King of Aragon and most probably also worked in the studio of Jan van Eyck. His *Virgin of the Councillors*, painted for the chapel of the Barcelona Ayuntamiento in 1445, reveals a close familiarity with the work of van Eyck, particularly with the *Madonna of Canon van der Paele*. Although more than merely a competent essay in the manner of the master, Dalmáu's work lacks the magic of the prototype and leaves one curiously unmoved. In striking contrast is the highly original style of Jaime Huguet (1414-92). Born in the province of Tarragona, he became the leading painter in Barcelona. In mid-career he seems to have been quite strongly influenced by Eyckian traditions, but later rejected the Flemish emphasis on depth and *chiaroscuro* – and also the new oil technique – in favour of a hieratic style in which his serene and spiritualised figures are posed in shallow space against sumptuous backgrounds. The decorative effect is further enhanced by the liberal use of gold tooling and incrustation. Typical of this last phase is his altarpiece of *St Bernardino and the Guardian Angel*.

278

The Hispano-Flemish style produced an enormous number of works, a large proportion of which have survived. Many are of great interest and charm and derive added significance from the fact that they are often still to be seen in their original setting; but few are intrinsically of the highest quality. The most interesting Castilian painter of the period was Fernando Gallego (active 1466-1507), whose austere landscape backgrounds evoke the arid plateau of Castile so faithfully, while the expressionistic distortion of the features of the protagonists – recalling that of Conrad Witz – intensifies the drama of the situation.

In the chapter-house of Barcelona Cathedral hangs a *Pietà* with the Latin inscription *'Opus Bartolomei Vermeio Cordubensis'*, and the date, 23 April 1490. It refers to Bartolomé de Cardenas, nicknamed 'Bermejo' (red) from the colour of his hair, and said to have been born in Cordova. First recorded in Aragon

305 Head of the Virgin from the *Pietà* by Bartolomé Bermejo. *Chapterhouse, Barcelona Cathedral*

between 1474 and 1477, Bermejo later worked in Valencia and then Barcelona where he collaborated with Jaime Huguet on paintings for Santa Maria del Mar. Five years after the completion of his *Pietà*, he is recorded working on designs for stained-glass for the cathedral (1495), and he probably died a few years later. Although evidently originally from Cordova, contemporary Andalusian painting could have taught him little. His primary discipline was that of Flemish painting with overtones of the Italian influences at work in Valencia and Barcelona. Where he acquired his mastery of Flemish technique is unknown, although one suggestion is that he spent a period of apprenticeship with Petrus Christus in Bruges (Van Eyck being dead), and another that he was trained in Portugal by Nuno Gonçalves.[36] The formative influences have, however, been thoroughly assimilated and transformed into a unique expression of the Spanish spirit. The *Pietà* is set in an enigmatic landscape bathed in the sombre glow of a stormy sunset that heightens the mood of foreboding, and the passionate anguish that fills the face of the Virgin, archetype of the Spanish *Mater Dolorosa*, while the flanking figures of St Jerome absorbed in his book and the humble piety of the donor, Canon Luis Desplá, with his realistic, powerfully modelled head and stubble beard, stress by contrast the supra-natural emotionalism of the Divine Drama. Bermejo's masterpiece, the *Pietà* provides both a fitting epilogue to the Gothic era and a prelude to the later developments of Spanish painting.

305

8 Portugal

It is one of the fascinating accidents of history that Portugal, with no natural barriers separating her from her neighbours to the north and east, and with a population more closely related to the Castilians than the Catalans, should have achieved and maintained her independence and developed a culture distinct from the remainder of the Peninsula.

Northern Portugal was reconquered from the Moors by the kings of Asturias and León. At the end of the eleventh century Alfonso VI of León gave the *Terra Portucalense*[1] in fief to Count Henry of Burgundy who had married his illegitimate daughter, Teresa. Their son Afonso Henriques took advantage of the dynastic squabbles that followed his grandfather's death to renounce his allegiance, and was eventually recognised as the first King of Portugal in 1143. His successors consolidated and

extended their territory. With the reconquest of the Algarve in the far south in 1249, almost two and a half centuries before the conquest of Granada, the Moors had been expelled from Portugal and the boundaries established which have remained practically unchanged to this day, so that Portugal can claim to be the oldest nation-state in continental Europe. King Dinís (1279-1325), the ablest ruler of the Burgundian dynasty, and himself a poet of distinction, heightened the national awareness by having official documents written in the Portuguese vernacular. He encouraged education, agriculture, trade and

306 West front of the abbey. On the right the Founder's Chapel, still lacking the lantern tower destroyed in the great earthquake of 1755. *Batalha Abbey*

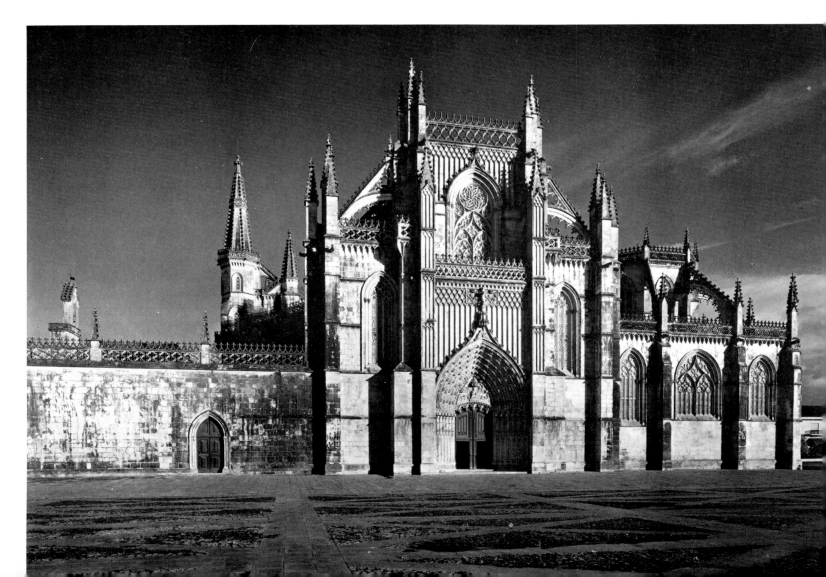

also shipbuilding, for at this period Portuguese merchant ships were already trading with France, Flanders and England.

One of the most bizarre romantic episodes in history took place near the beginning of the period we are covering. Dom Pedro, the heir to the throne, had married the Infanta Constanza of Castile. With her entourage came a beautiful young maid of honour, Doña Inès de Castro, with whom the prince fell passionately in love. After Constanza's death he made no secret of their relationship, or their offspring. Although Inès showed no signs of inordinate ambition, there was fear that her powerful relatives would take advantage of her position to further their intrigues. The king was reluctantly persuaded to consent to her removal, three nobles were assigned to the task, and during Dom Pedro's absence, Inès was stabbed to death in the lovers' retreat at Coimbra. Dom Pedro was griefstricken and on the death of his father in 1357 and his accession to the throne, his first act was to obtain the extradition from Castile of two of the assassins – the third had taken refuge in France – and have them tortured to death. Then the corpse of Inès was exhumed and brought in solemn procession to the Abbey of Alcobaça, dressed in robes of state, placed upon a throne, and the assembled grandees forced to kiss her hand and do obeisance to their 'queen'. At the king's command his tomb at Alcobaça was placed facing hers so that when he opened his eyes on the Day of Judgement, he would witness the resurrection of his beloved Inès. The tombs are among the most beautiful Gothic monuments in the Peninsula, but as yet have no specifically Portuguese character.

The reign of Pedro's son, Fernando I (1367-83), the last of the Burgundian dynasty, was again bedevilled by a romantic entanglement. Against all opposition Fernando insisted on marrying a Galician, the ambitious Leonor Telles, even though he had to break off his engagement to a Castilian princess, the insult being aggravated by the fact that Leonor was already married. A disastrous war with Castile ensued and a reconciliation was only finally effected by the betrothal of Fernando's only child, Beatriz, to Juan I of Castile. On Fernando's death in 1383, Leonor assumed the regency in the name of her daughter. Leonor's unpopularity and the pretensions of her lover, the Count of Ourem – rumoured to be the father of Beatriz – as also the unhappy prospect of Portugal's impending absorption by Castile, in fact if not in name, provoked an uprising centred around a young man in his early twenties, the Master of Avís, an illegitimate son of King Pedro by the humble mistress who had consoled him after the death of Inès. Placed in Holy Orders and made Grand Master of the Order of Avís (a Portuguese successor to the Order of Knights Templar), young João at first reluctantly accepted the role destiny had thrust upon him, assassinated the queen's lover, assumed the regency and then the throne and at the Battle of Aljubarrota in 1385 achieved a resounding victory over the vastly superior Castilian army sent to restore Beatriz to the throne.

Among the forces that Nuno Álvares, João's commander, deployed so successfully against the superior force of cavalry, was a contingent of five hundred English archers. England had become embroiled in Peninsular politics through the marriage of John of Gaunt, Duke of Lancaster, to the daughter of Pedro the Cruel of Castile, subsequently deposed by the Trastámara line represented by Juan of Castile. John of Gaunt's pretensions to the throne of Castile could best be advanced with Portuguese aid. To further their joint interests an alliance was signed between Portugal and England in 1386 and cemented by the marriage of João I of the new Avís dynasty to John of Gaunt's daughter, Philippa.

Before the Battle of Aljubarrota João had vowed to build a splendid abbey should he be victorious. Dedicated to 'Our Lady of Victory', the monastery is usually known simply as Batalha (Battle). As the symbol of national independence it is hardly surprising that the architecture of Batalha should deliberately eschew Spanish influence. The grandeur and basic simplicity of the concept recall that of the Early-Gothic abbey of Alcobaça not far distant, which provided the only precedent for a building on so monumental a scale. Afonso Domingues[2] was the first architect of Batalha, remaining in charge for almost twenty years, from c. 1386 to c. 1404. He was succeeded by a Master Huguête or Ouguête, a foreigner who may well have been an Englishman. This would have been a plausible choice in view of the fame of English masters such as Yevele at this period and the natural predilections of the English queen. Most certainly, those portions of Batalha executed under Huguête's direction between 1402 and 1438 betray considerable English influence.

Master Huguête completed the church and the vaulting of the cloister with its characteristically English continuous ridge rib; enclosed the sixty-two foot square chapter-house with one of the most audacious vaults of the period, and built the west façade so strongly influenced by the English Perpendicular style in the flat linear character of its decoration, particularly the regimented rows of blank arcading and the pierced and crested

306
307

307 Detail of the west façade by Master Huguête. *Batalha Abbey*

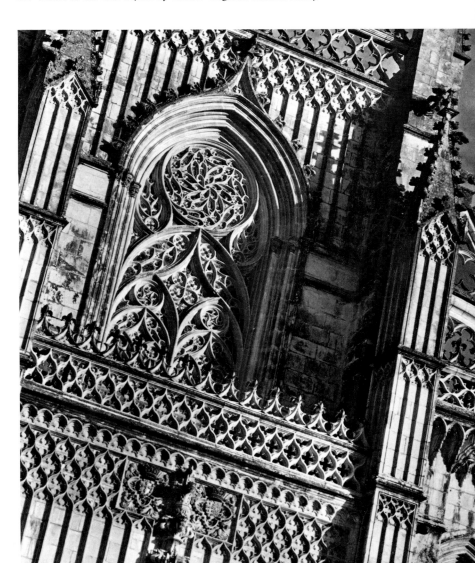

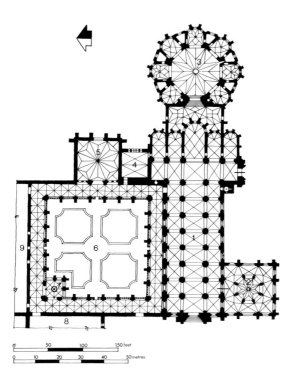

XIII *Above* Plan of Batalha Abbey:
1 Church; 2 Founder's Chapel; 3 'Unfinished Chapels'; 4 Vestry;
5 Chapter-house; 6 Royal Cloister; 7 Lavabo; 8 Refectory;
9 Granary.

308 *Below* View of the octagonal Founder's Chapel with the double tomb of King João I and Queen Philippa of Lancaster encircled by tall cusped arches. *Batalha Abbey*

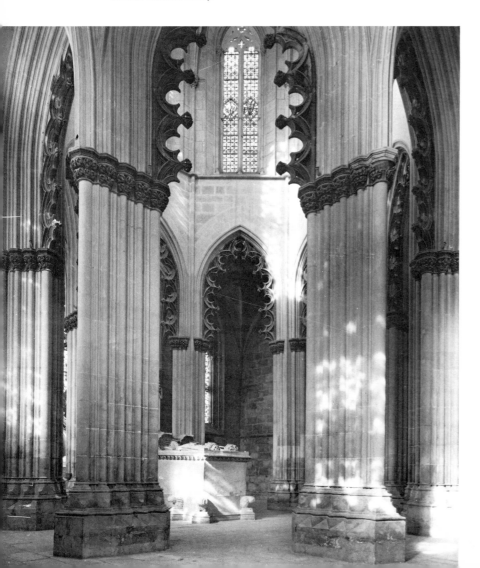

balustrade. By contrast, the swirling tracery of the rose within the high window reflects the dynamism of French Flamboyant. Huguête also added a Founder's Chapel in the form of an octagon within a square which may well have derived from the octagonal chapter-house within a square cloister at Old St Paul's in London, designed by William Ramsay.[3] Beneath a decorative star-vault stands the disproportionately bulky double tomb of King João I and Queen Philippa, depicted holding hands in a touching testimony of their love. Recesses in the external wall house the tombs of four of their remarkable sons, including Prince Henry the Navigator.

It was Prince Henry who was largely responsible for setting in train the events that, within a few decades, would transform a small kingdom on the outer fringe of the known world into Europe's first great colonial power with an empire spread over three continents.

Portugal's heroic age of expansion and exploration may be said to have commenced with the capture of the city of Ceuta in Morocco in 1415. The main impulse appears to have been a crusading spirit: to strike a blow against the Infidel and provide the young Plantagenet princes, steeped in the romance of the Arthurian legends, with a chance to show their mettle. The realisation that Ceuta had been the terminal for the Guinea gold trade, plus the fact that the practical benefits of occupation were to a large extent annulled by the Muslims diverting this trade after the loss of the city, inspired speculation as to the possibility of sailing down the west coast of Africa and tapping the gold trade at its source. Religious motives also played a leading role. The desire to make converts and spread the True Faith was linked with the hope of making contact with the legendary Christian kingdom of Prester John[4] and enlisting its aid in the struggle against Islam. In the background there was also the initially remote but tantalizing possibility of finding a sea route round Africa to India, a prospect all the more fervently to be desired with the obstacles to trade posed by the rising power of the militant Ottoman Turks in the Eastern Mediterranean.

Prince Henry was to devote his whole life to the discovery of Africa. He withdrew from the court and public life and established himself at Sagres near the tip of the lonely promontory of Cape Saint Vincent, the south-westerly extremity of Europe. Here he methodically set about acquiring the necessary information and skills to implement his ambition. He attracted Catalan, Genoese and Mallorcan mariners and cartographers, and correlated the available maps and charts, studied winds and currents and the science of navigation by the stars, improved the compass and the astrolabe and furthered the development of the caravel, a sailing ship capable of breasting the great Atlantic rollers. Chiefly at his own expense he equipped expedition after expedition that slowly rolled back the frontier of the unknown. A major triumph was the rounding of Cape Bojador, slightly south of latitude 27° in 1434 after a dozen unsuccessful attempts. With its contrary winds and currents it had constituted a major barrier – psychological as well as physical. Once contact was established with the gold-producing African states to the south of the Sahara, and the precious metal and also slaves and ivory were brought back in ever increasing numbers, the voyages for so long financially unprofitable became lucrative at last and this acted as a spur to ever more ambitious voyages. One of the truly great figures of history, Prince Henry's steadfast dedication to an ideal was worthy of the personal motto he chose as a young man: *Talent*

de Bien Faire. Sculpted in high relief in Gothic script, the thrice-repeated motto[5] forms a decorative frieze on his tomb at Batalha.

In 1488 Bartholemeu Dias rounded the Cape of Good Hope. With the way to the East open, it is no wonder that Portugal declined Columbus' proposal to seek a western route to the Indies.[6] Portugal's ultimate reward came with Vasco da Gama's return from his voyage of 1497-9 to India with spices worth sixty times the cost of the entire expedition. The following decades would see the establishment of a vast sea-borne empire. The apogee of Portuguese power and success coincided with the reign of King Manuel I, 'The Fortunate' (1495-1521), with wealth from the spice trade pouring into the coffers of *'le roi épicier'* as Manuel was maliciously nicknamed by Francis I of France.

'The Age of Discovery' found a worthy architectural expression in the Manueline style with its appropriate repertoire of decorative forms inspired by nautical and marine motifs and, for the first time in European art, exotic overtones of the art of Indian Asia.

So many of the most celebrated examples of the Manueline style have been attributed by the experts to Diogo Boytac (Boitaca or Boutaca), active *c.* 1490-1525, a Frenchman probably from the Languedoc region,[7] that he may with some justification be considered the creator of the style. An important early example of his work, dating from the reign of João II, is the church of the former Franciscan Nunnery of Jesus at Setúbal, erected between 1494 and 1498. With its twisted piers of trefoil plan which recall tropical lianas, the interior provides one of the earliest examples of the markedly

'Baroque' tendencies that would be so characteristic a feature of the Manueline style.

It was Boytac who designed the lace-like infilling of the arched openings of the Royal Cloister of Batalha. There are two basic designs. The first employs the Cross of the Order of Christ encircled with luxuriant vegetation and drooping poppy buds, seemingly so heavy with the languor of the tropics that they have to be laced together with rope. The second pattern is no less than a translation into stone of the turned wood lattice-screen of the Arab *moucharaby.* Here King Manuel's emblem, the armillary sphere – symbol of the globe-encircling Portuguese maritime empire – consorts strangely with stiff, spiky, thistle-like foliage and the 'cone-shaped vegetable form called *massaroca,* thought to represent a magnolia kernel, the surface of which is covered with beads that suggest the grains of an ear of corn'.[8]

The last major undertaking at Batalha was the construction of the so-called *Capelas Imperfeitas* or 'Unfinished Chapels', intended as a mausoleum for the House of Avís. This eastern extension to the church is in the form of a monumental corona, an octagon on twice the scale of that within the Founder's Chapel, surrounded by seven chapels – the eighth side being occupied by a portal affording access from the west – with six additional small, low chapels ingeniously inserted in the interstices between the large chapels (figure XIII). The plan, which shows strong English influence,[9] dates from the short reign of King Duarte (or Edward) 1433-8, the eldest son of João I. Progress was slow, however, and it is to Master Mateus Fernandes the Elder, who directed operations at Batalha from 1480-1515, that the major credit for the chapels as

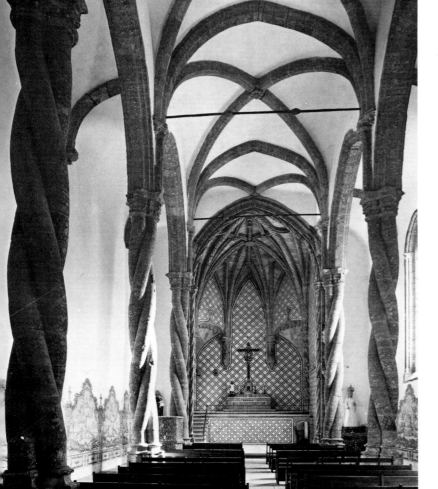

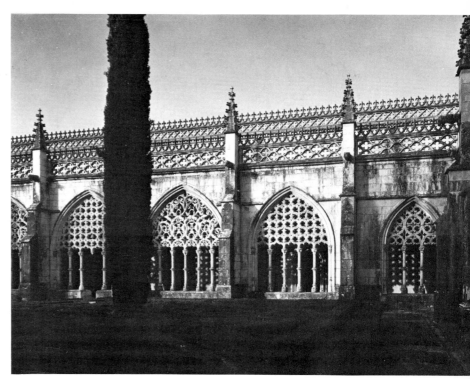

309 *Left* Interior of the church erected by Boytac in 1494–98. The combination of dark stone (here *breccia* marble from the nearby Arrábida quarries), whitewashed walls and ceramic tiles (*azulejos*) remains a constant in Portuguese architecture. *Former Convent of Jesus, Setúbal*

310 *Above* View of the Royal Cloister. *Batalha Abbey*

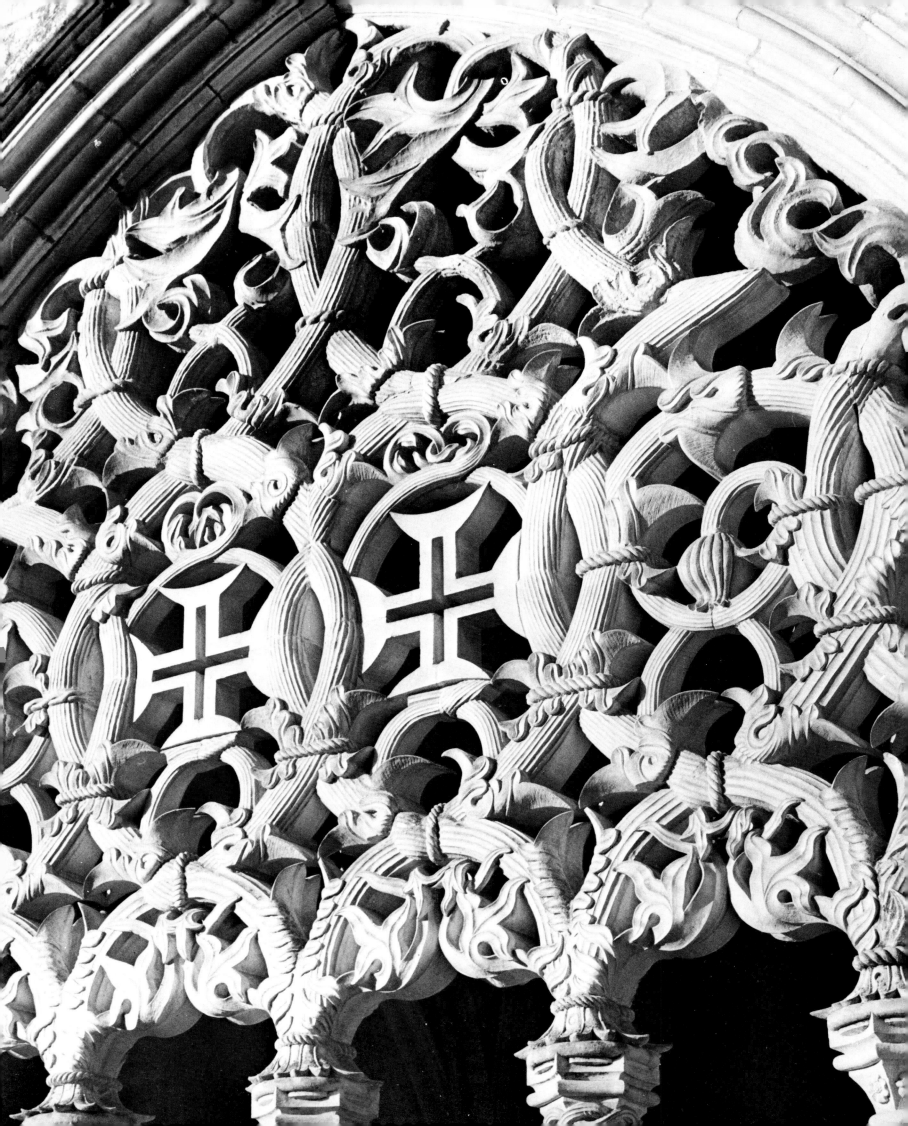

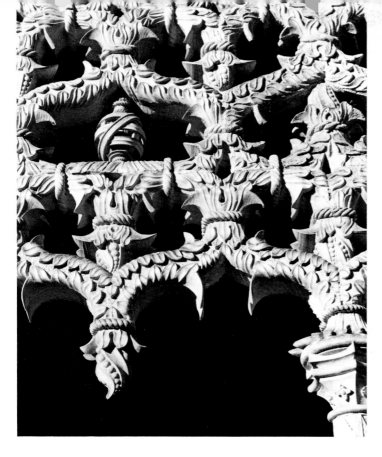

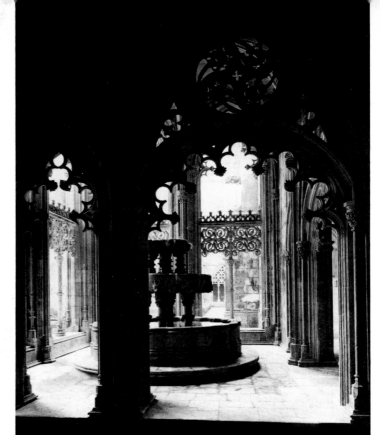

they now stand is due. He was responsible, in particular, for the design of the great portal, the supreme achievement of the Manueline style. The side of the portal facing into the octagon – 'exterior' in the sense that it is exposed to sun and rain since the vaulting of the octagon was never completed – boasts an arch of great beauty and complexity.[10] The inner face is even more impressive in scale since the opening has been splayed back at an acute angle to give an enormously deep, wide jamb. The diagonal approach with decoration of exquisite restraint, executed with the delicacy of an ivory carving, is unique. Although the ornament draws upon the current repertoire of Late-Gothic forms, including King Duarte's motto enclosed within two interlocking circles and repeated more than two hundred times, it is difficult to isolate these details. It is the overall impression that registers so indelibly on mind and memory – an impression of tropical luxuriance that has no antecedents in European architecture but evokes haunting visions of the Hindu and Jain temples of India. This oriental flavour reaches a climax in the series of arches that enclose the opening, now cinquefoil, now trefoil, and finally reversing direction and surging upward to terminate in pagoda-like curves as fantastic as the tiara of a Thai dancer. The exotic ambience is no less potent for the fact that there is not a single

314

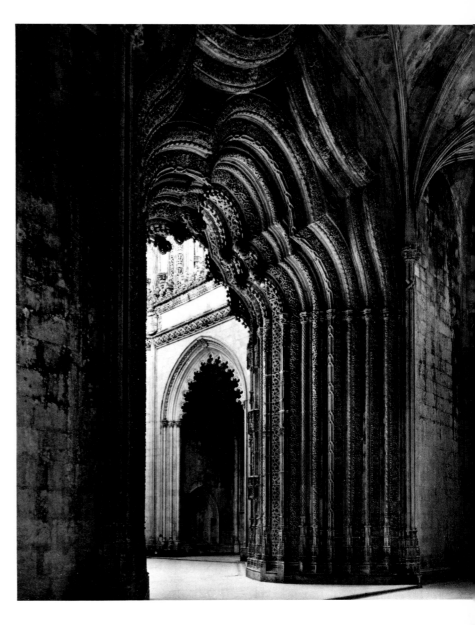

311 *Opposite* The motif of the Cross of the Order of Christ, emblazoned on the sails of the caravels of the Portuguese navigators, is here combined with tropical vegetation in the Manueline infilling of the Royal Cloister arcade. *Batalha Abbey*

312 *Above* Detail of pierced-stone infilling of the Royal Cloister arcade by Boytac. The armillary sphere was the emblem of King Manuel the Fortunate. *Batalha Abbey*

313 *Above right* The monks' lavabo in the Royal Cloister, where the sunlight filters through stone screens of filigree delicacy. *Batalha Abbey*

314 *Right* View from the vestibule of the great portal by Mateus Fernandes the Elder, giving access to the unfinished mausoleum of the House of Avis. *Batalha Abbey*

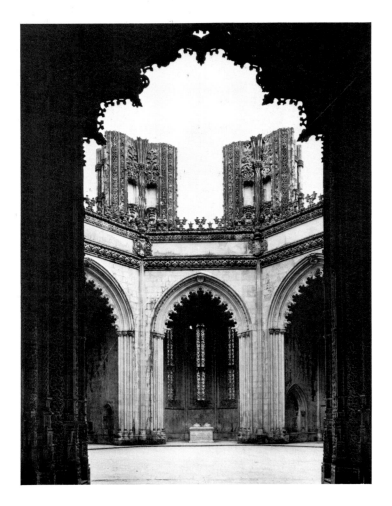

specifically Indian motif to be found here – or, indeed, in any other Manueline monument. Boytac continued the work on the *Capelas Imperfeitas* after the death of Mateus Fernandes in 1515. The piers that rise above the chapels and terminate abruptly in mid-air bear the hallmark of his robust, plastic ornament. Then the chisels fell silent. No satisfactory answer has been advanced as to why the work should have been abandoned when the end was in sight. The vaulting of the octagon remained to be built, but this was unlikely to have presented insuperable technical difficulties, since the chapter-house, with a clear span almost as great, had been successfully vaulted almost a century earlier. King Manuel died in 1521 and was succeeded by João III. It has been suggested that it was the combination of João III's enthusiasm for the new Renaissance style,[11] presumably coupled with a distaste for the Gothic, and the death of Master Boytac around 1525 that caused work to be abandoned.

To these reasons could be added a desire to concentrate available resources on the completion of the greatest building project of the Manueline era: the Hieronymite Monastery at Belém near Lisbon, known as the *Jerónimos*. This stands on the site of the little chapel of *Nossa Senhora de Belém* (Our Lady of Bethlehem) built by Prince Henry more than half a century earlier on the beach at Restelo at the mouth of the Tagus, where the navigators prayed before setting sail. Although the foundation of the Jerónimos dates from 1496 and thus antedates Vasco da Gama's epoch-making voyage of 1497, the construction of the monastery on such a scale and with such magnificence was only made possible by the wealth of the Orient flowing into King Manuel's coffers.

Since the destruction of the original tower in the great earthquake of 1755,[12] and the vast nineteenth-century additions obscuring the west front, the most important feature of the exterior is the south porch credited to Master João de Castilho. With its complex contrapuntal rhythms the centre of interest moves back and forth from the flanking buttresses to the central axis, and this lateral movement is combined in subtle interplay with a movement in depth: from the shadowy recesses of the porch forward to the front plane of the buttresses; up to the statue of the Madonna, poised dramatically over the ogee arch; falling back into the void of the window, then forward again and upward, to terminate in the crowning aedicule and the Cross of the Order of Christ. The restless Flamboyant forms of the porch are complemented to perfection by the stark wall surfaces and the serene, round-headed windows, richly ornamented with typically Manueline motifs from the vocabulary of Boytac.

On a sunny day the glare on wall and pavement is blinding. To step inside is to enter another world: with eerie reflected light playing over the vaulting and the ornament-encrusted pillars etched crystal sharp against the cavernous recess of the gloomy transept. To the redoubtable Boytac must be credited the conception of a 'hall-church' with nave and aisles of equal

315

318

321

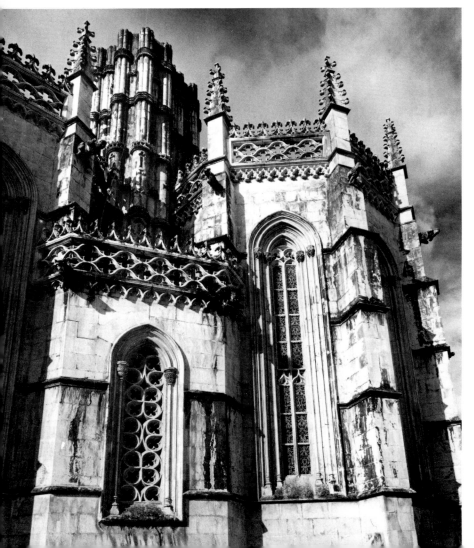

315 *Above left* View of the *Capelas Imperfeitas* or 'Unfinished Chapels' with the lavishly decorated piers, intended to receive the vaulting of the octagon, silhouetted against the sky. *Batalha Abbey*

316 *Left* Exterior treatment of the 'Unfinished Chapels'. The florid tracery of the window of one of the six small chapels (left), restored in modern times, forms a striking contrast to the *élan* of its original counterpart on the right. *Batalha Abbey*

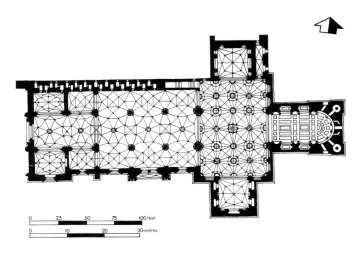

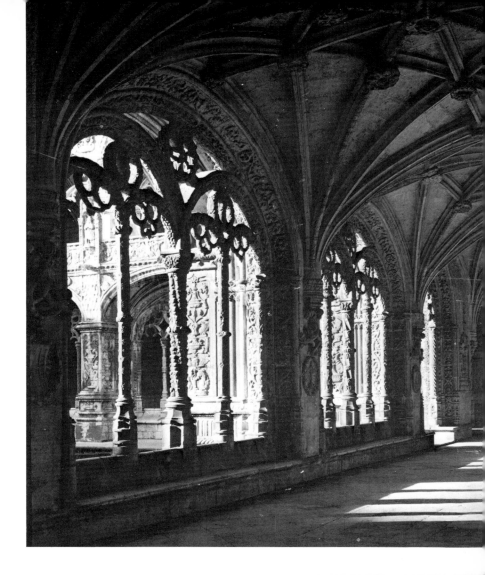

XIV *Above* Plan of the Monastery of the Jerónimos, Belém

317 *Right* Lower gallery of the cloister, attributed to Boytac. *Monastery of the Jerónimos, Belém*

318 *Below right* Monumental south portal of the church, attributed to João de Castilho. *Monastery of the Jerónimos, Belém*

width, supported on octagonal piers almost as slender as those of St Martin in Landshut (figure XIV). The transept of only slight projection is vaulted in a single bay ninety-five by sixty-two feet and over eighty feet high, conceived rather in the nature of a crossing. The original apse of minimal scale was replaced in the sixteenth century by the present chapel in classic style which functions as a royal mausoleum. Lacking in charm, its limited interest lies in the tombs, notably that of King Manuel, supported on elephants. Boytac directed the work from its inception in 1502 until 1516 when he probably left for Batalha and was succeeded by João de Castilho. It was he who actually constructed the vaults, a brilliant technical achievement underscored by the fact that they successfully withstood the Great Earthquake in 1755.

317 The double-storeyed cloister is imbued with the same poetic fantasy as the church interior. The basic concept and the construction of the lower gallery are attributed to Boytac, the completion of the upper gallery to João de Castilho under whose direction the surfaces facing the cloister-garth were embellished with Plateresque ornament by the French sculptor, Nicolas Chanterene, who was also responsible for the decoration of the piers in the church. If the application of Renaissance ornament to the buttresses cannot be adjudged a success, the design of the lower gallery in particular, with its fretted infilling of the arched openings, is an example of Manueline exoticism at its most seductive.

320 The pepper and cloves of the Indies may be said to have paid for the lavish decoration of the Jerónimos, and the first tribute of gold from East Africa, brought back by da Gama from his second voyage in 1503, was used to fashion its most splendid liturgical ornament, the Monstrance of Belém–an interesting parallel to the *custodia* of Toledo Cathedral, made from the first gold brought back from the New World by Columbus. The central feature of the monstrance is a group of the Twelve Apostles, highly individualised and exquisitely chased figures in gold and polychrome enamel, kneeling barefoot in adoration of the Host, which was displayed in a crystal cylinder. The monstrance, by one Gil Vicente,[13] was completed in 1506, and

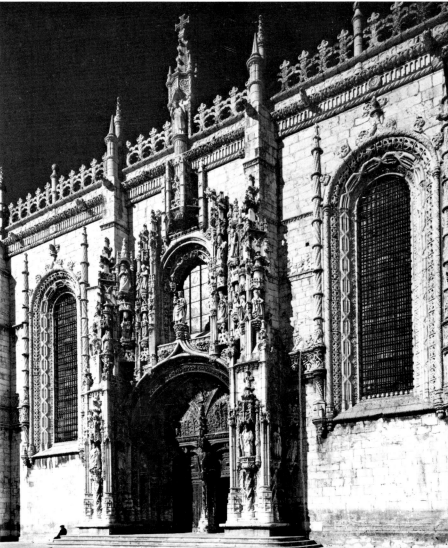

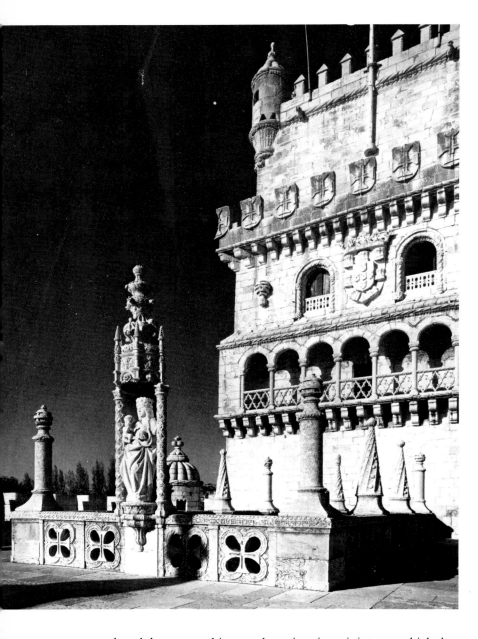

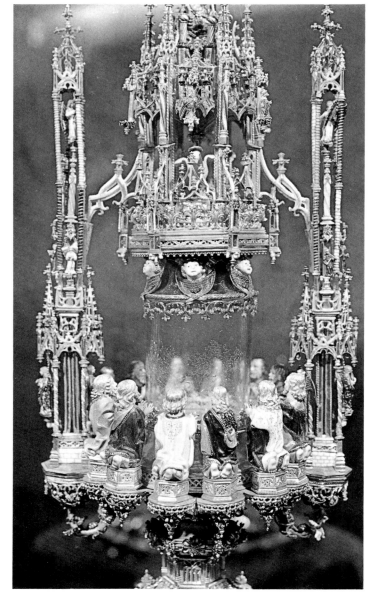

the elaborate architectural setting in miniature – which has several striking points of similarity with the composition of the south porch of the Jerónimos – is still Gothic in character, even if some of the details are of debased style or show Renaissance influence, while the unequivocally Italianate cherubs leave no doubt that a new age has dawned.

328 But a short distance from the Jerónimos the Tower of Belém, its limestone bleached to a dazzling whiteness by sun and sea air, rises like a mirage from the placid waters of the Tagus. Now connected to reclaimed land by a causeway, the tower originally stood further off-shore, at the very spot where Vasco da Gama embarked upon his historic voyages, and where the great caravels and *naos*, returning laden with the treasures of the East, cast anchor, the great Cross of the Military Order of Christ emblazoned on their sails echoed by the same motif on the heraldic shields of the crenellations of the Tower of Belém. Despite its complement of cannon, the fort should be interpreted as a ceremonial gateway on the sea approach to Lisbon, as a symbol of national exultation, expressed with a flourish of heraldic pomp. There is documentary evidence that the architect, Francisco d'Arruda, together with his brother, Diogo, who was responsible for the Manueline additions at

319 *Above left* On the lower terrace a Madonna and Child, beneath an elaborate canopy that combines florid Gothic and Renaissance motifs, looks out to the sea. *Tower of Belém*

320 *Above* Detail of the *Monstrance of Belém*, fashioned from the first tribute of gold brought back from East Africa by Vasco da Gama from his second voyage to the Indies in 1503. *Museu Nacional de Arte Antiga, Lisbon*

321 *Opposite* View of the light-suffused nave in the form of a 'hall-church', looking towards the transept. *Monastery of the Jerónimos, Belém*

Tomar, visited Safi, Azemour and Mazagan in Morocco during the years 1513-14, just prior to the construction of the Tower of Belém (1515-21). This would account for such typically Muslim architectural features as the ribbed melon cupolas of the watch-turrets, so reminiscent of the cupola crowning the minaret of the Kutubiya Mosque in Marrakesh.

A typical example of Manueline exuberance is to be found in the unlikely setting of the austere, Early-Gothic, Cistercian Abbey of Alcobaça, where the doorway to the sacristy is framed by a tropical arbour executed in stone. Naturalistic roots rise sheer from the floor plane, bearing knotty, coralline stems

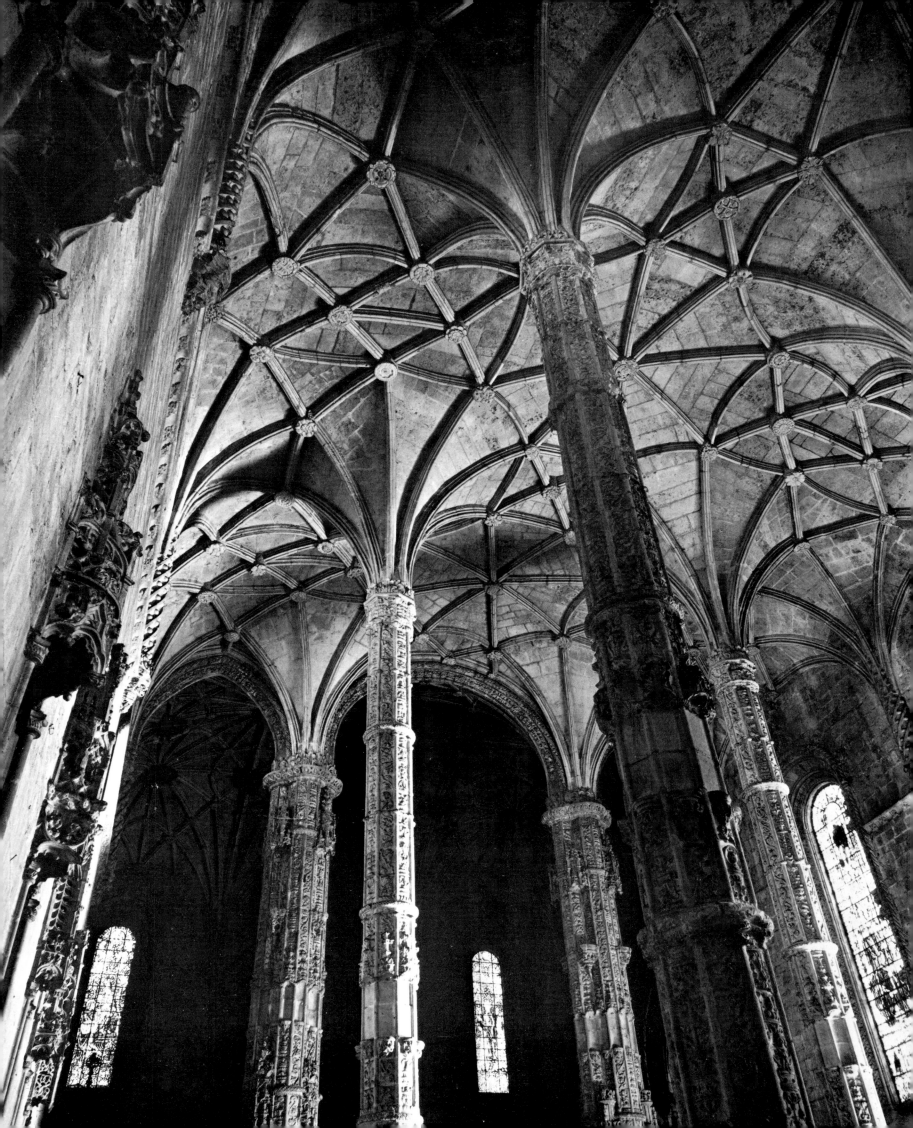

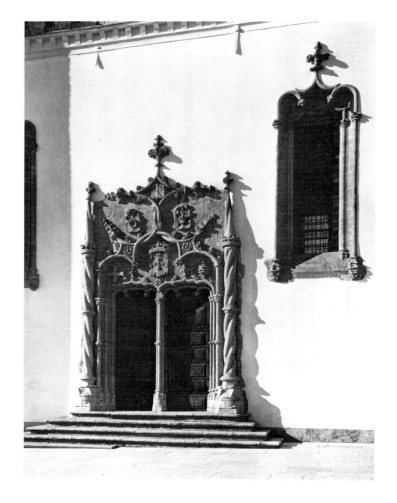

322 *Above left* Vestibule with Late-Gothic vaulting and the magnificent Manueline doorway to the sacristy. *Alcobaça Abbey*

323 *Above* Manueline portal and window. *University Chapel, Coimbra*

whose columnar rigidity and hint of a leafy capital provides just the right touch of architectural strength before fancy takes flight in the sinuous, truncated branches above, bent and roped together to form an ogee arch. With its luxuriant foliage the Alcobaça doorway provides a sap-filled equivalent of the sere and brittle branches used as a decoration in Spain, Germany and France.

On the suppression of the Knights Templar throughout Europe, King Dinís in 1319 founded the specifically Portuguese 'Order of the Knights of Christ'. Prince Henry the Navigator was Grand Master, and at his request the Pope granted to the order spiritual jurisdiction and the ecclesiastical revenues of all the regions conquered by the Portuguese. It is, therefore, singularly fitting that the headquarters of the order at Tomar should be enriched with the most spectacular and imaginative of all decorative schemes inspired by navigation and the sea.

Shortly after 1510 the twelfth-century rotunda modelled on the Holy Sepulchre was extended by a nave in the Manueline style, the architect being Diogo de Arruda, brother of the Francisco who designed the Tower of Belém. Subsequent accretions have all but obliterated the south façade,[14] and hidden the west front from general view. Only after climbing a series of spiral stairs does one emerge onto the roof terrace of the rather mean and claustrophobic little cloister of Santa Barbara to be greeted by the view of the west front. Its basic design is simplicity itself: a large rectangular window that opens into the chapter room, and a circular window above, set in blank walling, with round angle buttresses, and surmounted by a high balustrade. These elements have, however, been transformed into a phantasmagoric vision, without precedent anywhere. The focal point of the composition, the rectangular window, recalls a fabulous landing-stage from which the waters have receded, exposing barnacle-encrusted mooring poles festooned with seaweed. A plethora of knotted ropes, chains and hawsers, carved with great bravura seem to celebrate Portuguese control of the seas and the whole composition is moored in place by two string courses in the form of an enormously thick cable, below, and, above, as a realistically-carved rope threaded with cork floats – establishing the high-water mark, as it were.

But what is the significance of the rather incongruous bearded figure in contemporary dress, clumsily clinging to the roots of an oak-tree at the bottom of the window? The figure has generally been interpreted by authorities either as a portrait of the master-builder or a mariner, even the great navigator Vasco da Gama himself, in the role of a Portuguese Jason carrying the Golden Fleece on his shoulders, later converted into the roots of an oak when the King and da Gama quarrelled, and the portrait likeness of da Gama disguised by shortening the nose, resulting in the present abnormally long upper lip. The last intriguing hypothesis loses some credence from the fact that the present continuity of the vertical line between the roots and stem accords better with the total composition than the definite break between Fleece and tree-trunk would have done.[15]

The broad reveal of the circular window above is decorated with a design of curious bulbous forms interpreted by one critic as 'furled sails, coiled cables and a scattering of buoys'.[16] The motifs have been marshalled into a spiral pattern of extraordinary dynamism, that seems one moment to swirl outward with tremendous centrifugal force; then of an instant to reverse direction and suck one into a whirlpool-like vortex. The angle-buttresses are the least successful features of the west front, particularly in their present cramped location, where their echo of the form of the rotunda can no longer be appreciated. At mid-height the turgid forms are restrained on one buttress by a realistically carved chain, on the other by a gigantic buckled garter–an allusion, no doubt, to King Manuel's investiture with this English order of chivalry by Henry VII. The entire composition of the west front should be considered as an epic 324 poem in stone, dedicated to the sea and the intrepid navigators who sailed into the unknown to claim dominion, temporal and spiritual, in the name of Portugal, King Manuel and the Order of Christ, whose symbols, the national arms, Manuel's armillary sphere and the Cross of the Knights of Christ triumphantly crown balustrade and pinnacle.

In marked contrast to the rich pictorial legacy of Spain, Portugal has produced but a single painter of international stature: Nuno Gonçalves. The court painter of Afonso V, he was active between 1450 and 1472 and is known to have painted at least two monumental altarpieces, that for the cathedral of Lisbon, destroyed in the Great Earthquake of 1755 and the polyptych painted for the Convent of Saint Vincent in Lisbon, which was only rediscovered in 1882.

The reputation of Gonçalves as one of the most significant and original masters of the period rests upon this single surviving work. It is, however, truly a *magnum opus*, containing an assembly of no fewer than sixty large-scale figures on its six panels, two large and four small.[17] Historically the most 326 important is the large *Panel of the Infante*, which depicts members of the royal family in attitudes of devotion around St Vincent, patron saint of Lisbon. Kneeling before the saint is King Afonso V, with behind him his young son, the future João II, and clad in black and wearing the typical Burgundian turban-like headdress, the 'Infante', Henry the Navigator.[18] These figures are balanced by the kneeling queen and the widowed Duchess of Bragança in the habit of a 'Poor Clare'. The contrast between the serenely introspective and idealised head of the saint and the series of almost stringently objective portrait heads in the background could hardly be more telling. It has been suggested that the youthful figure of the saint is probably an idealised portrait of Prince Fernando, 'The Martyr of Fez', youngest son of João I, who died in captivity in Morocco.[19] The other large panel has an almost identical figure of Saint Vincent, this time together with kneeling princes and the Archbishop of Lisbon and his canons. The smaller panels depict Cistercian monks from the Abbey of Alcobaça, fishermen and sailors, nobles and knights, one representing the Moorish community, and a group of religious with relics, which

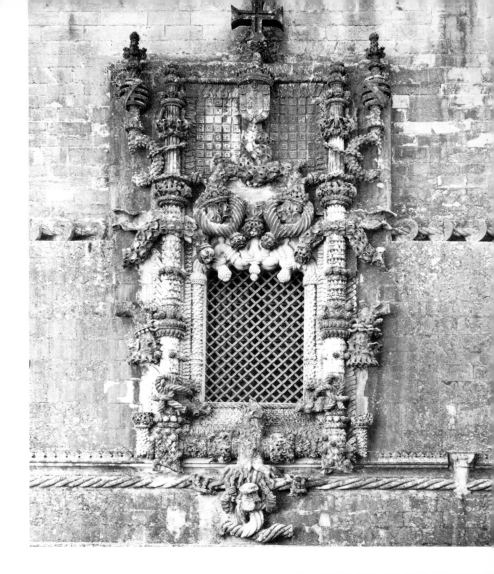

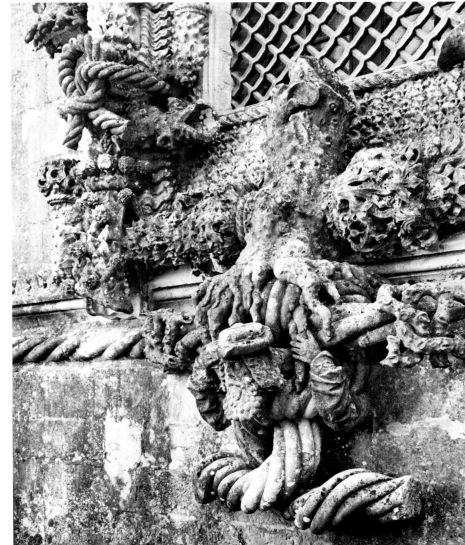

324 *Above right* Manueline great west window: an epic poem in stone in praise of the sea and the Portuguese navigators. *Monastery of the Order of Christ, Tomar*

325 *Right* Detail of the enigmatic bearded figure in contemporary dress at the base of the great west window. *Monastery of the Order of Christ, Tomar*

includes a portrait of the Grand Rabbi of Lisbon, holding the *torah*, as representative of the important Sephardic Jewish community. The altarpiece thus depicts a whole spectrum of Portuguese society, conveyed – and this is the unique feature of the work – not by way of stereotypes, but in the form of sixty highly individualised portraits.

Portuguese painting prior to Gonçalves provides scant explanation for the formation of his style. Rather must we look to Flanders. Jan van Eyck, as we recall, was sent to Portugal in 1428 by Philip the Good of Burgundy to paint the portrait of his prospective bride, the Infanta Isabella, daughter of João I. It is possible that Gonçalves met van Eyck at this time or even that he accompanied the retinue of the Infanta to Flanders and there acquired his knowledge of Flemish technique. However, if the

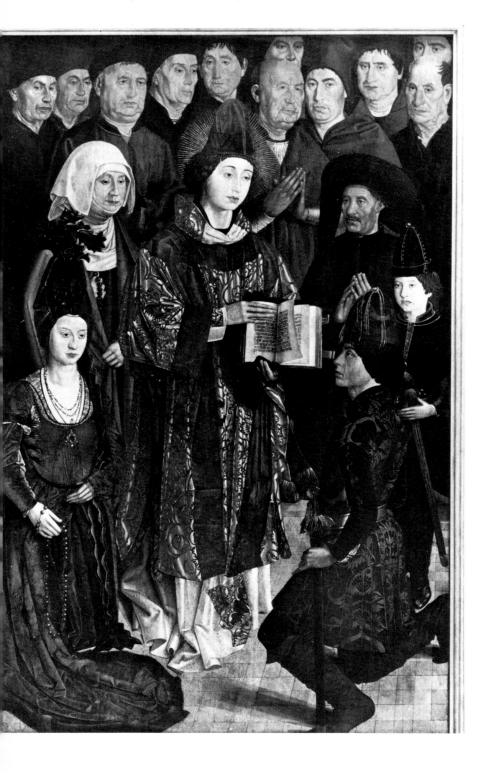

Gonçalves polyptych indicates a thorough familiarity with Flemish painting, it also demonstrates a remarkable independence of spirit in interpreting that tradition. The composition, with its deliberate rejection of aerial perspective, is related rather to contemporary tapestry design in its flat and decorative effect with a reliance on overlapping planes to locate the figures in depth. In this regard it is particularly interesting that the artist's name is linked with a superb set of tapestries celebrating two heroic exploits of Afonso V: the conquest of Tangier and Arzila.[20] Woven in Tournai around 1471, the tapestries may well have been executed according to cartoons prepared by Gonçalves himself; at very least by an artist strongly under his influence. To return to the Lisbon polyptych, the sole indication of perspective is in the pattern of the floor tiles, and this is effectively cancelled out by the scale of the people in the back row, larger, if anything, than those in the foreground. Typical of Gonçalves is the avoidance of the elaborate architectural or landscape settings of Flemish painting, the suppression of all extraneous detail, and the simplification of drapery and the structure of the heads into broad planes that recall contemporary wood sculpture in relief. This formal

326 *Left* The *Panel of the Infante* from the *St Vincent Polyptych* (c. 1467–70) by Nuno Gonçalves, whose presumed self-portrait appears in the top left-hand corner. The panel is named for Prince Henry the Navigator, on the right, clad entirely in black. *Museu Nacional de Arte Antiga, Lisbon*

327 *Above* Detail of the head of the Marquis of Montemór, from the *St Vincent Polyptych* by Nuno Gonçalves. *Museu Nacional de Arte Antiga, Lisbon*

stylisation is combined with the most acute psychological insight as a portraitist. Consider, for example, the head of the Marquis of Montemór from the *Panel of the Knights*. An intrepid warrior who took a leading role in Afonso V's African campaigns, and who is depicted at the head of the Portuguese cavalry entering the gates of Tangier in the Pastrana tapestries, he was later, during the reign of João II, convicted of treason together with his brother, the Duke of Bragança. The duke was executed and the marquis fled to Spain. How well the impetuous expression of the portrait tallies with his description in the *Historia Genealogica* as 'proud, haughty and rash'. And as the eye moves from one head to another, each portrait in the polyptych seems to offer the same assurance that not only the likeness, but the essential personality of an individual has been captured by the artist. It has been suggested that the painting was conceived in the nature of an *ex voto*, in gratitude for his African victories by Afonso V, who 'surrounded by the entire community consecrates the conquests which to him represent a realization of his ideal of chivalry'.[21] Whatever the precise intent, it provides the pretext for a unique group-portrait of the Portuguese people, poised on the threshold of the modern world.

327

328 The Tower of Belém, erected on the spot where Vasco da Gama embarked upon his historic voyages.

Epilogue

Where the Reformation took root, artists fell on lean times. Holbein departed from Basle in 1526 armed with letters of introduction from Erasmus that leave no doubt of the artist's predicament under the new order: 'Here the arts are shivering with cold; he is going to England to pick up a few coins'.[1] Sculptors were even worse off. There are complaints by the guild of cabinet-makers that the erstwhile *imagiers*, now unemployed, had encroached on their preserve and resorted to making furniture. And there is the pathetic case of the aged Veit Stoss, whose masterpieces adorned every church in Nuremberg, being forbidden by a decree of the city council in 1532 from setting up a stall to sell his sculpture in the market-place in front of the Frauenkirche in Protestant Nuremberg. At least, unlike artists in Holland and England, he was spared the anguish of seeing his life's work hacked to pieces or burnt to ashes.

In 1517, when the newly rebuilt gatehouse giving access to the close of Canterbury Cathedral from the Buttermarket was emblazoned with the arms of Henry VIII and Katherine of Aragon, Henry still deserved the Pope's encomium: 'Defender of the Faith'. Twenty years later Thomas à Becket, 'the blissful martyr' had been branded a 'traitor and rebel', and his shrine, the most celebrated place of pilgrimage in England, had been desecrated and totally demolished, so that today only the worn paving slabs indicate its past existence. The ensuing dissolution of the monasteries precipitated the wholesale destruction of one of the finest facets of England's cultural heritage. 'The valuable lead, stripped from the roofs of the great churches, was melted . . . over fires built in the monastic choirs from the stallwork . . . and mines, hitherto employed for the destruction of hostile fortifications, were sunk beneath the pillars supporting soaring towers which had for centuries been the glory of the English countryside, and the resulting heap of stones used as a quarry to build hovels in the surrounding district'.[2] In the parish churches the visual arts bore the brunt of the Reformers' iconoclastic wrath. Portable painting and sculpture disappeared, murals were plastered over and the architectural sculpture defaced. There must have been many such entries as that from the list of expenditures at Eton College for the year 1560: 'To Glover and his Laborer for two daies brekinge downe Images and filling their places with stone and plaister . . .'

In France the Wars of Religion that took such a toll of lives witnessed relatively minor damage to the medieval heritage, far less than from the transformations into the Baroque *'grand goût'* so beloved by the leading clergy of the eighteenth century – that 'Age of Reason' that would end with an orgy of wanton destruction in the French Revolution.

329 View of the apsidal chapels erected between 1518 and 1545 by Hector Sohier. *St Pierre, Caen*

It was in France, under that great patron of the arts, Francis I, that we first witness the radical change in the status of the artist that had long before taken place in Italy. In the same year in which Leonardo da Vinci died, an honoured guest of the French King at the Chateau d'Amboise, Peter Vischer the Elder, lauded by the Emperor Maximilian as 'the most skilled and famous copper-smith in Nuremberg', who designed as well as cast monumental sculpture,[3] completed the elaborate metal Shrine of St Sebaldus, and depicted himself among the now-fashionable classical detail, not in the Renaissance mould of the artist-humanist-gentleman, but still as an unassuming artisan

333

with leather apron, impatient to get down to work with his hammer and chisel.

A quarter of a century later the rebuilding of the Louvre Palace was in progress under the architect Pierre Lescot in an original yet thoroughly convincing Gallic variant of the Italian-Renaissance style. This could hardly be said for England and Germany, where travesties of classical principles and proportions were perpetrated. The informal charm and eminently livable character of the Elizabethan and Jacobean manor house can hardly blind us to the inescapable fact that only with Inigo Jones (1573-1652) did England once again produce an architect of international stature. German and Austrian architecture only truly came into its own again with its inimitable variants of Baroque and Rococo, which again

the place of pinnacles, for example. The same is true internally: the elaborate pendent vaults of the chapels create the overall impression of a festooned, Manueline-style grotto, but close inspection reveals pure Renaissance detail, complete to the most delicate bas-reliefs of cherubs amid wisps of cloud on the surface of the severies. 331

Even as this fascinating hybrid was being completed, Pierre Lescot, as we have noted, demonstrated a complete assimilation of the new style in his design for the rebuilding of the Louvre. In provincial backwaters, however, the Gothic style persisted for centuries, especially for churches. In 1694 the Collegiate Church of St Mary at Warwick was badly damaged 332 by fire. The Beauchamp Chapel was mercifully spared, but the portal giving access to it was ruined, and in 1704 'designed,

330 View of the grotto-like apsidal chapel. Note the transition from Flamboyant to Classical detail at cill level. *St Pierre, Caen*

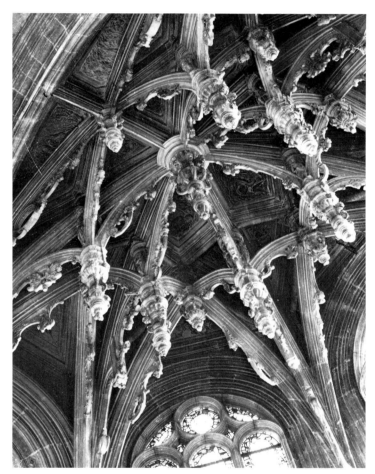

331 Detail of the vaulting of an apsidal chapel, pure Gothic in concept, pure Renaissance in detail. *St Pierre, Caen*

manifest the Gothic preoccupation with an all-embracing, totally-integrated flow of space; while the so-called 'Baroque' phase of Late-Gothic German sculpture sometimes lingered so long as to pass almost directly into the equally congenial true Baroque, without any intervening Renaissance classicism.

329-31 The choir and apsidal chapels of St Pierre at Caen, erected by Hector Sohier between 1518 and 1545, afford a classic example of a transitional phase in which Renaissance ornament was grafted onto a Gothic structure. The repertoire of elements, complete to flying buttresses, is still Gothic, but their rich ornamentation is pure Renaissance, sconce-like forms taking

built, carved and finished' by Samuel Dunkley, 'a poor mason' and the minister of the local Baptist chapel. The architectural detail clearly demonstrates a sympathetic allegiance to the old traditions, rather than a self-conscious attempt to resuscitate a dead style.[4]

For a fitting farewell we will journey to Ingolstadt in Bavaria where, in a series of chapels in the Frauenkirche, we may witness the ultimate phase of *Spätgotik* vaulting. The lozenge and star patterns have been superseded by a network of interlacing curves on the actual vault, below which is suspended a series of flying ribs, tracing out a completely different – though

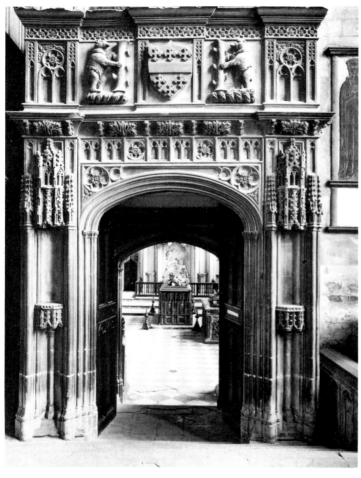

subtly interrelated – pattern of curves, through which one glimpses the upper vault. The flying ribs are in the form of gnarled stems with the branches lopped off, a popular conceit with the Late-Gothic designer, but not a single rib, either freestanding or attached, performs a functional purpose. The vaulting rib which, together with the pointed arch, had been the two major structural determinants in the evolution of the Gothic style, is reduced to the status of a decorative accessory.[5] After four centuries of heroic endeavour and achievement, the Gothic style had finally run its course.

334

332 *Left* Portal leading into the Beauchamp Chapel, rebuilt in the early years of the eighteenth century in provincial Gothic. The monumental brasses mounted on the wall are of Thomas Beauchamp (†1401), who built the chancel, and his countess. *Collegiate Church of St Mary, Warwick*

333 *Bottom left* Self-portrait of Peter Vischer the Elder, from his Shrine of St Sebaldus, the medieval artist who depicts himself as a craftsman alongside classical detail. *St Sebaldus, Nuremberg*

334 *Opposite* Detail of vaulting of a chapel (*c.* 1520) by Erhard Heydenreich, in which the lower series of flying ribs react in polyphonic fashion with the curvilinear – but also purely decorative – ribs of the vaulting surface above. *Frauenkirche, Ingolstadt*

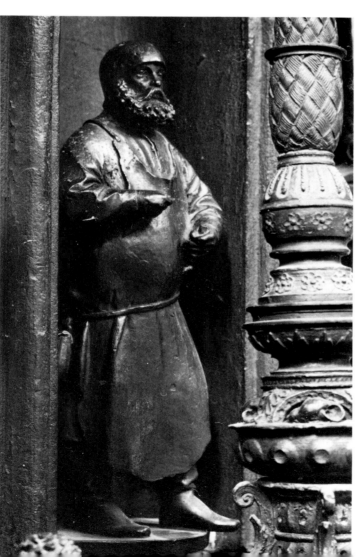

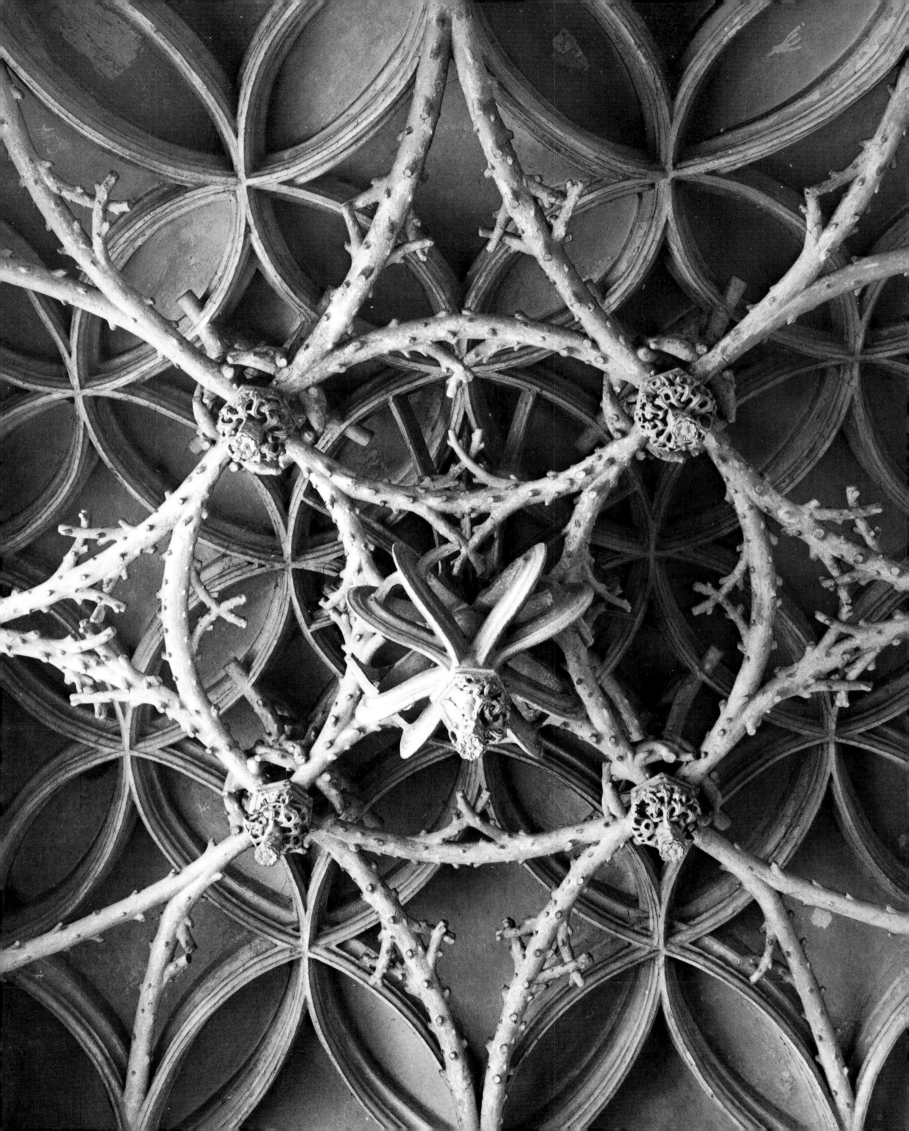

Notes

Chapter 1 The Tenor of the Age

1 According to recent studies by Russian scientists, probably near Lake Issyk-Kul in Kirgizskaya, one of the zones where bubonic plague is endemic.

2 See Philip Ziegler's enthralling study, *The Black Death*, London 1969, at once popular and scholarly, and containing a comprehensive list of references.

3 Of doubtful etymology, its first occurrence is as a proper name in a poem by Jean le Févre dated 1376: *'Je fis de Macabré la dance'*. The Hebrew word for grave-digger, *meqaber*, may also have something to do with it.

4 Erwin Panofsky has suggested that such 'double-decker tombs', as he dubbed them, were also intended 'to contrast the idea that the individual is subject to death and decay with the idea that his "dignity", be it that of a nobleman, a prince of the church, or a secular ruler, enjoys a permanence which has nothing to do with the immortality of his soul but attaches to his social or institutional status *per se*.' Erwin Panofsky, *Tomb Sculpture*, New York 1964.

5 J. Thorold Rogers, *A History of Agriculture and Prices in England*, Volume 1, Oxford 1866.

6 Denys Hay, *Europe in the Fourteenth and Fifteenth Centuries*, London 1966.

7 *Idem*.

8 Quoted by George Coulton in *Medieval Panorama*, Cambridge 1938.

9 Johan Huizinga, *The Waning of the Middle Ages*, London 1924.

10 The generic name for tapestries throughout Europe was *'arras'* from the town of that name in Artois, which was part of the Burgundian Netherlands in our period.

11 W. H. Stevenson, *Records of the Borough of Nottingham*, Nottingham 1882-1914.

12 Dr W. Hildburgh believed that the wound might have been added during its stay in Spain, and several authorities have doubted the English provenance of the sculpture itself. But see Lawrence Stone, *Sculpture in Britain: The Middle Ages*, Harmondsworth 1955: 'There is no good reason to doubt the English provenance of this alabaster, outstanding though it is from the general ruck. There is no evidence that other countries made such alabaster heads, and the position and angle of the wound, and the very distinctive artificial arrangement of the hair are just the same as those of heads of accepted English provenance.'

13 Lewis Mumford, *The Culture of Cities*, London 1938.

14 The guilds had already far earlier played an important role in the building of the great Gothic cathedrals, donating stained glass windows, for example, that included vignettes depicting the particular craft, placed in the best possible locations; but this was still in the service of the Church—a rather different proposition to building a guild-hall dedicated to the guild's exclusive use.

15 Lionel Vibert, *Freemasonry before the Existence of Grand Lodges*, London 1932, comments: 'Exactly what *free* meant has been much discussed. That the original meaning was a mason who worked in freestone is one explanation, but it is not without philological difficulty. Another interpretation is that the *free* mason was the workman out of his indentures, and so free of his guild or his borough. Another is that he was independent of his guild; free from it and its restrictions; free, for instance, to travel and work where he liked; or he may even have been free from certain restrictions of the borough, by reason of his having to work outside of the city as well as in it.' The generally accepted interpretation is that it refers to a worker in 'freestone', the name given to a fine-grained sandstone or limestone that can be freely worked in any direction and hence is capable of undercutting and particularly suitable for carving.

16 Johan Huizinga, *The Waning of the Middle Ages*, London 1924.

17 'From the point of view of the modern non-metaphysical man of science Ockham represents perfection of common sense . . . On nearly every purely logical or psychological question Ockham gives an answer which, right or wrong, might still be maintained in almost the same terms by a modern philosopher.' Hastings Rashdall, *The Universities of Europe in the Middle Ages*, Oxford 1936.

18 A classic example of this dichotomy of religious and philosophical truth occurred when one of Wyclif's disciples defended his master's criticism of the doctrine of Transubstantiation to the assembled masters of Oxford. When he argued that there was no idolatry to be compared with the worship of the consecrated Host, the Chancellor merely commented: 'Now you are speaking like a philosopher', and took the matter no further. Quoted by George Coulton, *Medieval Panorama*, Cambridge 1938.

19 When the Count of Provence founded the University of Aix-en-Provence in 1409, for example, he levied a tax on nationals studying abroad.

20 Johan Huizinga, *loc. cit*.

Chapter 2 England

1 See John Harvey, 'The Origin of the Perpendicular Style', in *Studies in Building History*, in honour of B. H. St J. O'Neil, edited by E. M. Jope, London 1961.

2 John Harvey stresses that the alternatively proposed name of 'Rectilinear style', if less evocative than the Perpendicular, could nevertheless be considered more accurate.

3 Henri Focillon, *The Art of the West in the Middle Ages*, London 1938; a translation of the French original, *Art d'Occident*, Paris 1938.

4 Where there are a large number of ribs, as in the chapter-house of Wells Cathedral (see the author's *The Gothic Cathedral*, London 1969), these assume virtually the same curvature and would, indeed, all be identical if the ridge rib, instead of following the octagonal outline of the walls, had described a circle, a form known to have existed in the demolished chapter-house of Hereford Cathedral, dating from 1360-70 and featured in the drawings and descriptions of the antiquary Stukeley. The Hereford example may well have been the first true fan vault.

5 Already commenced in 1292, this double-tiered structure with its crypt-like undercroft and lofty upper chapel, most lavishly painted and decorated, was clearly inspired by St Louis' Saint-Chapelle in Paris. The upper chapel, considerably altered by Sir Christopher Wren, served as the Chamber of the House of Commons from the sixteenth century until its destruction by fire in 1834.

6 Critical opinion varies greatly on the extent of French influence in the formation of the Perpendicular style. Geoffrey Webb, who attaches great importance to the rectangular panel system, the use of square labels over openings and the fondness for geometric forms displayed by the London 'Court School', considers these features examples of 'the importation and assimilation of foreign motifs'. With this emphasis St Stephen's Chapel achieves additional significance and supersedes Ramsey's work at St Paul's in importance. To John Harvey, on the other hand, the idiosyncratic treatment of tracery, in which the vertical members are carried up to cut the curve of the arch without deflection, is the *sine qua non* of the new style, and he finds that St Stephen's Chapel 'although it formed part of the movement which led to the establishment of Perpendicular as a ruling style, did not itself have a specifically Perpendicular character'. *Loc. cit* and Geoffrey Webb, *Architecture in Britain: The Middle Ages*, Harmondsworth 1956.

7 See John Harvey's definitive *English Medieval Architects: A Biographical Dictionary down to 1550*, London 1954, which has assembled all the documentary evidence, together with a complete list of sources.

8 Nicholas Broker and Godfrey Prest, 'Citeins & Copersmythes de Loundres'. The price for the effigies was £400, a considerable proportion of which must, however, have been spent on the costly copper alloy and gilding. The casting was apparently completed by 1 March 1396, when the King rewarded the workmen with a drink.

9 Work on the tomb commenced in 1374 and was due to be completed in 1378. In this instance, probably before Yevele's association with Stephen Lote, he collaborated with one Thomas Wrek, 'mason contractor of London'.

10 G. H. Cooke, *Mediaeval Chantries and Chantry Chapels*, London 1947.

11 Smithson Collection, Royal Institute of British Architects, London.

12 The most important services would be held on the anniversary of the death of the deceased, when we must envisage the chapel further enriched by heraldic banners such as hang permanently over the stalls at St George's Chapel, Windsor. A donation of eighteen banners for this specific purpose is recorded among the offerings at the formal interment services of the Earl of Warwick: '*Item:* XVIII nyewe baners of diverse lordes armes made of tartaryn alle of one sise. . . . kept to hang about my seide late lordes tumbe every year at his obite day.'

13 For details of the contracts, see Lawrence Stone, *Sculpture in Britain: The Middle Ages*, Harmondsworth 1955, and John Harvey, *Gothic England*, London 1947.

14 Reginald Pecock, Bishop of Chichester († *c.* 1460), *Repressor of Over-much Blaming of the Clergy*, Rolls S, Vol. II.

15 Two examples of the same principle on a truly monumental scale are the cathedrals of Gerona (p. 189) and Palma de Mallorca.

16 Cf. the discussion of the hidden meaning of Jan van Eyck's portrait *Giovanni Arnolfini and his Wife*, p. 113.

17 This is the generally accepted theory. The official guide to the church maintains that the porch was erected to provide a meeting place outside the precincts of the adjoining Cirencester Abbey for the conduct of its secular business with the Royal Commissioners. Canon Rowland E. Hill, *Parish Church of St John Baptist, Cirencester*, Norwich 1971.

18 For example, the eighth-century Cross at Ahenny in County Clare.

19 For a striking contrast, see the more sculptural stalls at Amiens Cathedral (p. 83-4).

20 It has recently been suggested that this was because otherwise holy images would be in contact with the clergy's posteriors. See Kraus, *The Hidden World of Misericords*, London 1976.

21 Witness the large number of pre-Reformation lecterns with the pelican motif that have survived in England and the Netherlands. See also Emile Mâle's definitive work on medieval iconography, *The Gothic Image*, London 1961; a translation of his *L'Art religieux du XIIIe siècle en France*, Paris 1902. The pelican was supposed to revive her young by sprinkling them with blood from her own breast: hence a symbol both of the Redemption of Man and the Resurrection.

22 The narrow aisles were usually roofed with main rafters defining each bay of the arcade, supporting purlins, which in turn supported common rafters on which boarding and the lead roofing finish were laid to a very slight inclination. The wider span of the nave could be handled in various ways. A popular method, employed continuously from Norman times to the very end of the Gothic period, was the 'tie-beam' roof (fig. I). This consisted of inclined rafters pitched one against the other, with the outward thrust countered by horizontal tie-beams of cambered form, i.e. sloping up slightly towards the centre to counter the natural tendency of a beam to sag (p. 48). A central post and intermediate struts were sometimes added, together with a decorative infilling, and curved braces used to connect the tie-beam to vertical wall-pieces below. The medieval carpenter was, however, unaware of the principle of the truss and allowed the various components to act independently, rather than as parts of a co-ordinated system. Thus the rafters and the tie-beam were not structurally connected, and the central post was allowed to *rest* on the tie-beam, rather than being suspended from the apex of the rafters to *support* the tie-beam at its centre, as in the case of a modern 'king-post' truss. Massive timbers compensated for this and ensured stability, but the span was severely limited. The desire to gain greater clear height internally, unobstructed by the tie-beam, led to the development of the 'trussed-rafter' roof in which the tie was raised two-thirds or more towards the ridge of the roof and now functioned as a collar stiffened by braces attached to the rafters (fig. II). At the base of the roof the rafters rested on the outer portion of the wall, restrained from slipping off by the wall-plate, and the construction was strengthened by bracing the rafter with a vertical member, flush with the inner face of the wall. The trussed roof with its closely-spaced, identical members was not particularly attractive, and was often concealed by canted boarding, following the line of collar, braces and rafters to create a pentagonal ceiling or, if one includes the vertical braces at the base, a seven-sided, boarded form known as a 'barrel' or, more aptly, as a 'waggon' roof. The facetted form of the trussed-rafter roof could be approximated by a continuous arch running from the collar above to the wall below, and even extending a distance down over the wall surface in the form of a wall-piece. Spaced one to a bay, and supporting the roof on a system of purlins, the 'collar-braced' roof is strong, sculptural and eminently satisfying. A variation is the 'arch-braced' roof, in which the collar is omitted and the arched braces carried up to meet each other just below the ridge.

23 The principle of the hammer-beam was known in France at an early date. An illustration in Villard de Honnecourt's celebrated sketchbook of *c.* 1240 shows a truss with the vertical struts supported on a hammer beam extended as a simple cantilever, without the additional support of an arched brace below—or above, for that matter. The accompanying caption recommends it as 'a good, light roof for use above a stone vault', i.e. as a purely practical device when it could be concealed. Even so, the form never seems to have been used extensively in France, and the English must, in any case, take full credit for developing the hammer-beam roof into a work of art of the first order.

24 Ely's Norman central tower collapsed in 1322 and was replaced by an octagon embracing the width of nave and aisles combined, surmounted by a lantern open to the interior. This was constructed using eight oak angle-posts, each no less than 63 feet long and 3 feet square. These enormous single timbers form the hammer-posts of eight modified hammer-beam roof trusses which transmit the load to the piers of the octagon. A unique and brilliant spatial conception which anticipated the centralised plans of the Renaissance and

Baroque, the Ely octagon, for all its beauty, cannot be said to have contributed to a distinctive timber aesthetic, with its structure clothed in decorative forms derived from stone construction, complete to applied stencil patterns of sham tracery. For a detailed description and illustrations of both the interior and exterior of the Ely octagon, completed by 1346 and, therefore, falling just outside the scope of our present study, see the author's *The Gothic Cathedral*, London 1969.

25 William and Hugh Herland are credited by John Harvey with a major role in the evolution of the classic form of the English choir-stall canopy, of which the finest example is that at Chester Cathedral. See John Harvey, *Gothic England*, London 1947.

26 See John Harvey, *English Medieval Architects: A Biographical Dictionary down to 1550*, London 1954.

27 The entire complex at Salisbury, including the cloister and chapter-house and excepting only the later central tower and spire, was built between 1220 and 1266 at a cost of 42,000 marks or £28,000; but we also have to take into account the rise in wages from a maximum of 4d a day for a skilled workman in the thirteenth century to an average of 6d a day for the period 1350-1500, after the shortage of labour occasioned by the Black Death.

28 Unfortunately the original reredos was badly battered during the Reformation and the mutilated fragments later plastered over, while the original hammer-beam roof was wantonly destroyed by Wyatt and replaced by a plaster ceiling. The present open roof, like the reredos, are exuberant specimens of Victoriana, dating from Sir Gilbert Scott's restoration during the 1870s and 80s. Though the additional height of Scott's hammer-beam roof is impressive internally, it involved raising the ridge of the roof, thereby compromising the external unity of chapel and hall which was such a fundamental principle of the original design concept.

29 See John Harvey, *English Medieval Architects: A Biographical Dictionary down to 1550*, London 1954.

30 The building had already been commenced by Richard Winchcombe in 1430, but progress had been slow and gradually came to a standstill during the troubled years of the mid century.

31 See Lawrence Stone, *Sculpture in Britain; The Middle Ages*, Harmondsworth 1955.

32 From a whitish Magnesian limestone to a buffish oolitic limestone.

33 See Geoffrey Webb, *Architecture in Britain: The Middle Ages*, Harmondsworth 1956.

34 The piers have the seven vaulting shafts more suitable for a lierne-vault than the five natural to a fan-vault, the two redundant shafts disappearing into the capital in a makeshift solution.

35 Towards the end of the fifteenth century work commenced on the 'New Building', an extension to the east end of the Norman abbey-church. Large windows were pierced in the central apse, the lateral apses removed, and the aisles extended and joined by a square-ended retrochoir covered with fan-vaults. The detailing of the fan-vaults at Peterborough is crisp and linear compared to the rather plastic, sculptural quality of the vaults of the Gloucester cloister.

36 In the chapel proper the architectural decoration is confined to some insignificant defaced figures over the doors to the vestries, and demi-figures of angels that serve as corbels for the vaulting shafts which terminate over the choir stalls.

37 See Lawrence Stone, *loc. cit.*

38 At an annual fee of £12, with an additional allowance of 10s for a robe and a periodic 'reward' varying between £2 16s 8d and £3 6s 8d.

39 The tomb was later walled in, so that the grille is today seen out of context. That it has survived all these years, when it no longer fulfilled any practical function, is remarkable, considering the vagaries of changing tastes.

40 See John Harvey, *loc. cit.*

41 The vaulting over the crossing, only dating from 1528, is far less successful. It has been suggested that the unusual sequence of construction of the vaulting may be due to an original intention to construct a lantern over the crossing. See Geoffrey Webb, *loc. cit.*

42 The lavish sculptural programme of Henry VII's Chapel, like that

of King's College Chapel, Cambridge, forms a striking contrast to the severely architectonic treatment of the earlier St George's Chapel, Windsor. The probable reasons for this change are mentioned in the description of King's College Chapel, p. 58.

43 Lawrence Stone considers the group of Apostles the English equivalent stylistically of the contemporary sculpture of the choir enclosure of Albi Cathedral, both revealing the belated influence of Flemish and Burgundian realism. See Lawrence Stone, *loc. cit.*

44 See Lawrence Stone, *ibid.*

45 Equivalent to £8900, since the mark was worth two-thirds of a pound sterling or 13s 4d.

46 By fusing a wash containing silver oxide or nitrate.

47 The great east window at Gloucester is actually still larger (72 feet high by 38 feet wide), but contains a considerable proportion of colourless glass.

48 See Emile Mâle, *The Gothic Image*, London 1961.

49 As in the case of the leading illuminator, Herman Scheere.

50 André Beauneveu, the French court-painter and sculptor, known to have visited Richard II's court in 1398, has been suggested by some authorities. Most, however, favour an English origin.

51 See Margaret Rickert, *Painting in Britain: The Middle Ages*, Harmondsworth 1954.

52 Jacques Dupont, *Gothic Painting*, Geneva 1954.

53 See Francis Wormwald, 'The Wilton Diptych', *Journal of the Warburg and Courtauld Institutes*, XVII, 1954.

54 Whatever the date of their addition, the placing of the badges and their blatant independence of the chiaroscuro treatment of the drapery points to their being an afterthought, probably added on command.

Chapter 3 France

1 See Glossary.

2 A virtually identical rose appears yet again on the south transept of the cathedral of Senlis, erected between 1506 and 1515 by Jean Dizieult and Pierre Chambiges, Martin's son.

3 The great church of St Wulfram at Abbeville (1488-1539) in its inimitable setting of old houses, so admired by Ruskin and the Romantics, was another casualty of World War II. Thirty years later, the church, including the west façade with its sumptuous Flamboyant portals, is still disfigured by shoring and scaffolding.

4 The asymmetrical placing of Mary Magdalen represents the triumph of pictorial tendencies over architectural considerations. The present figures are reconstructions, following damage in the Franco-Prussian War. The cathedral was again severely damaged in World War II.

5 Johan Huizinga, *The Waning of the Middle Ages*, London 1924.

6 Called the *Tour de Beurre* because it was largely financed by the sale of indulgences which allowed the purchasers to eat butter during Lent.

7 'To brave hearts nothing is impossible.'

8 The Book of Hours painted at Bourges for the grandson of Jacques Coeur by an artist associated with Jean Colombe is now in the State Library at Munich.

9 For an interesting comparison, see the *trompe l'oeil* painted tracery on the vaults of Milan Cathedral.

10 So-called since it was from the top of the gallery or tribune over the entrance to the choir that the Epistle and Gospel were read after the pronouncement of the Benediction: *'Jube domine benedicere'*.

11 The single exception, the plain area of the pilasters under the delicate canopies, is accidental, owing to the disproportionately small scale of the two statuettes that replace the lost, and obviously far larger, originals.

12 From funds left years before in the will of Louis I of Amboise expressly for the erection of a *'beau portail du côté du cimetière'*.

13 The initial contract was between the Cathedral Chapter and Arnould Boulin, a simple bin-maker of Amiens; and a further contract was entered into shortly afterwards with Alexandre de Heudenbourg (or Huet), who had as assistants Linard le Clerc, Guillaume Quentin

and Pierre Meurisse. Antoine Avernier, an image-maker, executed a large number of the misericords, and a certain Jehan Trupin (or Turpin) signed his work twice, notably beneath an elbow-rest ornamented with a figure of a woodcarver at work. For the details of the contracts, see Amédée Boinet, *La Cathédrale d'Amiens*, Paris 1922.

14 John Ruskin, 'The Bible of Amiens', Vol 1 of *Our Fathers Have Told Us*, London 1883.

15 Doubtless she intended to return eventually to take up residence in the religious house attached to the church, but died suddenly in 1530 at the age of fifty-one from a foot infection—a detail preserved for posterity in her effigy at Brou, with the left sole bared to show the lethal puncture.

16 The portrait is generally assumed to be a leaf of the polyptych mentioned in the inventory of the private rooms of Charles V at the Chateau de Melun, with portraits of the king, his father John II, his uncle, the Emperor Charles IV, and Edward III of England.

17 Significantly, the work of the greatest twentieth-century masters of the art of tapestry, notably Jean Lurçat, has been strongly influenced by medieval precedent.

18 Later bequeathed to Angers Cathedral, to which they still belong, the tapestries are now displayed under optimum conditions in a specially constructed museum in the grounds of the castle.

19 Depicted on the dedication page of a *Bible Historiale* preserved in the Museum Meermanno-Westreenianum in the Hague, presented to Charles V by one of his courtiers and signed and dated on the facing page by Jean Bondol: 'In the year of the Lord 1371, this work was illuminated by order and in honour of the illustrious Prince Charles, King of France, in the thirty-fifth year of his life and the eighth of his reign; and John of Bruges, painter of the said King, has made this miniature with his own hand.'

20 'The king lent it to Monsieur Anjou to make his beautiful tapestries.' Ms. lat. 403, Bibliothèque Nationale, Paris

21 André Beauneveu was in Charles V's employ from *c.* 1360 to 1374, and after that worked for Louis de Mâle, Count of Flanders, before settling in Bourges.

22 Jeanne of Burgundy's effigy has since disappeared.

23 The *Petites Heures du Duc de Berry*; the *Très Belles Heures de Notre Dame*; the *Très Belles Heures de Jehan de France, Duc de Berry* (generally known as the 'Brussels Hours'); and the *Grandes Heures du Duc de Berry*.

24 Erwin Panofsky, *Early Netherlandish Painting*, Cambridge, Mass. 1953.

25 The precisely delineated carpenter's workshop in the scene representing 'The Building of the Ark' in the Bedford Book of Hours, for example, shows how little woodworking tools have changed since the fifteenth century.

26 Quoted by Jacques Dupont, *Gothic Painting*, Geneva 1954.

27 According to Panofsky, no fewer than thirty of the forty-one miniatures exhibit the Boucicaut arms, motto or tournament colours. Erwin Panofsky, *loc. cit.*

28 The theory, proposed by Porcher on stylistic grounds, is all the more plausible since the wife of his patron, Louis II of Anjou, was the bibliophile Yolanda of Aragon. Jean Porcher, *The Rohan Book of Hours*, London 1959, and *Medieval French Miniatures*, New York 1960.

Chapter 4 Burgundy

1 Guy, designer of the fireplace-wall in the great hall at Poitiers, and Drouet, both members of a celebrated family of master-masons, were possibly brothers.

2 See J. Duverger, *De Brusselsche Steenbickeleren der XIV en XV eeuw*, Ghent 1933.

3 Most notably some sculptured corbels from the old town hall of Brussels, now preserved in the Musée Communal.

4 Hennequin also supplied a metal diadem for the lost statue of the Magdalen.

5 In 1402, when the Calvary had not yet been completed, and again in 1418, 1432 and 1445.

6 *Archives de la Côte-d'Or*, B 310, B² 360 III, nos. 342 and 2417, and the Archives Municipale de Dijon, B 158, fo. 21.

7 The exchange value of the *livre tournois* fluctuated with the relative fortunes of France and England from six to nine *livres tournois* to the livre sterling (£).

8 The tomb of the Duc de Berry was commenced in 1405 by Jean de Cambrai, collaborator and successor of André Beauneveu. The much-mutilated effigy is in the style of Beauneveu, as also the few mourners completed by de Cambrai. Work on the uncompleted tomb was only resumed in 1450 at the command of Charles VII by the sculptors Étienne Bobillet and Paul de Mosselman, to whom must be attributed the balance of the mourners, in alabaster rather than the marble used by de Cambrai, and dominated by the influence of the Burgundian ducal tombs.

9 Le Moiturier's major contribution was the sculpture of the effigies of the duke and duchess. As in the case of Sluter's effigy of Philip the Bold, mutilation during the Revolution and insensitive restoration have almost completely obliterated the master's hand.

10 The extremely popular little wood-block books on the *Ars Moriendi*, or 'Art of Dying', catered specifically to this need. See p. 164.

11 The attribution, though stylistically plausible, of necessity remains speculative.

12 Each panel of the diptych contains two scenes, chronologically arranged from left to right: *The Annunciation*, in an architectural setting; *The Visitation* in a landscape; *The Presentation in the Temple* in an architectural setting; and *The Flight into Egypt* in a landscape. It is noteworthy that Broederlam has eschewed a symmetrical arrangement of architectural and landscape settings in his composition and, furthermore, copes extremely skilfully with the awkwardly-shaped panels predetermined by de Baerze's carved Calvary on the other side.

13 Erwin Panofsky, *loc. cit.*

Chapter 5 The Netherlands

1 The terms 'Netherlands' and 'Netherlandish' are used throughout as pertaining to the 'Low Lands', as understood until the religious and political division into a Catholic south and Protestant north, and, therefore, includes both present-day Belgium and *Nederland* (Holland).

2 Investigated by Erwin Panofsky in the chapter on 'The Regional Schools of the Netherlands and their Importance for the Formation of the Great Masters', in *Early Netherlandish Painting, loc. cit.*

3 So-called from the reputed provenance of three panels in the Städelsches Kunstinstitut in Frankfurt.

4 Named for its former owner, the Princesse de Mérode.

5 Panofsky notes the parallel symbolism of an outshone candle in St Bridget's description of the Nativity in her *Revelationes*: St Joseph had placed a lighted candle in the cave, but after the birth of the Saviour the divine radiance that emanated from the Child totally annihilated *(totaliter adnihilaverat)* the material light *(splendor materialis)* of the flame. See Erwin Panofsky, *loc. cit.*, and also Millard Meiss, 'Light as Form and Symbol in Some Fifteenth-Century Paintings', *Art Bulletin*, XXVII, 1945.

6 In particular, by the celebrated chancellor of the University of Paris, Jean Gerson (1364-1429).

7 Jacobus de Voragine, *The Golden Legend*. Cf. Meyer Schapiro, *"Muscipula diaboli"*, 'the symbolism of the Mérode Altarpiece', *Art Bulletin*, XXVII, 1945, and I. L. Zupnick, 'The mystery of the Mérode mousetrap', *Burlington Magazine*, March 1966.

8 Quoted by Charles D. Cuttler, *Northern Painting*, New York 1968.

9 Payment for a third 'secret mission' in 1436 is recorded. The destination remains unknown but is surmised by some authorities to have been Prague.

10 *'Als ixh xan.'*

11 Writing of Jan van Eyck and his invention of oil-painting, Vasari comments that:

'. . . he began to try out various kinds of colours and, being fond of

alchemy, to play around with many oils in order to make varnishes and other things according to the fancy of such inquiring minds as his was. Now, on one occasion, when he had gone to very great trouble to paint a panel and completed it with the utmost diligence, he varnished it and put it in the sun as is the custom. But, whether the heat was too violent, or perhaps because the wood was badly joined or not sufficiently seasoned, said panel came badly apart at the joints. Therefore, seeing what harm the heat of the sun had done to him, Jan decided to fix it so that the sun would never again wreak such havoc with his works. And so, since he was no less disgusted with the varnish than with working in tempera, he began to think how he might find a kind of medium that would dry in the shade without his placing his pictures in the sun. Finally he discovered that, among all the oils which he had tried, linseed and nut oil dried better than all others. These, then, boiled together with other mixtures of his, gave him the varnish which he—and, for that matter, all the painters in the world—had long wished for. After having experimented with many other things, he saw that the mixing of the pigments with these kinds of oil gave them a very strong cohesion; and that, when dry [this binding medium] was not only absolutely unafraid of water but also set the colour afire to such an extent that it imparted to it a radiance by itself, without any varnish. And what appeared to him the most wonderful thing was that it blended (si univa) infinitely better than tempera.'

12 See C. R. Dodwell (ed.), *De Diversis Artibus*, London 1961.

13 Leo van Puyvelde, *The Flemish Primitives*, London 1948.

14 Jacques Lassaigne, *Flemish Painting: The Century of Van Eyck*, Geneva 1957.

15 The technical procedure employed was first to prime the wood panel with a coat of chalk mixed with glue. On this smooth, white, glossy ground the pigments were applied in a carefully calculated sequence: first a relatively opaque underpainting, known as *doodverw* or 'dead colour' in Flemish, which established the tone and general colour values; then successive glazes or translucent films of pigment which permitted light to penetrate to the opaque underpainting—itself only relatively opaque and in turn allowing the white ground to glow through, thus giving the paintings their extraordinary sense of glowing depth, as if illuminated from within. The precise nature of the binding medium used by Jan van Eyck has recently been thought to be a siccative, or quick-drying oil, with the addition of some undetermined ingredient soluble in oil but not forming an emulsion. Occasionally, passages painted in oil were given a final coat of tempera, and it was no doubt the chemical analysis of such examples of mixed media that led scholars such as van Puyvelde to maintain that van Eyck did not use oil at all, but merely perfected the tempera technique. Some brilliant varnish such as amber may also have been used.

16 The closest connection is the *Madonna of Chancellor Rolin*, in the Louvre, painted for Philip the Good's wily chancellor, the same Rolin who founded the Hôtel-Dieu at Beaune and commissioned the monumental *Last Judgement* by Rogier van der Weyden.

17 The church was dedicated to St John the Baptist until 1540, when it was rededicated to St Bavon. It was elevated to the status of cathedral in 1559.

18 The oldest surviving example of simulated sculpture painted in *grisaille* occurs in the work of the Master of Flémalle (St James and St Clare on the exterior of the *Betrothal of the Virgin*, *c.* 1420, in the Prado) and may well have been yet another of his brilliant innovations. The originality of the concept was all the greater since actual monochrome sculpture was a rarity, and votive sculpture, in particular, was invariably naturalistically coloured.

19 The original of the panel of the Knights of Christ and the Just Judges was stolen in 1934 and is at present replaced by a copy.

20 It includes details from Utrecht and Cologne as well as from towns in Flemish-Burgundy.

21 Arthur Pope observed that if one views a painting by Vermeer, for example, at a normal distance, one can discern the details to approximately the extent that one would in viewing the subject in nature. When one moves closer, one becomes conscious of the brush strokes but does not see any additional detail. By contrast, when one looks at a painting by Jan van Eyck at a convenient distance to comprehend the whole, one cannot discern the details as clearly as one can by walking up close and examining them piecemeal. The sensation is comparable to that of perusing a landscape through a pair of binoculars or a telescope. Arthur Pope, *The Language of Drawing and Painting*, Cambridge, Mass. 1929.

22 This central enthroned figure can also be read as God the Father with the Dove (the Holy Spirit) and the Lamb below (Christ), comprising the Trinity.

23 '... *ictor Hubertus e eyck · maior quo nemo repertus Incepit · pondus · q. Johannes arte secundus*

... *Judoci Vijd prece fretus VersV seXta MaI · Vos CoLLoCat aCta tVerI'*

The last line is in the form of a chronogram, the sum of the capital letters, read as Roman numerals, totalling 1432.

24 See Lotte Brand Philip, *The Ghent Altarpiece and the Art of Jan van Eyck*, Princeton 1971.

25 For example, Fra Angelico only signed the contract for his altarpiece *The Madonna of the Linaiuoli* in 1433, whereas Ghiberti had already been commissioned to supply the sculptured marble frame in 1432.

26 The damaged word '. . . *ictor*' in the first line of the quatrain was always assumed to have read *'Pictor'* (painter). Lotte Brand Philip suggests it actually read *'Fictor'* (sculptor). For the *'Frater perfectus'*, or *'Frater perfecit'* traditionally assumed as the missing first two words of the third line, she advocates *'Pictor perfectus'* (perfect painter)—possibly written in the form *'perfetus'* to rhyme with *'fretus'*. The quatrain would then have commenced:

'Fictor Hubertus (e eyck) · maior quo nemo repertus Incepit · pondus que Johannes arte secundus
Pictor perfëtus . . .'

She places *e Eyck* (van eyck) in parenthesis since she believes these words to be an interpolation by an early restorer, after the sculptural setting had been destroyed. The argument that these words were not part of the original quatrain is supported by the fact that they disturb the rhythm of the hexameter—the first line can only be properly scanned without them—and that their addition necessitated starting the line much further to the left than in the succeeding lines. The reader is referred to the monograph *loc. cit.* for modifications in the translation, of minor importance compared to the revolutionary thesis of Hubert the sculptor.

27 See Erwin Panofsky, *Early Netherlandish Painting*, *loc. cit.*

28 Even by the end of the fifteenth century, the marriage ceremony was still not held inside a church. The closest one could come was the church porch, the traditional locale in depictions of such events as the marriage of the Virgin. See Denys Hay, *Europe in the Fourteenth and Fifteenth Centuries*, London 1966.

29 In several Nativity scenes, for example that of Petrus Christus (Washington, National Gallery), and the *Portinari Altarpiece* by Hugo van der Goes (Florence, Uffizi), St Joseph, like Moses of old, has taken off his pattens.

30 Produced by Jacquemart for the Duc de Berry, it was bartered to Robinet d'Etampes by whom it was divided into two. The finished half in the Maurice de Rothschild Collection in Paris was confiscated by the Nazis and disappeared for years before being recovered and donated to the Bibliothèque Nationale. The other half early found its way into the collection of Duke William VI of Holland and Bavaria, and was completed with additional illuminations, some added as late as the middle of the fifteenth century. It is the penultimate group, of outstanding quality and originality, that have been attributed to Hubert and (or) Jan van Eyck around 1422. In turn subdivided, half of this portion was destroyed in the catastrophic fire of the Royal Library of Turin in 1904, fortunately after being photographed. The separated portion, at that time in a private Milanese collection, is now in Turin, where the twenty-eight pages constitute one of the greatest treasures of

the Museo Civico di Arte Antiqua.

31 Rogier's mother-in-law and Campin's wife both had the surname van Stockem.

32 The bombardment resulted in the destruction of much of the medieval town and, on the positive side, to the splendid rebuilding of the guild-houses on the Grande Place.

33 A rare exception is the plain, cream-coloured background of the *Portrait of Francesco d'Este* in the Metropolitan Museum, New York.

34 The identity of the young woman—so different from the typical Dutch-Flemish model—has given rise to speculation. One suggestion is Lady Talbot, first wife of Sir Edward Grimstone; his portrait by Christus, dated 1446, on loan to the National Gallery, London, from the collection of the Earl of Verulam, is the earliest known portrait of an Englishman abroad. However, the late date of the Berlin portrait, consistent with the style and confirmed by the costume, is against this hypothesis.

35 The wing panels were sold and found their way to Berlin and Munich, but were returned to Louvain as part of the reparations after World War I.

36 On the left: *Melchizedek Presenting Consecrated Bread and Wine to Abraham* and *Gathering Manna in the Wilderness*. On the right: *Elijah Fed by the Angel in the Wilderness* and *The Sacrifice of the Paschal Lamb*.

37 In particular, Charles D. Cuttler, *Northern Painting—from Pucelle to Bruegel*, New York 1968.

38 Joos van Ghent (Joos van Wassenhove) became a master of the Antwerp guild in 1460 and that of Ghent in 1464. He left for Italy in 1467 and spent the rest of his life there, known as Giusto di Guanto (Justus of Ghent), assimilating the *Quattrocento* tradition so successfully as to pass for an Italian painter. From 1473 to 1476 he was attached to the brilliant court of Federigo da Montefeltro, patron of Piero della Francesca at Urbino.

The major work of his pre-Italian period is a large *Calvary* triptych in St Bavon at Ghent, especially noteworthy for its placing of the figures in a barren landscape with naturalistic cloud formations, and the use of broken, atmospheric colour. Joos and Hugo van der Goes were close friends. Joos, as we noted, was one of Hugo's sponsors, and Hugo in turn lent Joos money for his journey to Italy.

39 Domenico Ghirlandaio's *Adoration of the Shepherds*, dating from 1485, only five years after the *Portinari Altarpiece* had been set up in the family chapel in San Egidio in Florence, clearly betrays its influence.

40 Identified by some critics with Alexander Bening, elected master miniaturist at Ghent in 1469, who, curiously enough, was married to a Katharina van der Goes. Whether she was related to the painter is not known.

41 A resemblance which may be more than coincidental in view of the close commercial ties between Bruges and Tuscany.

42 The cathedral has no less than three aisles, creating a triple-bay 'hall-church', so to speak, on each side of the nave, and opening up diagonal perspectives that evoke the interminable, mosque-like, horizontal extension of space of Spanish cathedrals such as Seville. The interior is, however, more notable for its size than its beauty, and the abiding memories are likely to be those of the Rubens' altarpieces—in particular the triptychs of the *Ascent* and *Descent from the Cross*—rather than of the architecture.

43 Almost completely destroyed in the First World War and subsequently rebuilt.

44 This traditional attribution is endorsed by Theodor Müller, *Sculpture in the Netherlands, Germany, France and Spain: 1400-1500*, Harmondsworth 1966.

45 A celebrated example is Borman's *St George Altarpiece*, dated 1493. Carved for the church of Ons Lieve Vrouw van Ginderbuyten at Louvain, it is now in the Musée du Cinquantenaire in Brussels.

46 Other suggestions include the tomb of Louis de Mâle, Count of Flanders, erected at Lille in 1455, and that of Marguerite of Brabant, erected at Brussels in 1458. If either of the above, then the statuettes

were probably cast by Jacques de Gérines, active in Brussels, who died in 1463-64.

47 Elevated to the status of cathedral in 1561, it was a parish church at the time of its construction.

48 See N. Beets in *Kunstgeschiedenis der Nederlanden*, edited by H. E. van Gelder, Utrecht, undated.

49 Founded by a Belgian weaver, the disciples of the 'New Adam' established a commune in Bohemia during the Hussite period. They went stark naked and so scandalized society with their morals that they were massacred in 1421.

50 This *'Armeleutekunst'* or 'poor man's art' was noted as a phenomenon of the age. Julius von Schlosser, *'Armeleutekunst' alter Zeit, Präludien*, Berlin 1927.

Chapter 6 Germany and Austria

1 Even within Brandenburg a dozen cities owed allegiance to the Hanseatic League rather than to the Margrave; while Bavaria was divided between three feuding Wittelsbach dukes, ruling from Munich, Straubing and Landshut, with a fourth for a while at Ingolstadt. See Denys Hay, *Europe in the Fourteenth and Fifteenth Centuries*, London 1966, who adds, 'the territorial complexities of even the bigger units elsewhere in Germany almost defeats cartography as it does brief description.'

2 German civic architecture never attained either the scale or magnificence achieved in Flanders, nor the clear differentiation of commercial and civic functions.

3 For an exact parallel see the traceried opening from aisle to transept at Gloucester.

4 The finest examples of ecclesiastical *Spätgotik* in brick, many severely damaged in World War II and not yet restored, are in the Eastern Zone and hence beyond the scope of the present volume.

5 The *trivium*: grammar, rhetoric and dialectic; and the *quadrivium*: arithmetic, geometry, astronomy and music.

6 The seven 'princes' who elected the German Emperor were the archbishops of Mainz, Cologne and Trier, the king of Bohemia, the Count Palatine of the Rhine, the Duke of Saxony and the Margrave of Brandenburg.

7 The figures are quoted from Lewis Mumford, *The Culture of Cities*, London 1938.

8 An example is Poitiers Cathedral, contemporary with the cathedrals of Laon and Paris, built under the patronage of Henry II of England and Eleanor of Aquitaine, from 1162.

9 See Eberhard Hempel, *Geschichte der deutschen Baukunst*, Munich 1949.

10 An explanation proposed by Paul Frankl, *Gothic Architecture*, Harmondsworth 1962.

11 The anteroom of the Berkeley Chapel in Bristol Cathedral, variously dated between 1300 and 1311.

12 Probably in 1359. The reason that construction of the chapel proceeded so slowly is that it is attached to the great south tower and was tied to the pace of the construction of this.

13 See James S. Ackerman, *'Ars sine scientia nihil est'*: Gothic Theory of Architecture at the Cathedral of Milan, *Art Bulletin*, XXXI, 1949.

14 In the nineteenth century, so obsessed with perfecting the heritage of the past, the cathedral architect drew up elaborate plans for the completion of the north tower, but these mercifully came to nothing.

15 The master Heinrich first mentioned in the archives is generally identified with the founder father of the dynasty, 'Heinrich of Gmünd'. He was succeeded by a Master Michael (probably a son) and in turn by Master Heinrich II.

16 The structure of Ulrich von Ensingen's aisles, each as wide as the nave, and vaulted almost a hundred years previously, was also affected and an intermediate row of slender columns was now introduced, transforming each aisle into a double-aisled, stellar-vaulted hall-church complete in itself.

17 Robert Branner, *Gothic Architecture*, London 1961.

18 They were, in fact, retained until the dissolution of the guilds by

Louis XIV of France in 1707 for political purposes.

19 Peter Baldass, 'Hans Stetheimer's wahrer Name', *Wiener Jahrbuch für Kunstgeschichte*, XIV, 1950.

20 Built as the parish church of the city and handed over to the Franciscan Order in 1635.

21 Paul Frankl, *Gothic Architecture*, Harmondsworth 1962.

22 At this time all the churches became Lutheran, with the single exception of St Elizabeth's which belonged to the Order of Teutonic Knights. In 1816 the Frauenkirche was given back to the Roman Catholic congregation as their parish church.

23 This is particularly true also of Spain and Italy.

24 See Theodor Müller, *Sculpture in the Netherlands, Germany, France and Spain, 1400-1500*, Harmondsworth 1966, who considers the statues an outcome of the Parler-lodge style, radiating from Prague as far afield as Cologne, Milan and Cracow, and feels it is wrong to attribute the finest specimens to a single artist, a 'Master of the "Fair Virgins".'

25 Formerly in the Liebfrauenkirche, now in the Bischöfliches Museum of Trier.

26 Jan van Eyck's *Madonna of Canon Van der Paele* comes immediately to mind in the treatment of the donor.

27 The already severely damaged busts were preserved in the Library of Strasbourg and recorded with plaster casts. After the destruction of the building during the siege of the city in the Franco-Prussian War, all traces of the busts were lost and only years later did the two heads come to light separately and find their way to different museums.

28 See Wilhelm Pinder, *Die deutscher Kunst der Dürerzeit*, Leipzig 1940: 'It is precisely in the finest of the busts that he thinks differently from Gerhaerts, although he is familiar with him.'

29 The group stands at the entrance to the choir of the Storkyrka, the main church of Stockholm, on the spot where Sten Sture, the Swedish Regent, had prayed to St George before the Battle of Bruckeberg where Sweden achieved independence.

30 The fifteenth century saw the culmination of the cult of St Wolfgang. A document issued at Constance mentions the four most popular places of pilgrimage—presumably restricted to the Empire—as Rome, Aix-la-Chapelle (Aachen), Einsiedeln and St Wolfgang. The Emperor Maximilian even expressed a desire to be buried at St Wolfgang.

31 Preserved in the Landesarchiv, Linz, and reproduced in I. Zibermayr, *Michael Pachers Vertrag über die Anfertigung des Altars in der Kirche zu St Wolfgang*, Innsbruck 1912.

32 In such striking contrast to the violent contortions of so many figures in the St Wolfgang paintings. In Pacher's next great commission, he translated the restrained grandeur of the sculptured figures at St Wolfgang back again into a pictorial medium, in his four monumental figures, The Fathers of the Church, 1482-83, seated beneath simulated sculptured canopies.

33 Nuremberg and Cracow at the time enjoyed particularly close trade relations.

34 There are records of the painter, Stanislaus, at Cracow from 1505, of the painter and carver, Johann, and the carver, Veit the Younger, in Transylvania (Romania) and of the goldsmith, Florian, at Görlitz. Veit Stoss the Elder's brother, Matthias, also a goldsmith, had already moved to Cracow in 1482, no doubt to assist in the gilding of the St Mary Altarpiece. Veit Stoss exercised a powerful influence on the course of Gothic sculpture in Poland, Silesia, Slovakia, Hungary and Romania.

35 Theodor Müller, *loc. cit.*

36 The oldest known illustration, *c.* 1646, by Michael Herr, shows the medallion surmounted by a large metal framework in the form of a crown, which must have acted as the support for the shroud.

37 Part of the larger power struggle between Adolf II of Nassau and the Archbishop of Mainz, Diether II von Isenburg, which ended with the deposition of the latter.

38 See Kurt Gerstenberg, *Tilman Riemenschneider*, Munich 1941.

39 Quoted by Theodor Müller, *loc. cit.*

40 His output was vast and varied, including such outstanding sepulchral monuments as the red granite memorial to the Emperor Henry II and his wife St Kunigund in Bamberg Cathedral, which he started in 1499 and only completed in 1513. In addition to altarpieces, he carved many single figures, large and small, the latest of which are permeated by a Renaissance Humanist spirit, though Reimenschneider remained faithful to Gothic forms to the end.

41 Famous for the series of portraits of saints in the Chapel of the Holy Rood at the Emperor's castle of Karlštejn outside Prague.

42 *The Buxtehude Altarpiece*, prior to 1410, now in the Hamburg Kunsthalle, is attributed by some authorities to Master Bertram; by others, seemingly with more justification, to a follower.

43 The iconographic programme is an exposition of the *Speculum Humanae Salvationis* (*Heilsspiegel* or 'Mirror of Salvation').

44 The second version, in which Christ is depicted without the Crown of Thorns, is in the National Gallery, London.

45 St Ursula and St Gereon were both martyred in Cologne. For the religious and political importance of the relics of the Three Magi, brought to Cologne from Milan by Frederick Barbarossa, see the author's *The Gothic Cathedral*, London 1969.

46 The standard iconographic attributes of the subject in Gothic art. Another example can be found among the thirteenth-century sculpture from the portal of Strasbourg Cathedral.

47 Panofsky made the pertinent observation that 'where Jan van Eyck fused and transformed his memories of buildings and sceneries into imaginary vistas, however "real", Conrad Witz recorded them in topographical portraits, however stylized.' Erwin Panofsky, *loc. cit.*

48 There are, as we noted earlier, far older examples from the Far East.

49 For example, the *Virgin and Child with a Parrot*, *c.* 1465-70.

Chapter 7 Spain

1 The classic example of a French cathedral on Spanish soil is that of León.

2 Antonio de Lebrija is credited with the invention of the devices and the related motto, *Tanto Monta* ('It amounts to the same thing').

3 Theodor Müller, *loc. cit.*

4 In the manner of an English 'Lady Chapel'.

5 So fine, indeed, as to be attributed by some authorities to Gil de Siloé, the greatest Spanish sculptor of the day. Similar in effect, though not in quality of execution, are the giant escutcheons on the exterior of the Capilla de los Vélez of Murcia Cathedral.

6 After his visit in 1442 to Germany, Switzerland and Bohemia.

7 See Glossary.

8 The vault is credited by some authorities to Felipe Biguery (Vigarny) from Burgundy.

9 Probably following the Portuguese precedent: the Monastery of Batalha was founded after the Portuguese victory over Castilian invaders at the Battle of Aljubarrota in 1385.

10 Outstanding examples are the domed ceilings of the *media naranja* (half-orange) type in the Halls of the Ambassadors in the Alhambra at Granada and the Alcázar of Seville, the first still truly Moorish, the second executed by *Mudéjar* craftsmen for Pedro the Cruel of Castile.

11 Gil's previous commitment to carve the now lost retablo of San Gregorio in Valladolid probably accounts for this delay.

12 Discussed at length by Beatrice Proske, *Castilian Sculpture*, New York 1951.

13 Funerary monuments tend to be conservative but it is interesting to observe that Donatello's characterful *David* antedates the tomb by about forty years, and Michelangelo's *Pièta* was carved only ten years later.

14 See Harold E. Wethey, *Gil de Siloé and His School*, Cambridge, Mass. 1936, and Beatrice Proske, *Castilian Sculpture*, *loc. cit.*

15 See Note 21 in the England chapter.

16 Antonio Ponz, *Viage de España*, Madrid 1788.

17 The value of the *maravedí* was approximately $\frac{1}{6}$ of an old penny sterling, and the total cost of the tombs and retablo, therefore, around

£418 and £705 respectively—very considerable sums for the period. John Harvey suggests using the multiplier of 80 (*The Gothic World*, London 1950) to obtain the modern equivalent of medieval money values for the century and a half after the Black Death; to this must be applied a further factor to account for inflation from 1950 to 1977.
18 See John Harvey's excellent introduction to his *Cathedrals of Spain*, London 1957.
19 An example of *'la más evolucionada modalidad borgoñona'*. See Sampere A. Durán and J. Ainaud de Lasarte, *'Escultura Gotica', Ars Hispaniae*, Vol VIII, Madrid 1955. Müller espied in Mercadente's works 'a precision and tautness of linear form in which the austerity of expression and the unemotional treatment of the subject matter is characteristic of the mid-century, and perhaps also of Mercadente's Breton origin.' Theodor Müller, *loc. cit.*
20 Although rare at this late date, the legend of the midwives was often depicted in the art of the cathedrals during the twelfth and thirteenth centuries. A favourite scene shows them bathing the Child. The legend is recounted by Émile Mâle, *L'Art Réligieux du XIIIe siècle en France*, Paris 1902.
21 *'Declaration or Judgment which was pronounced in Salamanca in a Junta which was held Sept. 3rd, 1512, by the Masters of Architecture Antón Egas, Juan Gil de Hontañón, Juan de Badajos, Juan de Álava, Juan de Orozco, Alonzo de Covarrubias, Juan Tornero, Rodrigo de Saravia, and Juan Campero, as to the mode of constructing the Cathedral.'*

'That which appears to the Masters who were called and assembled by the most reverend and most magnificent in Christ, Father and Lord Don Francisco de Bobadilla, by the grace of God, and of the Holy Church of Rome, Bishop of Salamanca, and of the Council of the Queen our Lady, and by the Reverend the Dean and Chapter of the Church of Salamanca, to give the plan of the site and building of this holy church and temple, which it has been unanimously decided by the said Lord Bishop and Chapter—our Lord helping—to make and begin, is as follows:-

Firstly, the said Masters decided that the site of the church should be in length as far as the church of San Cebrian, and in width as far as the Schools.

Item.—That the three clear naves should begin from the line of the tower unto the place of the Schools, so that all the three doors of the front may show themselves and be clear of the tower.

Item.—They determine that the church should be directed and turned as much as possible to the east; and it appears to them that it can turn directly to the said east.

Item.—They determine that the principal nave may have fifty feet in width in the clear, and a hundred and ten in height.

Item.—That the side naves shall have thirty-seven feet in clear width, and seventy feet in height, or seventy-five, not being of the height of the other.

Item.—They determine that the chapels opened in the side walls may have twenty-seven feet in clear width, and forty-three or forty-five in height.

Item.—That the three gable walls of the west front may have all three seven feet of thickness, and the side walls throughout the church six feet; but to some of the said Masters it appeared that the end walls should be eight feet in thickness.

Item.—That the buttresses of the end walls may project beyond the wall twelve feet, and in thickness may have seven feet in front.

Item.—That the buttresses of all the side walls of the church may be five feet thick in front, and project six feet beyond the wall outside.

Item.—That the divisions of the chapels in the walls may be seven feet thick.

Item.—That the four principal columns of the Cimborio may be eleven-and-a-half feet thick.

Item.—They determine that the head of the Trascoro may be octagonal.

Item.—They determine that the Capilla Mayor may have in length and breadth two chapels of the sides.

Item.—That the chapels in the walls of the Trascoro may be twenty-seven feet in depth from wall to wall, and that in the spaces of the walls and buttresses in the angles of the octagons, which are formed between the chapels on the outside, sacristies for each chapel may be made.

Item.—They declare that the feet, of which in this their declaration and determination mention is made, are to be taken as the third of a yard; and (marking out the form of the said church) the said Masters declare that from the mark towards the door of the Schools to the first step there may be seven yards and a third, which is twenty-two feet.

Item.—They declare that the wall of the west front within the tower has to be begun forty-nine feet from the corner of the said tower on the inside, and should be in thickness from there forward so much as to leave forty-nine feet of the tower visible.

Item.—They declare that the wall of the side nave, from towards the old church, has to come with the side of the tower, and has to contract itself the thickness of the said wall in the said tower.

And inasmuch as some persons, as well members of the Chapter as out of it, have held certain opinions in regard to the site of the said building, and where it ought to stand, the said Lord Bishop and Chapter, desiring to avoid and escape such opinions as at present and in future may impede the order and form of the said building, command the said Masters to give the reasons and motives that may have moved them to direct and propose the site and position determined on by them, and not the other places, lines, or sites suggested; and that they should say specifically for their satisfaction why, with all quietness and willingness, the order, form, and site laid down by them may be followed. The which said Masters, in order to satisfy persons who either held or might hold opinions contrary to their own, gave the following reasons:—

Firstly. That making or putting the church in another part or site than that determined on by them, it and its cloister would be separated from the view of the city, and would be concealed; that it could not be seen round about, only the end wall by itself, and the Chevet by itself, and there would be no entire view.

The second reason is, that the said church would be put behind the Schools from the Crossing almost to the end, where the best view and the most frequent part of the church ought to be, because there the doors have to be placed.

The third reason is, that of the cloister—which already exists—the two parts are so placed that it would leave a narrow passage between the church and the Archbishop's chapel, and the library and Chapter-house, and the said chapels would remain separated, and one would enter them from the narrow passage, and in a roundabout way; for though it might be desired to make a door from the Chevet, it could not be done, because the sacristy would prevent it.

The fourth reason which they give is, that if the said church has to be moved to another site opposed to that declared and determined on by them, the tower would have to be destroyed, which is a good and singular work, and could not be rebuilt without a great sum of maravedis, and the church could not be without a tower.

The fifth reason is, that if the said church has to be moved to another site, it will be necessary to take down the house of the said Lord Bishop, and to restore it opposite the front of the church; and in order to restore it, besides the great sum of maravedis it would cost, it would be necessary to destroy fourteen houses, the rent of which is of much value, and this would be costly to the church, and involve loss to the treasury of the Chapter.

The sixth reason is, that in order to make the cloister on another site contrary to their determination, many houses must be taken; and in order to make it on the south, it would be necessary to go into it by what is called the River-door, and afterwards to be more away from the city, and out of view, and it would be very costly to make the foundations of such great depth, and to raise the walls to the

level of the church.

The seventh reason which they give is, that the Chevet of the church would cover the door of the chapel of the Archbishop and the library in order to join them.

The eighth reason which they give is, that the Crossing would not come in the line of any street, and there would be no way out by way of the cloister, because the new and old cloister would stop it; and supposing a remedy to be sought, by separating the new cloister, it would be so high when they had to go out, that it would have at least more than fifteen steps, and the entrance would be by a narrow passage; because on one part would be the new cloister, and on the other part of the old cloister the chapel of the Archbishop.

The ninth reason which they give is, that the church would encroach upon the principal street of the schools, which comes before the house of his Lordship, and the other street, 'del Desafiadero'; so that if there was none at the apse of the church there would be no way out; and the height of the church, putting it so much between the sun and the schools on the south, would take away much of their light, and darken them much.

The which reasons they give against the opinions of them who say or desire to say that the site of the said church should be towards the house of the Lord Bishop, and towards the street 'del Desafiadero'; and in order to answer the other opinion of some who argue that the site of the said church could go through the cloister, which is already built to the River bridge, because this would not be a convenient site for the church; and in order to oppose the opinion for it, they give the following reasons:—

Firstly. That it would be more separated from the city, and would not go well with the Schools, and would lack the appearance which it would have going, as is agreed, towards the Schools.

The second reason which they give is, that it would stand at an angle with the Schools and would be an ugly thing, and the façades of the church and the Schools would not be harmonised together by the said arrangement of the plan.

The third reason which they give is, that the Plaza of the Lord Bishop's house would be narrowed in great part, so that the Plaza would be a street; and the height of the church would shut out the sun from the said house of his Lordship, and would stifle it very much; and the doors of the church would be behind the tower in the view as one comes from the city through the Street of the Schools.

The fourth reason which they give is, that the west front of the church would have to join the wall of the Archbishop's chapel, and through its inequality and depth it would be necessary to have many steps through that part, and towards the town not any, and this would be a defective and ugly thing.

The fifth reason which they give is, that, making the cloister towards the Schools, all the view of the church would be shut out, and the cloister would be gloomy, and it would be without the harmony and order of good churches, and without grace.

The sixth reason which they give is, that the church standing close to the chapel of the Archbishop and the library, its height would shut out the light from the small chapels in the walls, and there would be no exit for the water from the roof of the middle of the church at that part.

The seventh reason which they give is, that in order to make the new church it would be necessary to clear out immediately all the church and the cloister, and the chapel of the Doctor of Talavera, and of Sta. Barbara, and the Chapter-house; and in their opinion it would be a grand inconvenience to be so many years without having where to celebrate the Divine offices.

The eighth reason which they give is, that if the church is separated from above, and put as in a corner, part in the shade through the one part of the tower and cloister, and through the other of the library and the chapel of the Archbishop, it could not have as much of its walls in light as is convenient.

The ninth reason which they give is, that the door of the transept would come out so high from the street, in their opinion, as more than ten or twelve steps, and would cut across the street 'del Chantre', and would be bad in its arrangement, and a place where nuisance would be caused.

This opinion having been given, it is then pronounced by the deputies appointed by the Chapter to confer with the architects, that as they were all agreed both as to the site and as to the general form of the church, and as they are such learned and skilful men, and experienced in their art, their opinion ought certainly to be acted on. But for the more certainty it was thought well to make every one of the architects take an oath: 'by God and S. Mary, under whose invocation the church is, and upon the sign of the Cross, upon which they and each of them put their right hands bodily,' that they had spoken the entire truth, which each of them did, saying 'So I swear, and amen.'

Quoted in the translation by George Edmund Street, *Some Account of Gothic Architecture in Spain*, London 1865, from J. A. Ceán Bermúdez, *Diccionario histórico de los más ilustres profesores de las Bellas Artes en España*, 1800.

22 John Harvey, *The Cathedrals of Spain*, London 1957.

23 The author of the design was Peti Juan (Petit Jean) who was assisted by the Burgundians Felipe Vigarny and Juan de Borgoñia, the Netherlandish artists Diego Copin and Christiano, the German Rodrigo Alémán, and the Castilian Sebastián de Almonacid (designer of the tombs of the Condestable Don Álvaro de Luna and his wife in the Santiago Chapel of the cathedral).

24 It was from Valladolid that Philip II moved the capital to Madrid in 1560.

25 The County of Barcelona became part of the Kingdom of Aragon through the marriage of Ramon Berenguer IV of Barcelona to the heiress of Ramiro II of Aragon in 1150. Jaime I, 'The Conqueror', of Aragon wrested the Balearic Islands (1229-35) and Valencia (1238) from the Moors. The independent 'Kingdom of Mallorca' was created for his younger son, but again reunited with the Crown of Aragon in 1344.

26 Only the timely intervention of some devoted medievalists prevented the demolition of the entire Gothic façade when the Neo-classical addition was erected in 1847.

27 A superb hall some 100 feet by 45 feet, unfortunately restored almost to the point of reconstruction.

28 José Gudíol, for example, cites Ça Anglada as the author in *The Arts of Spain*, New York 1964.

29 Pere Johan was also responsible for the alabaster reliefs of the High Altar of Tarragona Cathedral (1425-36) and, between 1441 and his death c. 1445, worked on the High Altar of the Seo at Zaragoza.

30 According to the contract under which Sagrera was to furnish all necessary building material, work was to be completed within fifteen years. In 1448, twenty-two years later, work was still in progress, and Sagrera submitted his dispute with the building council to royal arbitration. Soon afterwards he entered the king's employ in charge of the work at the Castel Nuovo in Naples, and the completion of the *Lonja* was entrusted to Guillermo Vilasolar, 'lapicida et magister fabricae'. The delay and contentious issues do not seem to have been connected with the form of the contract, for an identical agreement was entered into with Vilasolar, to act as both architect and contractor for the unfinished balance of the work.

31 Possibly already suggested by Jacques Favran of Narbonne, who had worked on the choir, or by Pedro Ça Coma, master of the works from 1369.

32 Josef Gudíol Ricart, 'Pintura Gótica', *Ars Hispaniae*, Vol IX, Madrid 1955.

33 Charles D. Cuttler, *Northern Painting from Pucelle to Bruegel*, New York 1968.

34 Jacques Lassaigne, *Spanish Painting*, Vol I, Geneva 1952.

35 The two most distinguished Catalan masters were Luis Borrassá, a native of Gerona, who first introduced the style, and Bernardo Martorell who was probably trained in Borrassá's studio.

36 See Josef Gudíol Ricart, *loc. cit.* and Eric Young, *Bartolomé*

Bermejo: the Great Hispano-Flemish Master, London 1975.

Chapter 8 Portugal

1 From the fifth century *Portucale* was the name of the small town on the bank of the River Douro, the present-day Oporto. In the ninth century the use of the name was extended to cover the entire territory north of the river as far as the River Minho which marked the boundary of Galicia.

2 Afonso may very well have belonged to the same family of master masons as the Domingo Domingues who had commenced the great cloister of Alcobaça in 1310.

3 John Harvey, *The Gothic World*, London 1950.

4 Probably inspired by and ultimately identified with Ethiopia, the reality proved very different from the legend.

5 In the contemporary spelling: *Talant de bien fere*.

6 The Portuguese had, moreover, made an accurate assessment of the terrestrial degree and were well aware that a western route, if such existed, would be incomparably longer. Even in the excitement and wild conjecture that followed the return of Columbus from his voyage of discovery in 1493, the Portuguese remained unconvinced that he had arrived anywhere near India.

7 On the strength of stylistic affinities between the cathedral of Albi and the curious chapel of Saõ Bras at Evora, attributed by Reynaldo dos Santos to Boytac; and because the last syllable of his name calls to mind such place names as Aurillac, Figeac and Souillac.

8 Robert C. Smith, *The Art of Portugal 1500-1800*, London 1968.

9 The location recalls the typical placement of the English 'Lady Chapel', extending the main axis to the east, and the concept may well have been inspired by the great octagon at Ely, as argued by John Harvey, *loc. cit.*

10 '... formed by a trefoil arch, entwined with a curtain arch which begins at each side with a normal, concave quarter-circle, continues with a wave on each side, and reaches its apex with a convex arch from which a cusp hangs downwards.' Paul Frankl, *Gothic Architecture*, Harmondsworth 1962.

11 By Reynaldo dos Santos. A loggia in the Plateresque Renaissance style was commenced over the great portal in 1533.

12 The present cupola is a nineteenth-century pastiche of Manueline elements.

13 Certain critics have sought, without convincing justification, to identify the goldsmith with the celebrated contemporary playwright of like name.

14 With the sole exception of the fine portal by João de Castilho.

15 See Emil Delmár, 'The Window at Tomar—a Monument to Vasco da Gama, the Portuguese Argonaut', *Art Quarterly*, Vol X, Detroit Institute of Arts, 1947. Delmár maintains that on the left side the design has been altered only slightly and that one can still see the 'sloping back of a sheep with the knees, shank and hooves. The part above and to the right of the head seems to have been changed to a greater degree by removing parts of the pelt and carving out the masonry to a deeper level.'

Delmár asserts that the generally accepted interpretation of the figure as a portrait of the sculptor is untenable since 'it can be regarded as an uncodified law among artists that, whenever they insert their own image into a work of their own, if never appears in a prominent place'. If so, there have been some notable breaches of the law. Anton Pilgram, for example, at precisely this period, was sculpting his self-portrait as the dominant feature of the organ console in the Stephansdom in Vienna.

16 Robert C. Smith, *loc. cit.*, London 1968.

17 It would appear that the altarpiece in its original setting was disposed symmetrically on either side of a statue of St Vincent, the two large panels being placed next to the statue, flanked on the outside by two small panels on each side. This generally accepted arrangement was first proposed by Reynaldo dos Santos, the great authority on Portuguese art and Nuno Gonçalves in particular. Formerly the panels had been arranged in the form of two triptychs.

18 Readily identified from the annotated miniature in the *Chronicle of Guinea* in the Bibliothèque Nationale, Paris. The miniature is obviously based upon the Gonçalves painting, or one almost identical.

19 The young prince was given as pledge for the promised surrender of Ceuta to the Moors after the disastrous Portuguese defeat of 1437. The Portuguese, for reasons of state, reneged on their agreement, and Dom Fernando remained captive until his death eleven years later.

20 The tapestries were brought from Lisbon by Philip II of Spain and given to his mistress, the Duchess of Eboli, and in turn donated to the Collegiate Church of Pastrana, a small town in Castile.

21 Reynaldo dos Santos, *Nuno Gonçalves*, London 1955.

Chapter 9 Epilogue

1 From the letter of recommendation to Petrus Aegidius of Antwerp.

2 Hugh Braun, *An Introduction to English Mediaeval Architecture*, London 1968.

3 Including two of the life-size figures of purported ancestors of the Emperor, King Arthur and Theodoric, from his tomb at Innsbruck, and the magnificent bronze effigy of Archbishop Ernst von Sachsen in Magdeburg Cathedral.

4 The tower, nave and transepts were rebuilt by Sir William Wilson, a former mason, in a hybrid style, mingling Renaissance and Gothic elements.

5 See Paul Frankl, 'The Secret of the Medieval Masons', *The Art Bulletin*, XXVII, 1945.

335 The emphatic horizontal line of the gallery, conclusively interrupting the soaring vertical of the pier, together with the classical animal frieze underneath, announces the triumph of a new aesthetic. *Salamanca 'New' Cathedral*

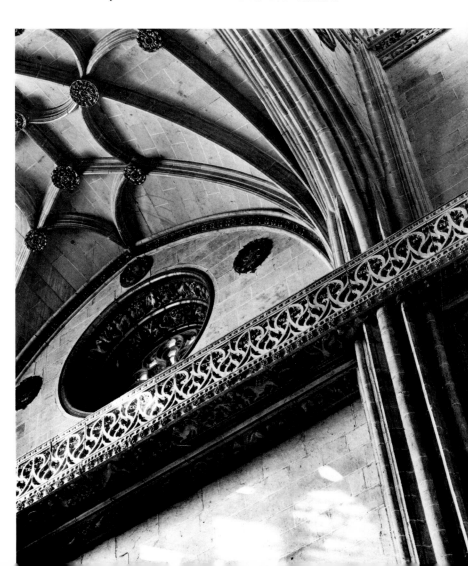

Cracow •

• Lübeck

Hamburg • • Lüneburg

• Brunswick

Hanover • • Prague

• Münster • Vienna

Beverley • Amsterdam
York • Haarlem • Utrecht • Bamberg
Louth • 's Hertogenbosch Cologne Würzburg • Nürnberg • Regensburg
Lincoln • Frankfurt-am-Main • Creglingen • Rothenburg Landshut •
Boston Middelburg • • Burg Eltz Dinkelsbühl • Ingolstadt • • Altötting
Peterborough March Woolpit Bruges • Antwerp Nördlingen Salzburg • • St Wolfgang-am-Abersee
Chester Lavenham • Ufford Ghent • • Louvain Schwäbisch Gmünd • • Munich
Cambridge • Long • Brussels Maulbronn • • Ulm
Warwick Melford
Northleach Oxford Canterbury • Tournai
Gloucester • London • Strasbourg
Cirencester Fairford Windsor • Arras
Bradford-on-Avon • • Winchester • Amiens • Freiburg-im-Breisgau
• Wells Toul • • Basle
Tiverton • Beauvais
Plymtree • Cullompton Caudebec-en-Caux • Venice
Launceston Rouen • Troyes
Louviers • • Paris • Sens • Tonnerre
• Caen • Dijon
• Beaune • Milan
• Vendôme • Geneva
• Bourges • Bourg-en-Bresse • Florence
• Angers
• Château de Josselin • Rome
• Poitiers
• Avignon
• Rodez
Montpellier •
• Albi
• Toulouse
Perpignan •
Gerona •
Barcelona •
Poblet Monastery • • Palma
Tarragona •
Leon • • Burgos • Zaragoza
Santiago de Compostela • • Aranda de Duero
• Valladolid
Zamora •
Segovia • Manzanares el Real
Salamanca • • Avila • Madrid Valencia •
Porto • • Toledo
• Coimbra • Algiers
Murcia •
• Tomar
Batalha
Alcobaça
Lisbon
Setúbal • Granada
• Seville
Sagres •
• Ceuta
Tangiers

Glossary

Ambulatory

The aisle enclosing the apse. Usually semi-circular or polygonal, it could also, particularly in the case of English churches with their characteristic square east end, be rectangular.

Apse

The semi-circular or polygonal termination of the east end of the chancel or a chapel.

Archivolt

The reveal or inner surface of an arch, often decorated with concentric rows of sculpture or mouldings.

Armillary sphere

A skeletal celestial globe composed of metal bands to represent the equator, tropics, arctic and antarctic circles, and colures, revolving on an axis.

Artesonado

Applied to a specifically Spanish panelled ceiling of Moorish origin, made up of small pieces of wood assembled to form interlocking geometric designs.

Azulejos

Glazed ceramic tiles, a favourite Portuguese form of architectural decoration. The earliest specimens have geometric patterns of Moorish inspiration; later, pictorial motifs became popular.

Barrel vault

A semi-circular tunnel or waggon vault.

Bauhütte

Mason's lodge in the German Empire.

Baumeister

The German term for the architect or, more accurately, master-mason in charge of building works.

Blind arcade

A series of arches attached to a wall as a decorative, rather than a free-standing structural feature.

Boss

(From the French *bosse*: lump or knob.) A projecting block at the intersection of vaulting ribs, often elaborately carved.

Bowtell

A convex roll-moulding, usually around three-quarters of a circle in section, applied to an angle.

Capilla mayor

The sanctuary housing the high altar in a Spanish church.

Centering

Temporary wood support used in the construction of a masonry vault or arch.

Chantry chapel

A small chapel endowed with land or other source of regular income for the maintenance of a priest to say masses for the soul of the donor.

Chevet

The French term for the east end (head or *chef*) of a Gothic church, comprising an apse, ambulatory and radiating chapels.

Ciborium

A decorative canopy or *baldacchino* over an altar or tomb.

Cimborio

The name given to the lantern over the crossing admitting light to the interior in a Spanish church.

Clerestory

(Most probably from the French *clair*: light.) The upper stage of a wall, rising above the adjoining roofs and pierced with clerestory windows.

Collar-braced roof

A timber roof in which the facetted form of the trussed-rafter roof is approximated by a continuous wooden arch running from the collar above to the wall below, and even extending down over the wall surface in the form of a wall-piece.

Collegiate church

One endowed for a chapter of secular canons, without a bishop's see.

Corbel

A projecting bracket bonded into the wall and supporting a weight.

Coro

The choir of a Spanish church, usually located in the eastern bays of the nave.

Crocket

(From the French *croquet*: a hook.) A projecting spur with foliate ornament spaced at regular intervals along the edges of a gable, pinnacle, etc.

Cusp

The projecting point formed by the intersection of two segmental arcs or foils.

XV Cusp

Custodia

Spanish term for a monstrance of precious material for the display of the Host.

Dagger

A tracery motif, rounded or pointed at the head, pointed at the foot and cusped inside (*mouchette*).

Decorated style

The name given to the lavishly ornamented second phase of English Gothic, extending from the late thirteenth century to the mid-fourteenth. It is sometimes further subdivided into an earlier Geometric Period and a later Curvilinear Period, the names referring primarily to the pattern of the window tracery.

Falchion

Literally, a broad curved sword; another name for a *mouchette*.

Fan vault

A regularized highly decorative form of vaulting developed in England in which the ribs all have the same curvature.

Finial

(From the Latin *finis*: end.) A carved terminal ornament at the apex of a gable, etc.

Flamboyant

Used to describe tracery with sinuous flame-like forms. The late phase of French Gothic is known as *style flamboyant*.

Flèche

(French: arrow.) A slender wooden spirelet over the crossing; particularly characteristic of French Gothic.

Flushwork

A uniquely English wall treatment formed of knapped or split flints, often using flints of different colours to create decorative patterns.

Flying buttress

A quadrant arch used to transfer the thrust of a vault to a detached pier.

Foil

Name given to each of the small arcs separated by cusps. The number of foils is designated by the terms trefoil, quatrefoil, etc. See diagram under *Cusp*. *Four-pointed arch*

See *Tudor arch*.

Groined vault

A vault formed by the intersection of two barrel or tunnel vaults, the line of intersection of the vaulting surfaces being known as a groin.

Hall-church (Hallenkirche)

A church with nave and aisles of equal or near-equal height; a form particularly characteristic of German Gothic.

Hammerbeam-roof

An open timber roof in which the effective span is reduced by horizontal

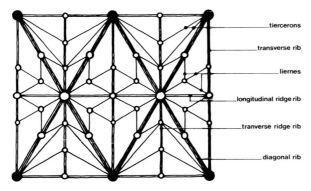

XVI Plan of two bays of stellar vaulting clarifying the nomenclature of Gothic vaulting ribs

brackets (hammer-beams), projecting at the wall-plate level, their free end supported on a curved strut, in turn supported on a corbel. (See page 49.)

Isabelline
Applied to the Spanish Late-Gothic style prevailing during the reign of Isabella *'La Catolica'* (1474-1504).

Jamb
The upright surface (frequently splayed) forming the side of an archway or window.

Jubé
The French term for a screen separating the choir from the nave.

Junta
A commission of architectural experts, usually master-masons of renown, appointed to resolve some contentious issue; a procedure unique to Spain in the Late Middle Ages.

Lantern
A tower, usually over the crossing, glazed to admit light to the interior.

Lierne
(From the French *lier*: to bind, tie.) A short, purely decorative, intermediate vaulting rib which does not rise from the main springer and is not a ridge-rib.

Lonja
A commercial exchange in the kingdom of Aragon (Catalonia).

Mandorla
An almond-shaped aureole enclosing the figure of Christ or the Virgin Mary.

Manueline
Applied to the Portuguese Late-Gothic style prevailing during the reign of Manuel I 'The Fortunate' (1495-1521).

Massaroca
A cone-shaped decorative motif resembling a magnolia kernel that figures prominently in Manueline ornament.

Misericord
(From the Latin *misericordia*: pity.) A projection under the hinged, tip-up seat of a choir stall, frequently elaborately carved, which, together with the arm-rests, affords a measure of support for members of the clergy required to stand during the offices.

Moucharaby
A window or balcony enclosure with protective screens of turned lattice-work, a characteristic feature of North African Islamic architecture which influenced Iberian Gothic.

Mouchette
A curvilinear, dagger-shaped tracery motif characteristic of the English Decorated and French Flamboyant styles. Also known as a *falchion*.

XVII Mouchette

Mudéjar
Spanish style of markedly Moorish character produced by Moorish craftsmen under Christian rule.

Mullions
Slender vertical stone members used to divide a Gothic window into a number of 'lights'.

Oculus
A circular opening or window without stone tracery.

Ogee
A continuous, S-shaped, reverse-curve. An ogee arch: a pointed arch with a head so shaped, inscribed by means of four centres.

XVIII Ogee arch

Ogival
Pertaining to the Gothic pointed arch or vault.

Openwork
Applied to spires, gables, ornament, etc., where open tracery takes the place of solid material.

Oriel
A projecting window corbelled out from the wall.

Perpendicular style
The last of the three great styles of English Gothic, so-called from its emphasis on the vertical line. It superseded the *Decorated style* (which had taken over from Early English) in the second half of the fourteenth century and prevailed until the advent of the Renaissance style.

Pier
The preferred term for a support other than a column in Gothic architecture. Particularly characteristic of the mature Gothic style is the 'Compound Pier', composed of a cluster of colonnettes which continue the line of the vaulting shafts to ground level.

Pinnacle
A turret-like termination, the weight of which helps to stabilise such forms as a buttress; also used purely decoratively.

Poppy-head
(Supposedly from the Latin *puppis*: a poop.) The termination of a bench-end, usually in the form of a foliated finial.

Plateresque
Literally, resembling the art of the *platero*, or silversmith. The name given to a Spanish style of the late Gothic and early Renaissance periods, characterized by lavish, delicately-chiselled superficial ornament.

Predella
Narrow horizontal strip used to elevate an altarpiece; usually decorated with small scenes.

Presbytery
The portion of the church east of the choir reserved for the priests and housing the high altar.

Pulpitum
The screen closing off the west end of the choir. The English equivalent of the French *jubé*.

Quadripartite vault
The classic Gothic solution, with each vaulting bay divided by diagonal ribs into four triangular cells.

Rayonnant
The name given to the French style of the period 1250-1350, characterized by the ultimate paring down of supports to create veritable window-walls, a certain linearism in the detail, and a particular fondness for rose windows with 'radiating' tracery–hence the name.

Reredos or retablo
Spanish term for an altarpiece of carved and painted wood, stone or precious metal rising above the rear edge of an altar.

Retablo mayor
The principal altarpiece or *reredos* of a Spanish church.

Retrochoir
An area behind the high altar, particularly applicable to English Gothic, where the retrochoir between the presbytery to the west and the Lady Chapel to the east often functions as a rectangular ambulatory.

Ridge-rib
A decorative rib following the ridge of a vault, either longitudinally or transversely.

Rood loft
A gallery surmounted by a monumental Crucifixion or Rood (from the Anglo-Saxon for a rod).

Sakramentshaus
German Late-Gothic term for a stone tabernacle or receptacle for the Sacrament, surmounted by a traceried canopy.

Schnitzaltar
The German name for a carved wooden altarpiece.

Sedilia
Seats for the priests, generally of masonry, on the south side of the presbytery.

Severy
A compartment or section of the vaulting web enclosed between vaulting ribs.

Soufflet
An elongated quatrefoil with one pair of opposite ends pointed, popular as a tracery motif in the Flamboyant style.

XIX Soufflet

Spandrel
The triangular space enclosed between an arch, a vertical line rising from the springer and a horizontal line at the level of the apex.

Spätgotik
German Late-Gothic, including the idiosyncratic *'Sondergotik'*.

Springing
The point at which an arch begins to curve upwards from the impost block.

Squinch
An arch bridging the angle between two walls. Placed diagonally in the internal angles, squinches may, for example, conveniently be used to convert a square to an octagon.

Strainer arch (or beam)
An arch or beam inserted across an opening to resist an end thrust tending to cause distortion of, for example, a pier.

String-course
A projecting horizontal course or moulding.

Tie-beam roof
A timber roof with inclined rafters pitched one against the other, with the outward thrust countered by a horizontal tie-beam of cambered form, i.e. sloping up slightly towards the centre to counter the natural tendency of a beam to sag (see page 49).

Tierceron
An intermediate vaulting rib, rising from the main springer and terminating at the ridge-rib.

Tracery
A filigree of thin stone members which subdivide the glass area of a Gothic window into manageable sizes and provide the necessary framework. In the Late-Gothic period tracery often extends over blank expanses of wall as well.

Transom
A horizontal member of stone or wood used in the upper part of an opening or panel.

Triforium
An arcaded wall passage opening towards the nave, at the height of the sloping roof over the aisle vaulting and below the clerestory.

Trumeau
A central pillar supporting the tympanum and dividing a wide doorway in two: in French Gothic frequently carved with figure sculpture of major iconographic importance.

Trussed-rafter roof
A timber roof in which the tie-beam is raised to gain greater clear height internally. The tie-beam now functions as a collar, stiffened by braces attached to the rafters (see page 49).

Tudor arch
A depressed, four-centred, pointed arch.

Tympanum
The triangular space between the lintel and an arch over a doorway.

Vault
A ceiling or roof of masonry constructed on the principle of the arch.

Vaulting shaft
A vertical member supporting a vaulting rib and extending for a part or the entire height from the springing of the vault to the ground.

Voussoirs
The wedge-shaped blocks of masonry used in the construction of an arch.

336 *Below* A galliass, an armed merchantman used in the export trade, and below, the merchant's mark of John Greenway: relief commemorating the donor on a buttress of the Greenway chapel. *Tiverton Parish Church, Devon*

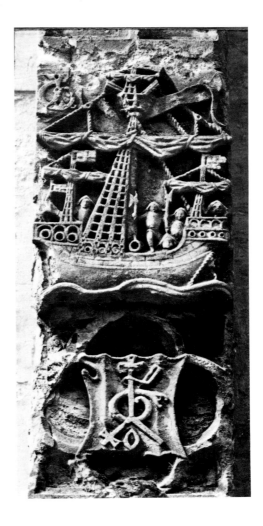

Bibliography

General

BARRACLOUGH, GEOFFREY
Origins of Modern Germany, Oxford, 1946
BOXER, CHARLES R.
The Portuguese Seaborne Empire, London, 1969
CAMBRIDGE ECONOMIC HISTORY, Vol. II, 1952
CAMBRIDGE MEDIEVAL HISTORY, Vols. VII and VIII, 1932 and 1936
CARTELLIERI, OTTO
Am hofe der Herzöge von Burgund, Basel, 1926.
Also available in translation as: *The Court of Burgundy*, London, 1929
CHAMBERS, SIR EDMUND K.
The Mediaeval Stage, Oxford, 1903
COULTON, GEORGE G.
Life in the Middle Ages, 4 vols, Cambridge, 1930
COULTON, GEORGE G.
Mediaeval Panorama, Cambridge, 1938
COULTON, GEORGE G.
Art and the Reformation, Cambridge, 1953
DE ROOVER, RAYMOND A.
Money, Banking and Credit in Medieval Bruges, Cambridge, Massachusetts, 1948
DOLLINGER, PHILIPPE
La Hanse, Paris, 1964.
Available in translation as: *The German Hansa*, London, 1969
DUBY, GEORGES
L'Économie rurale et la vie des campagnes dans l'Occident médiéval, Paris, 1962
DUBY, GEORGES
Foundations of a New Humanism, 1280-1440, Geneva, 1966
EVANS, JOAN (editor)
The Flowering of the Middle Ages, London, 1966
FLICK, ALEXANDER C.
The Decline of the Medieval Church, 2 vols, London, 1930
FOWLER, KENNETH
The Age of Plantagenet and Valois, London, 1967
HAY, DENYS
Europe in the Fourteenth and Fifteenth Centuries, London, 1966
HEERS, JACQUES
L'Occident aux XIVe et XVe siècles: aspects économiques et sociaux, Paris, 1963
HUIZINGA, JOHAN
The Waning of the Middle Ages, London 1924
KEEN, MAURICE
The Laws of War in the Late Middle Ages, London, 1965
LIVERMORE, H. V.
A History of Portugal, Cambridge, 1947
MUMFORD, LEWIS
The Culture of Cities, London, 1938
PARKES, JAMES W.
The Jews in the Mediaeval Community, London, 1938
PIRENNE, HENRI
Histoire de Belgique, II, Brussels, 1922
PIRENNE, HENRI
Economic and Social History of Mediaeval Europe, London 1936
PIRENNE, HENRI
A History of Europe from the Invasions to the.XVI Century, London, 1939

POWER, EILEEN
The Wool Trade in English Mediaeval History, Oxford, 1941
RASHDALL, HASTINGS
The Universities of Europe in the Middle Ages, new ed. by F. M. Powicke and A. B. Emden, 3 vols, Oxford, 1936
SCHOLDERER, VICTOR
Johann Gutenberg, British Museum, London, 1963
SOLDEVILA, FERNANDO
Historia de España, II, Barcelona, 1952
STEINBERG, SIGFRIED H.
Five Hundred Years of Printing, Harmondsworth, 1966
WALEY, DANIEL
Later Medieval Europe, London, 1964
ZIEGLER, PHILIP
The Black Death, London, 1969

Late Gothic Art and Architecture

ACKERMAN, JAMES S.
'Ars Sine Scientia Nihil Est', *The Art Bulletin* XXXI, New York, 1949
ACLAND, JAMES H.
Medieval Structure: The Gothic Vault, Toronto, 1972
BALTRUSAITIS, J.
Le Moyen-âge fantastique, Paris, 1955
BRANNER, ROBERT
Gothic Architecture, London, 1961
BUHLER, CURT F.
The Fifteenth-Century Book, Philadelphia, 1960
CALI, FRANÇOIS
L'Ordre Flamboyant et son Temps, Essai sur le style gothique du XIVe au XVIe siècle, Paris, 1967
CUTTLER, CHARLES D.
Northern Painting, New York, 1968
DEHIO, GEORG and BEZOLD, GEORG VON
Die Kirchliche Baukunst des Abendlandes, Vol II, Stuttgart, 1901
DUBY, GEORGES
Foundations of a New Humanism, 1280-1440, Geneva, 1966
DUPONT, JACQUES and GNUDI, CESARE
Gothic Painting, Geneva, 1954
FREY, DAGOBERT
'Architekturzeichnung' in *Reallexikon zur deutschen Kunstgeschichte*, Vol I, Part II, Stuttgart, 1937
FOCILLON, HENRI
The Art of the West in the Middle Ages, Vol II, *Gothic Art*, London, 1963–a translation of the French original: *Art d'Occident*, Paris, 1938
FRANKL, PAUL
'The Secret of the Mediaeval Masons', *The Art Bulletin* XXVII, New York, 1945
FRANKL, PAUL
Gothic Architecture, Harmondsworth, 1962
HARVEY, JOHN
The Gothic World, London, 1950
HAUSER, ARNOLD
The Social History of Art, London, 1951
HOLT, ELIZABETH
A Documentary History of Art, Vol 1, New York, 1957
KNOOP, DOUGLAS and JONES, G. P.
The Mediaeval Mason, Manchester, 1949
MÂLE, EMILE
L'Art Réligieux de la Fin du Moyen Age en France, Paris, 1908
MARTINDALE, ANDREW
Man and the Renaissance, London, 1966
(Includes a discussion of Late Gothic paralleling the Renaissance in Italy)
MÜLLER, THEODOR
Sculpture in the Netherlands, Germany, France and Spain, 1400 to 1500, Harmondsworth, 1966
MUSPER, HEINRICH T.
Gotische Malerei nördlich der Alpen, Munich, 1961
PANOFSKY, ERWIN
Tomb Sculpture, New York, 1964
PEVSNER, NIKOLAUS
An Outline of European Architecture, London, 1948
SALZMAN, LOUIS F.
Building in England down to 1540, Oxford, 1952
SCHELLER, ROBERT W.
A Survey of Medieval Model Books, Haarlem, 1963

THIEME, ULRICH and BECKER, FELIX
Allgemeines Lexikon der bildenden Künstler, 37 vols, Leipzig, 1908-50
VERDIER, P. (editor)
The International Style: The Arts in Europe around 1400, Walters Art Gallery, Baltimore, 1962
VIBERT, LIONEL
Freemasonry before the Existence of Grand Lodges, London, 1932
WEITENKAMPF, FRANK
The Fifteenth Century. The Cradle of Modern Book-Illustration, New York, 1938

England
BOND, FRANCIS
Gothic Architecture in England, London, 1906
BOND, FRANCIS
Introduction to English Church Architecture, 2 vols, London, 1913
CHATWIN, P. B.
'The Decoration of the Beauchamp Chapel, Warwick, with special reference to the Sculptures', *Archaeologia*, LXXVII, 1927
COOK, G. H.
Mediaeval Chantries and Chantry Chapels, London, 1947
COOK, G. H.
Portrait of Canterbury Cathedral, London, 1949
COOK, G. H.
The Story of Gloucester Cathedral, London, 1952
COOK, G. H.
The English Medieval Parish Church, London, 1954
COOK, G. H.
The English Cathedral, London, 1957
EVANS, JOAN
English Art 1307-1461, Oxford, 1949
GADD, M. L.
English Monumental Brasses of the 15th and early 16th Centuries, British Archaeological Association Journal, 3rd series, II, 1937
GARDNER, ARTHUR
A Handbook of English Medieval Sculpture, Cambridge, 1935
HARVEY, JOHN
Henry Yevele, c. 1320 to 1400. The Life of an English Architect, London, 1944
HARVEY, JOHN
Gothic England 1300-1550, 2nd edition, London, 1948
HARVEY, JOHN
English Cathedrals, London, 1950
HARVEY, JOHN
English Medieval Architects: A Biographical Dictionary, down to 1550, London, 1954
HARVEY, JOHN
The Origin of the Perpendicular Style, in *Studies in Building History*, in honour of B. H. St. J. O'Neil, edited by E. M. Jope, London, 1961
HARVEY, JOHN
The Master Builders, London, 1971
HASTINGS, MAURICE
St Stephen's Chapel, Cambridge, 1955
HOWARD, F. E.
The Medieval Styles of the English Parish Church, London, 1936
KNOWLES, JOHN A.
The York School of Glass Painting, London, 1936
LETHABY, WILLIAM R.
Westminster Abbey Re-examined, London, 1925
PEVSNER, NIKOLAUS (editor)
The Buildings of England, Harmondsworth, 1951 seqq.
PRIDEAUX, E. K.
Late Medieval Sculpture from the Church of St Peter, Tiverton, Archaeological Journal, LXXV, 1918
PRIOR, EDWARD S. and GARDNER, ARTHUR
An Account of Mediaeval Figure Sculpture in England, Cambridge, 1912
READ, HERBERT
English Stained Glass, London, 1926
RICKERT, MARGARET
Painting in Britain: The Middle Ages, Harmondsworth, 1954
ST. J. HOPE, W. H.
The Heraldry and the Sculpture of the Vault of the Divinity School at Oxford, Archaeological Journal, LXXI, 1914
SALZMAN, LOUIS F.
English Industries of the Middle Ages, 2nd ed., Oxford, 1923

SALZMAN, LOUIS F.
Building in England down to 1540, Oxford, 1952
SHELBY, L. R.
The Role of the Master Mason in Mediaeval English Building, Speculum, XXXIX, 1964
SHELBY, L. R.
The Education of Medieval English Master Masons, Mediaeval Studies, XXXII, Toronto, 1970
STONE, LAWRENCE
Sculpture in Britain: The Middle Ages, Harmondsworth, 1955
WEBB, GEOFFREY
Architecture in Britain: The Middle Ages, Harmondsworth, 1956
WILLIS, REV. ROBERT
Architectural History of the University of Cambridge, Cambridge, 1886
WORMALD, FRANCIS
The Wilton Diptych, Journal of the Warburg and Courtauld Institutes, XVII, 1954

France & Burgundy
AUBERT, MARCEL
La sculpture française au moyen-âge, Paris, 1946
AUBERT, MARCEL; CHASTEL, ANDRÉ; GRODECKI, etc.
Le Vitrail Français, Paris, 1958
AUBERT, MARCEL
Gothic Cathedrals of France and their Treasures, London, 1959
BOINET, AMÉDÉE
La Cathédrale d'Amiens, Paris, 1922
CALI, FRANÇOIS
L'Ordre Flamboyant et son Temps, Essai sur le style gothique du XIVe au XVIe siècle, Paris, 1967
DAVID, HENRI
Claus Sluter, Paris, 1951
DIJON, MUSÉE DES BEAUX-ARTS (QUARRÉ PIERRE)
Les Pleurants dans l'Art du Moyen Age en Europe, Dijon, 1971
DIJON, MUSÉE DES BEAUX-ARTS (QUARRÉ PIERRE)
Jean de la Huerta et la Sculpture Bourguignonne au milieu du XVe siècle, Dijon, 1972
DUVERGER, J.
De Brusselsche Steenbickeleren der XIV en XV eeuw, Ghent, 1933
(Discusses Claus Sluter's stay in Brussels before his departure for Dijon)
ENLART, CAMILLE
Origine anglaise du style flamboyant, Bulletin Monumental, LXX, 1906
EVANS, JOAN
Art in Mediaeval France 987-1498, Oxford, 1948
FAVIÈRE, JEAN
Les Anges de Bourges, L'Œil, no 57, 1959
GANDILHON, A. and GAUCHERY, R.
Bourges, Hôtel Jacques Coeur, Congrès archéologique de Bourges, 1931
GRODECKI, LOUIS
The Jacques Coeur Window at Bourges, Magazine of Art, Washington, February, 1949
*LARAN, JEAN
La Cathédrale d'Albi, Paris, 1911
*LEBLOND, VICTOR
La Cathédrale de Beauvais, Paris, 1956
*LOISEL, ABBÉ ARMAND
La Cathédrale de Rouen, Paris, 1913
MATHEY, FRANÇOIS
L'église de Brou, Paris, 1957
MEISS, MILLARD
French Painting in the Time of Jean de Berry, London, 1967
MÜLLER, THEODOR
Sculpture in the Netherlands, Germany, France and Spain: 1400-1500, Harmondsworth, 1966
*NODET, VICTOR
L'église de Brou, Paris, 1911
PLANCHENAULT, R.
L'Apocalypse d'Angers, Bulletin Monumental, 1953
PLAT, GABRIEL
L'église de la Trinité de Vendôme, Paris, 1934
PORCHER, JEAN
L'Enluminaire française, Paris, 1959
RING, GRETE
A Century of French Painting 1400-1500, London, 1949

STERLING, CHARLES
La peinture française: les primitifs, Paris, 1938
TAMIR, MAX M.
The English Origin of the Flamboyant Style, Gazette des Beaux-Arts, Paris, 1946
TROESCHER, GEORG
Die burgundische Plastik des ausgehenden Mittelalters, Frankfurt, 1940
TROESCHER, GEORG
Claus Sluter, Paris, 1951
VIOLLET-LE-DUC, EUGÈNE E.
Dictionaire raisonné de l'architecture française du XI^e au XVI^e siècle, 10 vols., Paris, 1854-68
*WALTER, JOSEPH
La Cathédrale de Strasbourg, Paris, 1933
ZARNECKI, GEORGE
Claus Sluter: Sculptor to Duke Philip the Bold, Apollo LXXVI, 1962

*Monographs on French Cathedrals in the series *Petites Monographies des Grands Edifices de la France,* edited by Marcel Aubert.

Netherlands
BALDASS, LUDWIG
Jan van Eyck, London, 1952
BATTARD, MARIUS
Beffrois *Halles, Hôtels de Ville dans le Nord de la France et la Belgique,* Arras, 1948
BEENKEN, HERMANN THEODOR
Rogier van der Weyden, Munich, 1951
BORCHGRAVE D'ALTENA, JOSEPH, COMTE DE
OEuvres de nos Imagiers Roman et Gothiques, 1025-1550, Brussels, 1944
BRAND PHILIP, LOTTE
The Ghent Altarpiece and the Art of Jan van Eyck, Princeton, 1971
COLLON-GEVAERT, SUZANNE
Histoire des arts du métal en Belgique, Brussels, 1951
DAVIES, MARTIN
Rogier van der Weyden. An Essay, with a Critical Catalogue of the Paintings assigned to him and to Robert Campin, London, 1972
DE TOLNAY, CHARLES
Le maître de Flémalle et les frères van Eyck, Brussels, 1939
DE TOLNAY, CHARLES
Hieronymus Bosch, rev. ed., Baden-Baden, 1966
FREEMAN, MARGARET
The Iconography of the Mérode Altarpiece, Bulletin of the Metropolitan Museum of Art, XVI, 1957
FRIEDLÄNDER, MAX J.
Die altniederländische Malerei, Berlin, Leyden, 1924-37
HEZENMANS, J. C. A.
La cathédrale Saint Jean à Bois-le-Duc, Bulletin Monumental, 1873
HULIN DE LOO, G.
Heures de Milan, Brussels, 1911
HULIN DE LOO, G.
Rogier van der Weyden, in *Biographie nationale de Belgique,* XXVII, 1938
KOCH, ROBERT A.
Flower Symbolism in the Portinari Altar, Art Bulletin, XLVI, 1964
LASSAIGNE, JACQUES
Flemish Painting: The Century of Van Eyck, Geneva, 1957
MÜLLER, THEODOR
Sculpture in the Netherlands, Germany, France and Spain: 1400-1500, Harmondsworth, 1966
MUSPER, HEINRICH T.
Die Urausgaben der holländischen Apokalypse und Biblia Pauperum, Munich, 1961
PÄCHT, OTTO
The Master of Mary of Burgundy, London, 1948
PANOFSKY, ERWIN
Early Netherlandish Painting: its Origin and Character, Cambridge, Massachusetts, 1953
SCHAPIRO, MEYER
Muscipula Diaboli: The Symbolism of the Mérode Altarpiece, Art Bulletin, Vol XXVI, 1945
VAN DE WALLE, A. J. L.
Gothic Art in Belgium, Brussels, 1971
VAN GELDER, H. E. (and others)
Kunstgeschiedenis der Nederlanden, 2nd ed., Utrecht, 1946

VAN MANDER, CAREL
Het Schilderboek, Haarlem, 1604; available in translation as: *Dutch and Flemish Painters,* New York, 1936
VAN PUYVELDE, LEO
The Flemish Primitives, London, 1948
VAN PUYVELDE, LEO
La peinture flamande, au siècle des Van Eyck, Paris, 1953
VERMEULEN, FRANS
Handboek tot de Geschiedenis der Nederlandse Bouwkunst, 2 vols, 1928 and 1931
WINKLER, FRIEDRICH
Das werk des Hugo van der Goes, Berlin, 1964
ZUPNICK, IRVING L.
The mystery of the Mérode mousetrap, Burlington Magazine, March, 1966

Germany and Austria
BAUM, JULIUS
Die Ulmer Plastik um 1500, Stuttgart, 1911
CLASEN, KARL HEINZ
Die schönen Madonnen, Königstein, 1951
CLASEN, KARL HEINZ
Deutsche Gewölbe der Spätgotik, Berlin, 1958
DEHIO, GEORG
Geschichte der deutschen Kunst, Berlin, 1921
DEHIO, GEORG
Handbuch der deutschen Kunstdenkmäler, 5 vols, Berlin, 1927
FISCHEL, L.
Nicolaus Gerhaerts und die Bildhauer der deutschen Spätgotik, Munich, 1944
FÖRSTER, OTTO
Stephan Lochner, Bonn, 1952
GERSTENBERG, KURT
Deutsche Sondergotik, Munich, 1913
GERSTENBERG, KURT
Das Ulmer Münster, Burg, 1926
GERSTENBERG, KURT
Hans Multscher, Leipzig, 1928
GERSTENBERG, KURT
Tilman Riemenschneider, Munich, 1962
HANFSTAENGL, EBERHARD
Hans Stetthaimer, Leipzig, 1911
HEMPEL, EBERHARD
Michael Pacher, Vienna, 1931
HEMPEL, EBERHARD
Geschichte der deutschen Baukunst, Munich, 1949
LANDOLT, HANSPETER
German Painting, The Late Middle Ages (1350-1500), Geneva, 1968
LUTZE, EBERHARD
Veit Stoss, Berlin, 1968
MORISON, STANLEY
German Incunabula in the British Museum, London, 1928
MÜLLER, THEODOR
Sculpture in the Netherlands, Germany, France and Spain, 1400-1500, Harmondsworth, 1966
OETTINGER, KARL
Anton Pilgram und die Bildhauer von St Stephen, Vienna, 1951
PAATZ, WALTER
Bernt Notke und sein Kreis, Berlin, 1939
PAPWORTH, JOHN W.
Roriczer on Pinnacles, London, 1848-1853
PEVSNER, NIKOLAUS
Review of K. H. Clasen's *Deutsche Gewölbe der Spätgotik,* Art Bulletin, XLI, 1959
RORICZER, MATTHÄUS
Das Büchlein von der Fialen Gerechtigkeit, Regensburg, 1486
SCHULZE, KONRAD W.
Die Gewölbesysteme im spätgotischen Kirchenbau in Schwaben von 1450-1520, Reutlingen, c. 1940
SCHWEMMER, WILHELM
Adam Kraft, Nuremberg, 1958
SEIFERT, HANS
Das Chorgestühl im Ulmer Münster, Konigstein-im-Taunas, 1958
SHESTACK, ALAN (editor)
Complete Engravings of Martin Schongauer, New York, 1969
STANGE, ALFRED
Deutsche Malerei der Gotik, Berlin, 1934

SWOBODA, KARL M.
Peter Parler, der Baukünstler und Bildhauer, Vienna, 1940
THIEME, ULRICH and BECKER, FELIX
Allgemeines Lexikon der bildenden Künstler, 37 vols, Leipzig, 1908-50
VÖGE, WILHELM
Jörg Syrlin der Ältere und sein Bildwerke, II, Berlin, 1950

Spain
AINAUD DE LASARTE, J.
Ars Hispaniae, Vol X, Cerámica y Vidrio, Madrid, 1952
ALOMER, GABRIEL
Guillem Sagrera y la arquitectura gótica del siglo XV, Barcelona, 1970
BEVAN, BERNARD
History of Spanish Architecture, London, 1938
CHUECA, FERNANDO
La Cathedral nueva de Salamanca, Salamanca, 1950
DURÁN Y SANPERE, AGUSTÍN
La Casa de la Ciudad de Barcelona, Barcelona, n.d.
DURÁN Y SANPERE, A. and AINAUD DE LASARTE, J.
Ars Hispaniae, Vol VIII, Escultura Gótica, Madrid, 1955
*GAYA NUÑO, J. A.
Burgos, Madrid, 1949
*GUDÍOL RICART, J.
Toledo, Madrid, 1947
GUDIÓL RICART, J.
Arte de España: Cataluña, Barcelona, 1955
GUDÍOL RICART, JOSEF
Ars Hispaniae, Vol IX, Pintura Gótica, Madrid, 1955
*GUERRERO LOVILLO, L.
Sevilla, Madrid, 1952
HARVEY, JOHN
The Cathedrals of Spain, London, 1957
KUBLER, GEORGE, and SORIA, MARTIN
Art and Architecture in Spain and Portugal and their American Dominions, 1500-1800, Harmondsworth, 1959
LAMPÉREZ Y ROMEA, V.
Historia de la arquitectura cristiana en la edad media, Barcelona, 1904-09
LOZOYA, JUAN DE CONTRERAS, MARQUES DE
Historia del Arte Hispánico, Barcelona, 1934
MÜLLER, THEODOR
Sculpture in the Netherlands, Germany, France and Spain: 1400-1500, Harmondsworth, 1966
POST, CHANDLER, R.
History of Spanish Painting, II-XII, Cambridge, Massachusetts, 1930-58
PROSKE, BEATRICE
Castilian Sculpture, New York, 1951
RANDALL, RICHARD, H.
Flemish Influences on Sculpture in Spain, Bulletin of the Metropolitan Museum of Art, XIV, 1956
STREET, GEORGE EDMUND
Some Account of Gothic Architecture in Spain, London, 1865
TORRES BALBÁS, L.
Ars Hispaniae, Vol VII, Architectura Gótica, Madrid, 1952
WETHEY, HAROLD E.
Gil de Silhoe and his School, Cambridge, Massachusetts, 1936
ZERVOS, CHRISTIAN
L'art de la Catalogne, Paris, 1937

*Monographs on Spanish Cathedrals in the series *Guias Artisticas de España,* edited by Josef Gudiól Ricart.

Portugal
BARREIRA, JOÃO
L'art manuélin, Gazette des Beaux-Arts, 1934
DELMÁR, EMIL
The Window at Tomar—a Monument to Vasco da Gama, the Portuguese Argonaut, Detroit Institute of Arts, Art Quarterly, Vol X, 1947
DOS SANTOS, REYNALDO
Arquitectura em Portugal, Lisbon, 1929
DOS SANTOS, REYNALDO
A escultura em Portugal, 2 vols, Lisbon, 1948 and 1950
DOS SANTOS, REYNALDO
Nuno Gonçalves, London, 1955

GONÇALVES, ANTÓNIO MANUEL
A custódia de Belém, Panorama, 1958
SMITH, ROBERT C.
The Art of Portugal 1500-1800, London, 1968
WATSON, WALTER CRUM
Portuguese Architecture, London, 1908

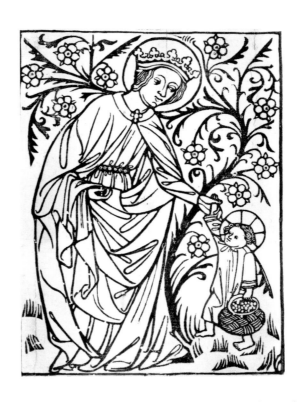

337 *St Dorothy,* German woodcut, *c.* 1420. *Staatliche Graphische Sammlung, Munich*

Acknowledgements

My sincerest thanks are due to the ecclesiastical and civil authorities in England, France, Belgium, the Netherlands, Germany, Austria, Spain and Portugal for their courtesy and assistance in enabling me to take photographs often at great inconvenience. I recall, in particular, the kindness of the authorities at the Pilgrimage Church of Altötting, who volunteered to disconnect the complicated burglar alarm so that I could photograph the priceless *Goldenes Rössel* under ideal conditions; the graciousness of Graf Eltz and the co-operation of his staff in photographing the uniquely evocative interiors of Burg Eltz, still in the possession of the same family for whom it was built in the Middle Ages; the unique privilege in these days of mass tourism of visiting museums and monuments when they were closed to the public, and being left alone with the ghosts of the past during the siesta hours in the echoing silence of Seville Cathedral; the indulgence of my colleague, the architect in charge of the restoration work at the St Janskerk at 's-Hertogenbosch, for keeping me company so patiently on the roof of the cathedral, waiting for the capricious Dutch weather to break and provide the perfect lighting for the sculptured figures straddling the flying-buttresses. A special note of thanks is due to the authorities of the Musée des Beaux-Arts de Dijon for the unique opportunity to photograph the statuettes of mourners from the tombs of Philip the Bold and John the Fearless of Burgundy *ex situ* during the exhibition, *Les Pleurants dans l'Art du Moyen Age en Europe*, held in the Palace of the Dukes of Burgundy in Dijon in 1971, on which occasion I was also able to photograph the mourner from the tomb of the Duc de Berry, on loan from the Hermitage, Leningrad. I would like to express in particular my thanks for the courteous assistance I received when photographing Henry VII's Chapel in Westminster Abbey, in St George's Chapel, Windsor, Magdalen College, Oxford and King's College, Cambridge.

Thanks to the generosity of the publishers and the co-operation of all concerned, it was possible for me personally to take all the photographs of architecture, sculpture, stained-glass, tapestry and *objets-d'art*. For better or worse, text and photographs, therefore, represent a single, unified viewpoint. The only exceptions are of some paintings, drawings, engravings and manuscripts, where a subjective approach was of less moment and excellent photographs were available from the museums.

My thanks are due to the following museums for permitting me to take photographs of works in their collections: the Victoria and Albert Museum, London; the Musée du Louvre and the Musée de Cluny, Paris; the Musée des Beaux Arts, Dijon; the Musée de l'Hôtel Dieu, Beaune; the Musée de l'Œuvre Notre-Dame, Strasbourg, and the Musée des Tapisseries, Angers; the Rijksmuseum, Amsterdam; the Kunsthistorisches Museum, Vienna; the Städtische Galerie Liebieghaus, Frankfurt-am-Main; the St Annenmuseum, Lübeck, and the Mainfränkisches Museum, Würzburg, and the Museu Nacional de Arte Antiga, Lisbon. Photographs of paintings, engravings, woodblock prints and manuscripts in their collections were supplied, and are reproduced by kind permission of the Trustees of the British Museum and the National Gallery, the Victoria and Albert Museum, London, and of the Warden and Fellows of New College, Oxford; the Musée du Louvre, the Bibliothèque Nationale and the Musée Jacquemart-André, Paris, the Musée Condé, Chantilly; the Bibliothèque Royale, Brussels; the Gemäldegalerie, Berlin-Dahlem, the Städelsches Kunstinstitut, Frankfurt-am-Main, the Kunsthalle, Hamburg, and the Alte Pinakothek and Staatliche Graphische Sammlung, Munich; the Österreichische Nationalbibliothek, Vienna; the Musée d'Art et d'Histoire, Geneva, Kunstmuseum, Basel; the Prado, Madrid; the Uffizi, Florence, and the Museo Civico, Turin; the National Gallery, Washington, and the Pierpont Morgan Library, and the Metropolitan Museum of Art, The Cloisters Collection, New York.

All the works listed in the bibliography have been consulted with profit. I should, however, like to acknowledge a special debt of gratitude to the definitive works in their respective fields by Marcel Aubert, Carl Clasen, Reynaldo dos Santos, Henri Focillon, Paul Frankl, Max Friedländer, Kurt Gerstenberg, Theodor Müller, Nikolaus Pevsner and Lawrence Stone; to John Harvey's indispensable *English Medieval Architects: A Biographical Dictionary down to 1550*, and the mine of information in his other works; to Erwin Panofsky's inimitable *Early Netherlandish Painting* and Charles Cuttler's *Northern Painting*; to Johan Huizinga's classic, *The Waning of the Middle Ages*, to Denys Hay's *Europe in the Fourteenth and Fifteenth Centuries*, and to Philip Ziegler's *The Black Death*.

Most of the specialised research was done in the library of the Victoria and Albert Museum in London and in the Avery Library of Columbia University in New York, to whose director, Professor Adolf Placzek, I am particularly indebted, as well as to the staff of the White Plains Public Library, New York.

Finally, my grateful thanks to Professor Peter Kidson of the Courtauld Institute, University of London, who kindly read the manuscript and made some valuable suggestions, and last, but by no means least, to my specialist editor Christine Arno, and to Janet Haffner and Moira Johnston of Paul Elek Ltd.

W.S.

Index